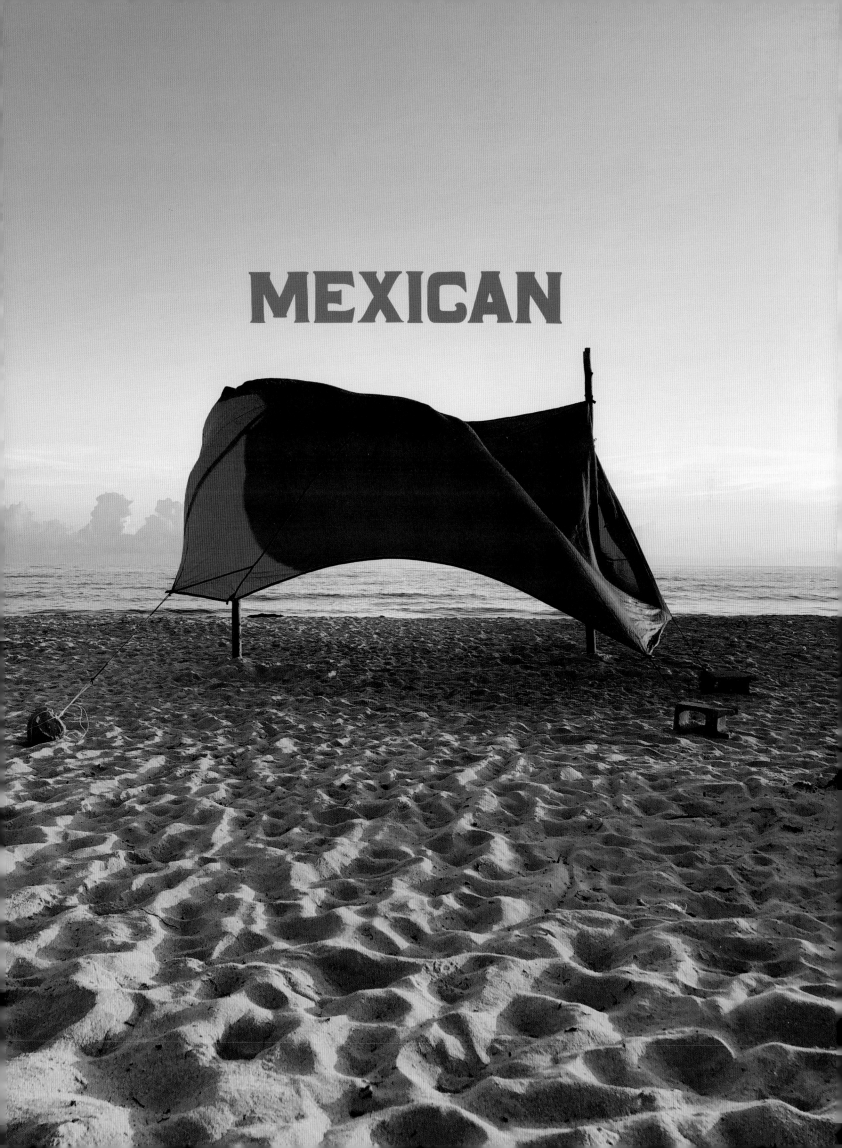

MEXICAN

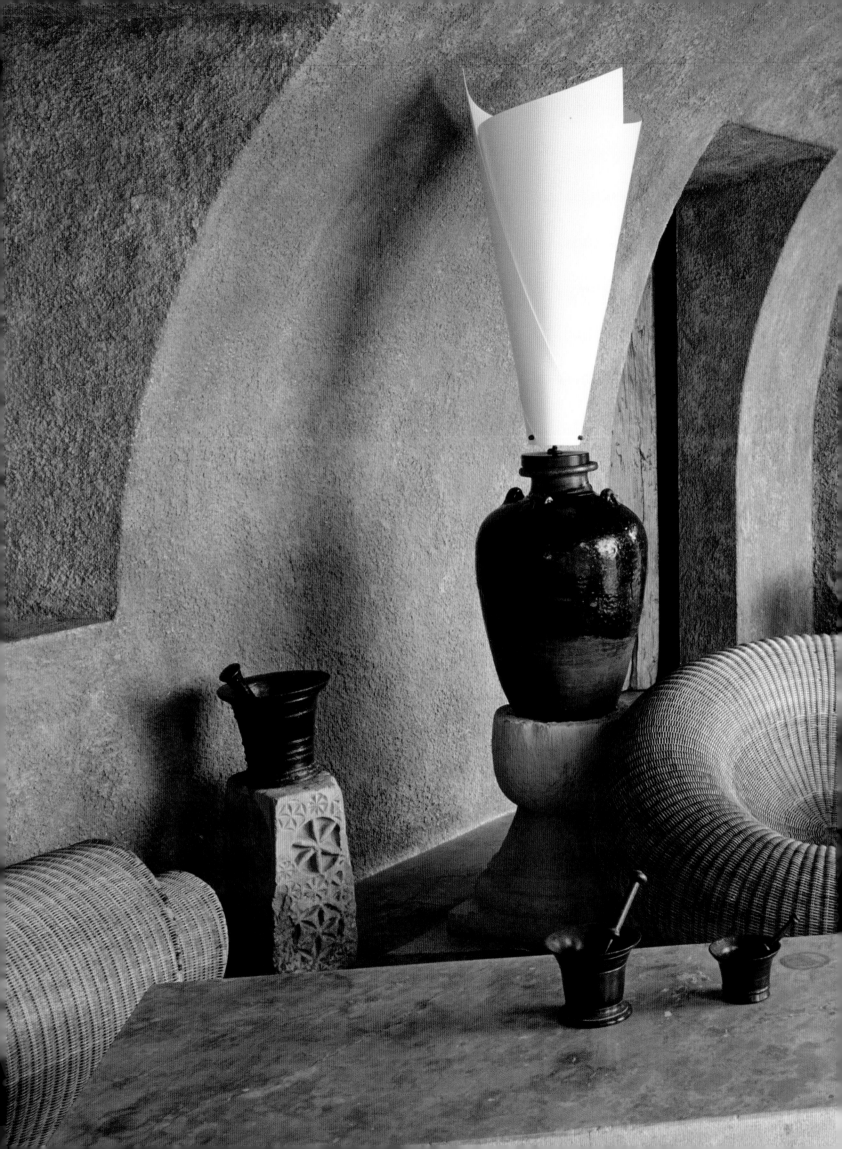

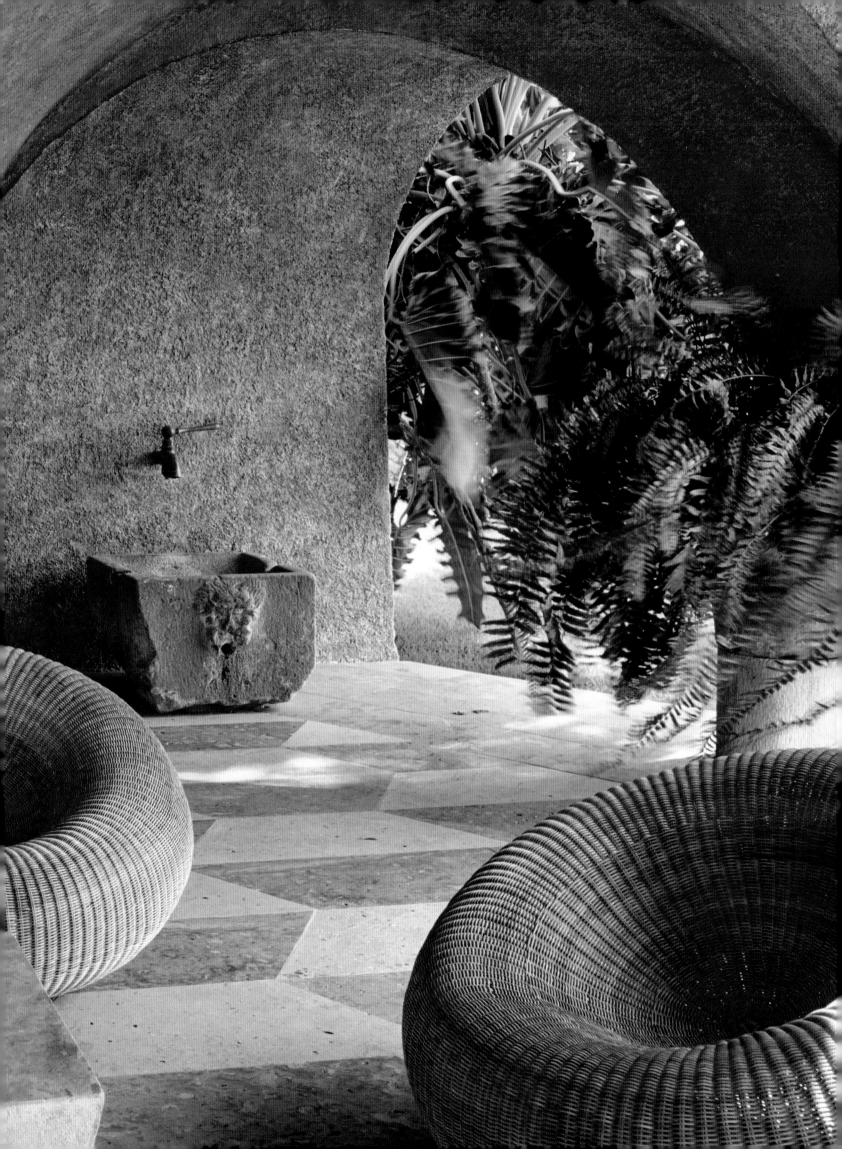

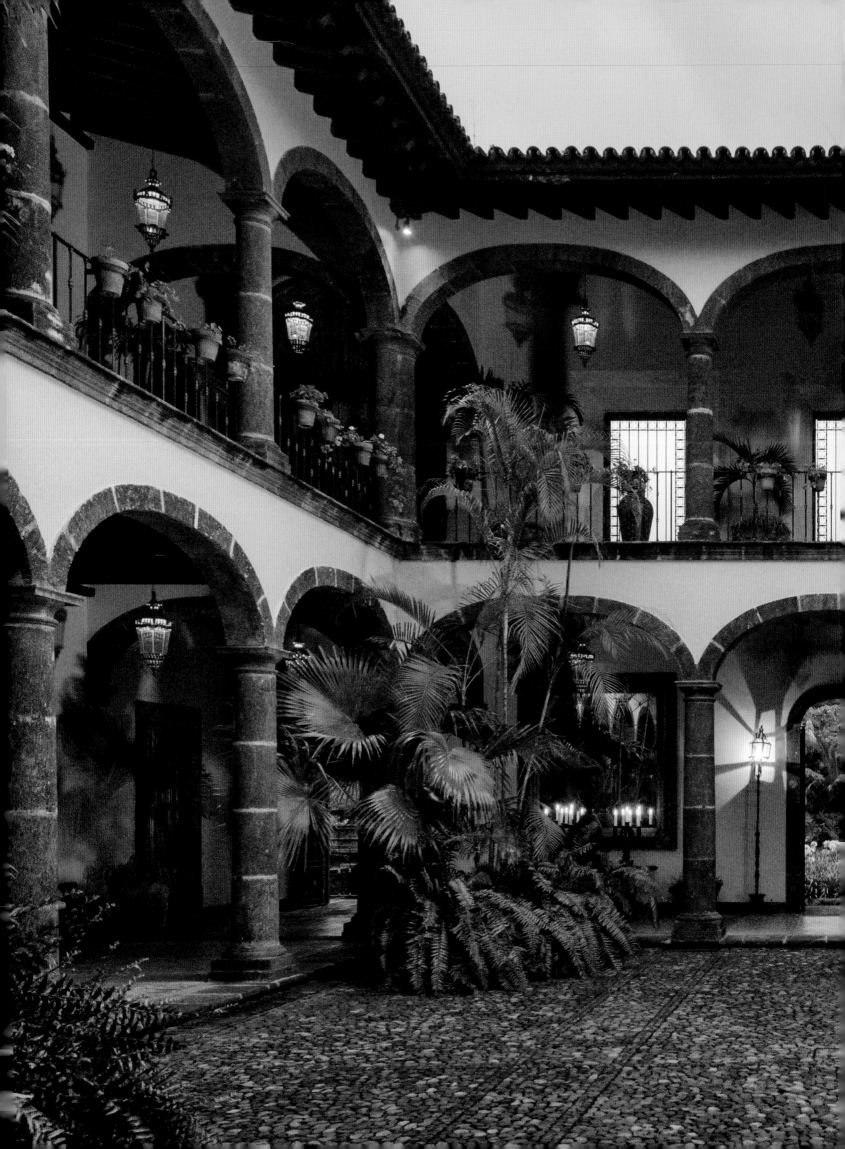

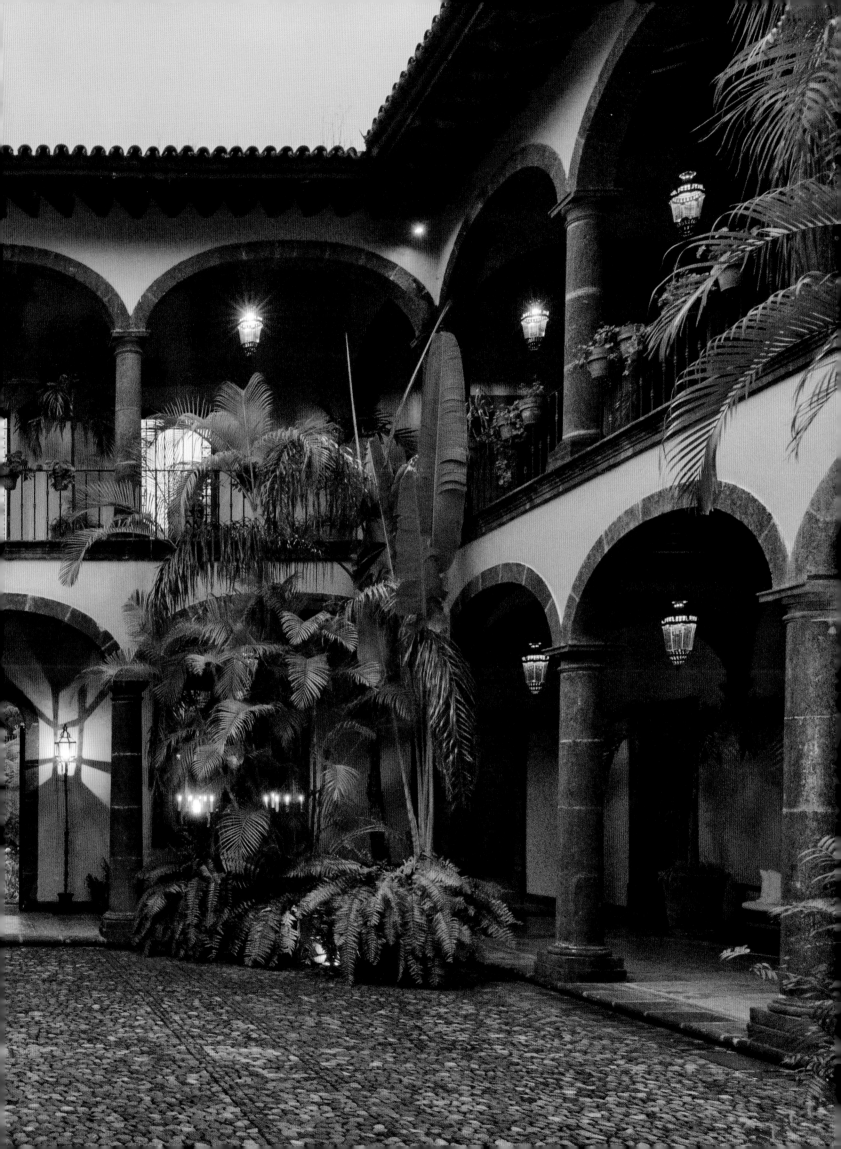

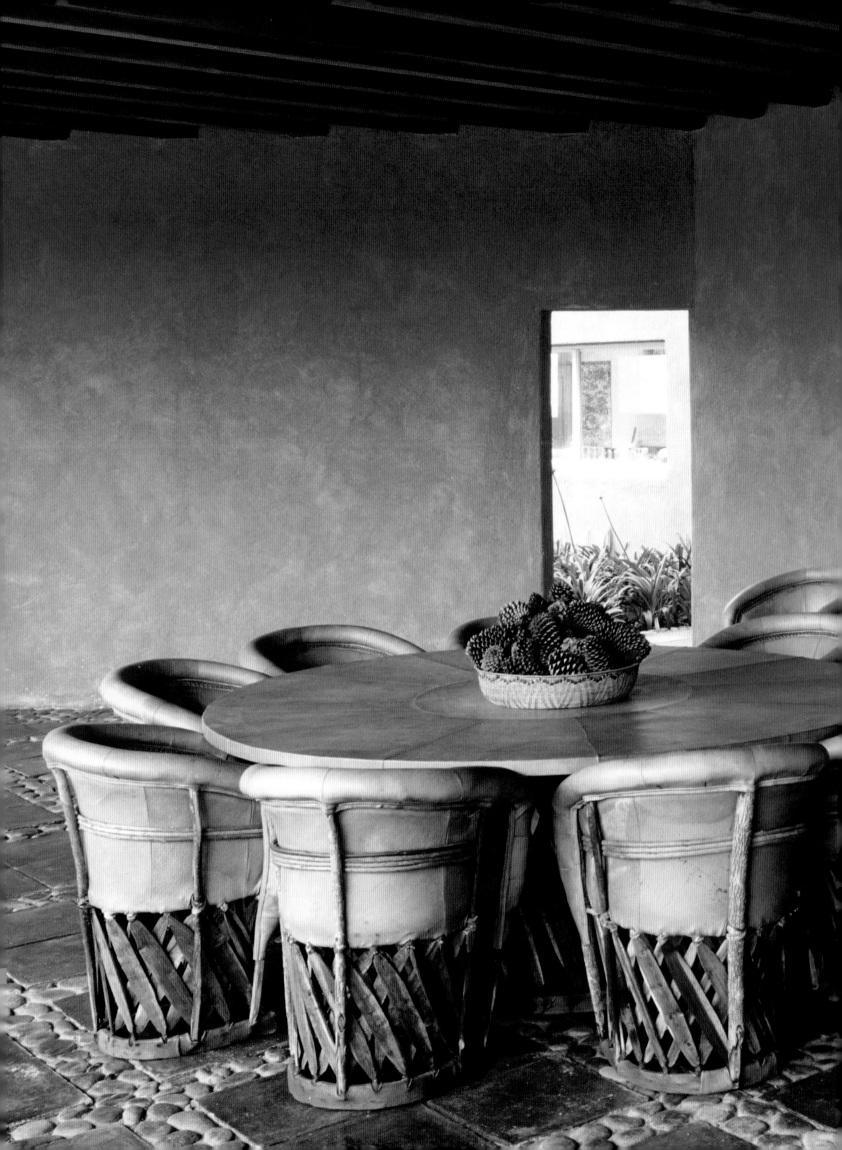

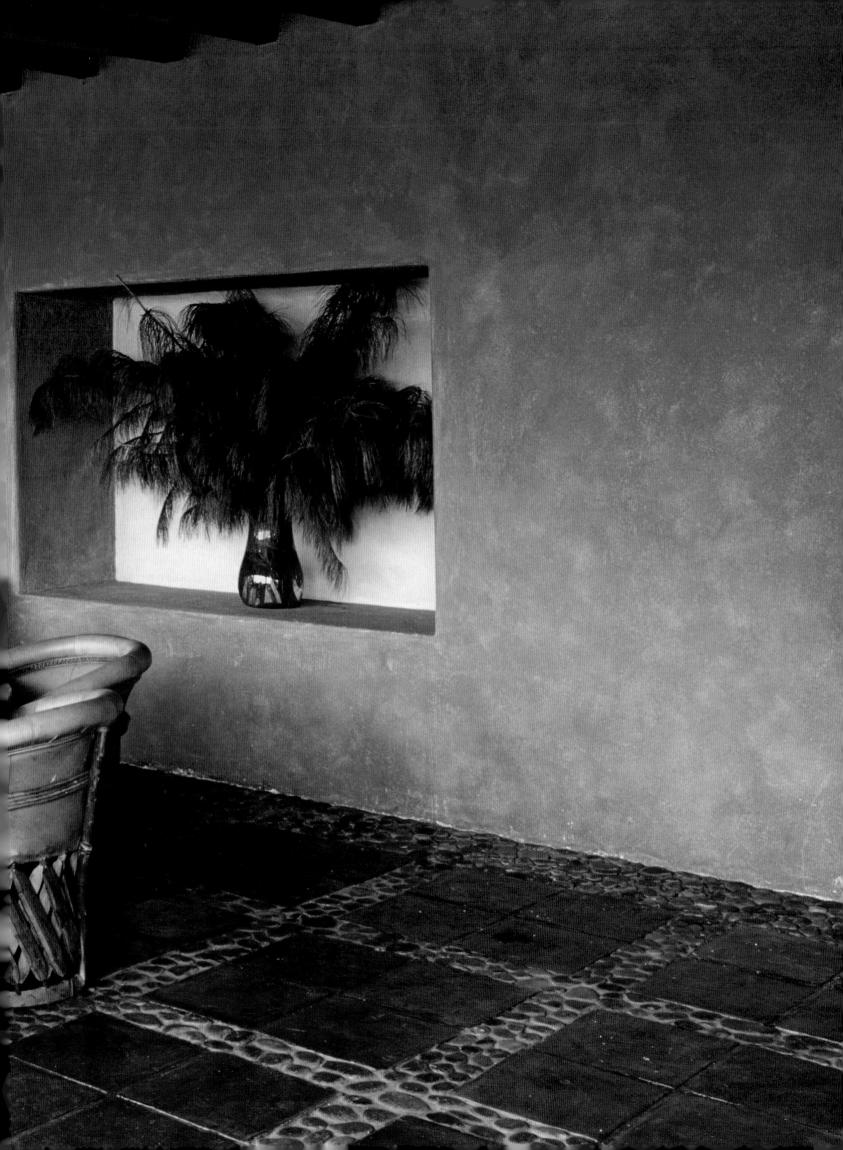

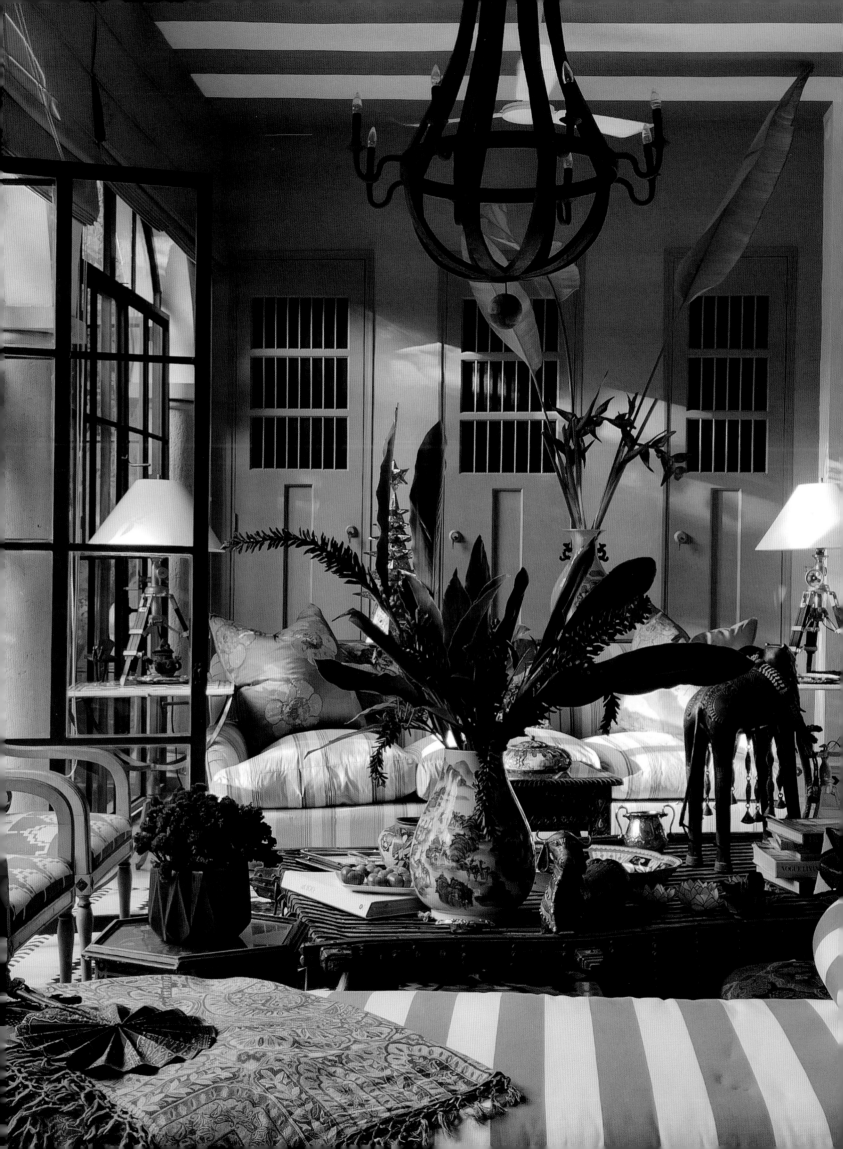

MEXICAN

A JOURNEY THROUGH DESIGN

NEWELL TURNER

FOREWORD BY SUSANA ORDOVÁS

A STEPHEN DRUCKER BOOK

VENDOME

NEW YORK · LONDON

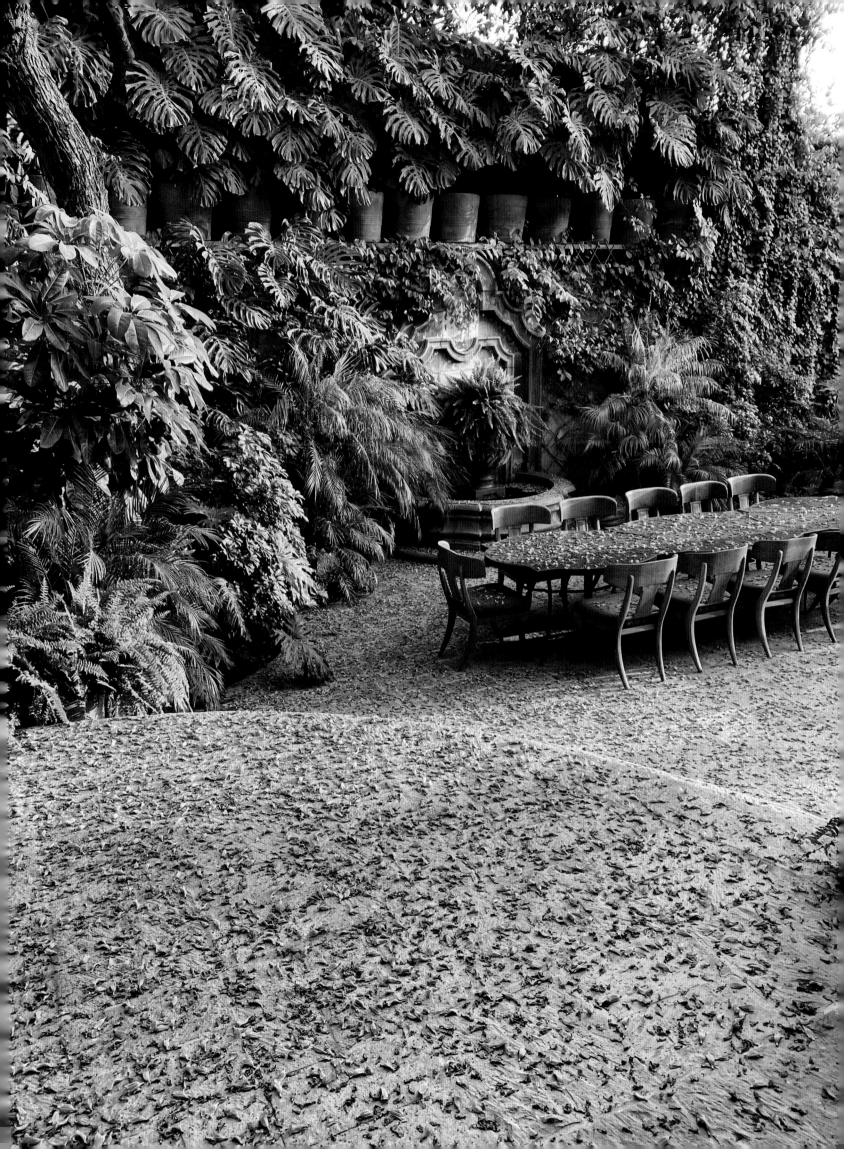

CONTENTS

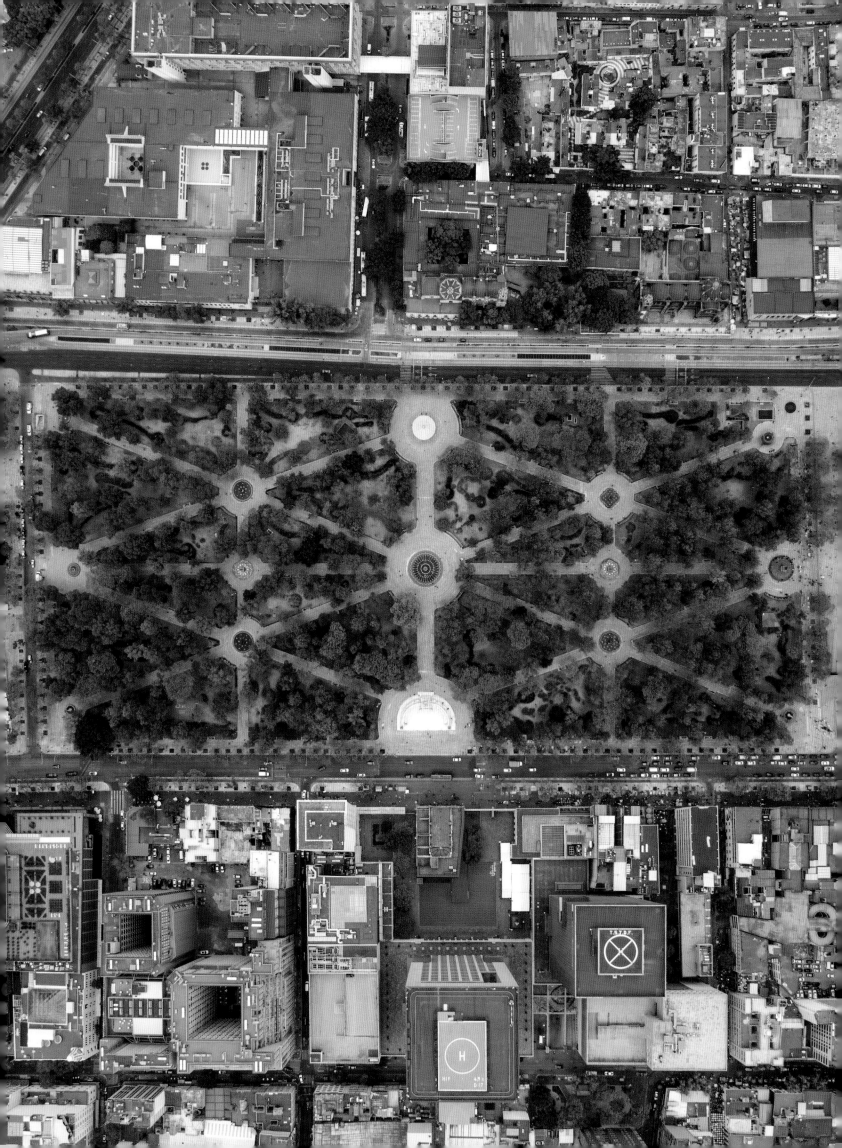

FOREWORD

SUSANA ORDOVÁS

~~~~~~~~~~~~~~~~~~~~~~~~~~~~~~~~~~~~~~

"México is not perfect, but it is lovely," Newell Turner said to me during an intimate conversation. We hadn't known each other for long, but I immediately recognized a kindred spirit in him. As he expressed his deep love for México, and for Mexican design, as a foreigner myself living in this fascinating and vast land of contrasts, I appreciated his passion for the country we had both chosen to call home.

I remember flying into México City for the first time twenty-odd years ago. I was working for a press agency that had taken me to the far corners of the earth, and I was looking forward to finally working in a country where I could speak the language and relate to its people and culture. I was also excited about the prospect of visiting a place I had heard so much about. My parents had traveled here when I was a child and came back with fascinating stories of a wondrous land. The silver bangles purchased in Taxco that adorned my mother's arms sparkled and danced as she showed me photographs of the Pyramid of the Sun in Teotihuacán; it was the first time I had seen Aztec motifs, and I was hopelessly captivated. Little did I know that this seductive nation would one day mean so much to me and have such a huge influence on my life. Because it is here, in this idiosyncratic country where I have settled, that I have discovered the true meaning of aesthetic.

Built by revolutionary minds and artisanal hands, México enchants and stirs the soul, and is indeed a country with many faces. It is a land of extremes, from arid deserts to dense rainforests, from deep canyons to fertile valleys. Lapped by the Atlantic on one side and the ruthless Pacific on the other, it is rugged territory where death is always present, which is probably why life is so cherished and the joy of living is manifested in every aspect of life.

México is also a mystical land with a rich blend of indigenous and Spanish customs. The wealth of its pre-Hispanic and colonial heritage, as well as the legacy of leading figures such as the muralist Diego Rivera, the artist Frida Kahlo, and the architect Luis Barragán, has been passed down from generation to generation. Dotting the landscape are old colonial towns and rural villages where craftsmen still weave textiles on traditional looms and create an amazing variety of objects out of clay, tropical wood, natural fibers, and lava stone—all produced by hand. Land of the Toltecs, the Aztecs, and the Mayans,

México has a rich history that has fascinated travelers for centuries. The rise and fall of great civilizations, the dramatic collision and fusion of cultures, and a revolutionary war that changed the political landscape of the country and renewed its sense of cultural uniqueness are all part of its identity.

In 1519, when the *conquistadors* arrived, they were mesmerized by the breathtaking architecture and intricate urban planning they encountered in the grand city of Tenochtitlán, ancient capital of the Aztec empire (modern-day México City). The Spaniards brought their own cultural baggage to the native traditions that had flourished here, resulting in an extraordinarily rich and multilayered design heritage that survives to this day, as this book so vividly explores. Over time, the indigenous people of México, descendants of the great builders and sculptors of pre-conquest eras, naturally combined their designs with decorative schemes brought from Spain (a country itself laden with a wealth of influences, with Moorish-Arabic spicing those of European descent). It was this combination that produced the vitality that México possesses today.

Newell Turner understands that this conjunction of culture and design could only arise from a country that experienced this unique history. Possessed with exceptional sensibility and a true understanding of this country, he takes the reader on an extraordinary visual voyage. You will discover mesmerizing images layered with related or relevant photography of Mexican interiors, architecture, and culture, revealing the rich history and traditions of design and style, all through his singular, worldly point of view.

He has a special ability to watch and listen, with a broad curiosity for life, that allows him to understand a time and a place through all the different aspects of culture, from history to architecture to popular culture, art, and food. His profound appreciation of México's unique heritage is backed by years of study; nothing about this book is superficial or banal. Newell can look at something and truly analyze it, a rare talent he always brought to his celebrated career in design and lifestyle magazine publishing, and which he has now done here.

There have been countless books about México and Mexican design, but in these pages the reader will see connections, and have a bird's-eye view of history and design, in ways I have never seen before. A pink beachside villa inspired by pre-Columbian architecture. A colonial home with delicate frescoes portraying the *ceiba*, a tree of huge cultural significance to the Mayans. A baroque-style kitchen in San Miguel de Allende decorated with ceramic Talavera tiles from Puebla. And so on. It is perhaps ironic that a foreigner, an American from Mississippi, has been able to capture with such grace and insight the complex essence of México's style and design legacy. But this is a book that no one else could have put together.

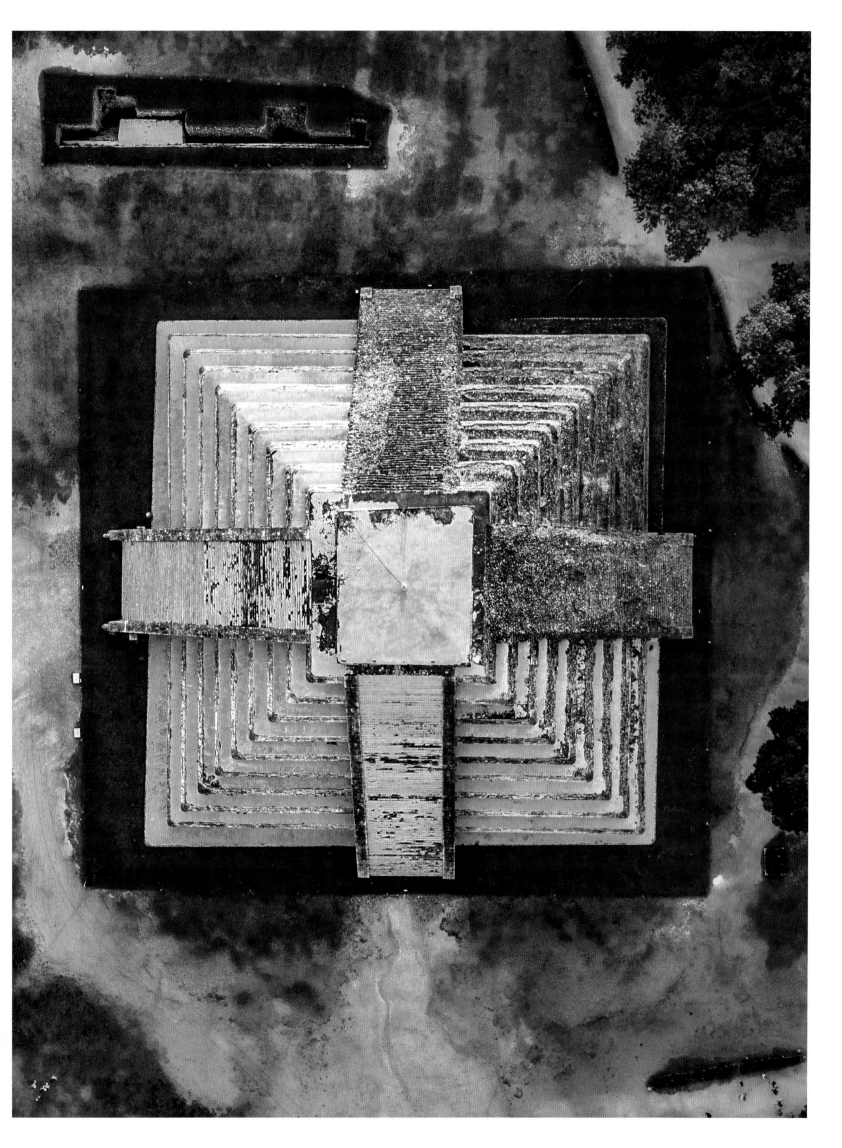

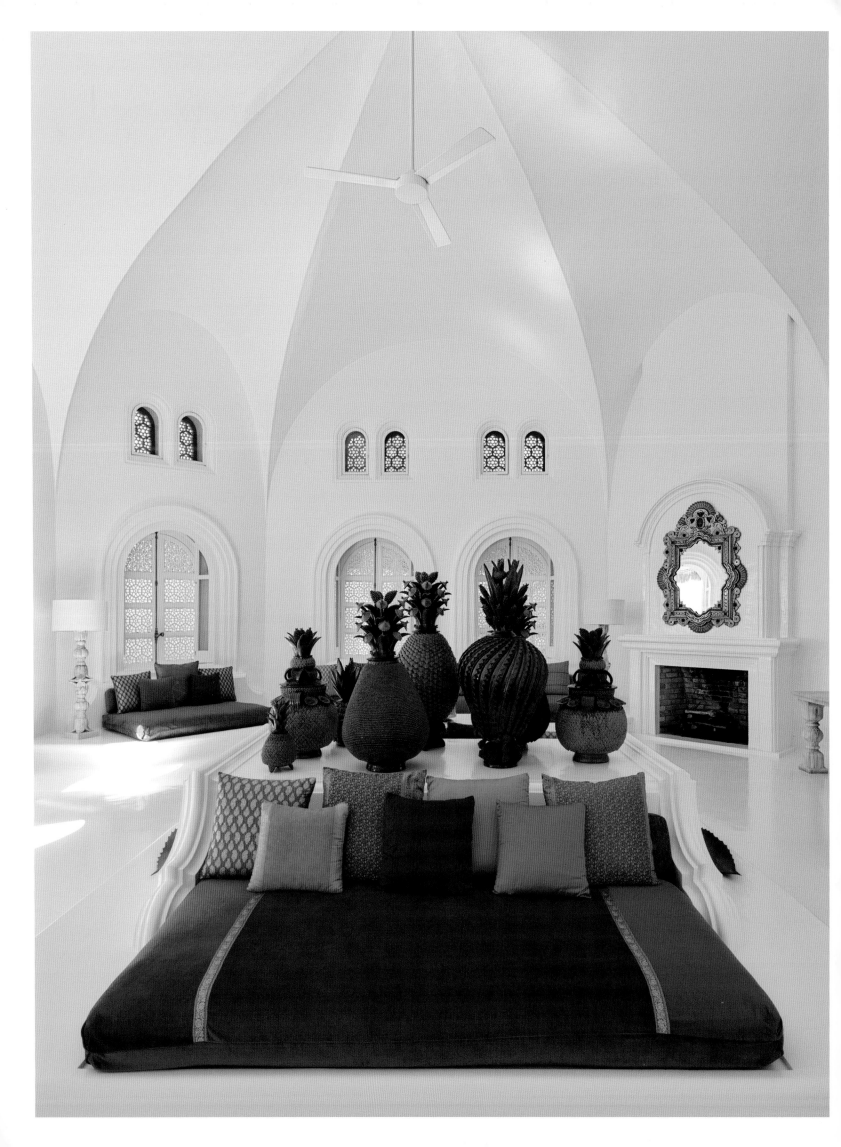

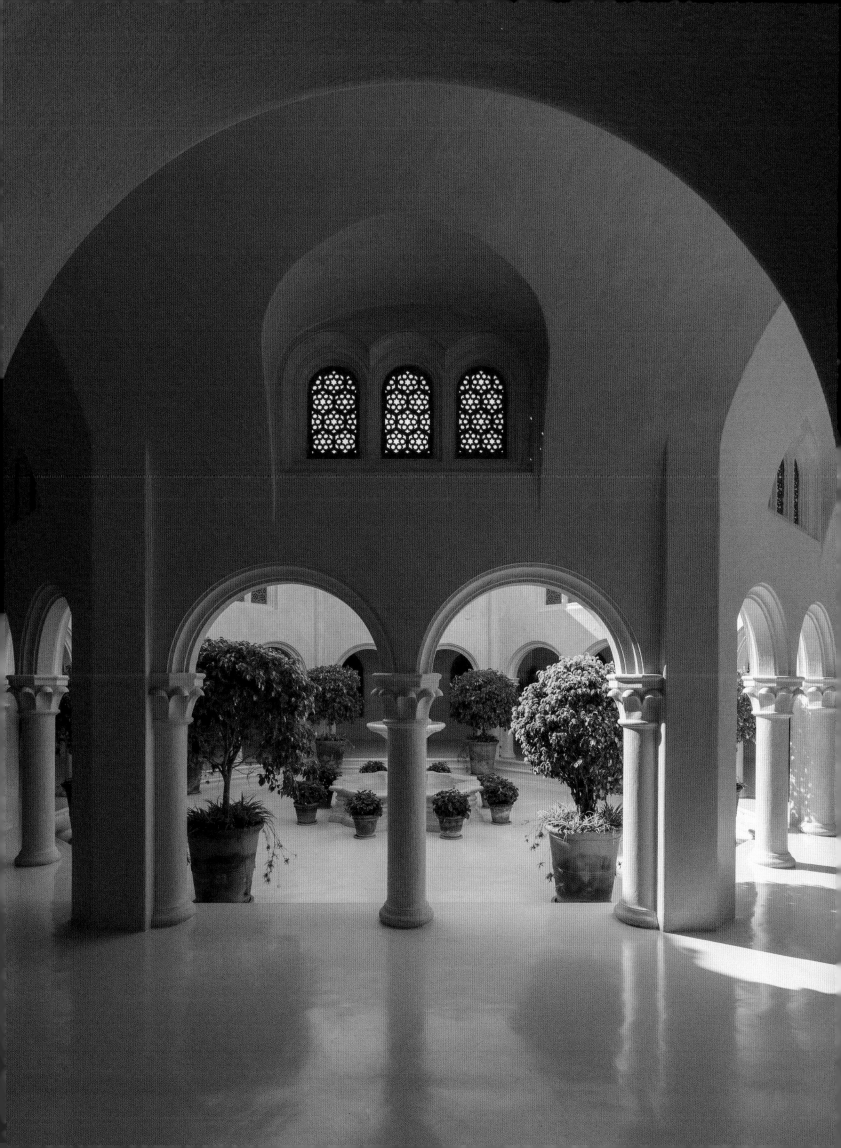

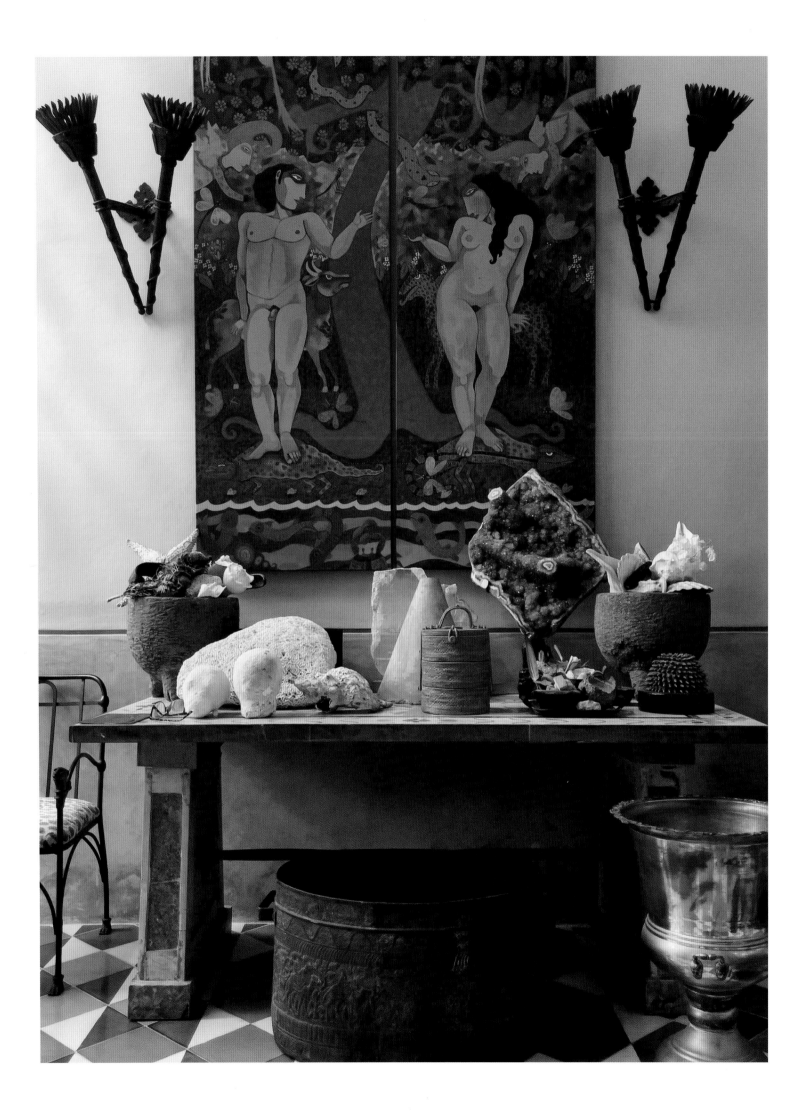

# INTRODUCTION

▲▲▲▲▲▲▲▲▲▲▲▲▲▲▲▲▲▲▲▲▲▲▲▲▲▲▲▲▲▲▲▲▲▲▲▲▲

My story is a classic expat story: the combination of an escape and a search for something missing in my life.

In 1993 a friend and I flew to Mérida, México with a plan to travel around the Yucatán exploring Maya ruins (to burn off the angst of our Manhattan jobs) before settling down for a week at the beach in Tulúm.

I really didn't like Mérida when we arrived. It was a big city, with all the daily hustle and bustle of a metropolis. It was already a haven for snow-bird pensioners, but at the time there was very little interesting to do or enjoy. We stayed only a couple of days.

On the other hand, Tulúm was magnificent in its isolation. It was somewhat remote then, still basically unknown and definitely undeveloped. We stayed at Osho, a yoga/ vegetarian retreat run by the followers of Bhagwan Shree Rajneesh. It was just a step above Maya-style houses with sand floors . . . and it was perfect. With a roof made of dried palm leaves and no glass in the windows, the salty Caribbean breezes blew away all our stress.

It was also where I had my first insight into the subtleties of Mexican design and life. Staying put for a week, I discovered my love for—and the salutary benefits of—hammocks. Maya hammocks are in fact furniture with multiple uses, meant for sitting in a variety of ways. Most people think you simply lie in them straight, end to end, or maybe perpendicular. But they are truly enjoyed when you are lounging, at an angle, with your legs dangling. Your back relaxes into the fine weave of cotton fiber. Your body and mind unlock and cool in their ancient design. Try it before paying a chiropractor. This was just the beginning of my understanding that, as with so many things in México, beauty is rarely straightforward, symmetrical, or rigid.

Fast-forward around twenty years, and I found myself planning a last-minute Christmas holiday in México, although already thinking about, in my typical nature, what might come next in my life. I had a hectic magazine publishing career and life in New York City, with a summer-friendly retreat in a Catskills farmhouse. But no career is forever. What would I do after it? And just as important, where could I spend the dark, cold Northeast winters that were becoming increasingly unbearable to me?

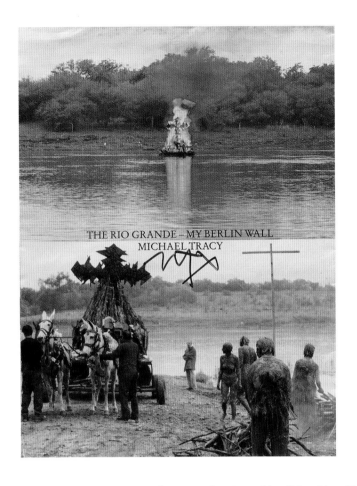

THE RIO GRANDE – MY BERLIN WALL
MICHAEL TRACY

That Christmas visit, to Mérida of all places, couldn't have been a better introduction, even template, for where I am in life now. As my partner and I met people and made friends, invitations to their homes turned out to be the Mexican experience we had always been looking for. Traditional Mexican houses are protected oases, both physically and mentally. Once behind the walls, gates, and doors, I found another world of interior design and lifestyle. The seeds of many friendships were planted during our visits to those private worlds.

Over the next couple of years, we returned to Mérida regularly for longer and longer stays. We also started looking at real estate, imagining a future spending at least significant time living here. We connected with a fantastic realtor, which is not exactly the same profession in México as it is in the United States; they're more like archaeologists on expedition. He took us on what I would call joyrides. House-hunting was both a challenge—it's not so easy to buy real estate in México—as well as a game of "What would you do?" We explored the ruins of so many houses in every state, from "holding on" or "barely there" to architectural treasures that had been mercilessly chopped up.

Finally, we committed to a *casona*, a grand, elegant city house from the turn of the twentieth century and the height of the Porfiriato Era, when President Porfirio Díaz was obsessed with all things French. Our house is a typical Mexican blend of styles. The floorplan, with a center courtyard, high ceilings, and many doors, is unquestionably colonial Spanish. At the same time, the decorative details combine a heavy dose of French neoclassicism with hints of Moorish and even Art Nouveau. It was definitely not a blank canvas (and that excites me to no end). It's also much larger than any house I've ever owned. A former tenant (a small school) had chopped up its very tall, long rooms to create still more rooms and even add a second floor. It had also been stripped of anything resembling a family house, though fortunately the original owner's monogram had been preserved above all the exterior doors and windows. Its complex style is a challenge that I am enjoying as I return the house into a home and "write" its history into a design for the future that reflects the past, the present, and my Southern roots.

Something I've learned from years of psychotherapy is that I have an extreme curiosity for how people live. This goes way back to my childhood. In hindsight, it's what led me to a career in journalism at shelter and lifestyle magazines. I devoted myself to American interior design, always trying to answer the question, what is American style?

These days I also dream about México. I have fallen in love with this country and the people who make it home. It's a unique place with a fascinating design legacy that deserves better than always being compared and contrasted with the United States, or any other country or culture. The one question I've been asking myself and hope to begin answering through this book is, what actually is Mexican style?

While England and Spain were the two primary colonizers of North America, they had two profoundly different experiences, not least that the English landed on a part of the continent that was far less organized and inhabited, while Spain encountered multiple pre-Columbian cultures on par with the ancient civilizations of the Near East and cities of the Old World. Mexican just might be the authentic "American style."

Mexican design is somehow both foreign and familiar to us in the United States. Its roots are in colonial Spain, with its unique stew of Catholic, Greco-Roman, and Moorish Islamic influences, grafted onto the already highly developed indigenous civilizations of the Aztecs, Mayans, and Olmecs, to name just three. Out of this blend of the Old World and the New evolved the *mestizo* culture that deeply fascinates me.

So much has been said and written about the melting pot of people and design in the United States. But I would call our melting pot a gravy, while I would describe the Mexican melting pot as both an exotic and humble *mole*. Basic American gravy is a fairly simple sauce of meat drippings and a thickener, plus salt and pepper. *Mole*, on the other hand, is a rich sauce with a complex range of taste sensations. The base is always one or more chilies, and then local and exotic ingredients are added. Twenty is considered the minimum for the classic poblano *mole*. Regional variations, like Oaxacan-style *moles*, can include more than thirty.

Similarly, Mexican design is a fusion of multiple cultures, styles, and eras. Classic elements are creatively combined, circling and overlapping each other in ways that feel new. These ideas often take shape in the hands of craftsmen whose traditions stretch back to Pre-Columbian times. It's intoxicating.

It's impossible to define Mexican design in one book. It's an astonishingly large and far too rich a topic. My intention here is to share private interiors while giving them some context—showing connections I see to the countless visual pleasures of this country, like regional crafts and textiles, and natural elements like feathers and corn husks. I've loosely organized everything around the key decorative periods that have been shaped and reinterpreted through the centuries here. It's my personal design journey to date, sharing a passion for interior design and architecture through a visual narrative that doesn't need words to understand or enjoy—and, I hope, learn from.

Artist Michael Tracy's eye-opening performance in San Ygnacio, Texas, seen on the opposite page, made a startling statement about the tragic lack of design dialogue

across our border, and how the Rio Grande is the natural yet unnatural barrier between two extraordinary cultures. My dream is for more design dialogue between *Los Estados Unidos Mexicanos* and the United States of America, with México preserving all its complex design legacy. The future of design in both countries has the potential for being the most delicious, elegant *mole*.

If there is one thing that México has taught me, it is patience. My career and life have taken some unexpected and dramatic turns lately, and peace and even pleasure come with patience. Time to explore. Time to experience. Time to absorb Mexican.

NEWELL TURNER
*Mérida, Yucatán*

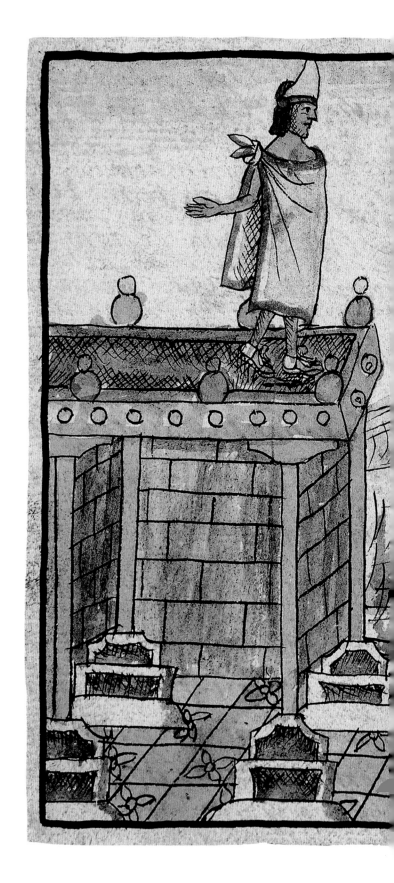

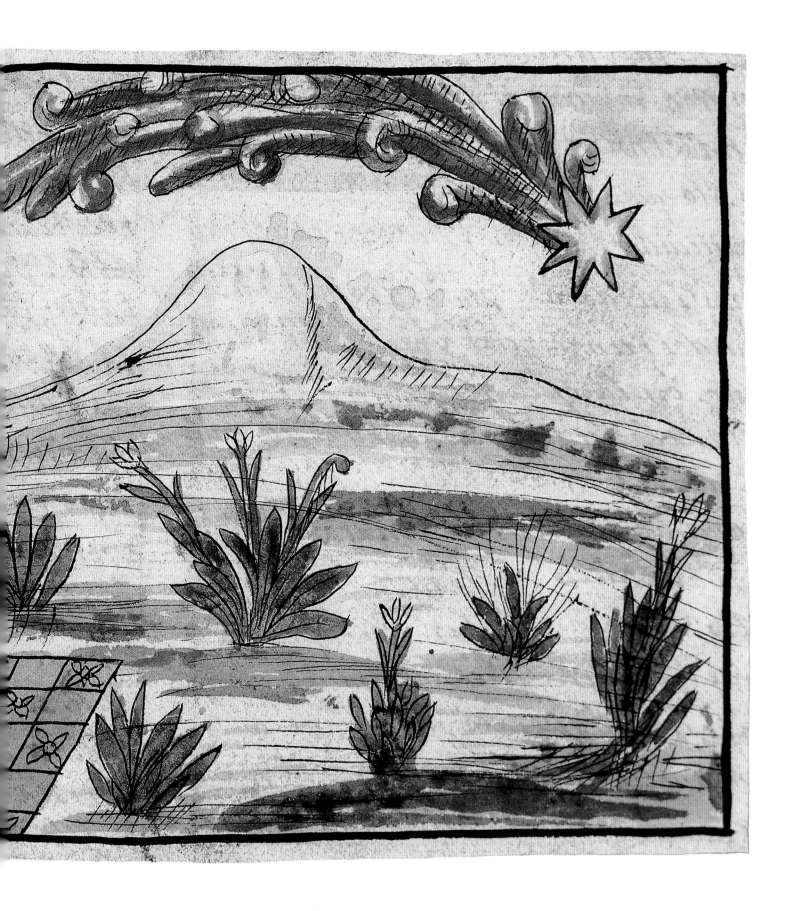

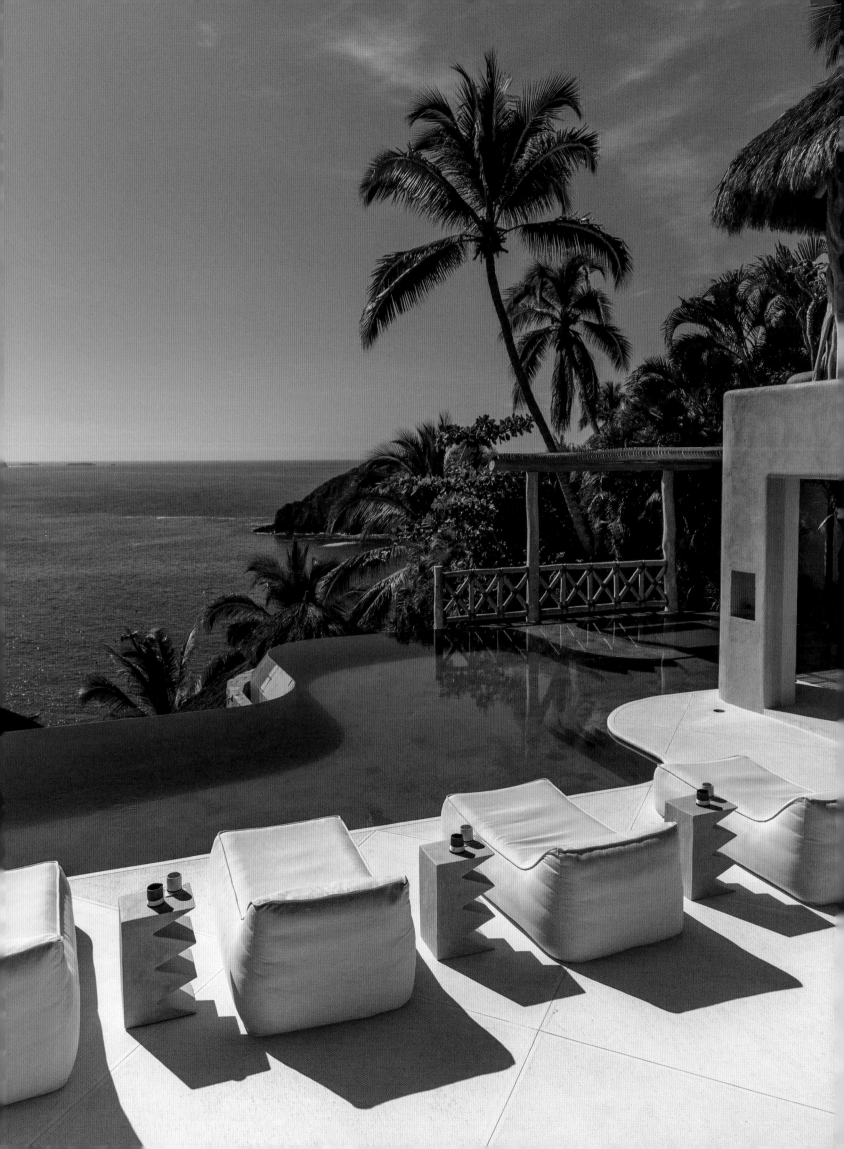

# PRE-COLUMBIAN

When the Spanish sailed into the New World they had no idea that they were about to stumble upon not just one but many highly developed civilizations with histories going back 2,000 to 3,000 years . . . in 1492. Their first encounter was on the Yucatán Peninsula with the Maya, who worshipped on spectacular red stepped pyramids and travelled between their cities on paved roads. Maya culture was advanced in many ways, including agriculture, salt harvesting from the Gulf of México, pottery that was functional as well as purely decorative, cross-continental trade, the study of the medicinal properties of plants, tracking the movement of the stars for calendars, and a numbering system that included zero. Similarly, the Aztecs of central México were building cities in stone with an advanced, frequently cosmic orientation of major pyramids and avenues. Tenochtitlán, their capital, built in the middle of a large lake laced with causeways and canals, was so cosmopolitan that other indigenous civilizations established distinct neighborhoods in the city that reflected their own cultures.

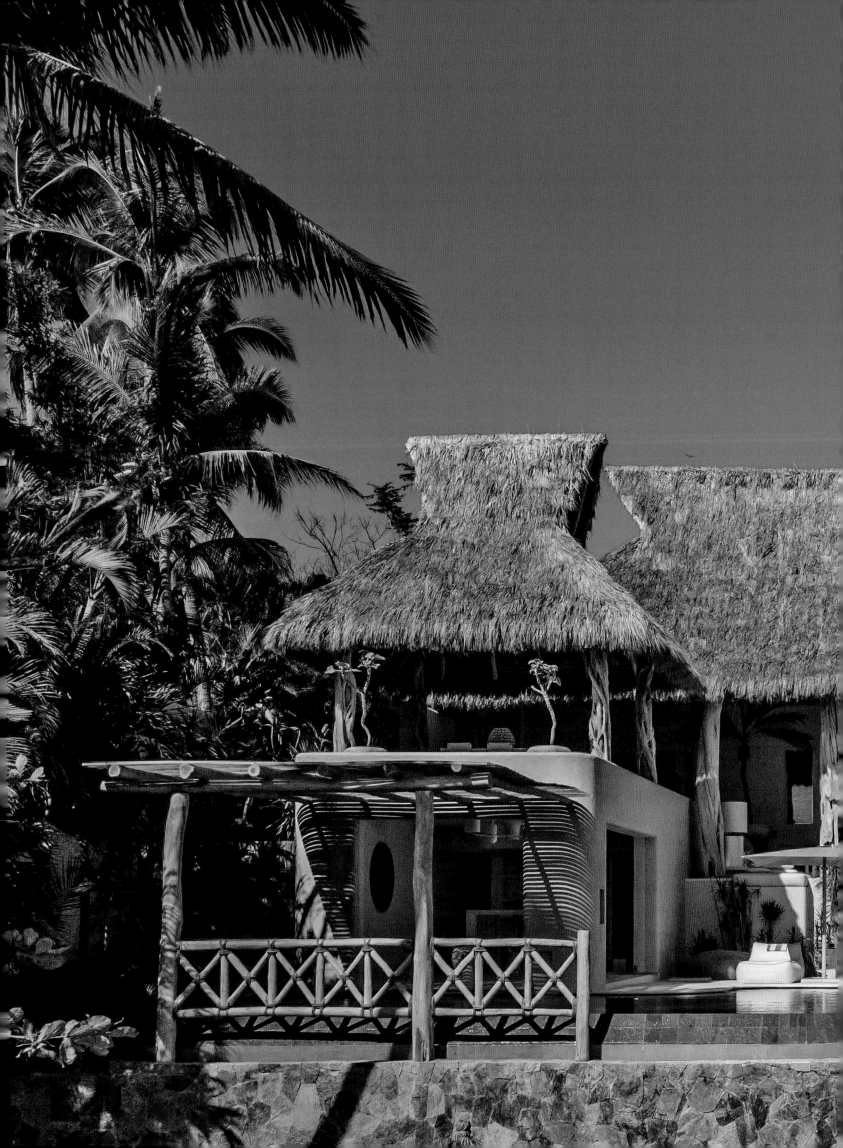

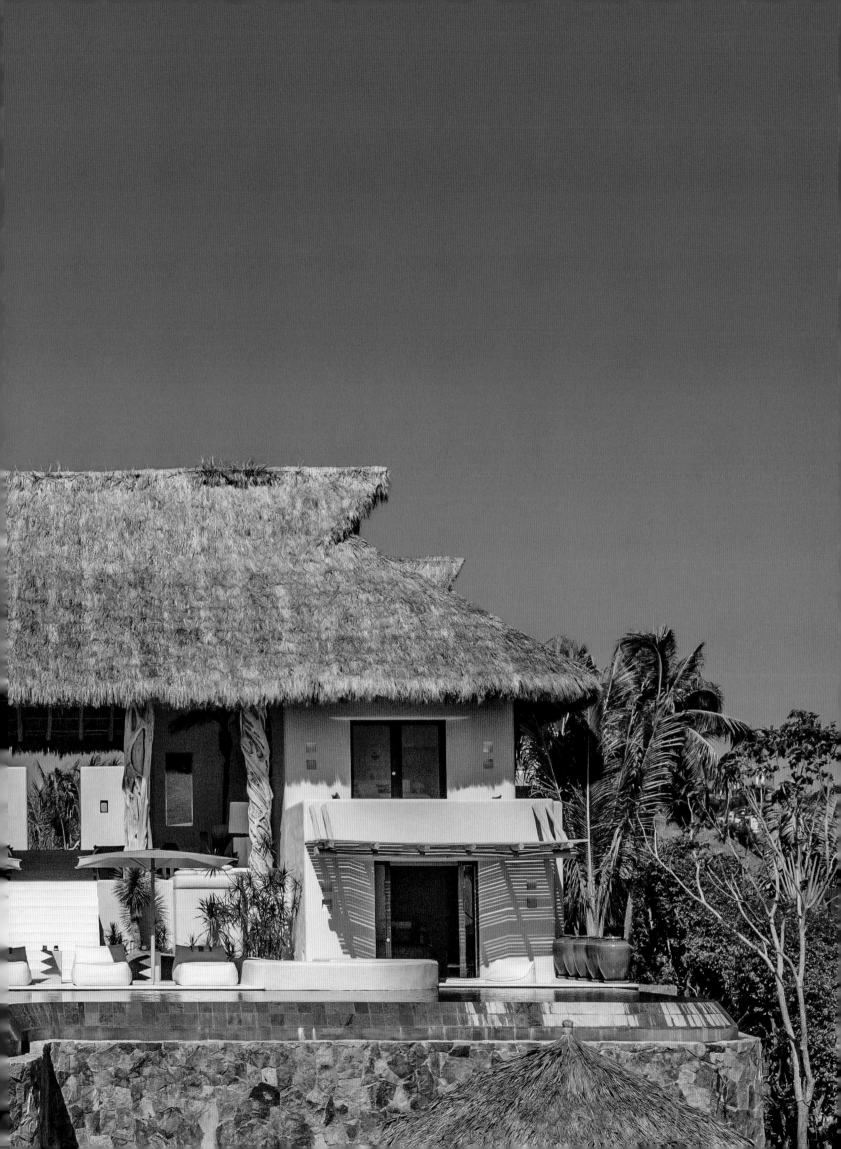

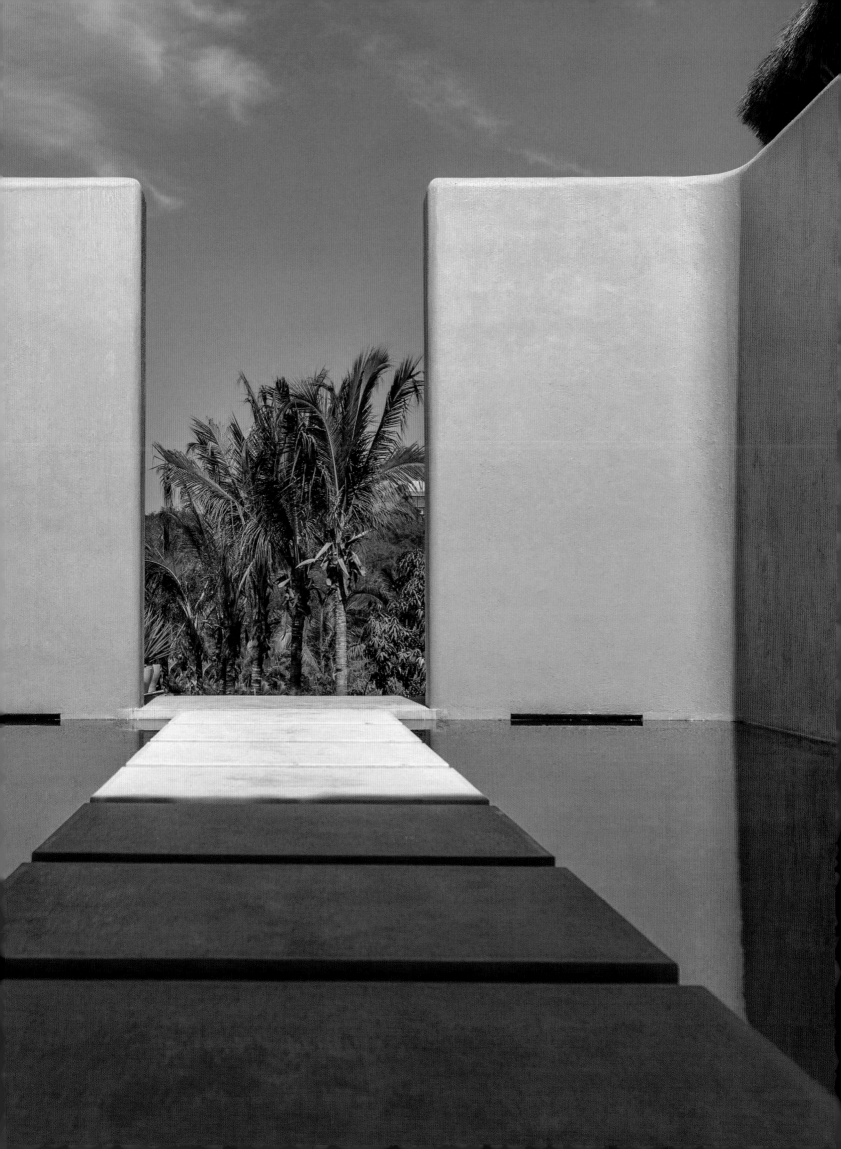

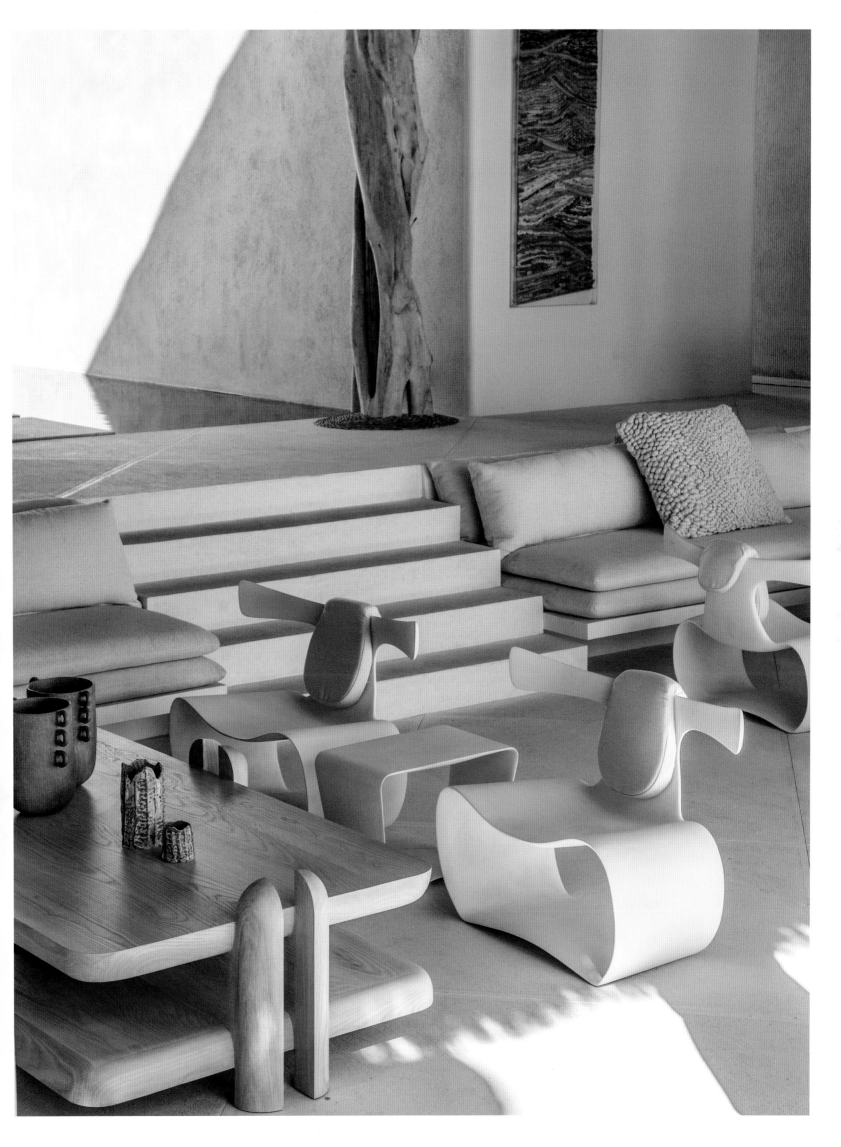

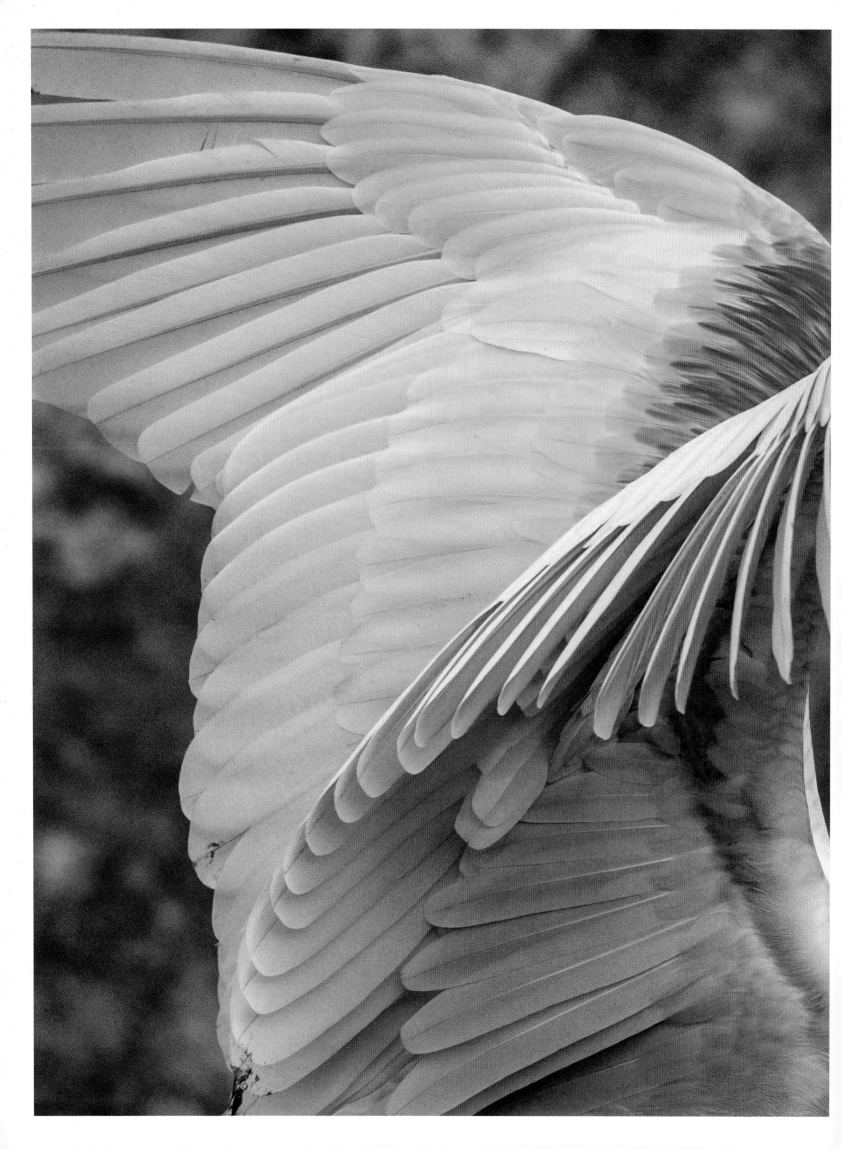

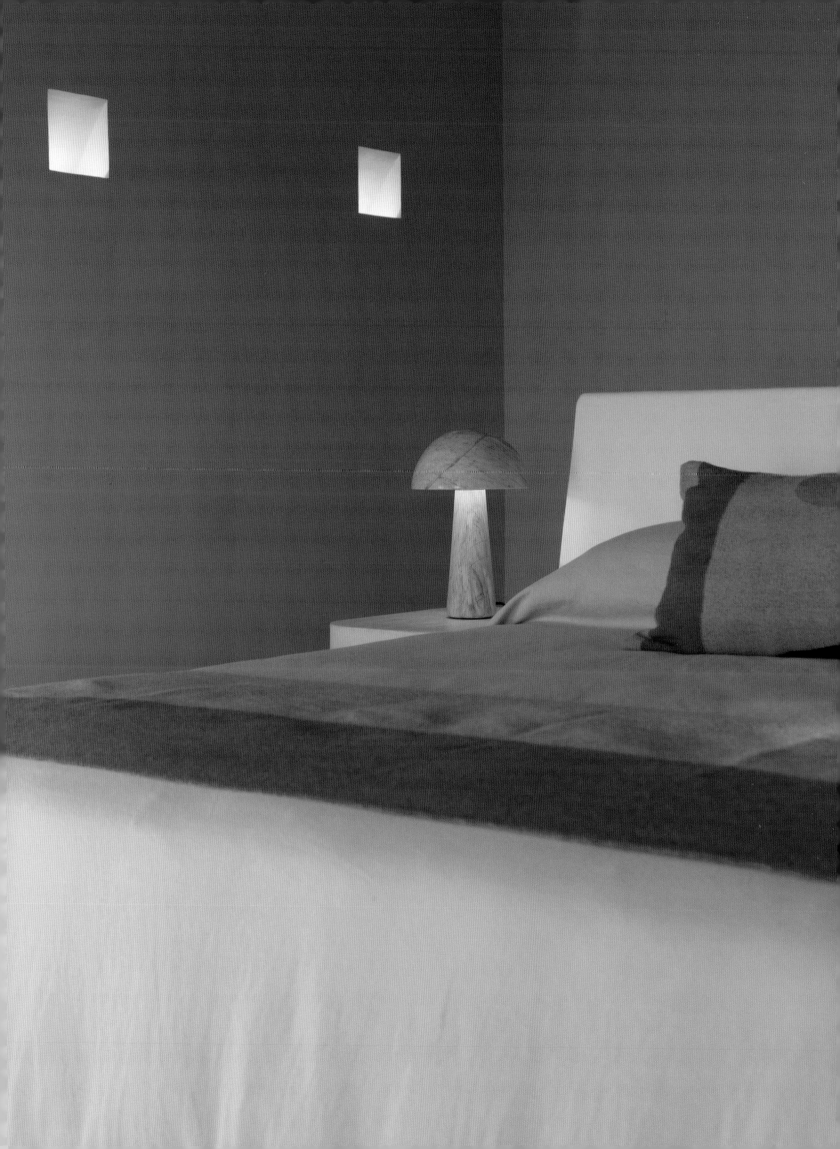

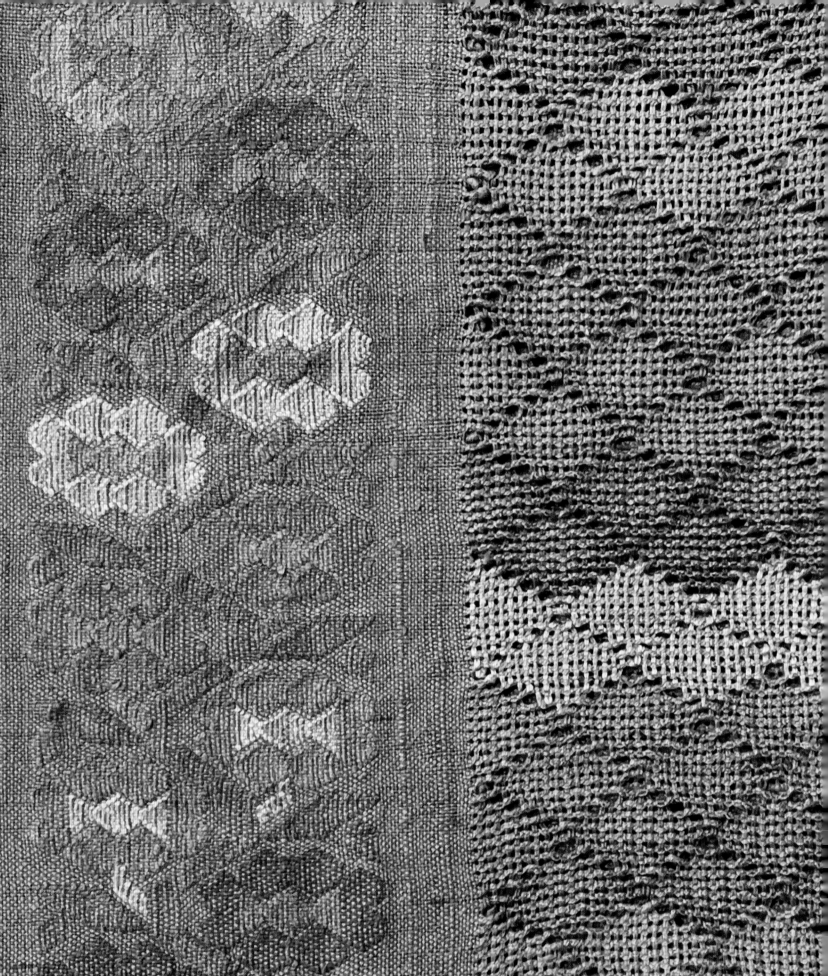

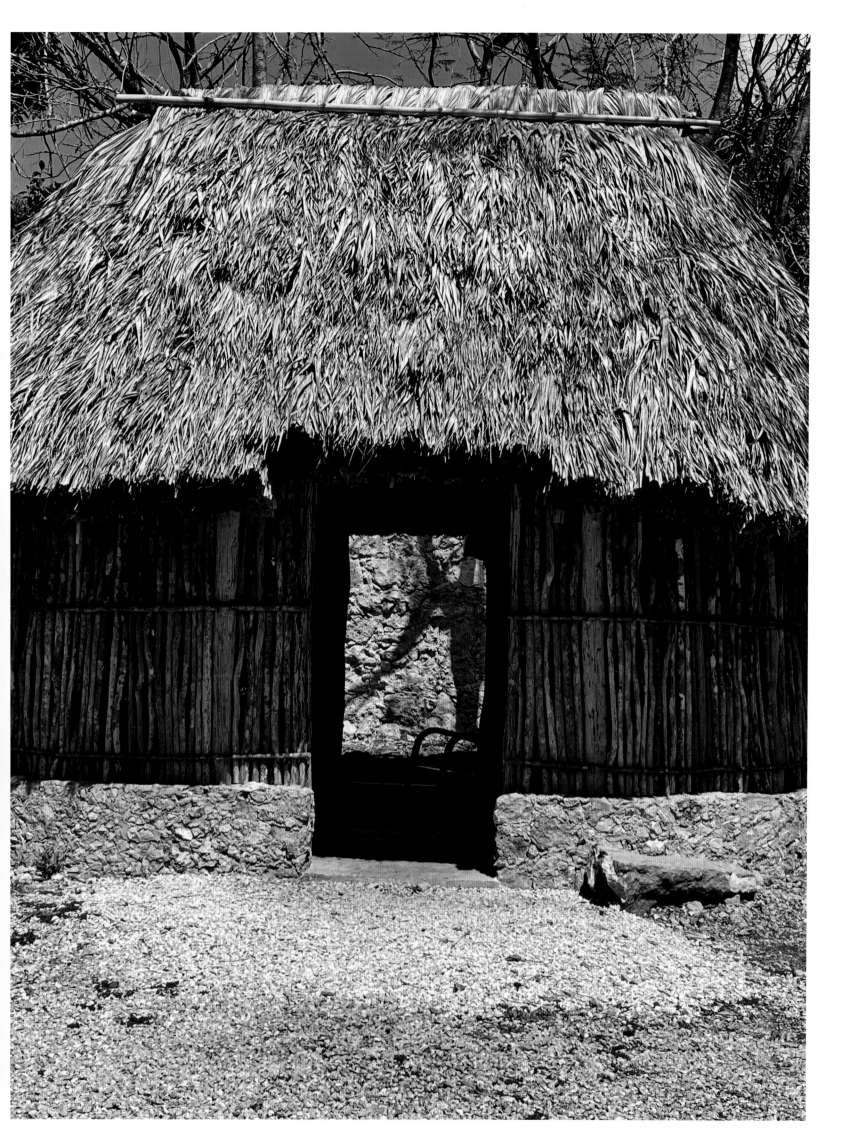

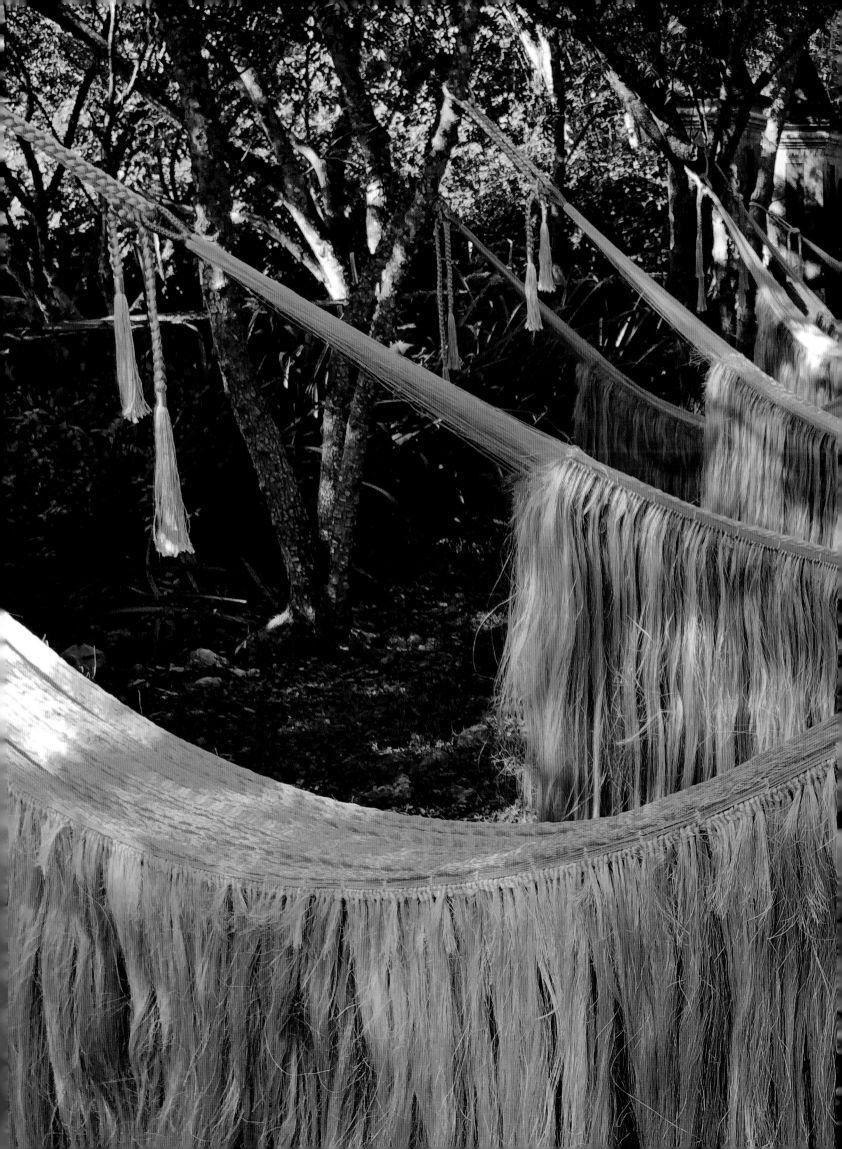

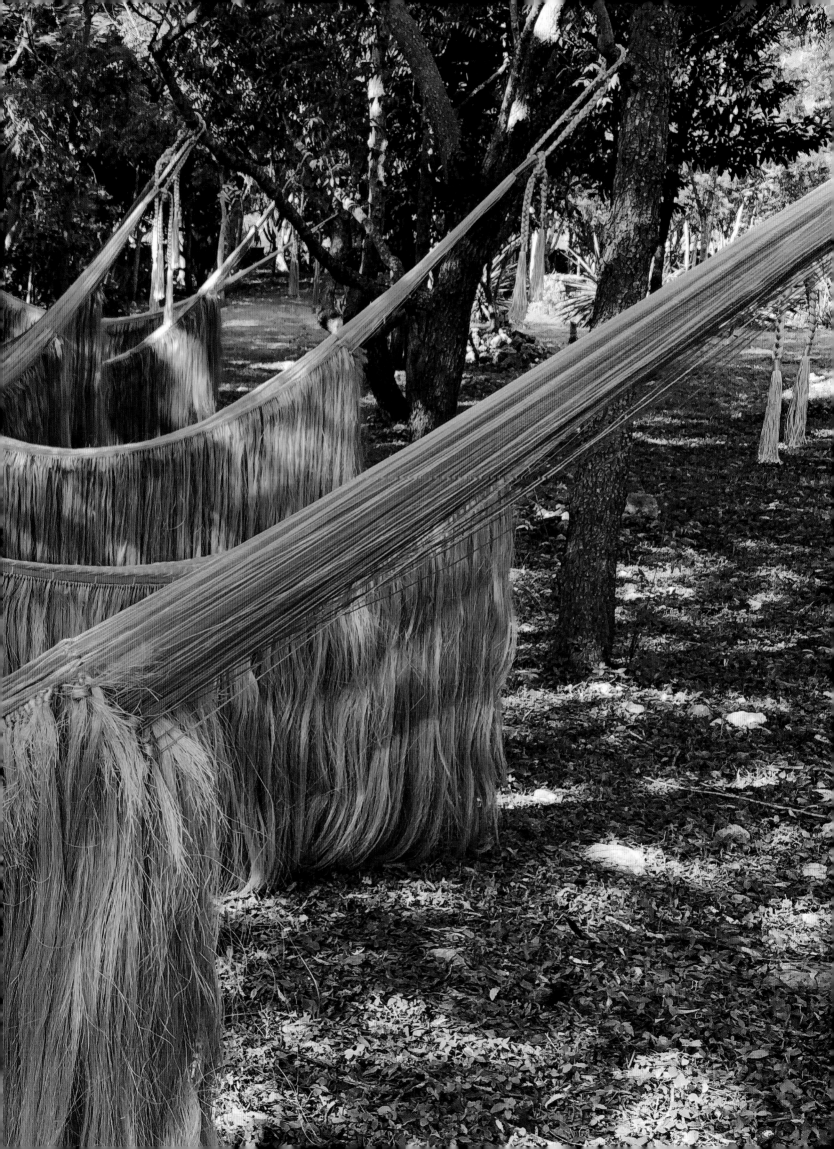

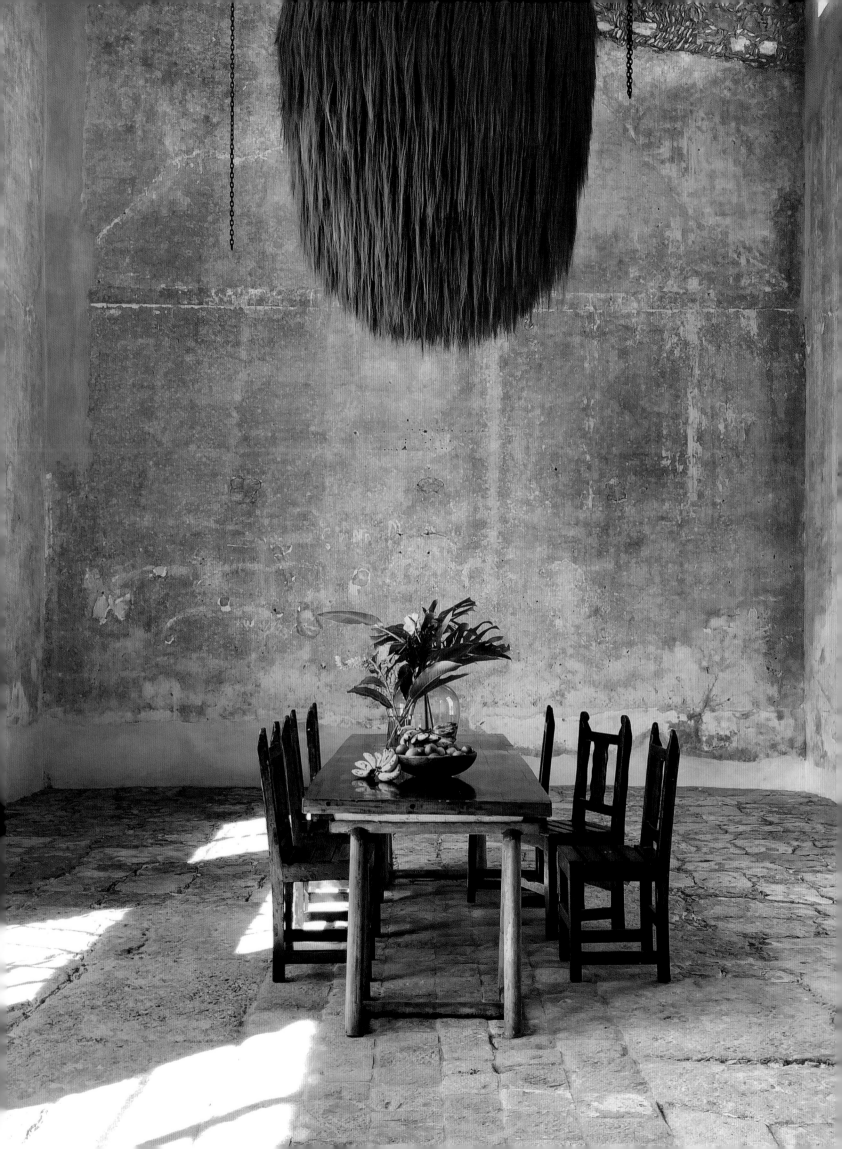

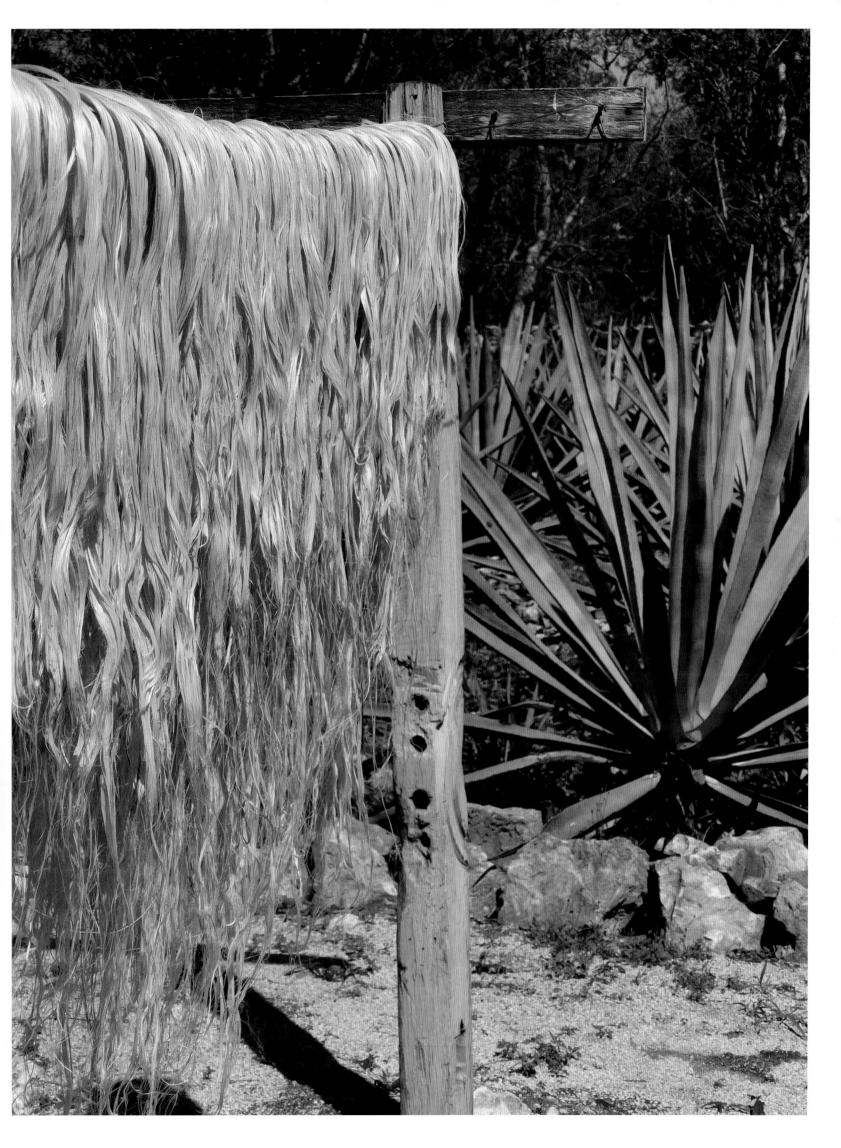

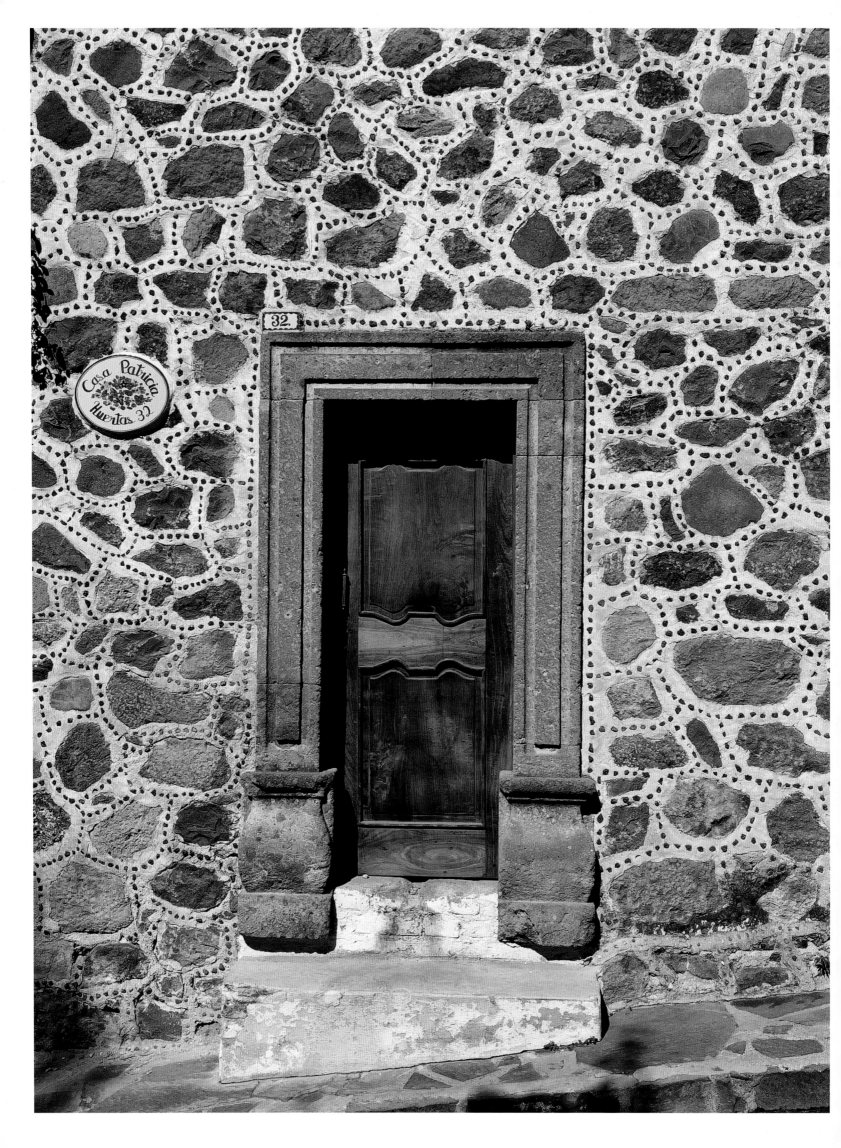

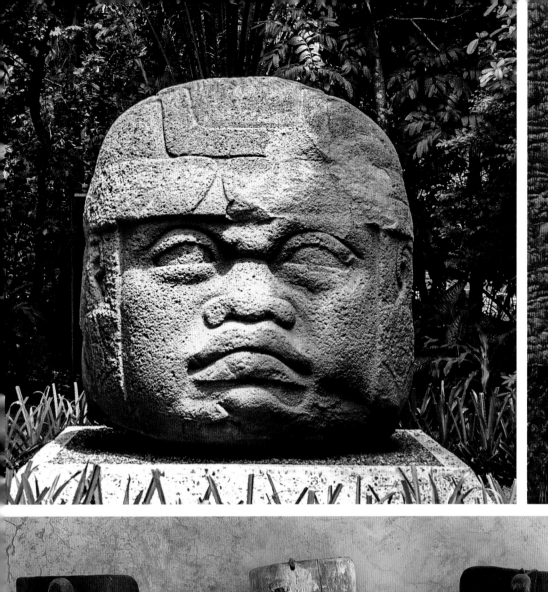

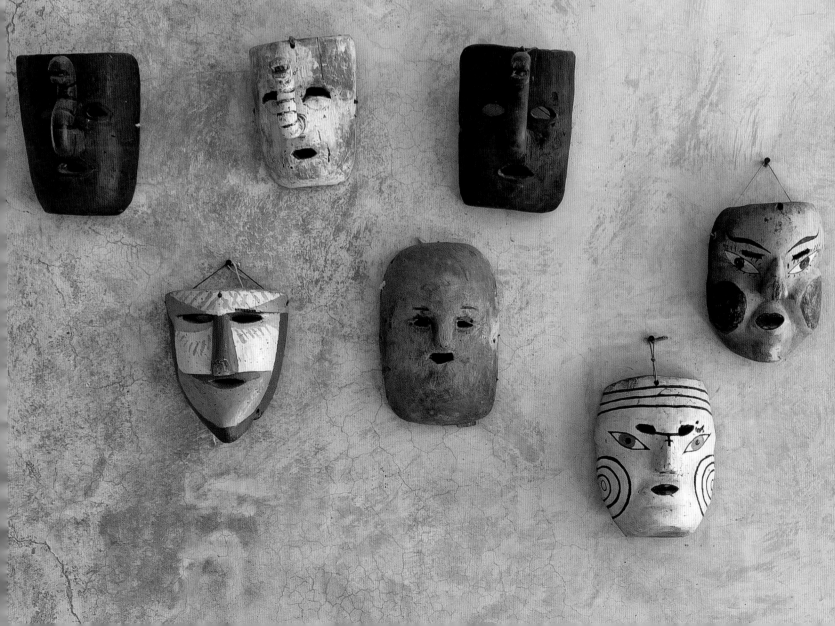

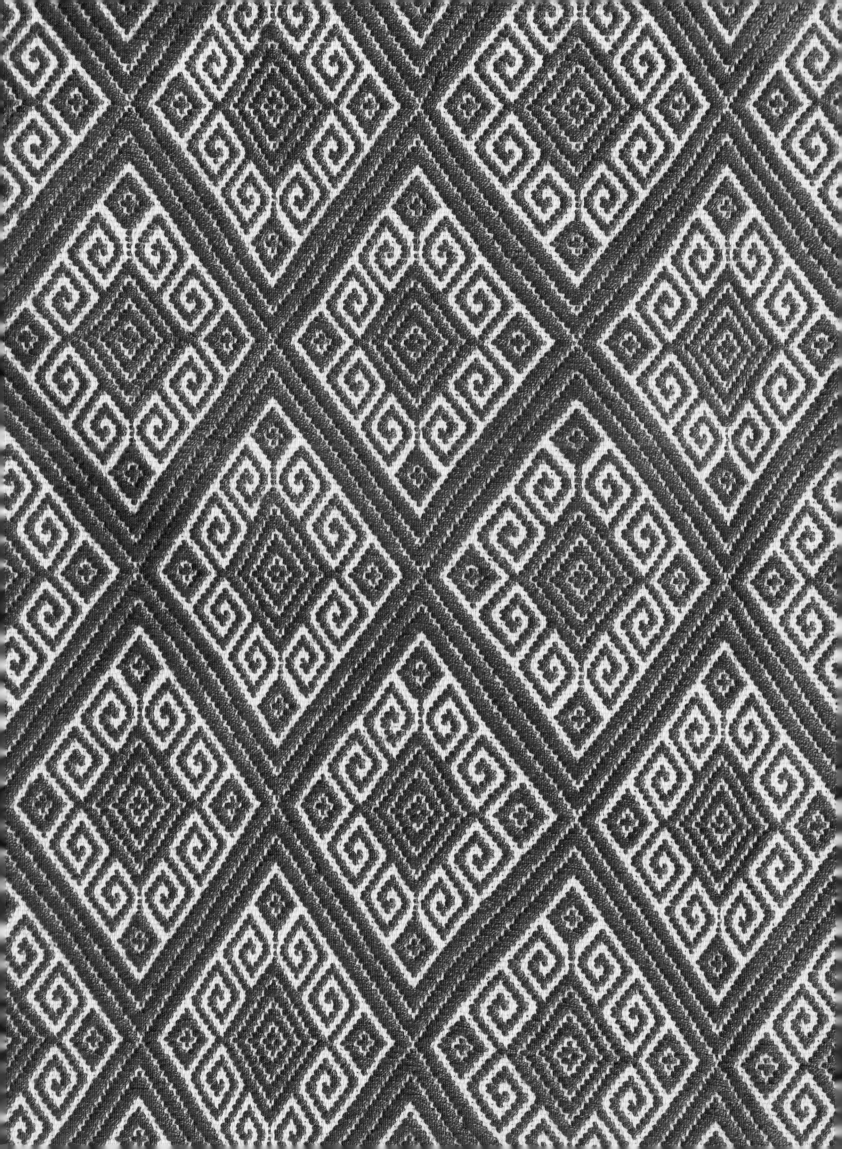

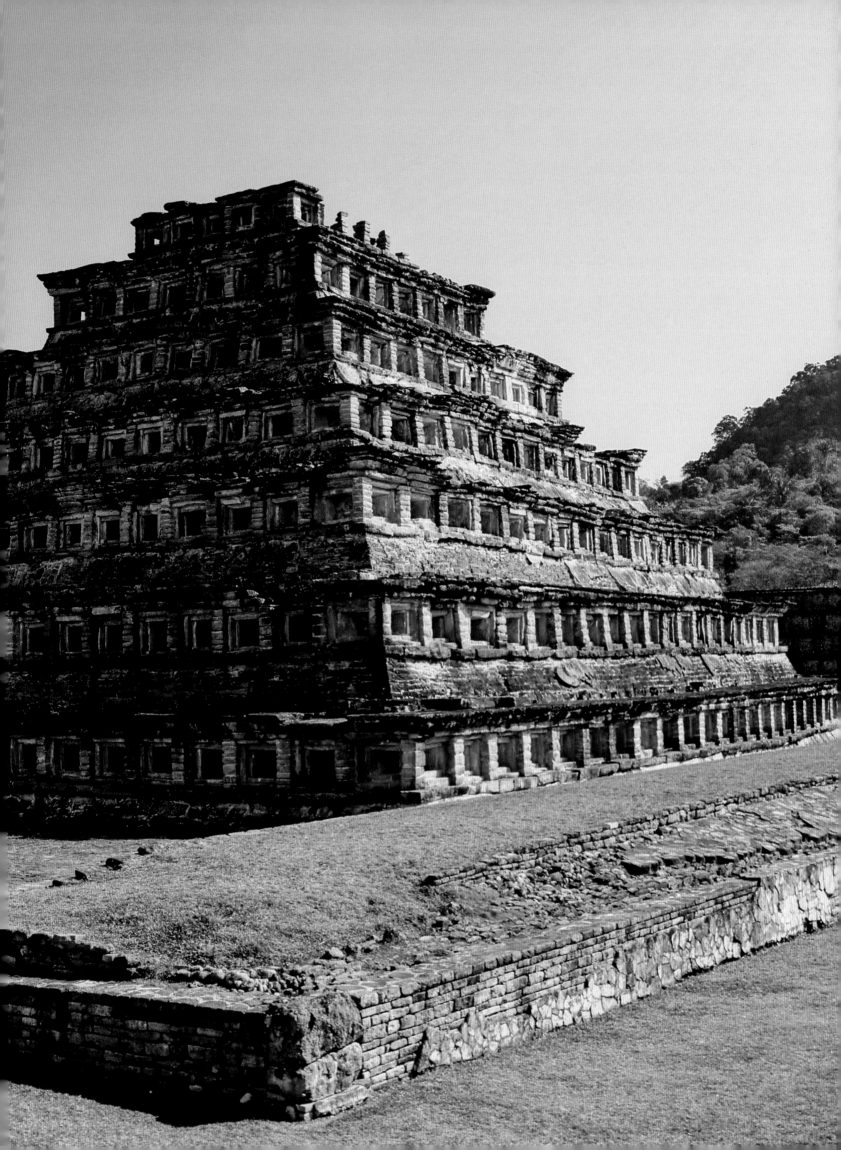

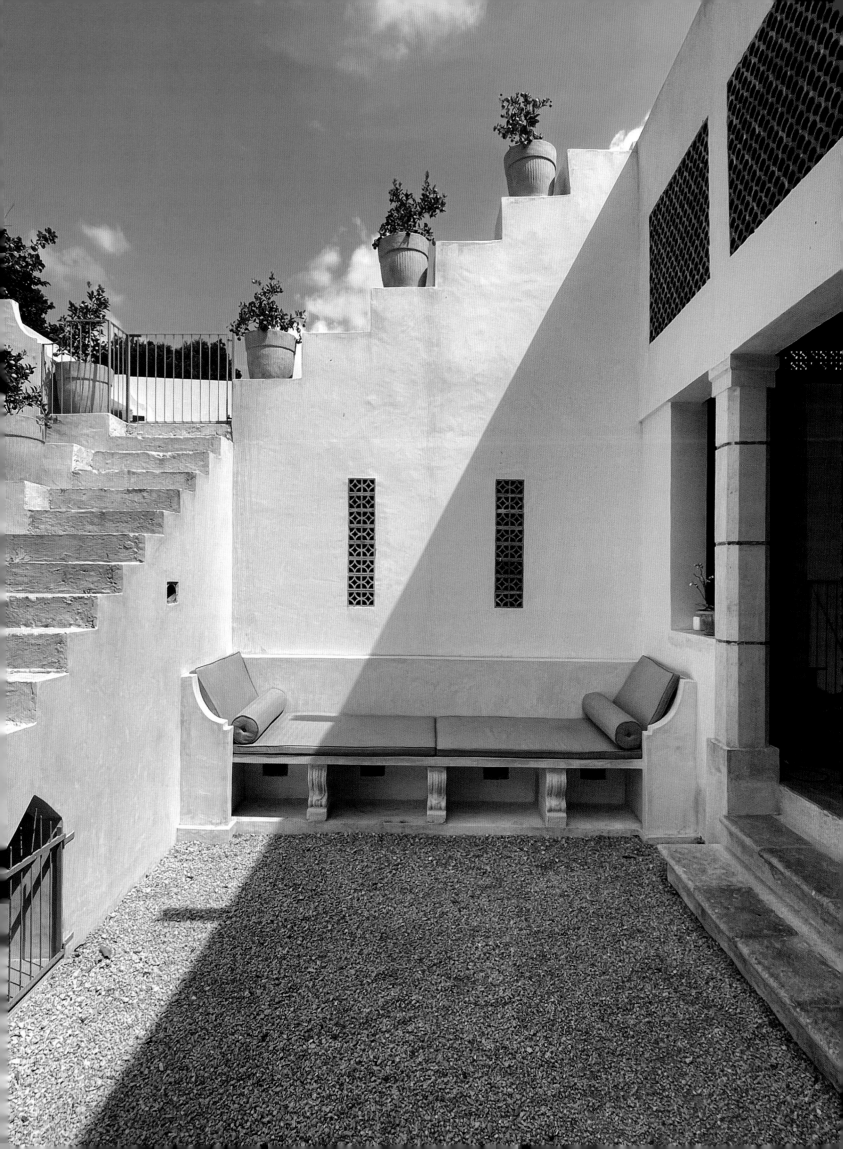

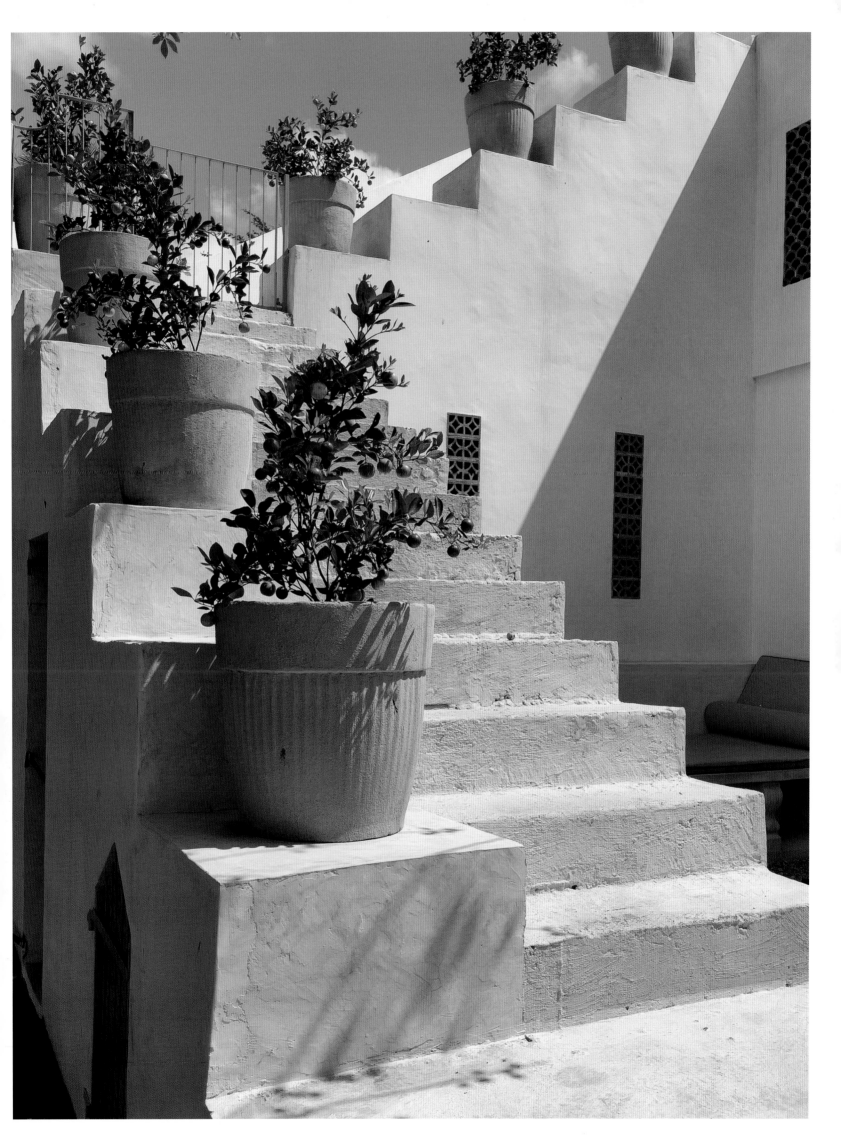

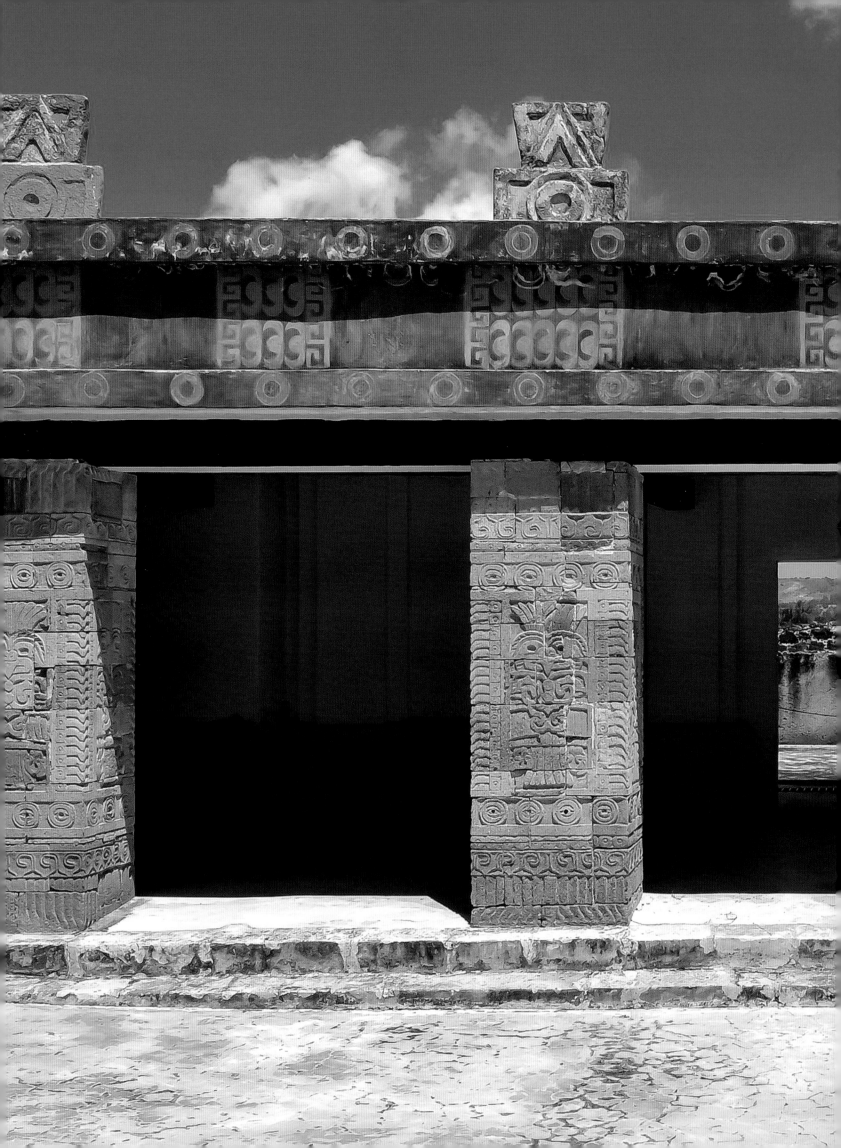

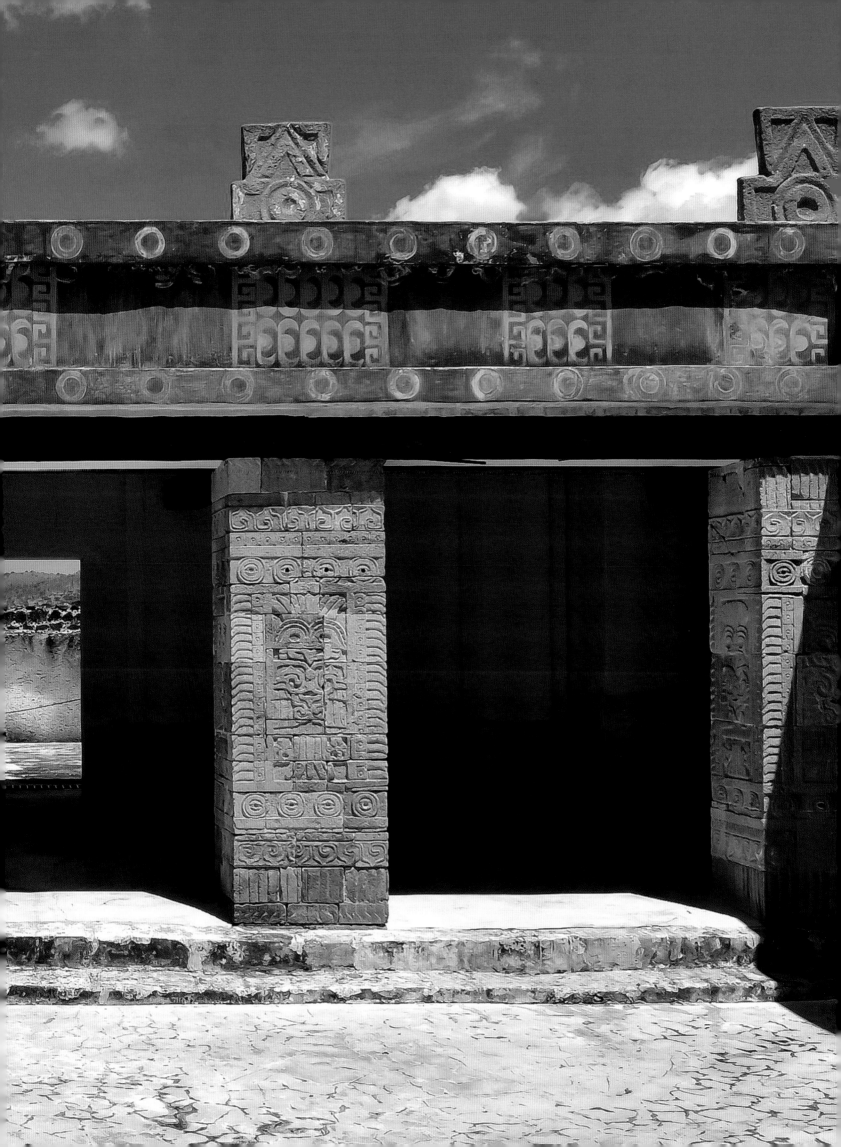

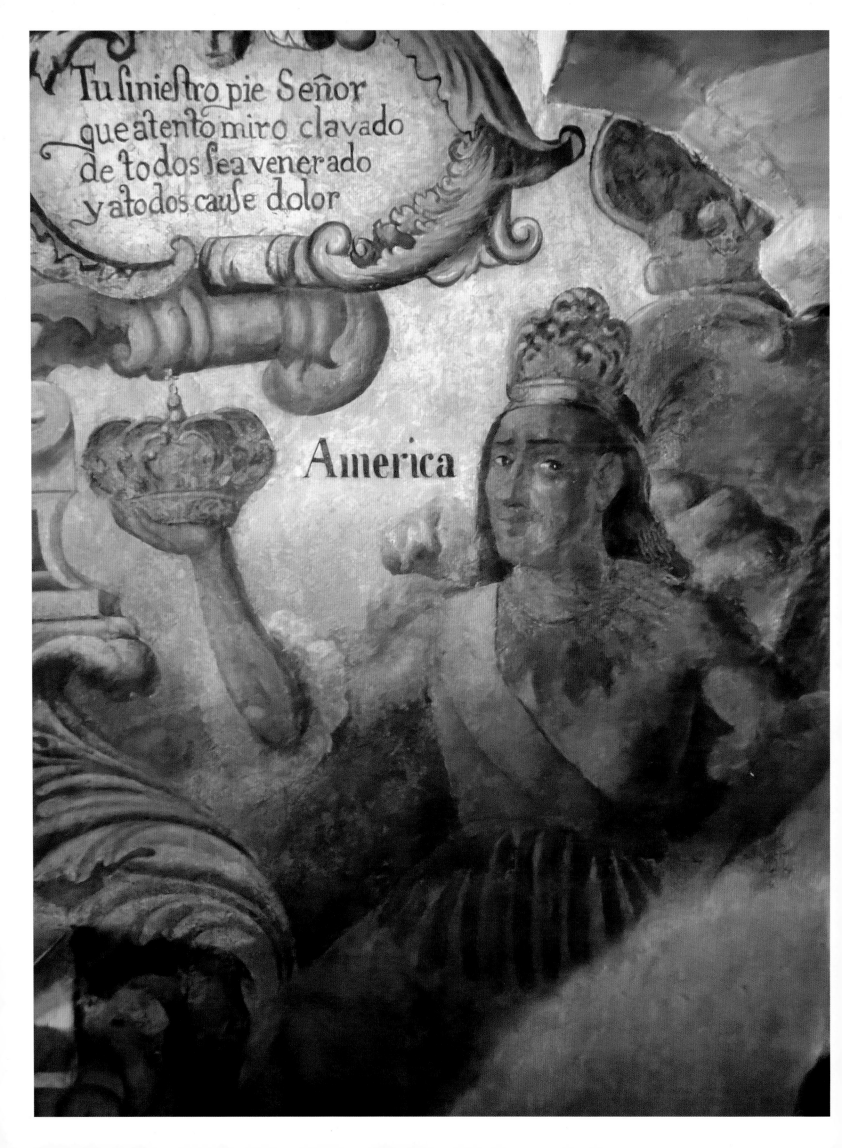

Tu siniestro pie Señor
que atento miro clavado
de todos sea venerado
y a todos cause dolor

America

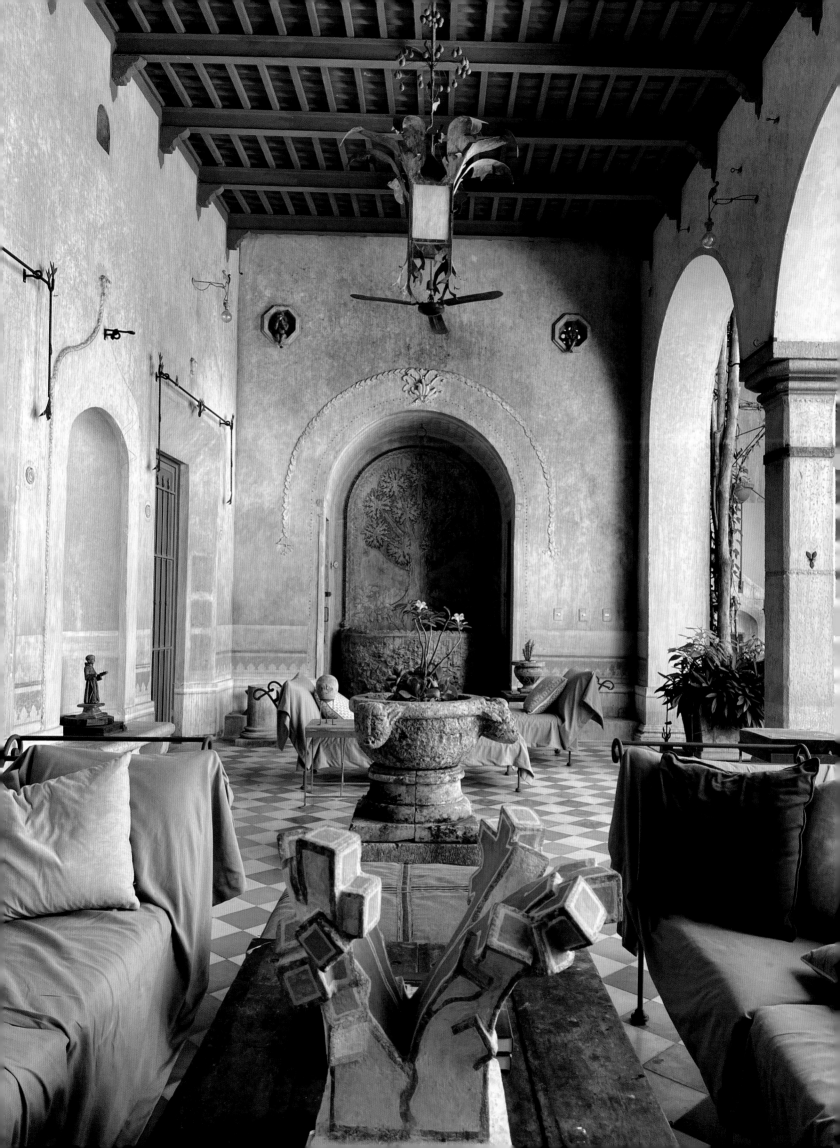

# BAROQUE

The Baroque style was particularly fortuitous for both
the Spanish and the advanced civilizations in México
of the late sixteenth century. It allowed them to find ways
to understand each other's spiritual passions through
architecture and design. Baroque designs became a visual
and physical powerplay for Spanish conquerors, while the
indigenous people already aspired to reach their gods through
monumental architecture with exuberant embellishment of
pyramids and houses for the ruling elites. A distinct Mexican
Baroque flourished into the mid-eighteenth century, taking
on an array of New World characteristics in the combined
hands and vision of Europeans and indigenous artisans,
whose generations of stone masons, plasterers, artists,
and weavers seem to have instinctively understood
the Baroque impulse.

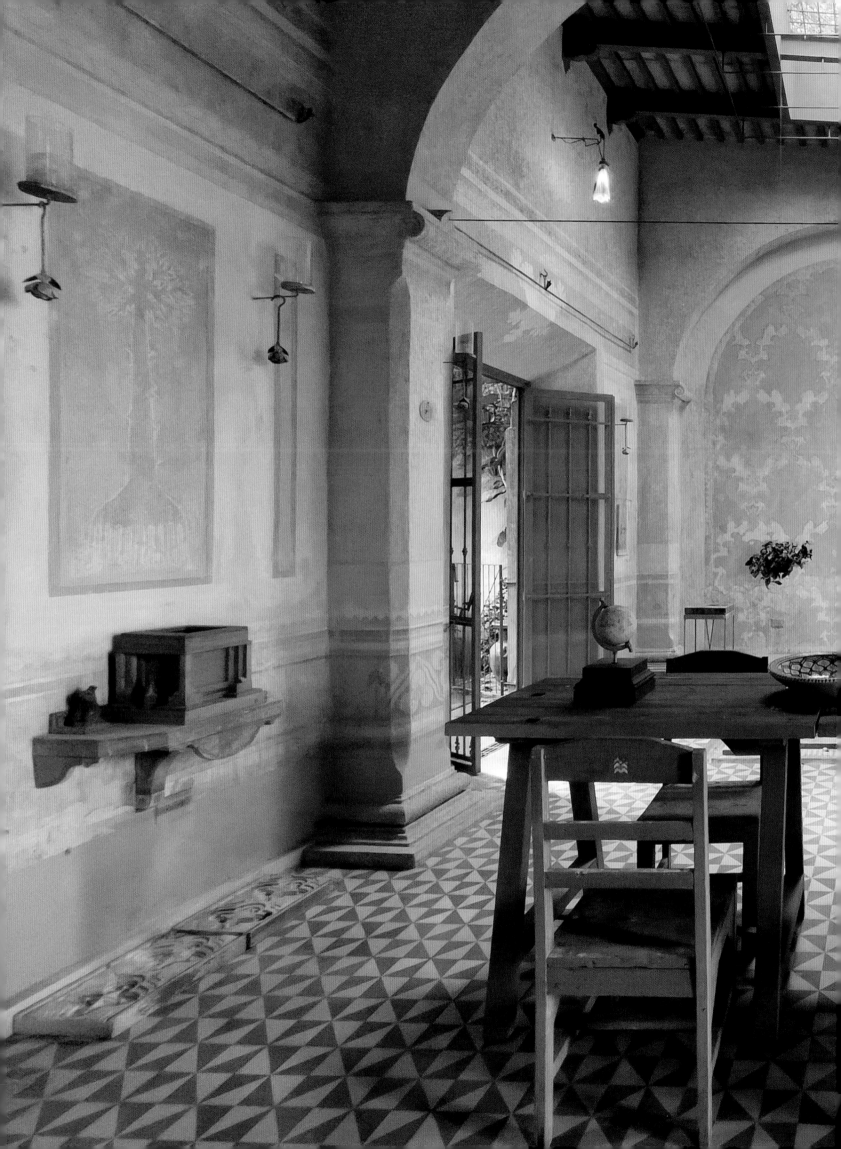

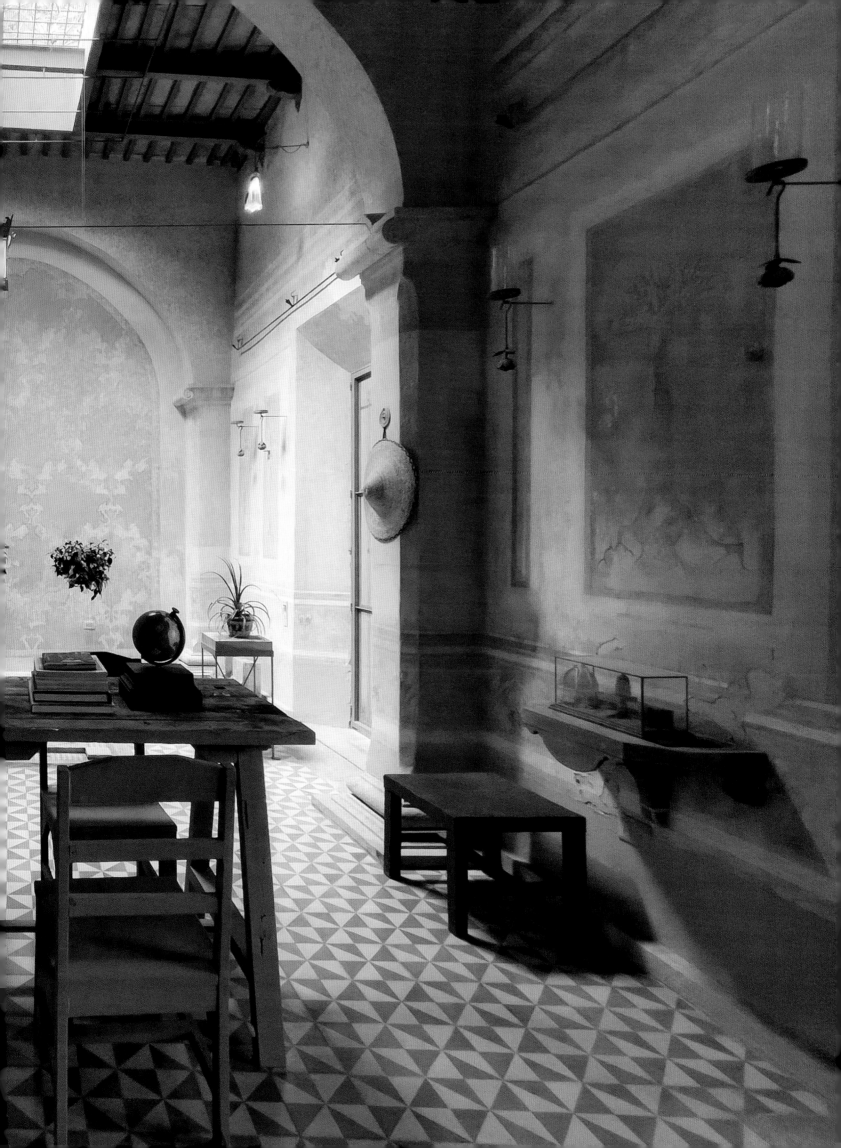

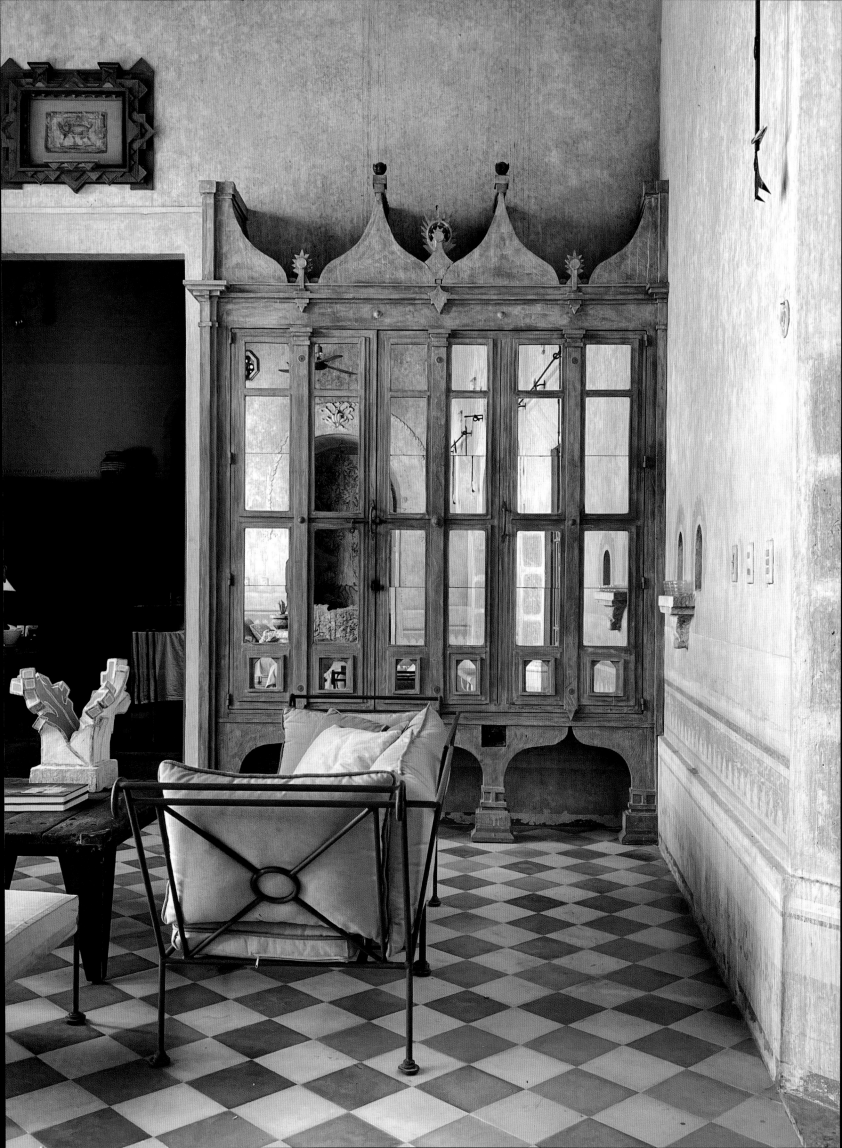

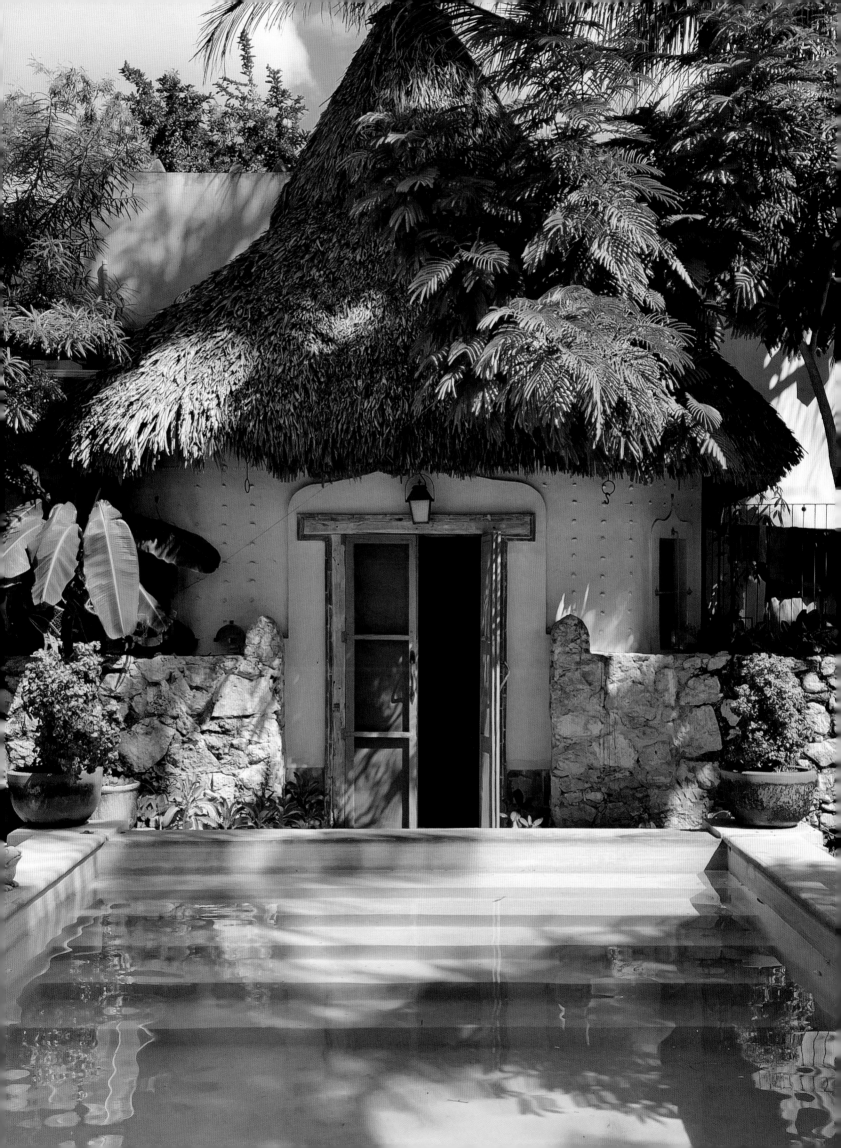

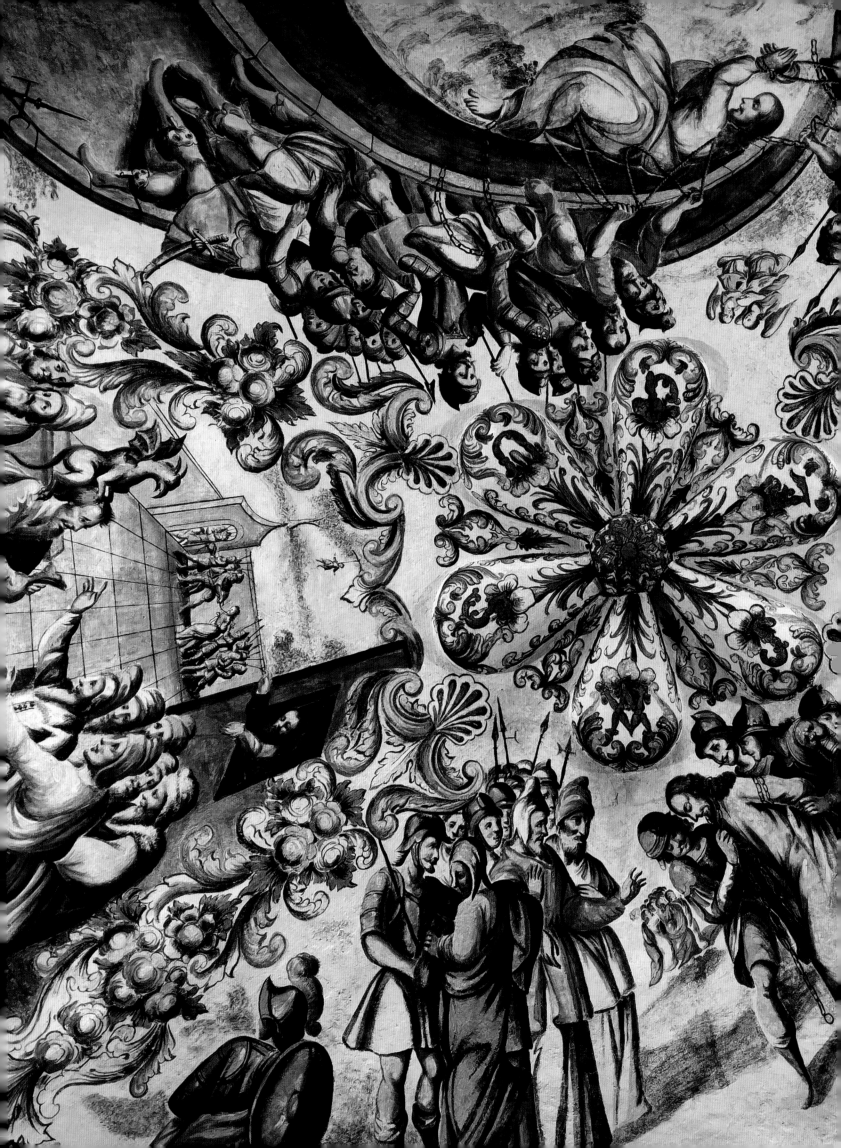

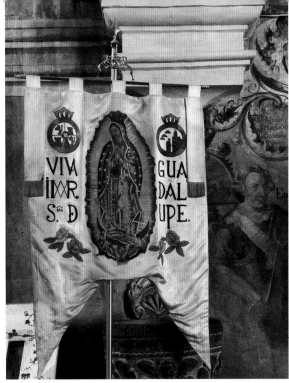

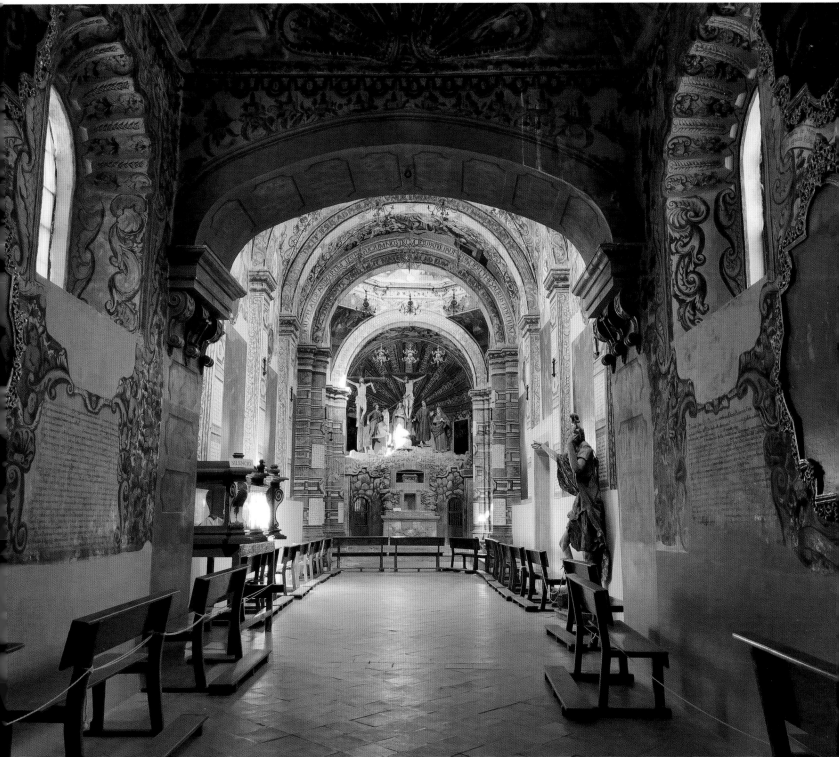

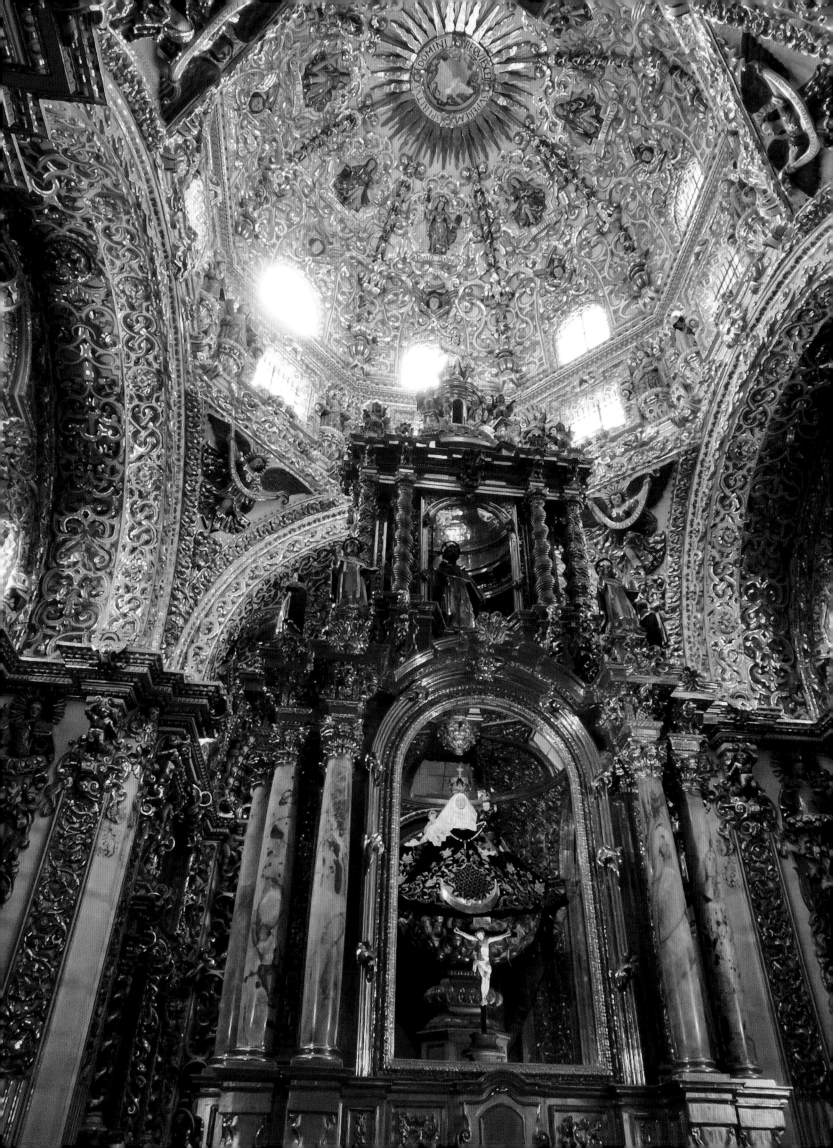

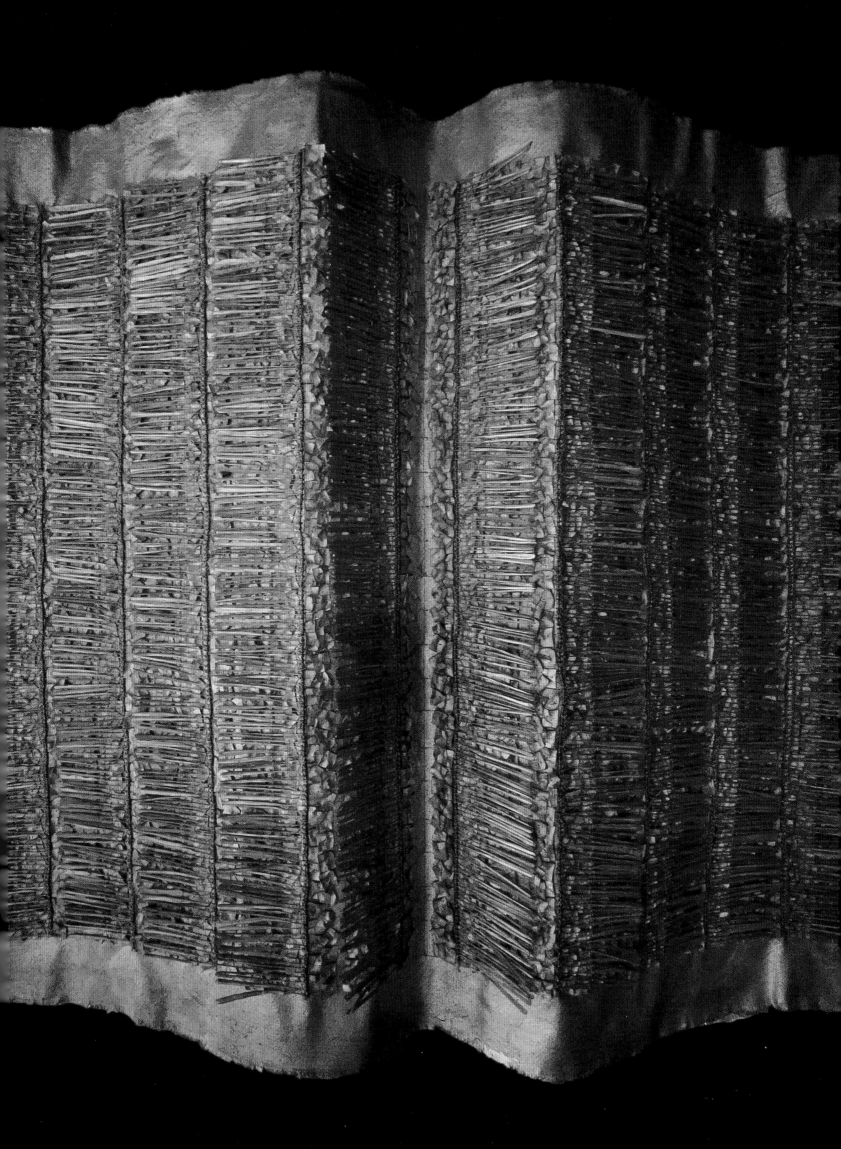

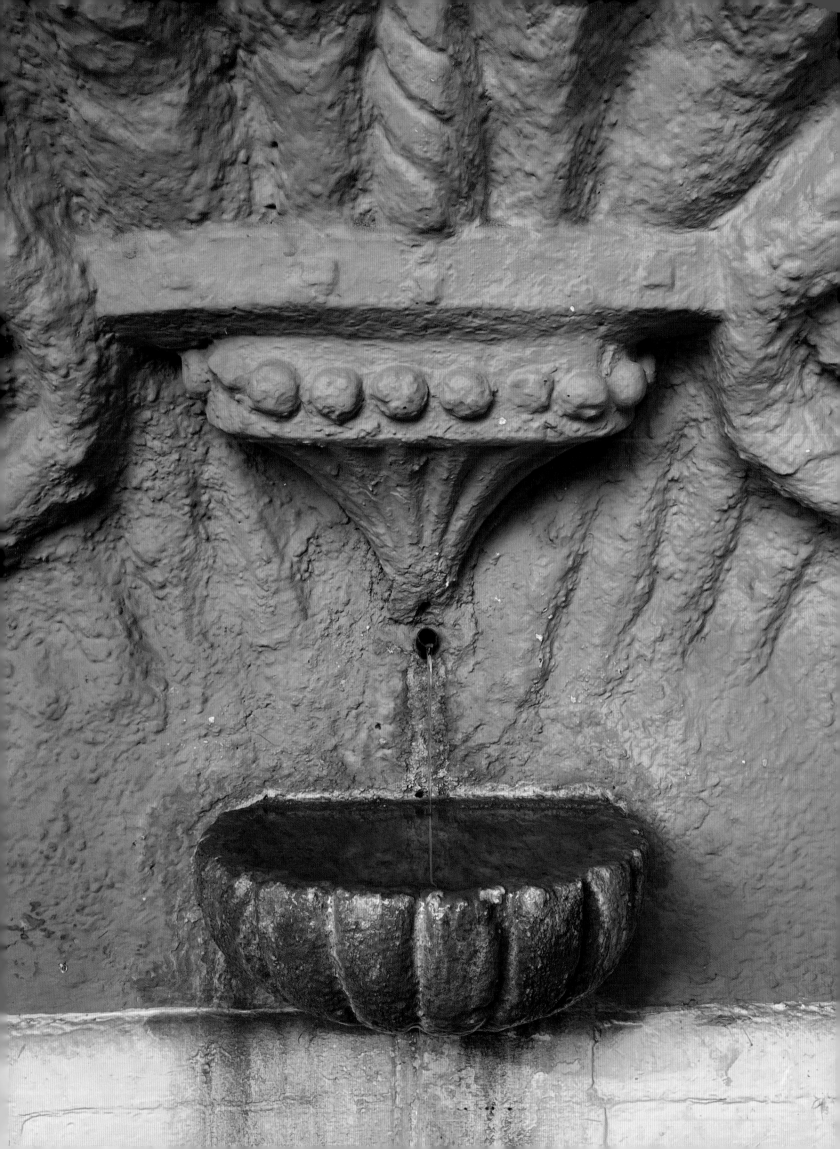

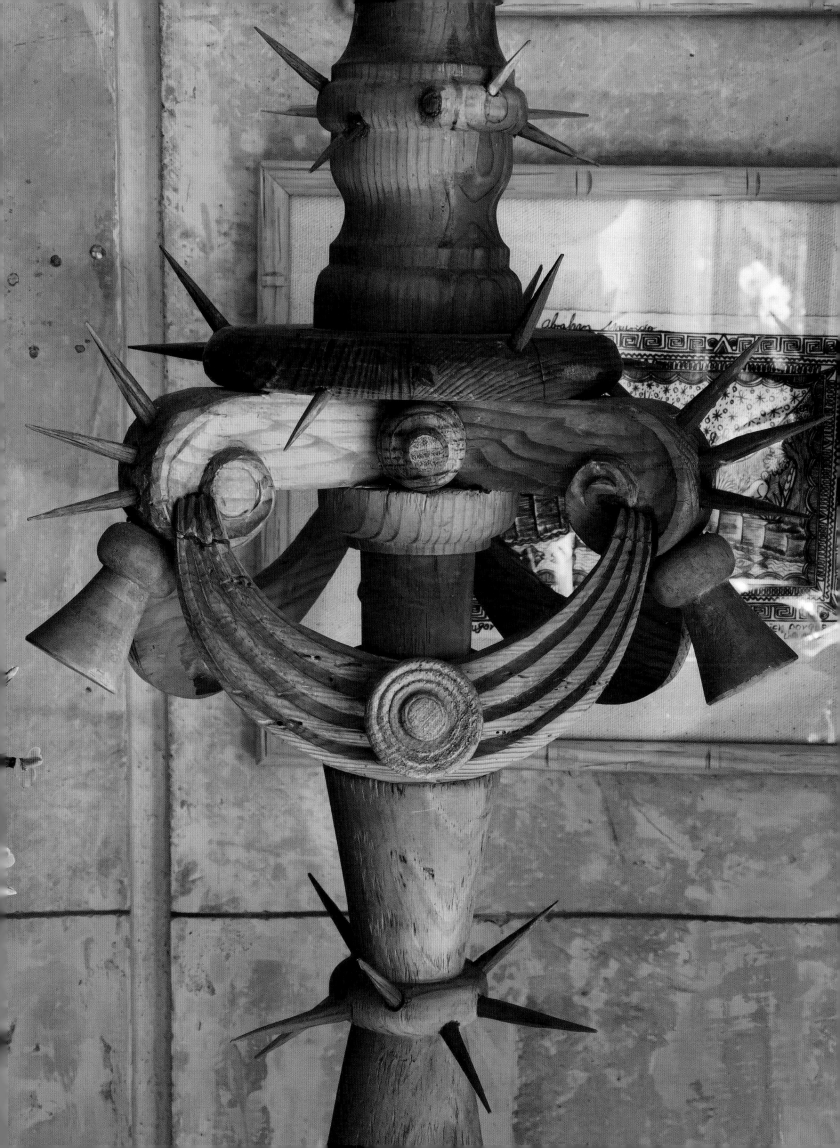

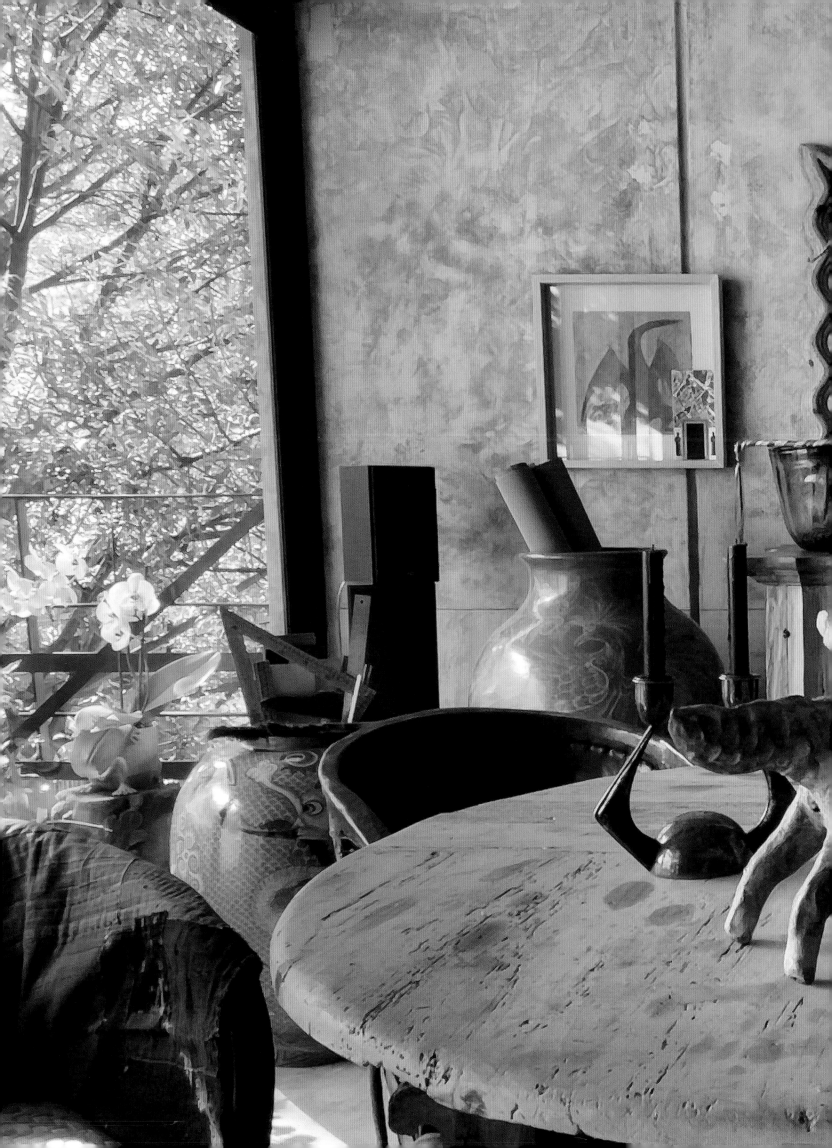

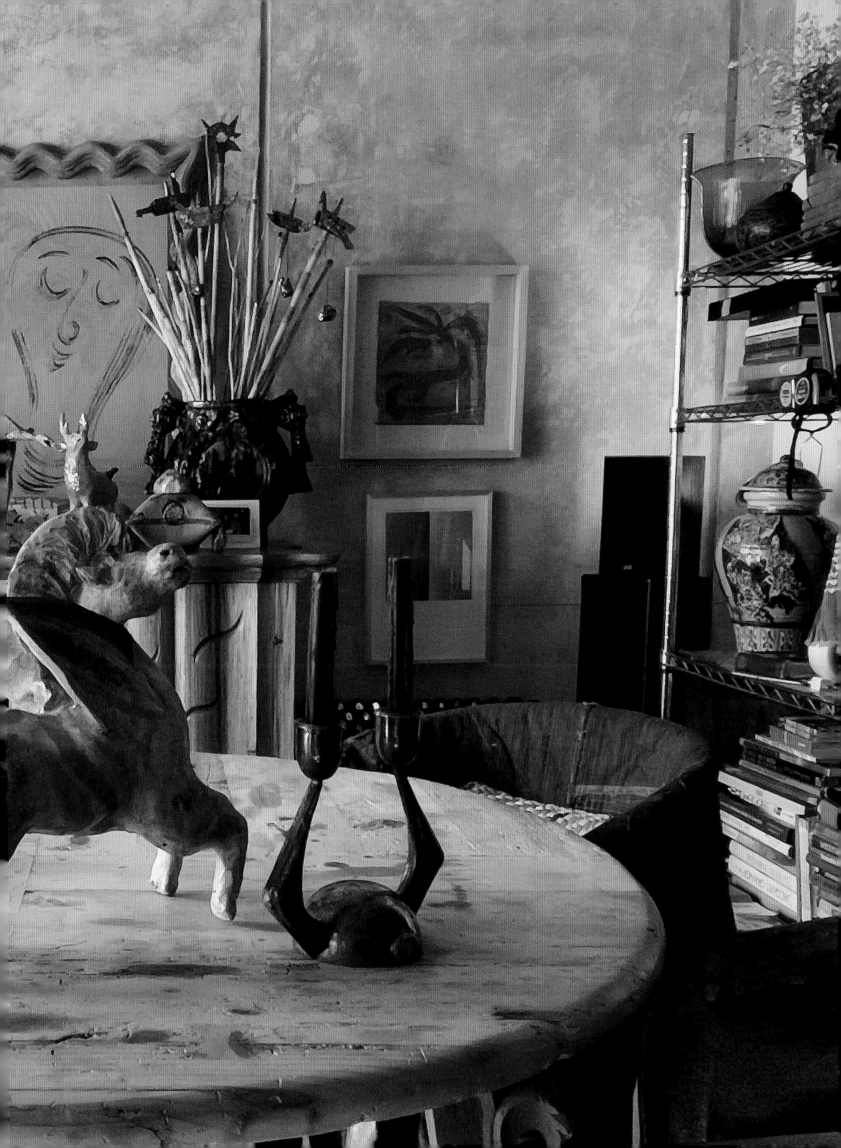

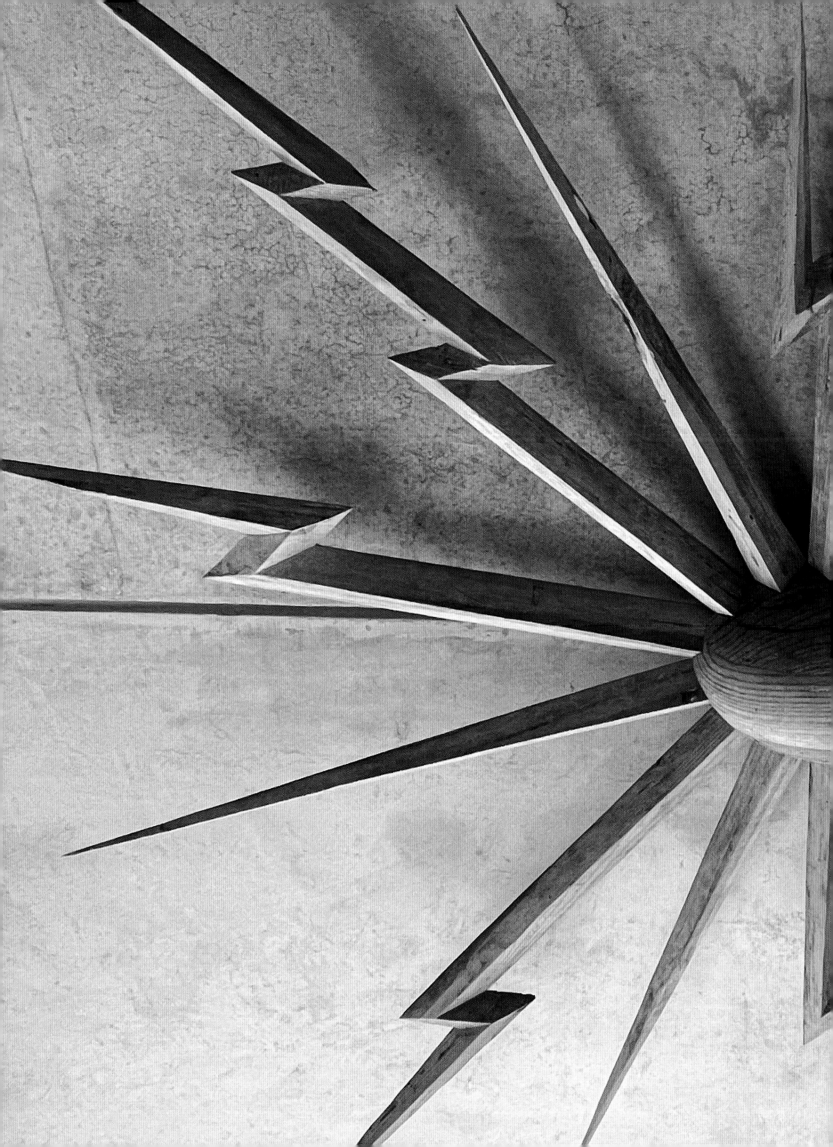

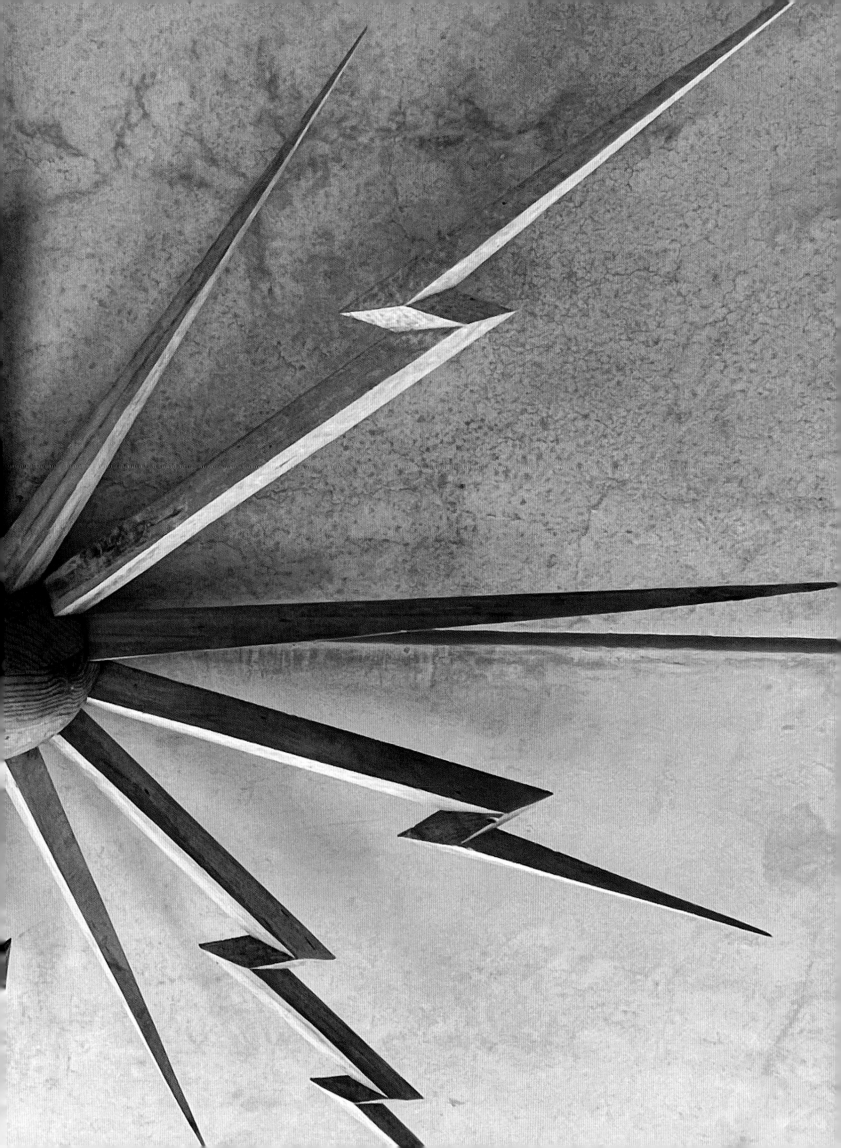

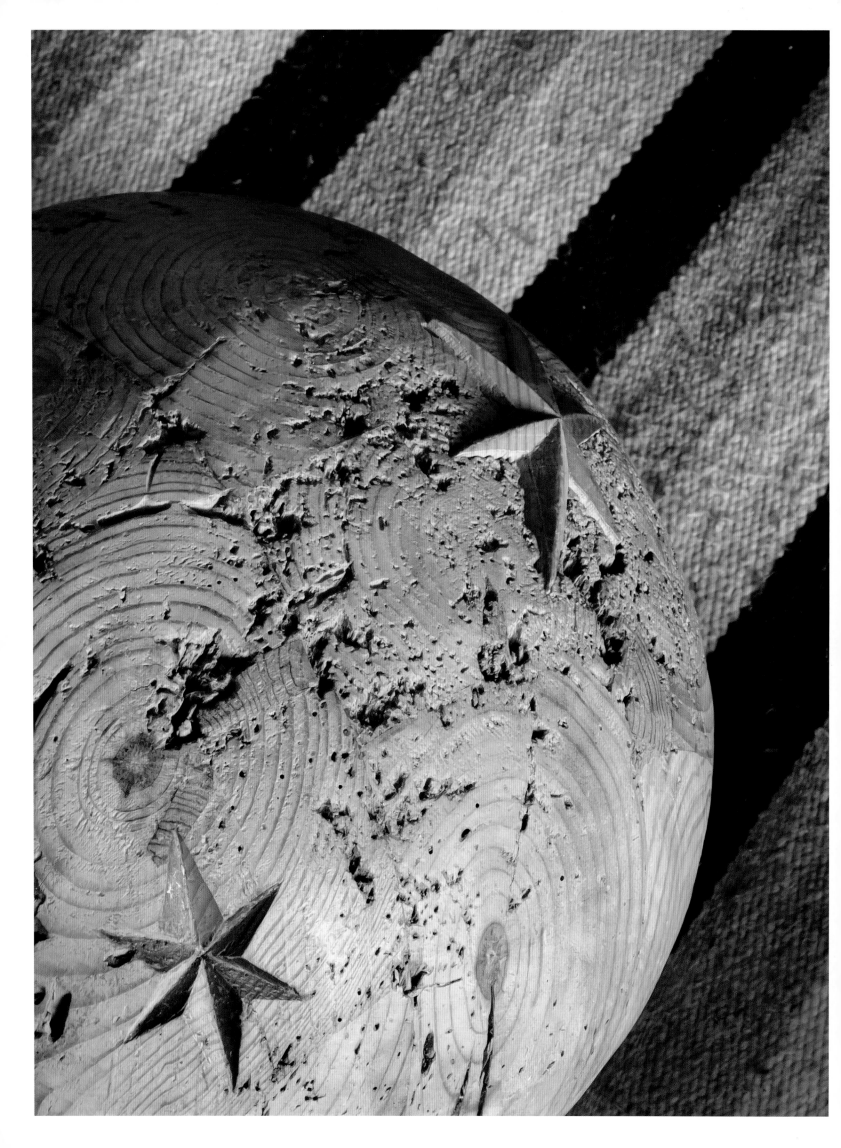

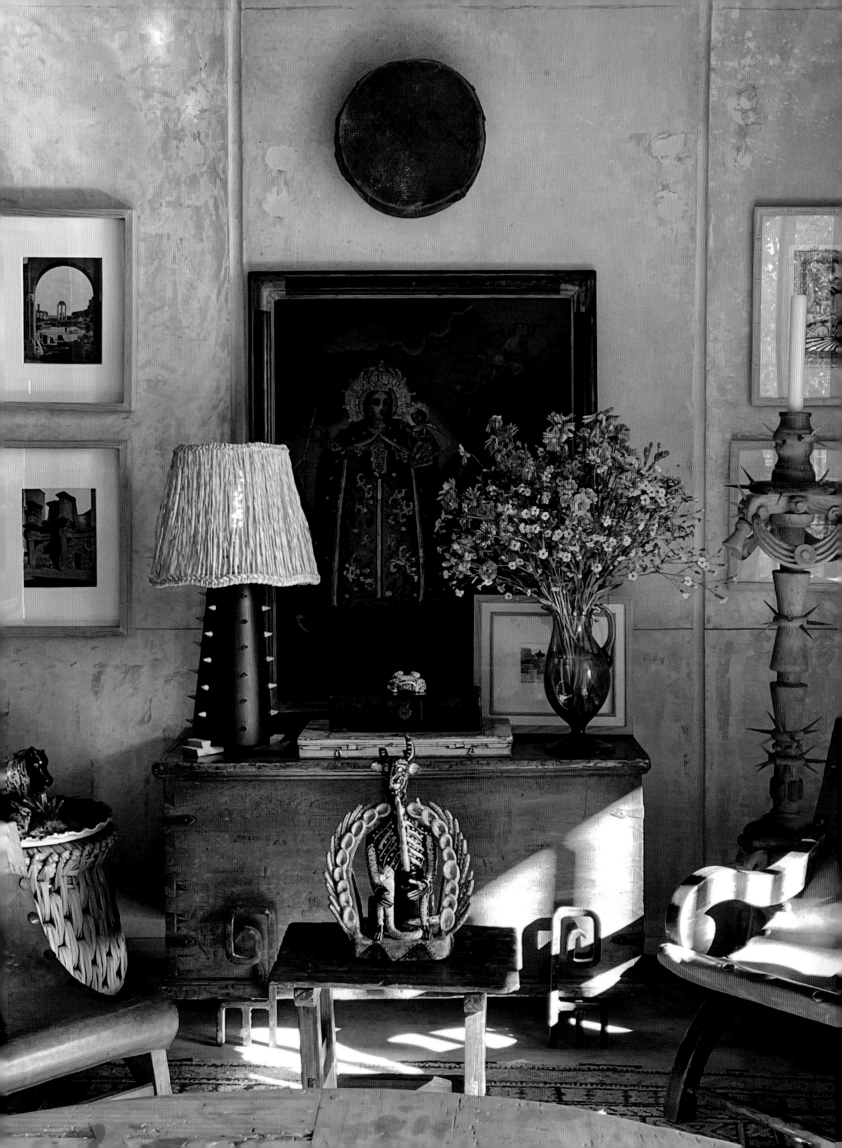

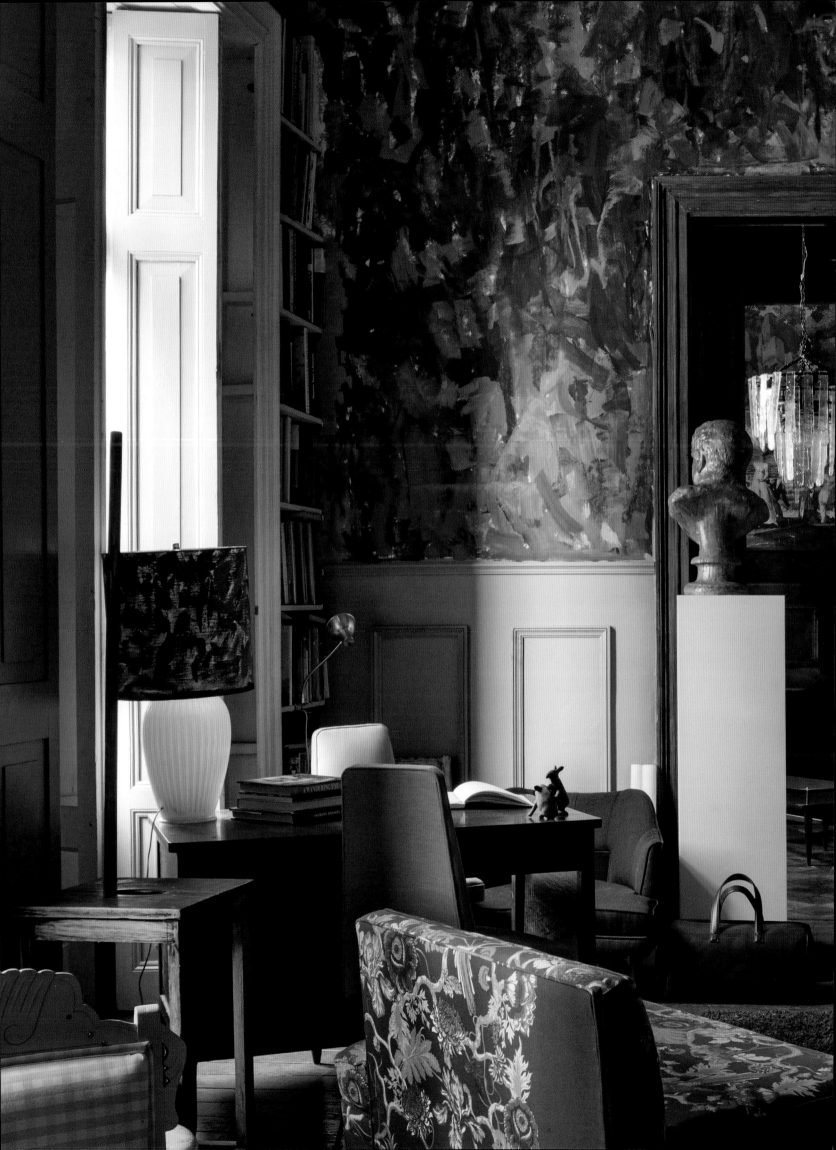

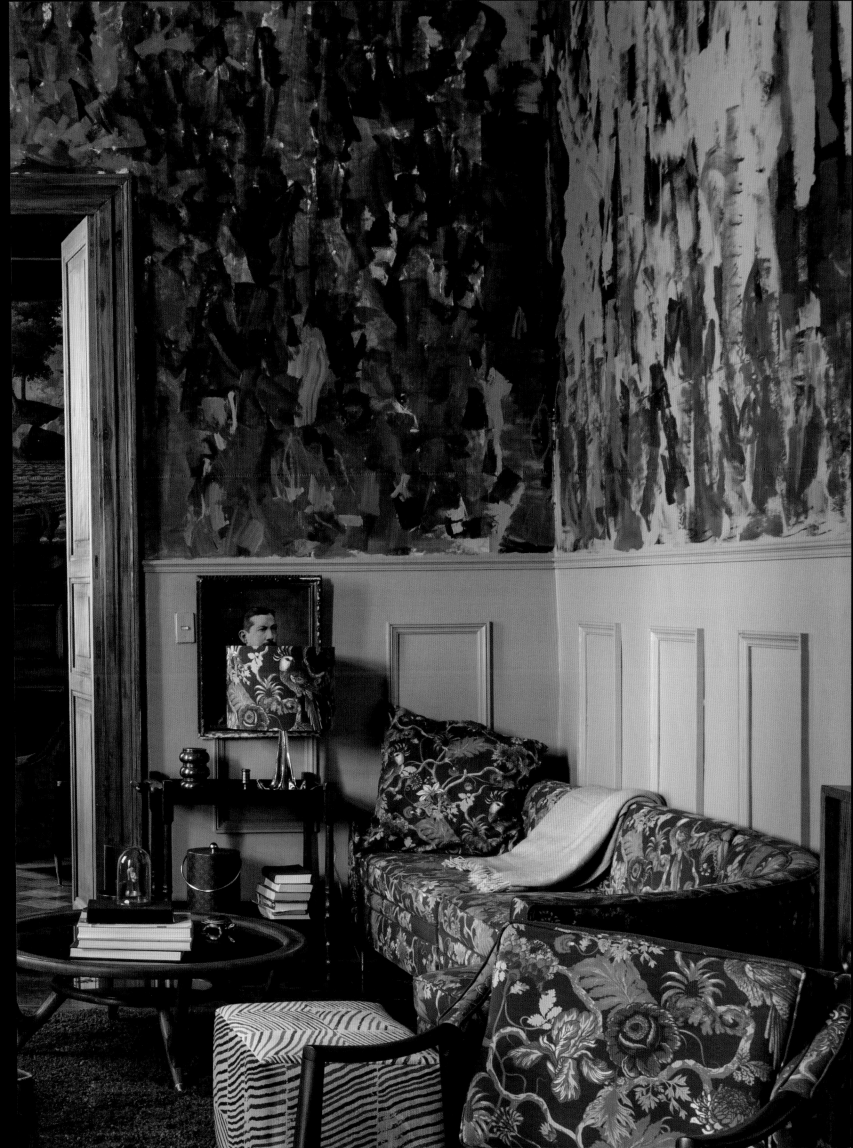

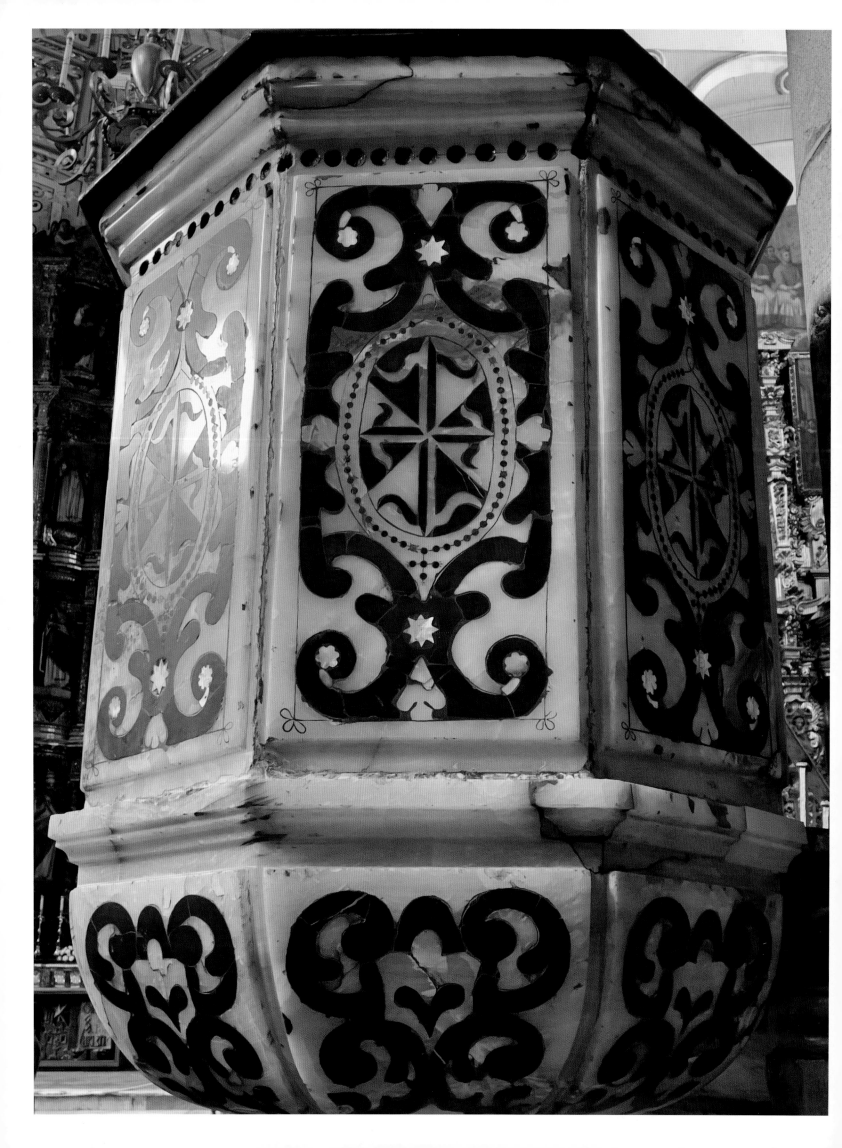

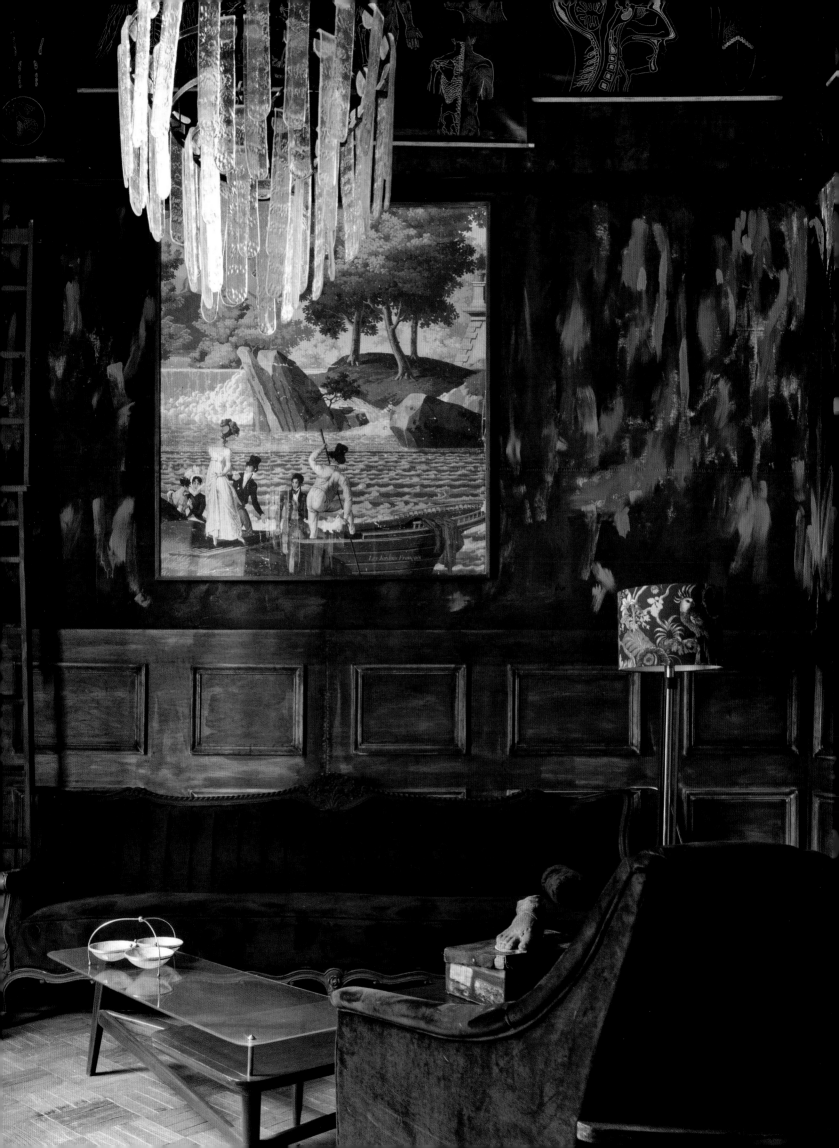

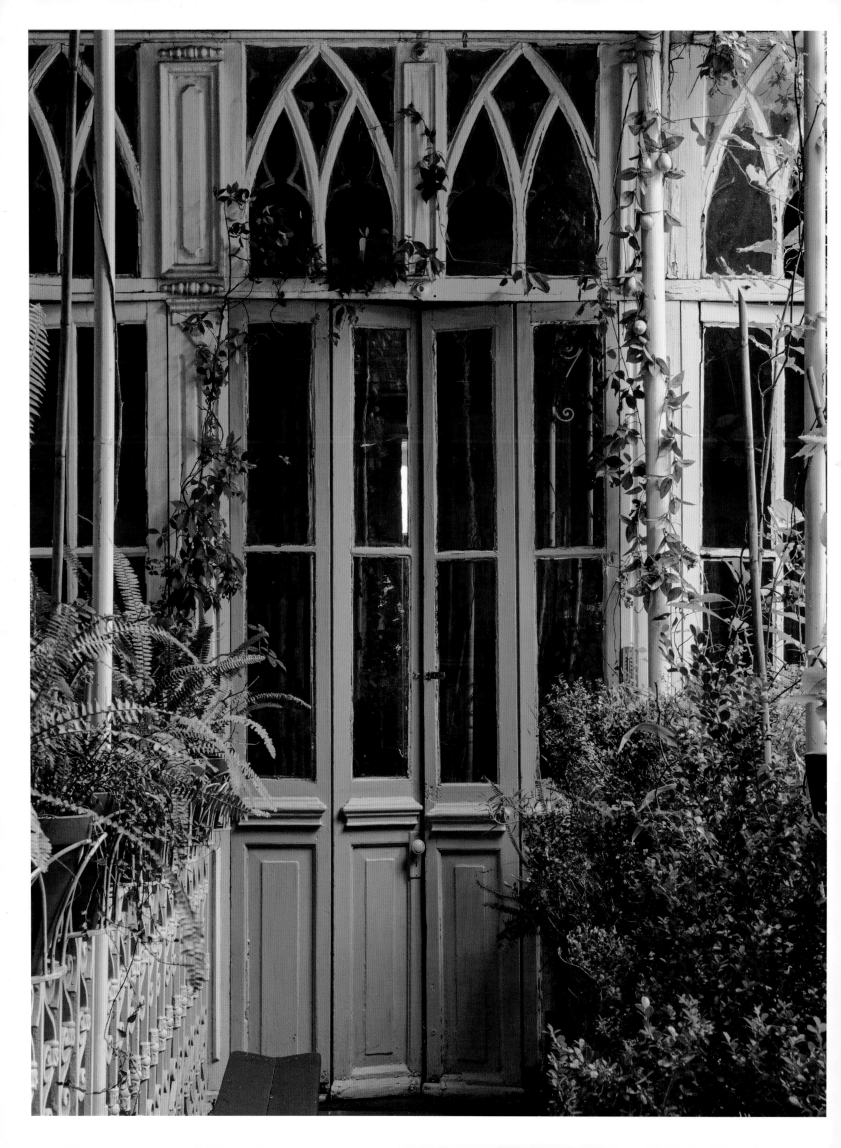

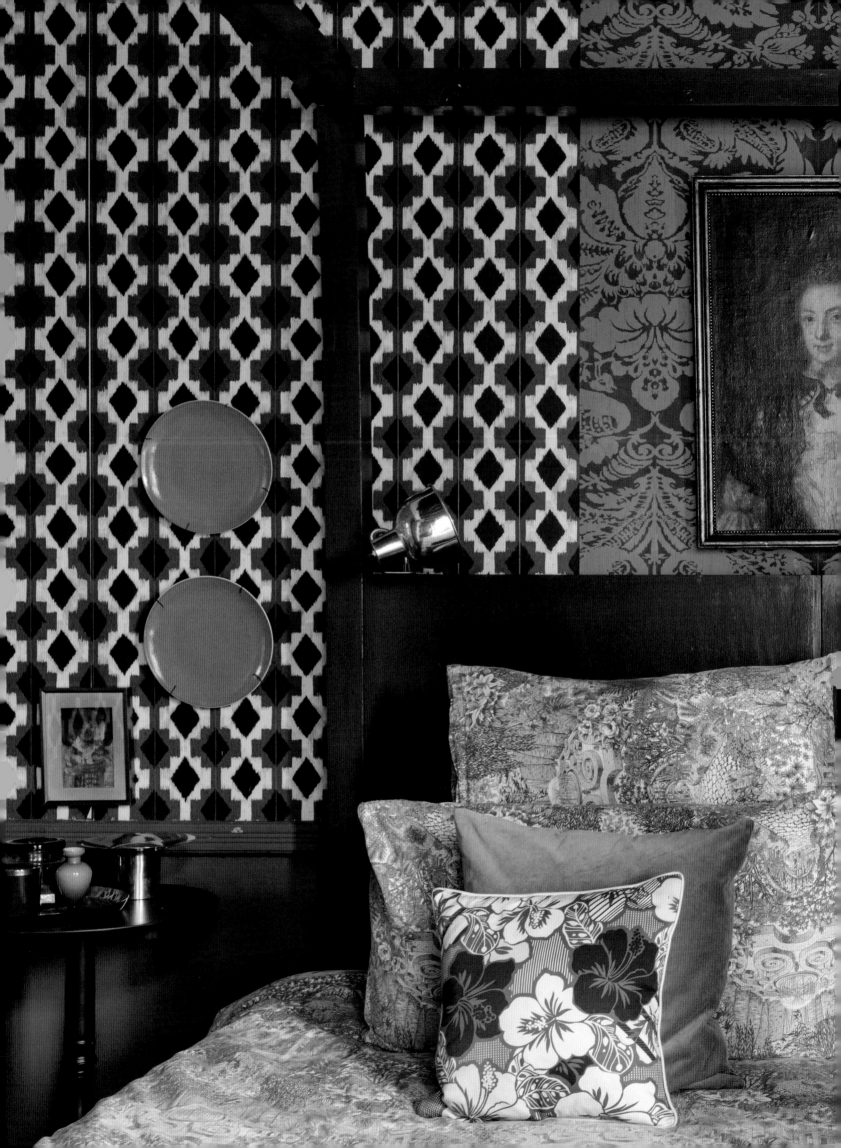

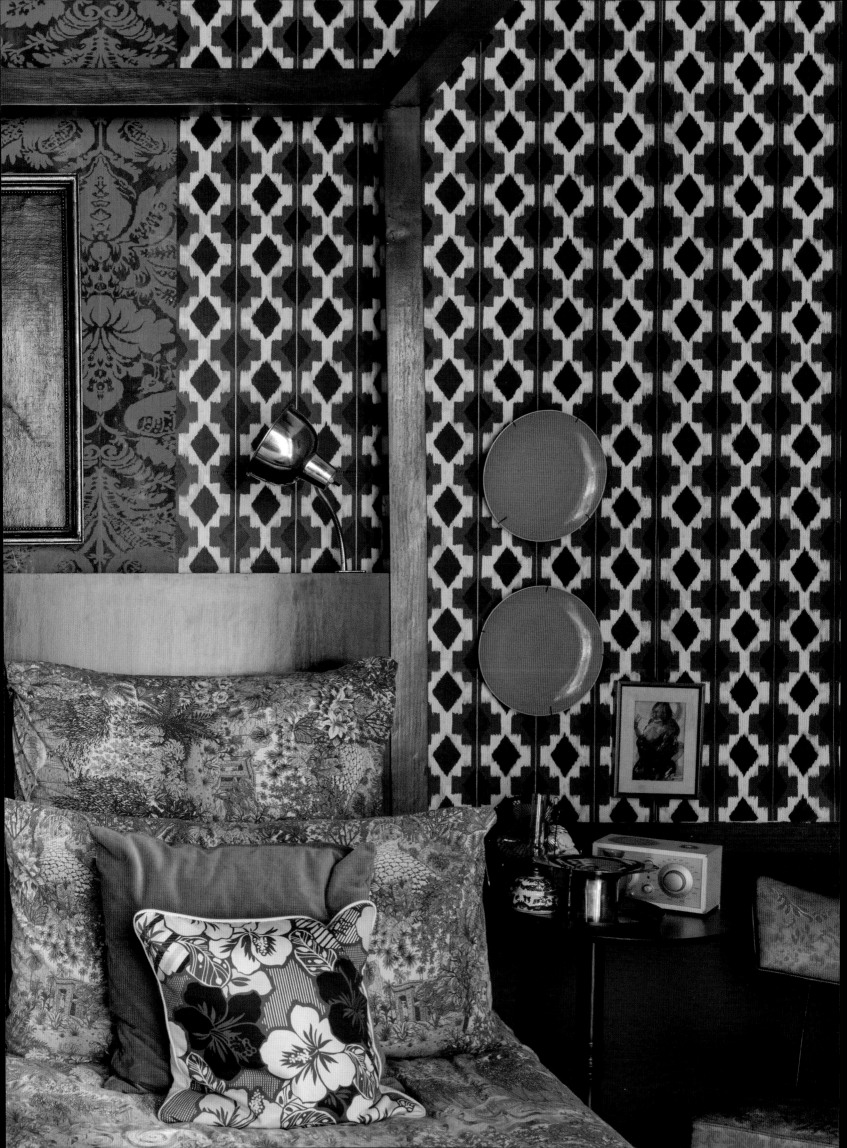

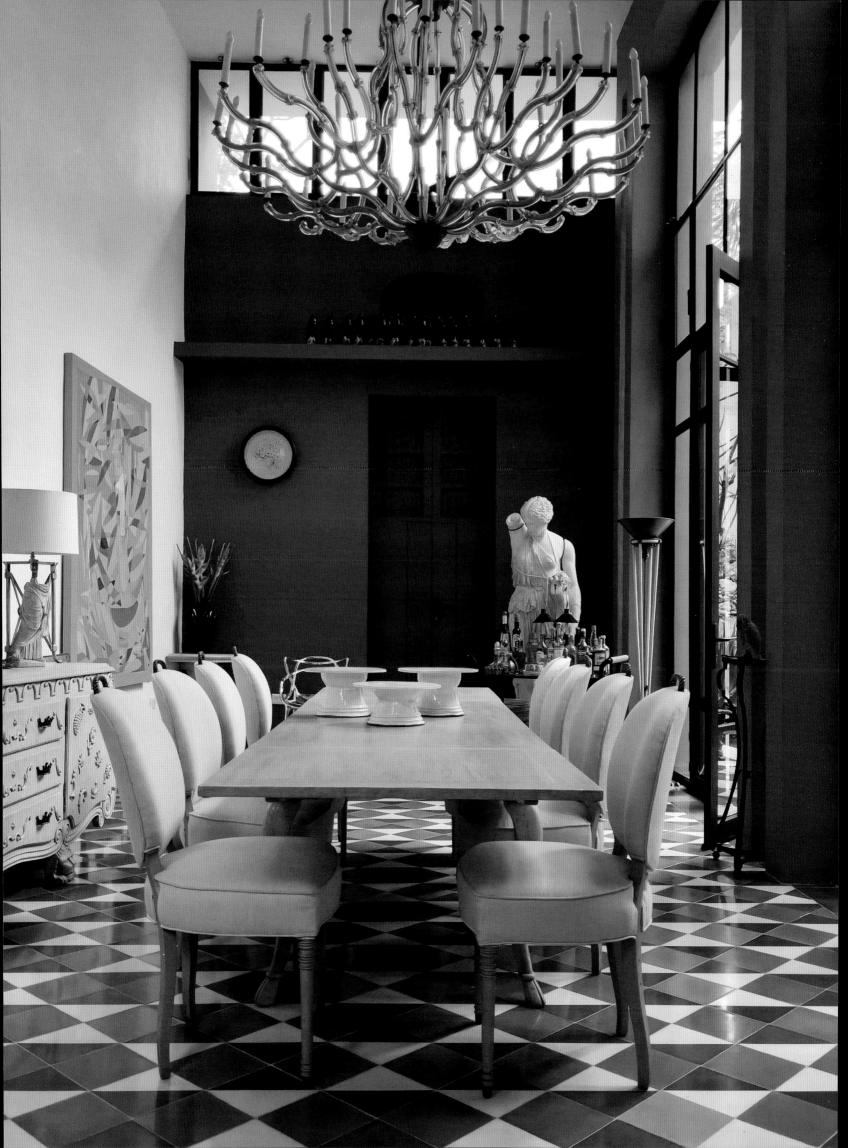

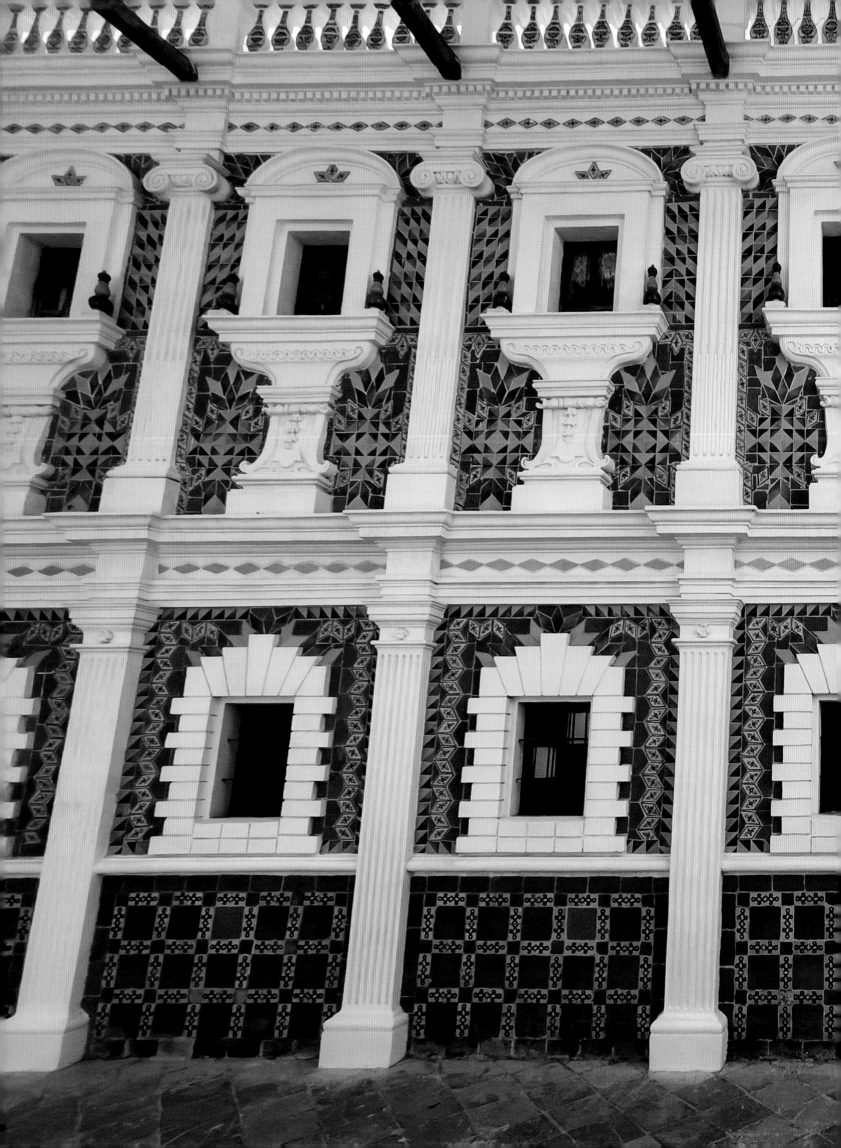

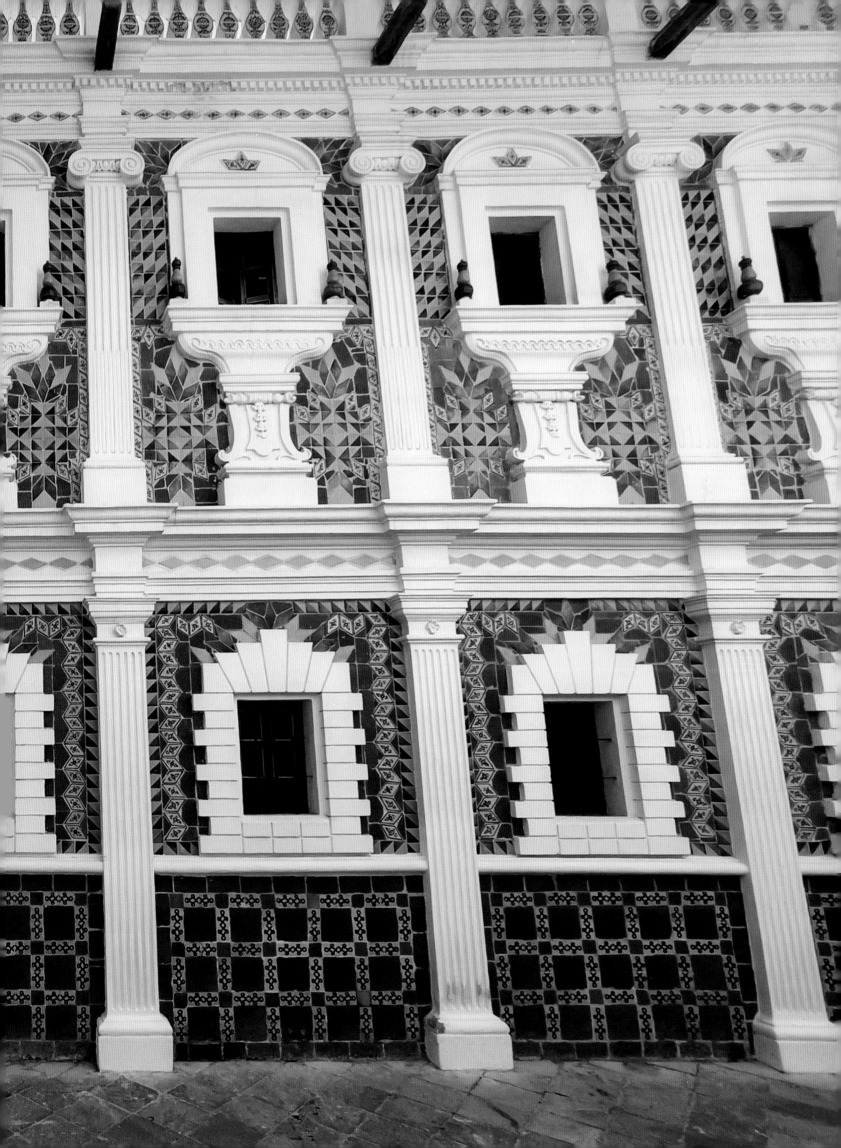

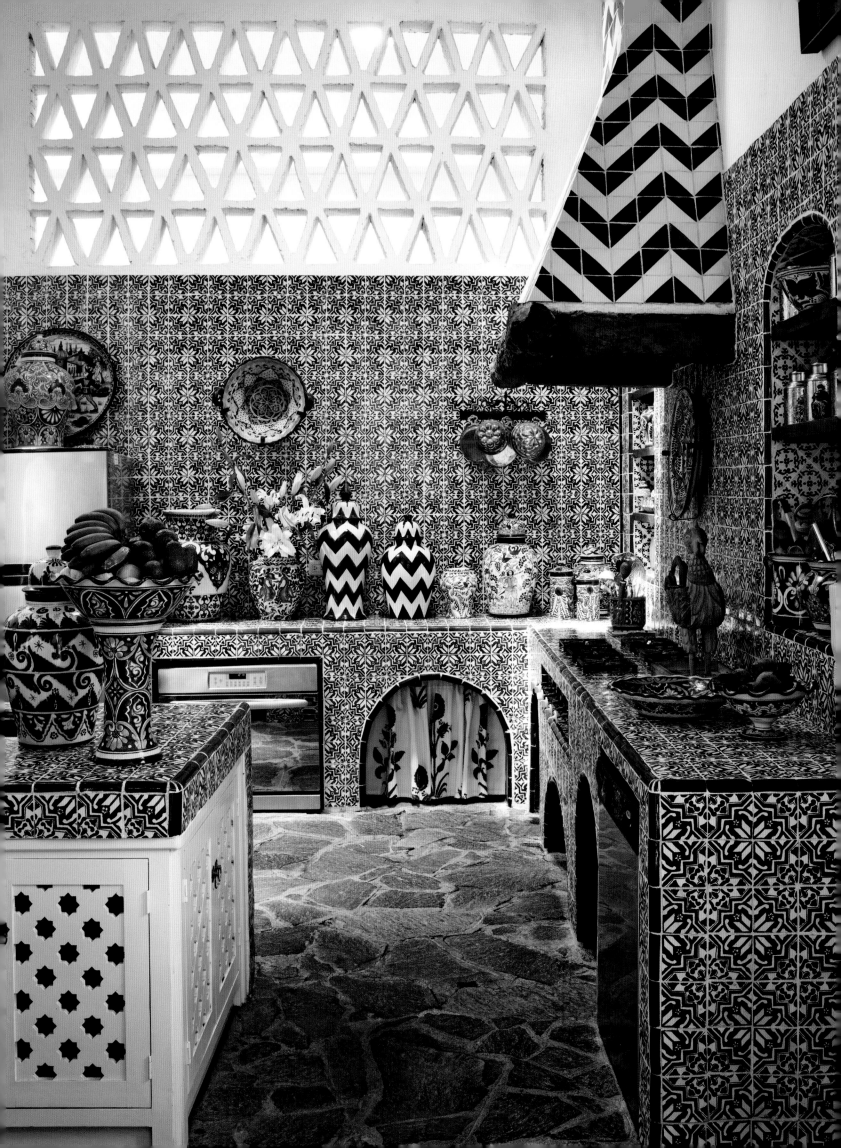

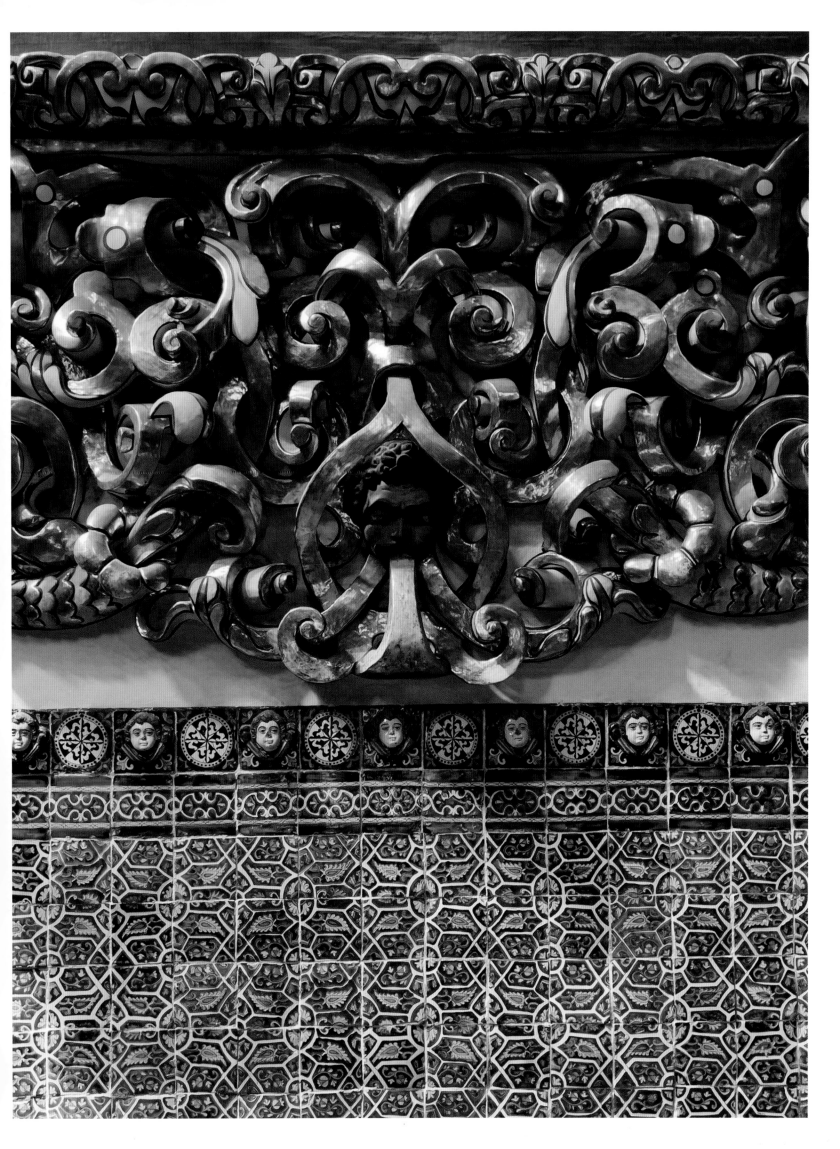

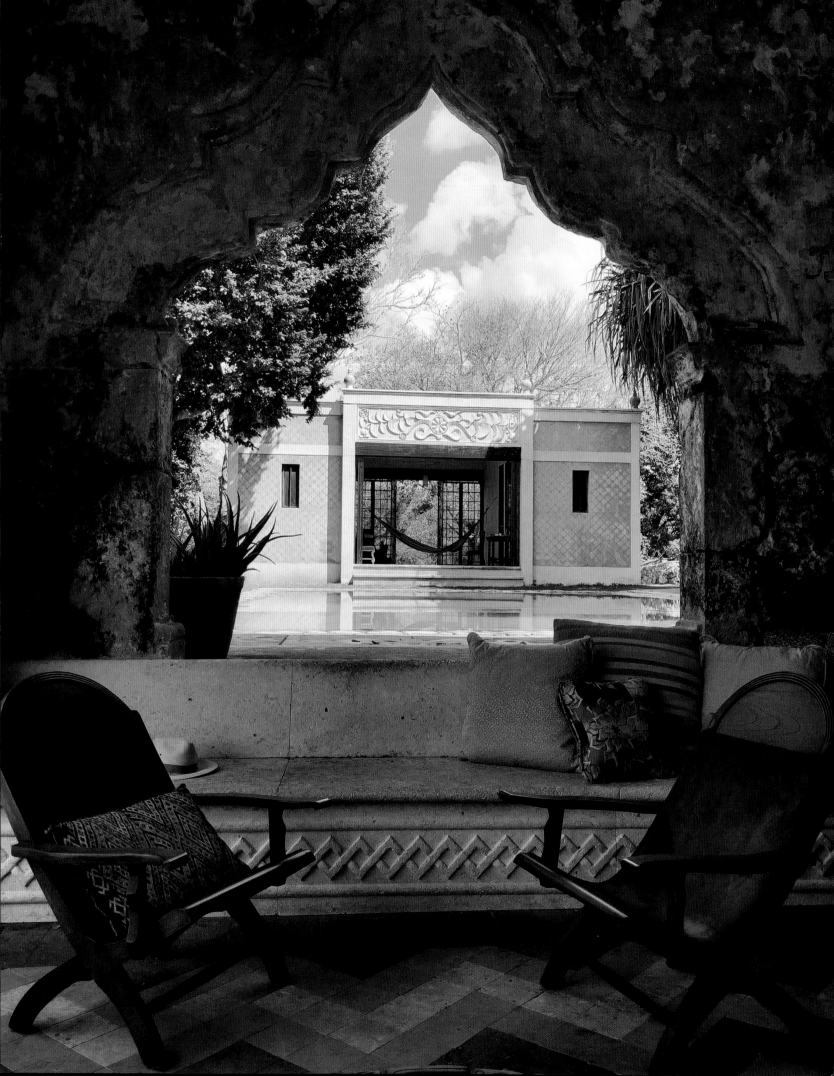

# COLONIAL

For 300 years, starting with the fall of Tenochtitlán in 1521, the Spanish conquered and ruled a vast empire in the New World—originally stretching from present-day Oregon down the Pacific coast and across the southern United States of America to Florida, all the way south to the Guatemala highlands. During this time, both the *conquistadors* and the Roman Catholic Church, particularly their religious orders, used architecture—and heavy-handed subjugation of indigenous people—to stake their claim to land through public and domestic architecture. Cathedrals, *templos*, convents and monasteries, plantations, and spacious houses all drew from the rich design vocabulary of the Mediterranean, in particular the fascinating history of the Spanish *convivencia* (almost a thousand years of cultural intermingling of Christians, Jews, and Muslims). The design legacy of this period crossed the Atlantic and, with the New World's ancient building techniques and craftsmanship, indelibly imprinted Mexican style.

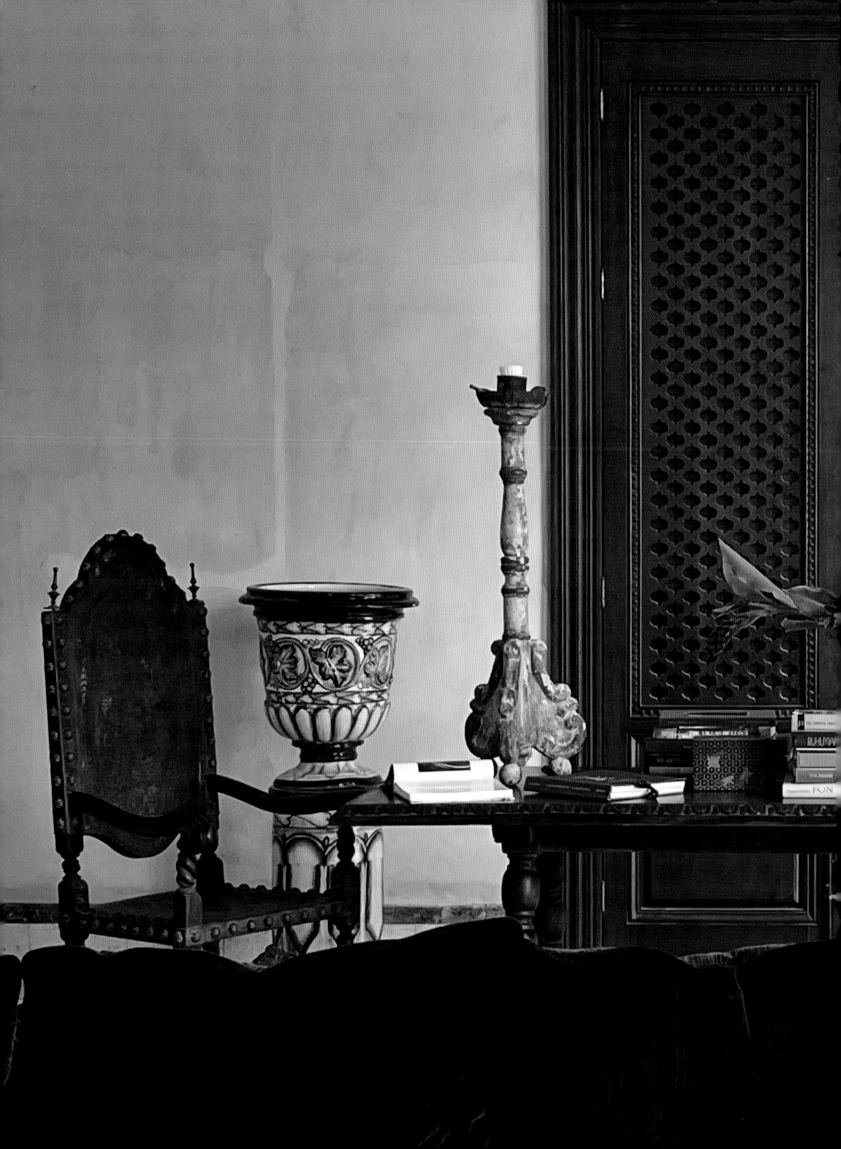

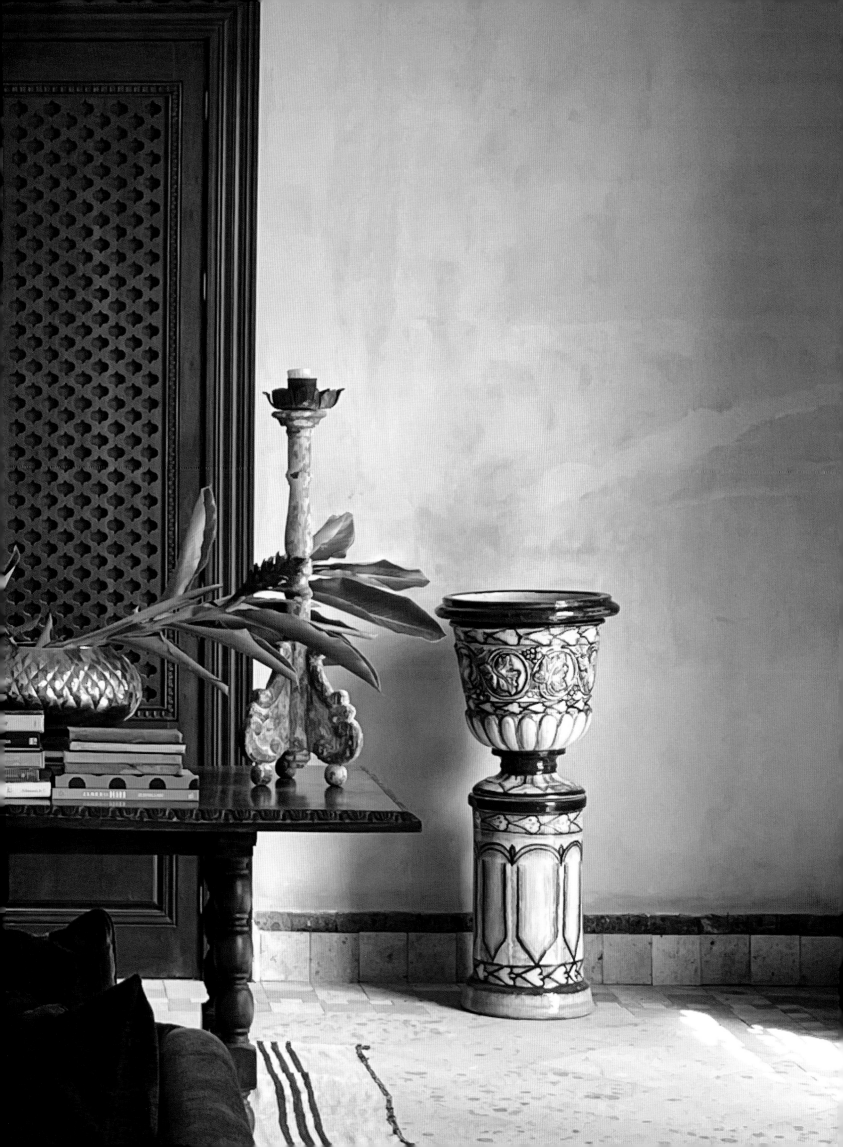

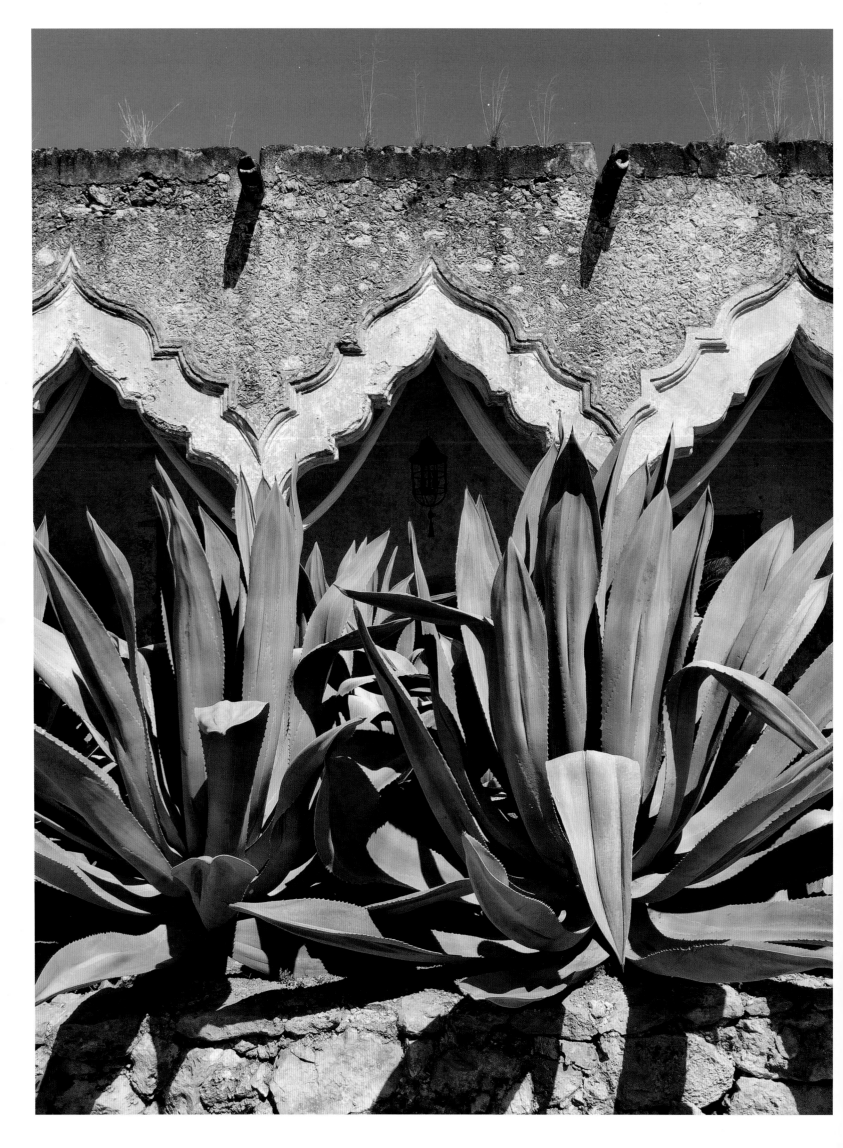

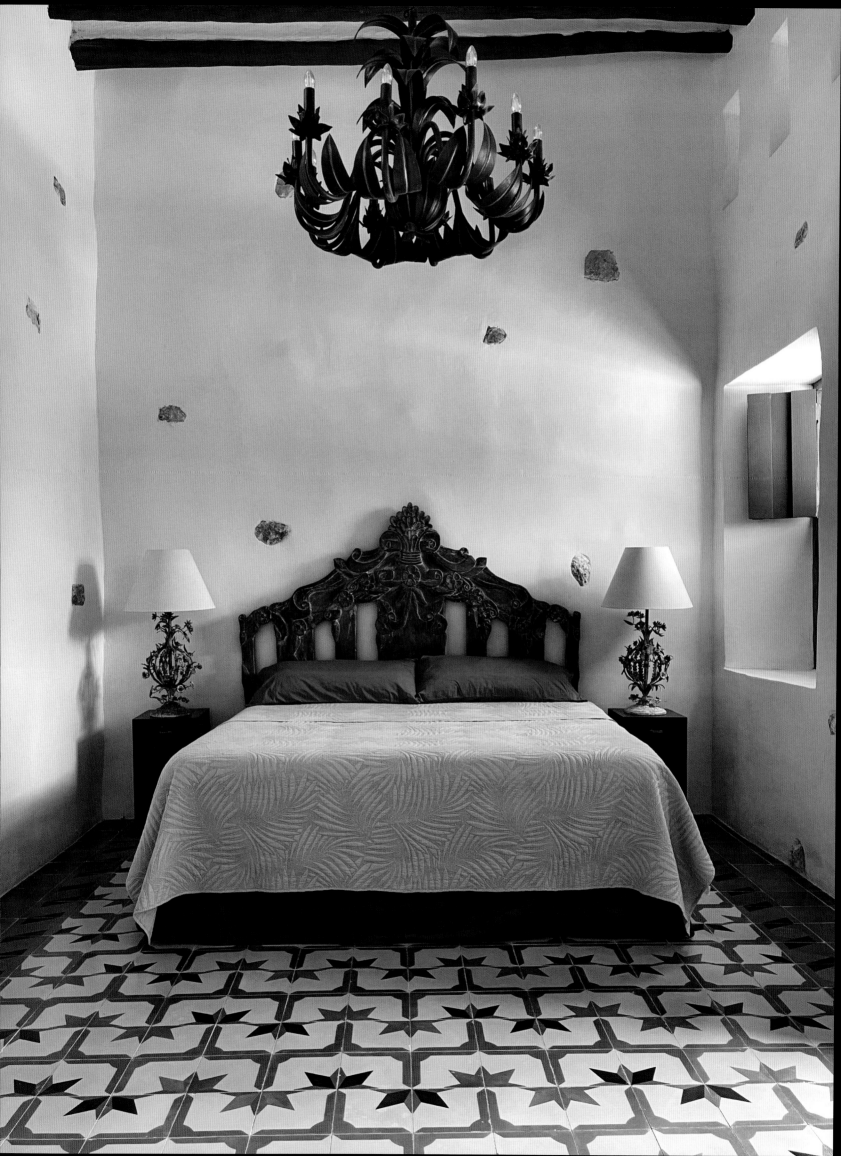

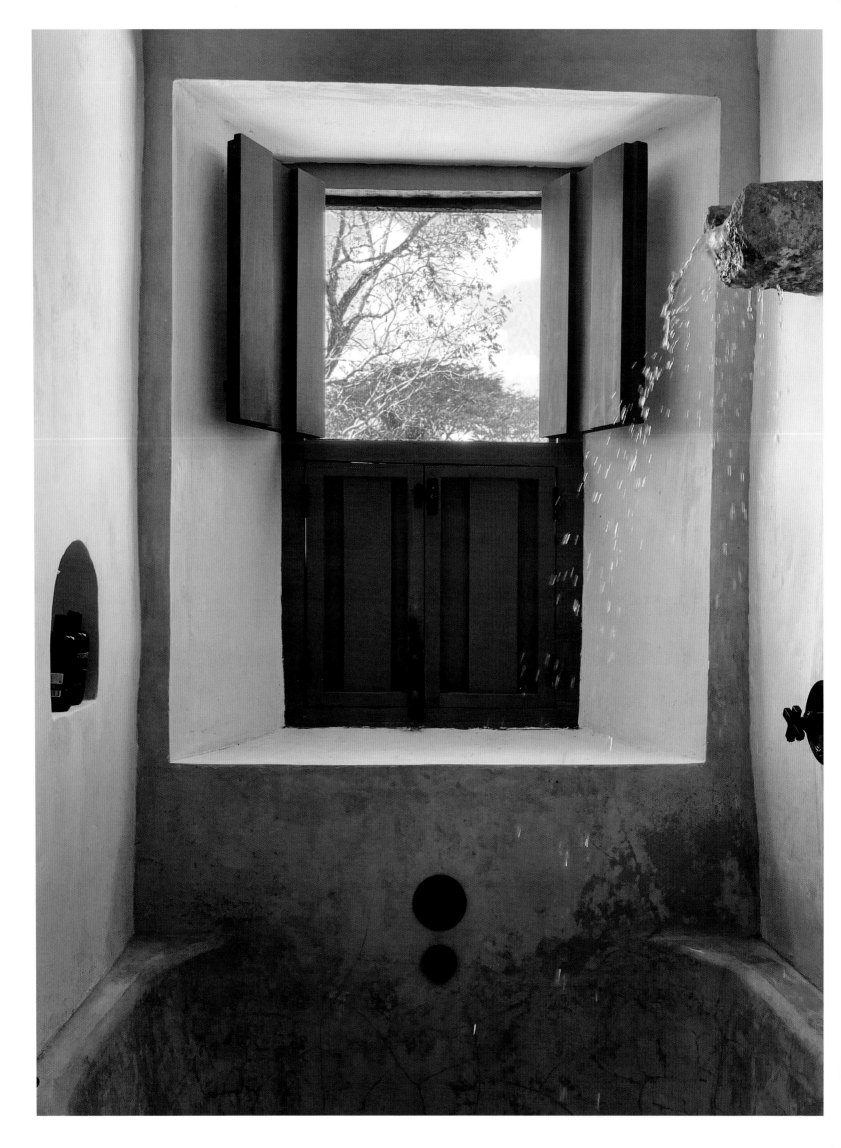

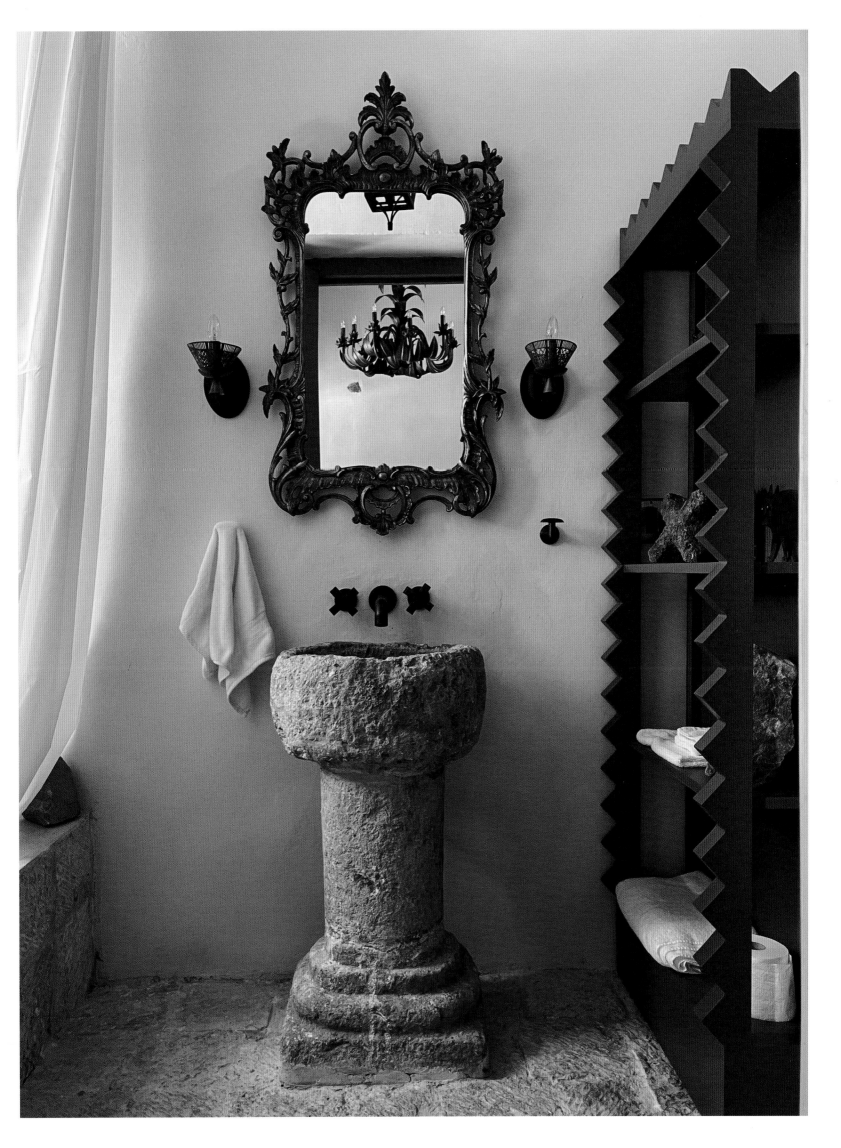

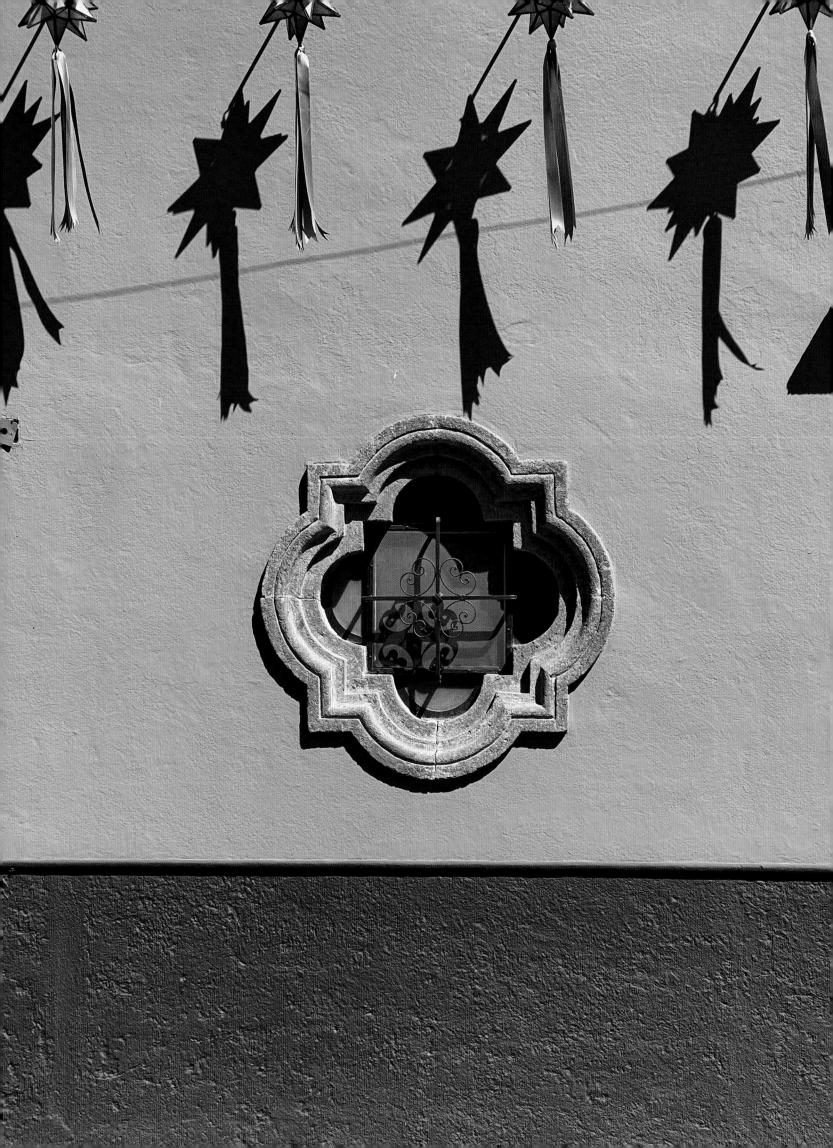

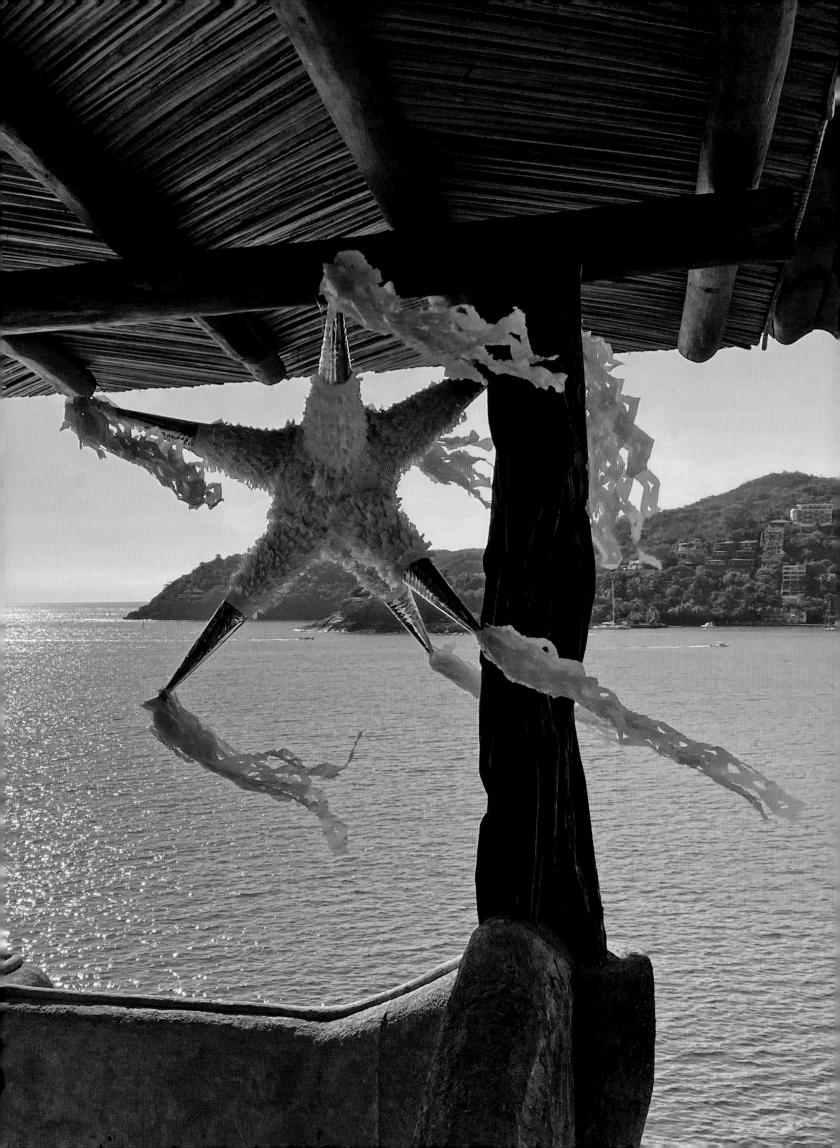

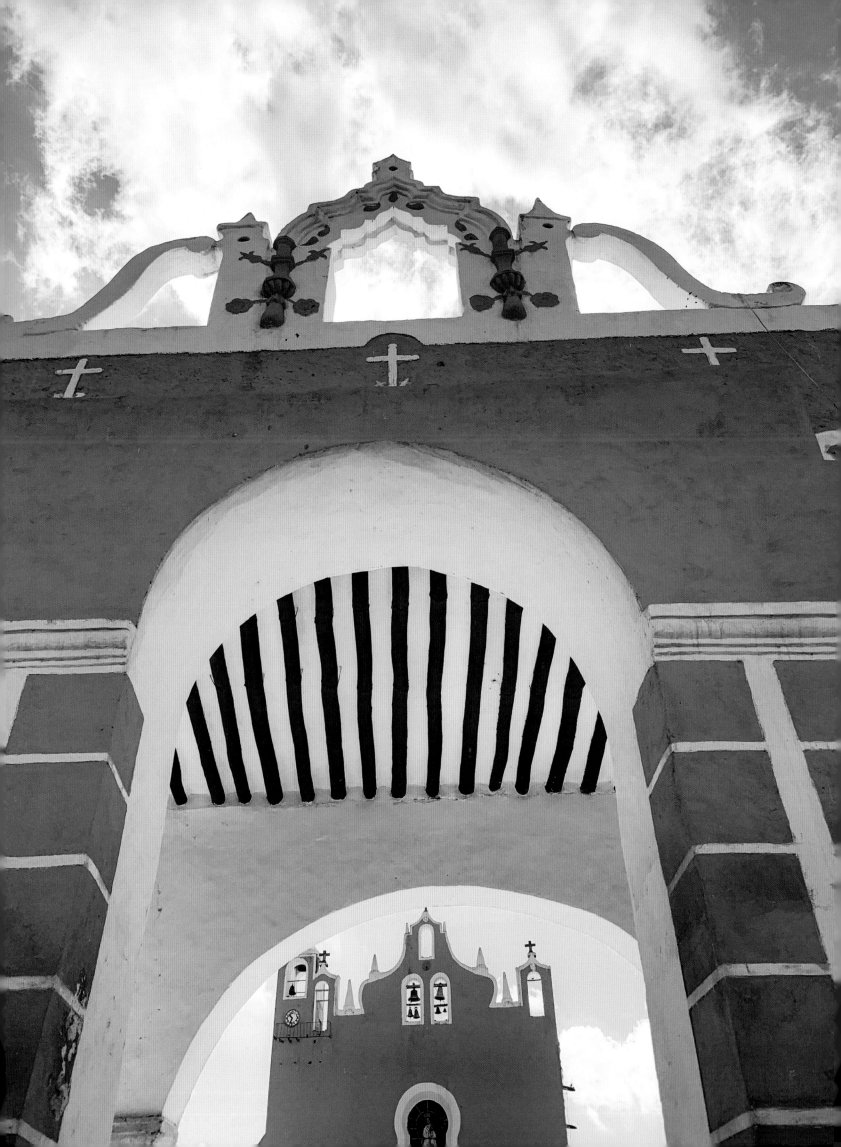

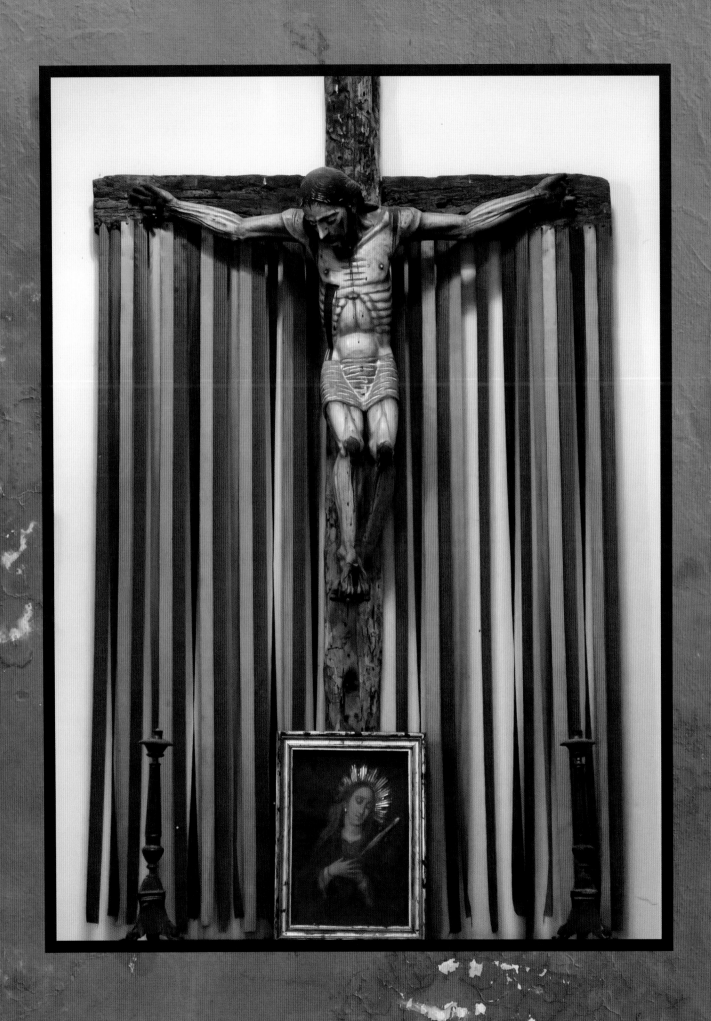

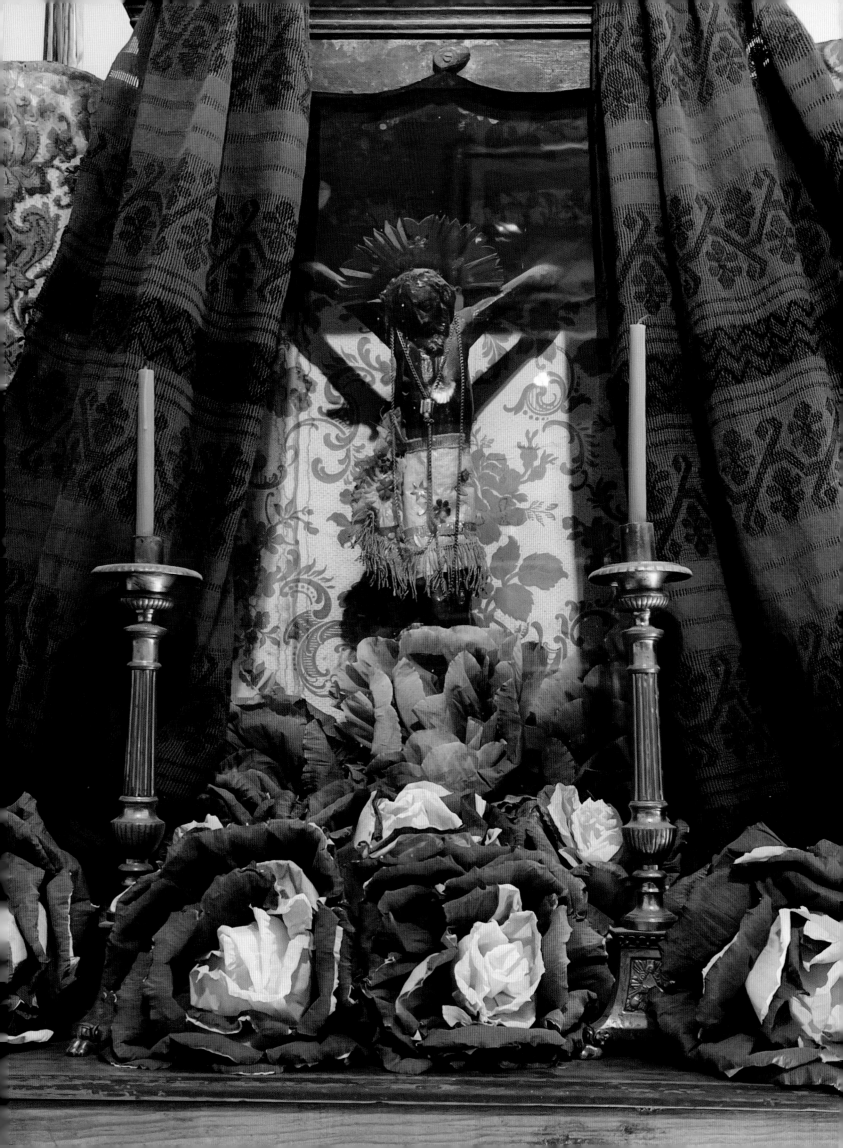

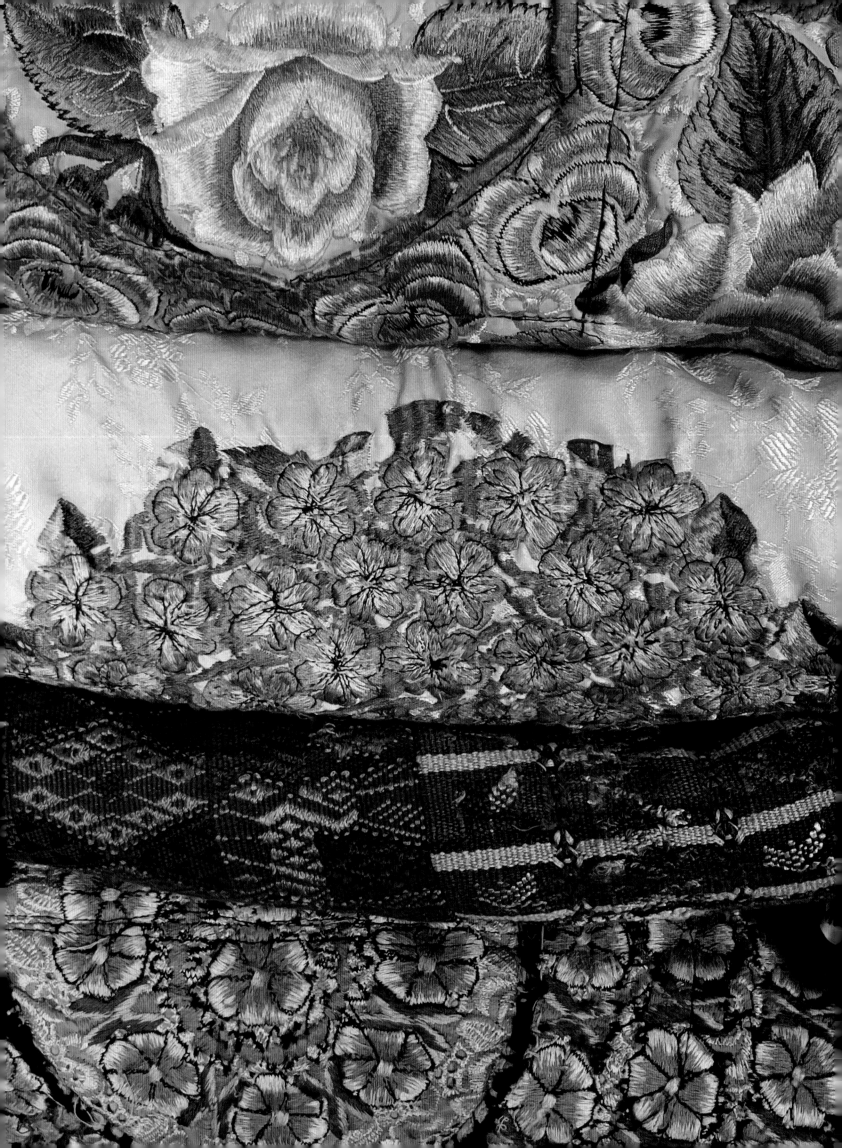

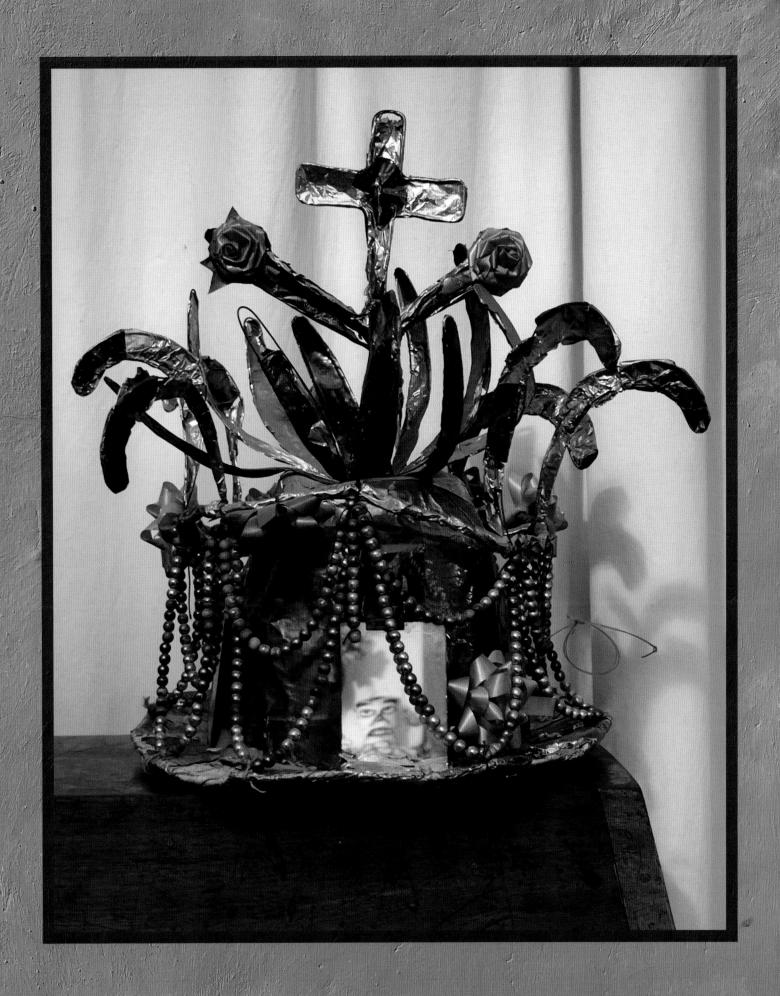

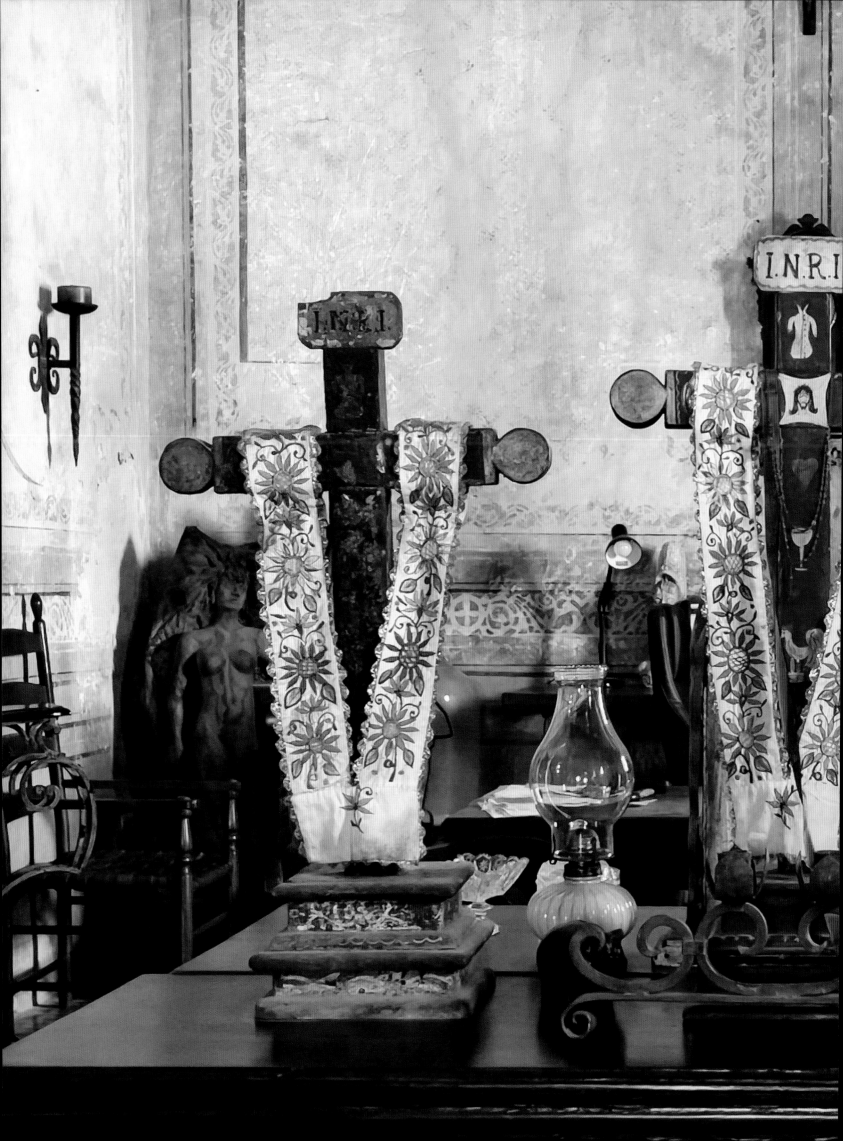

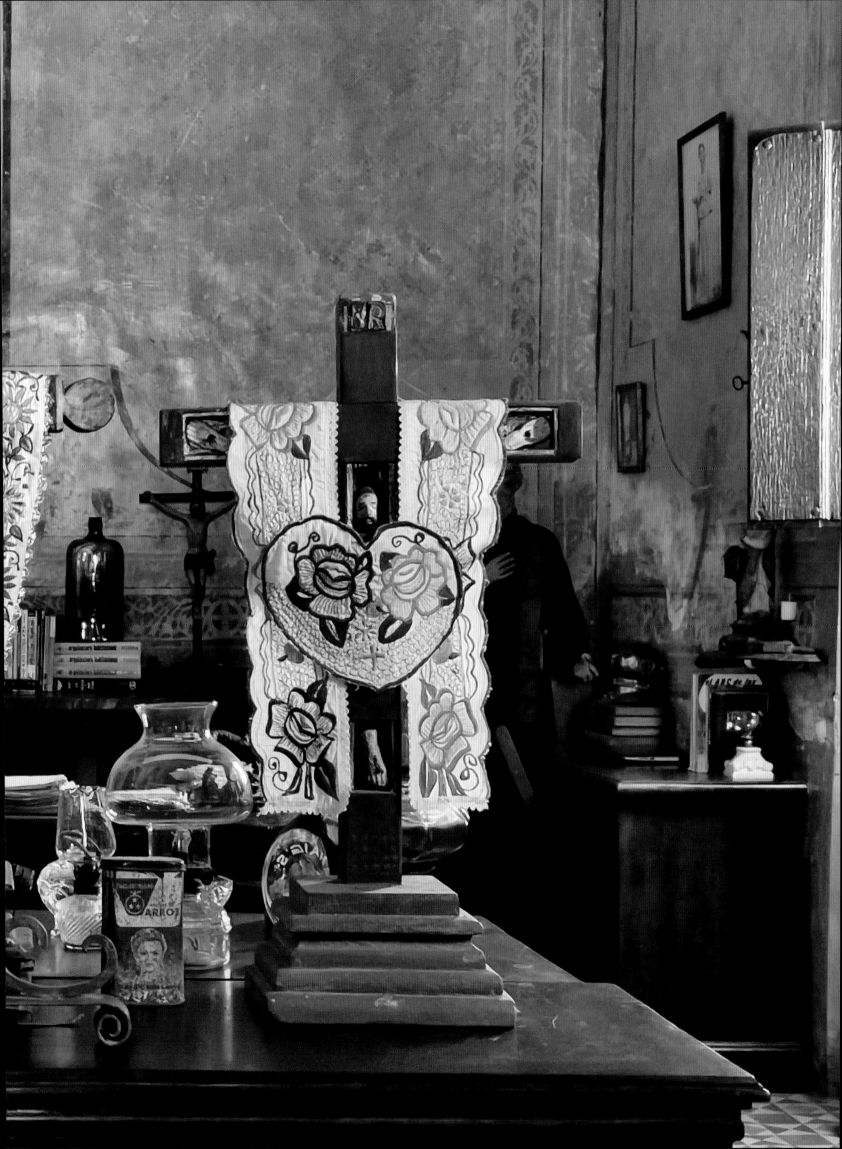

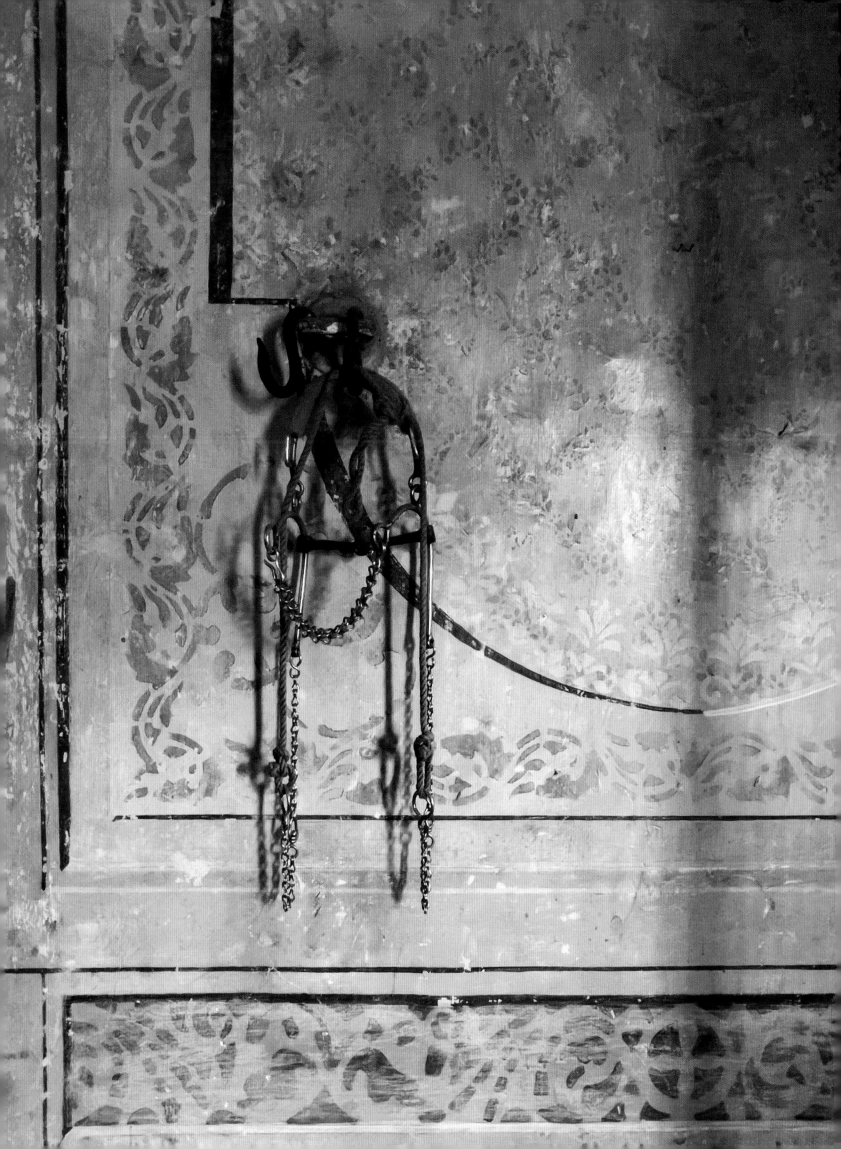

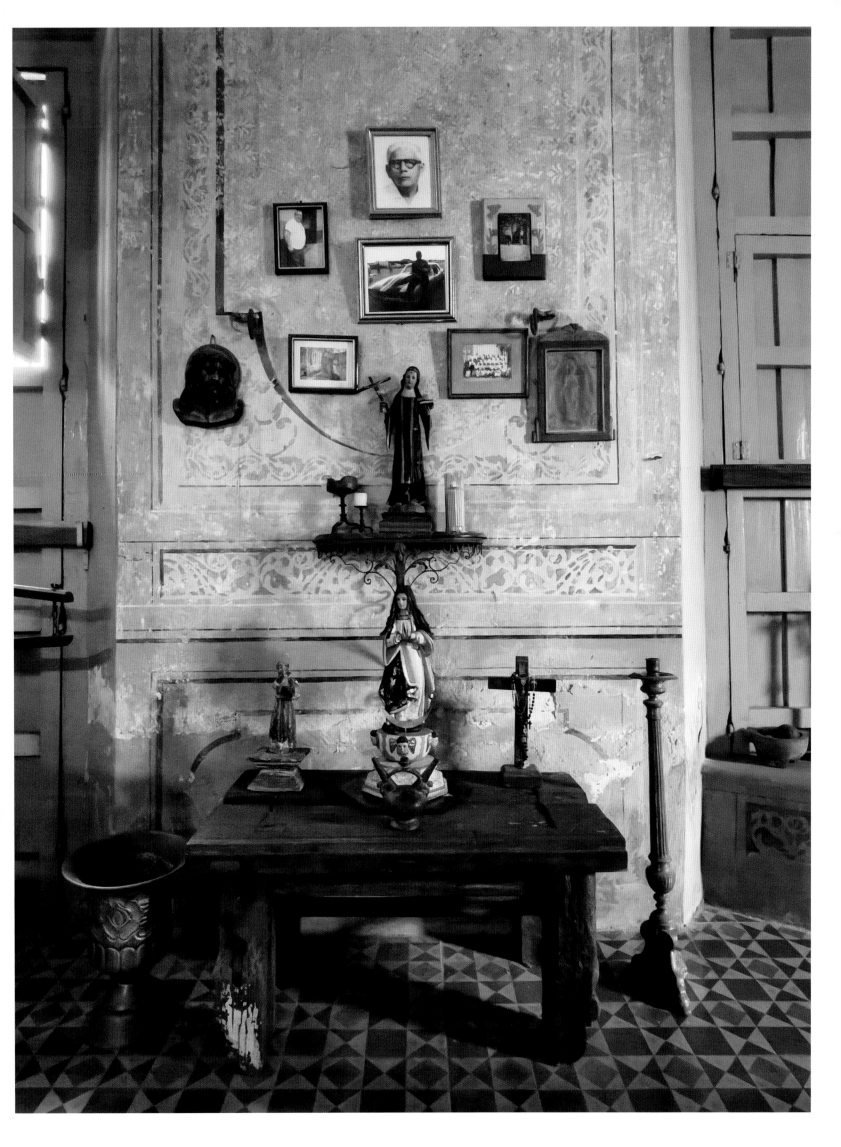

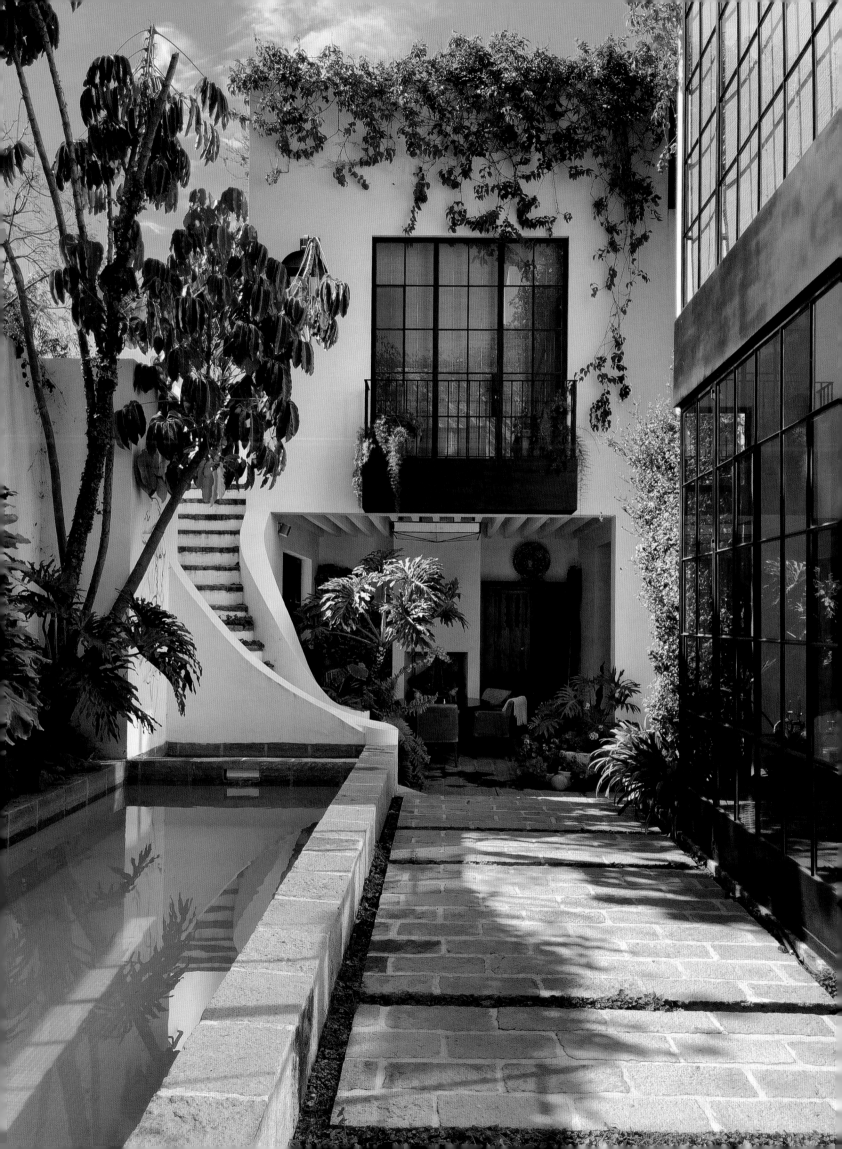

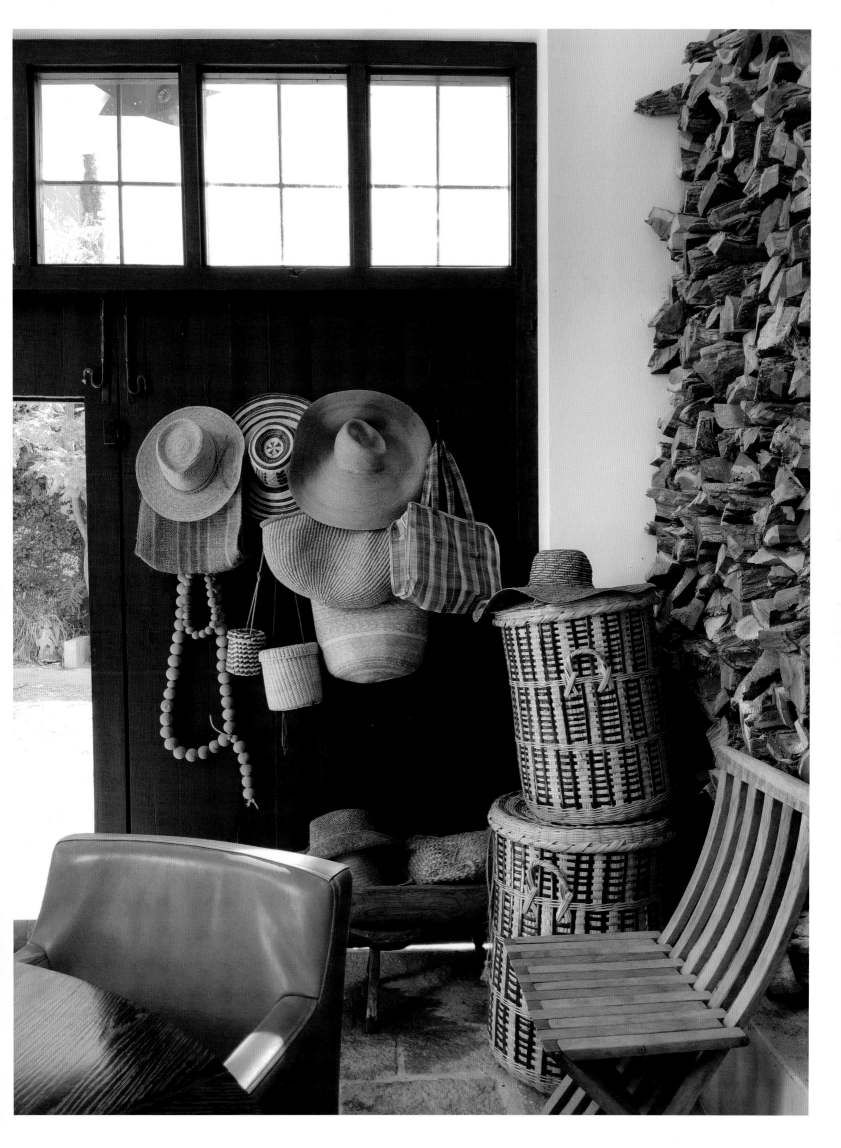

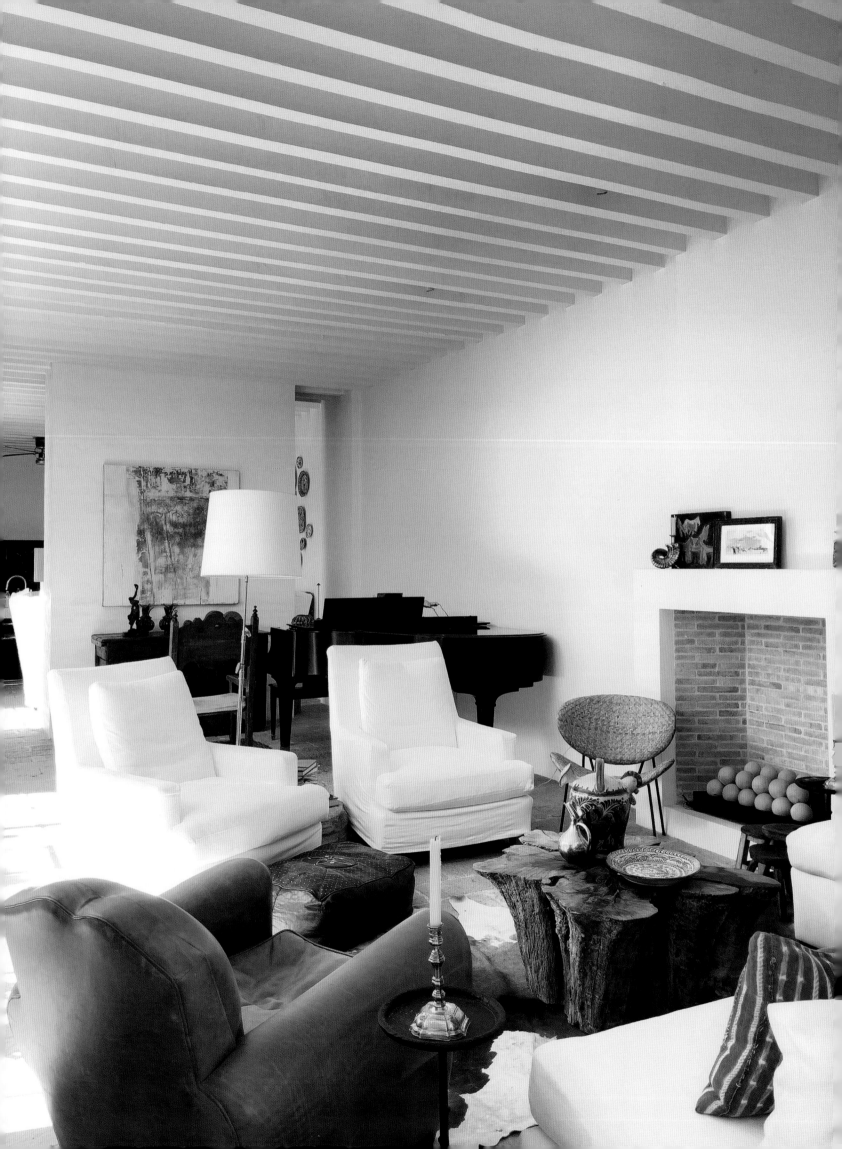

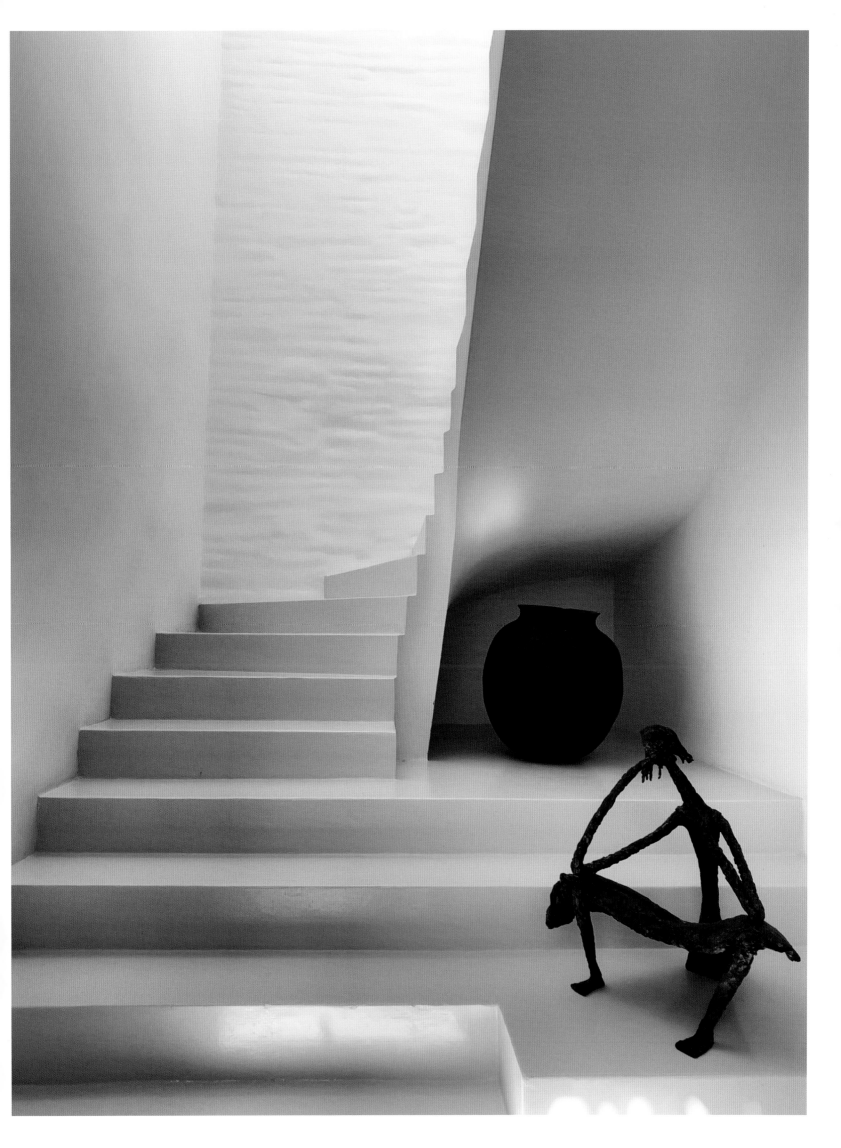

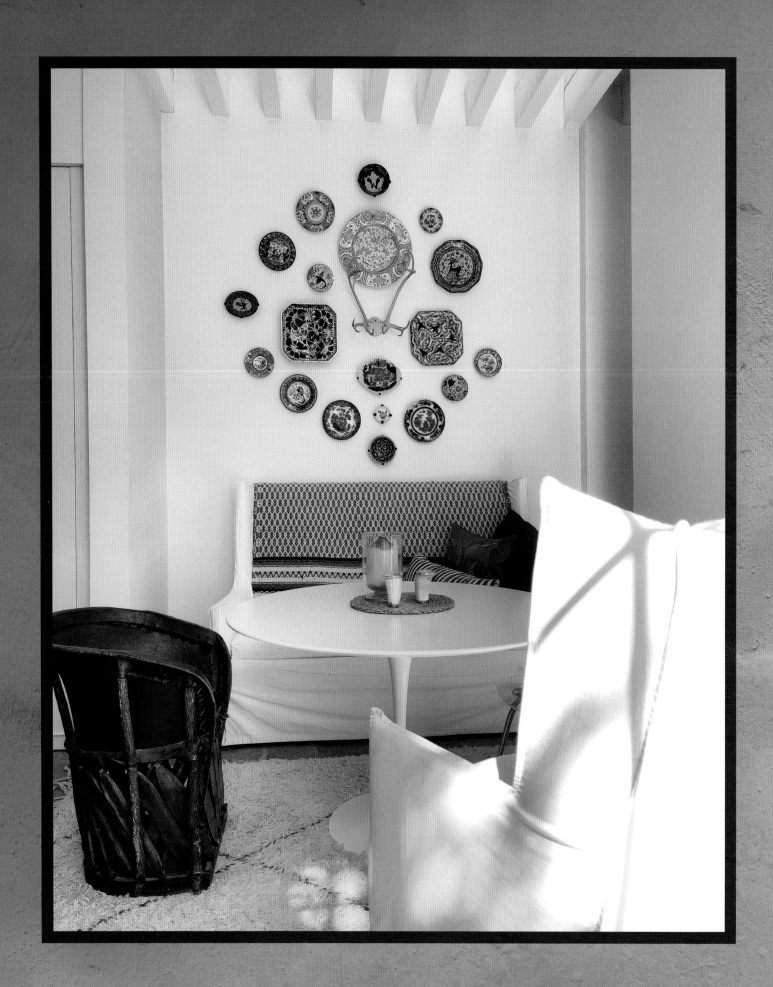

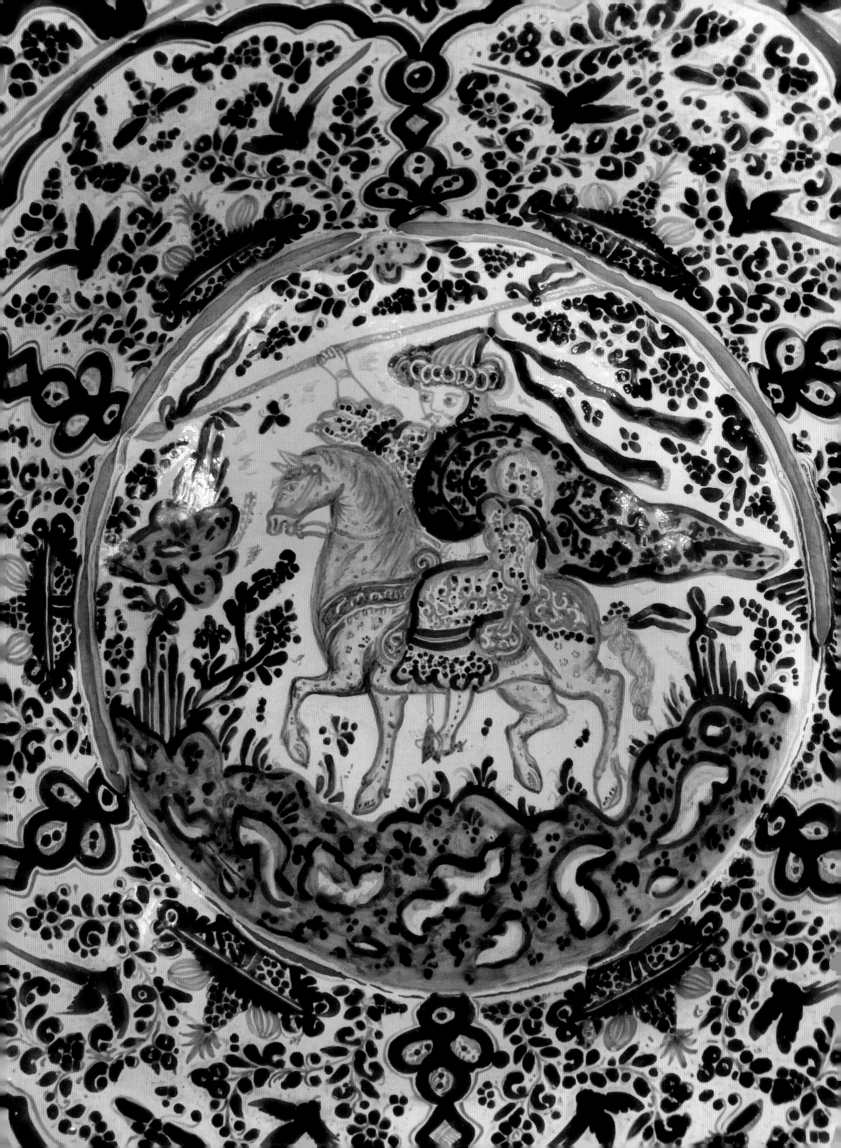

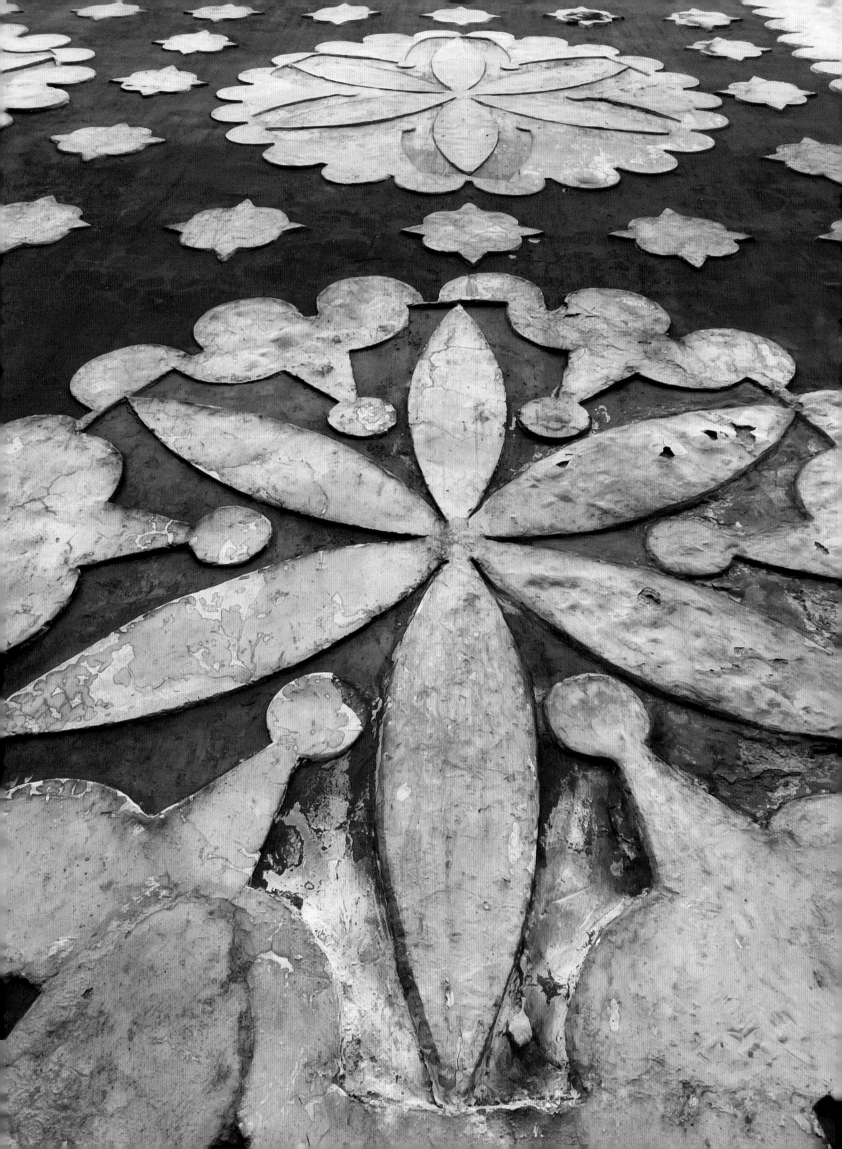

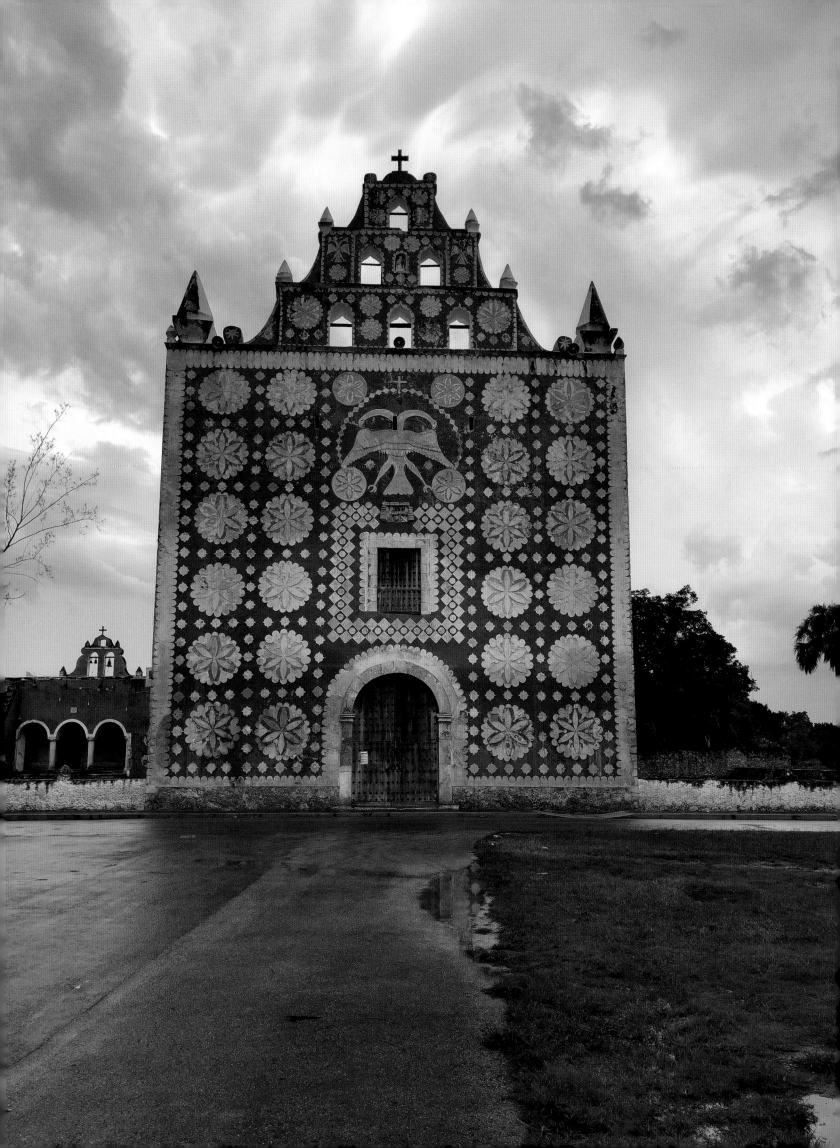

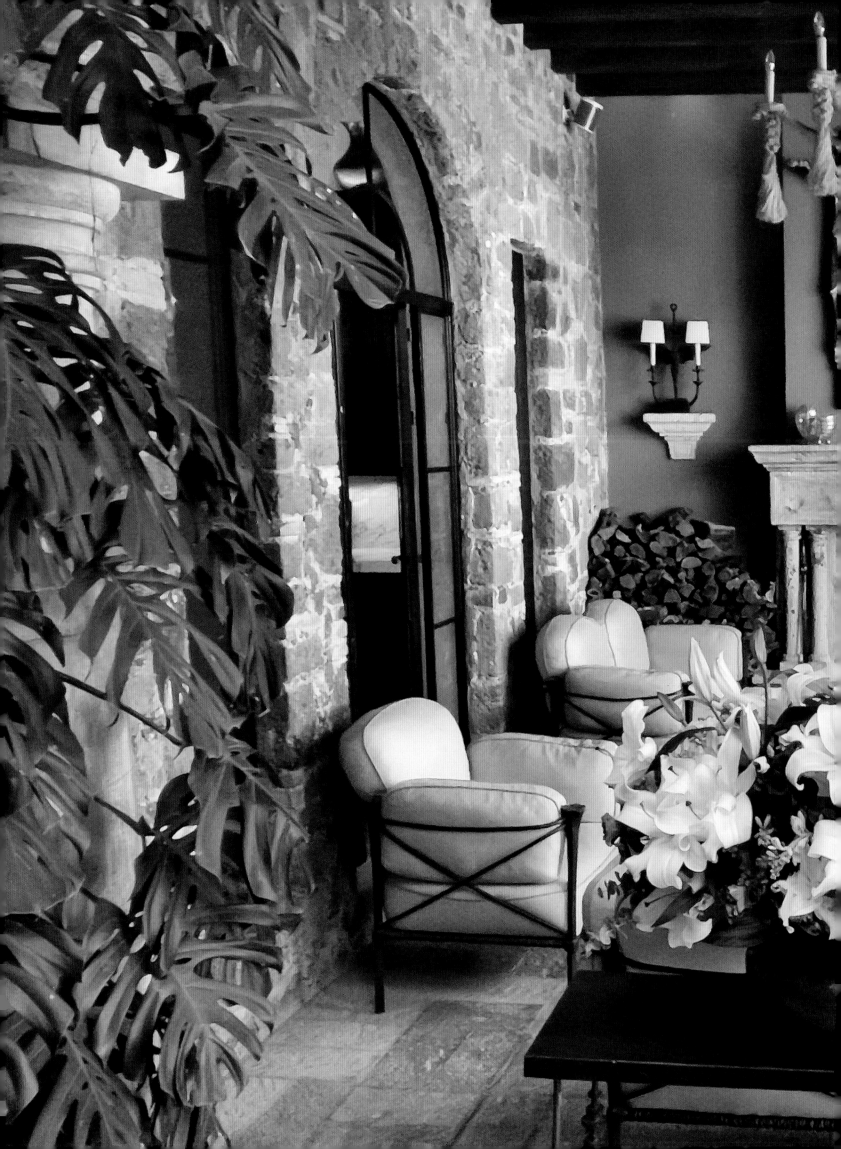

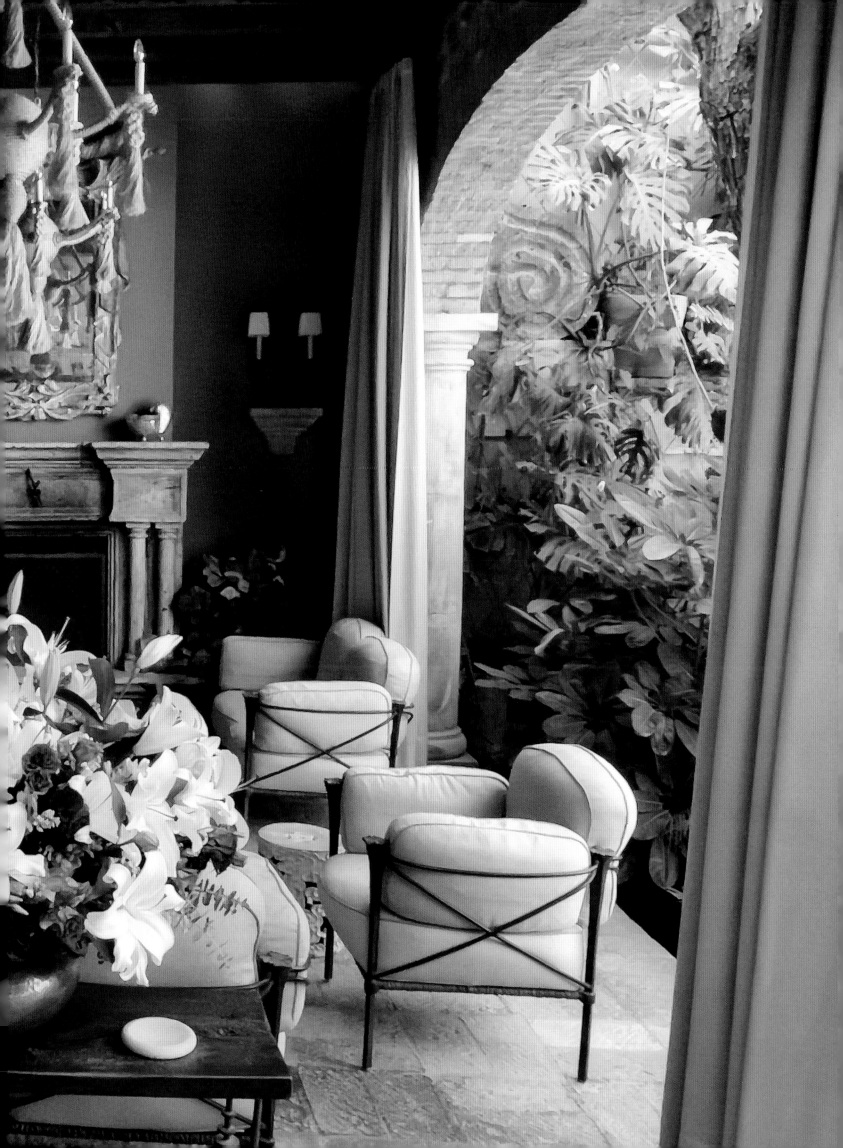

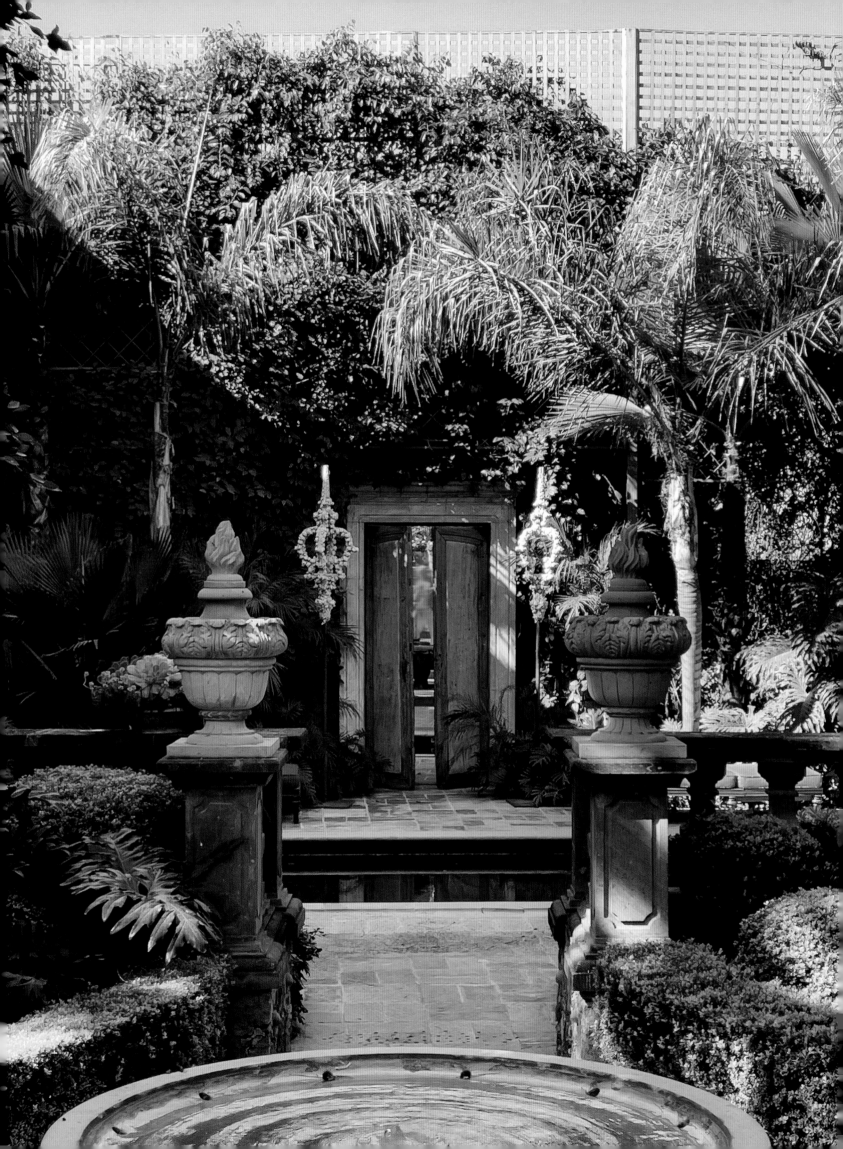

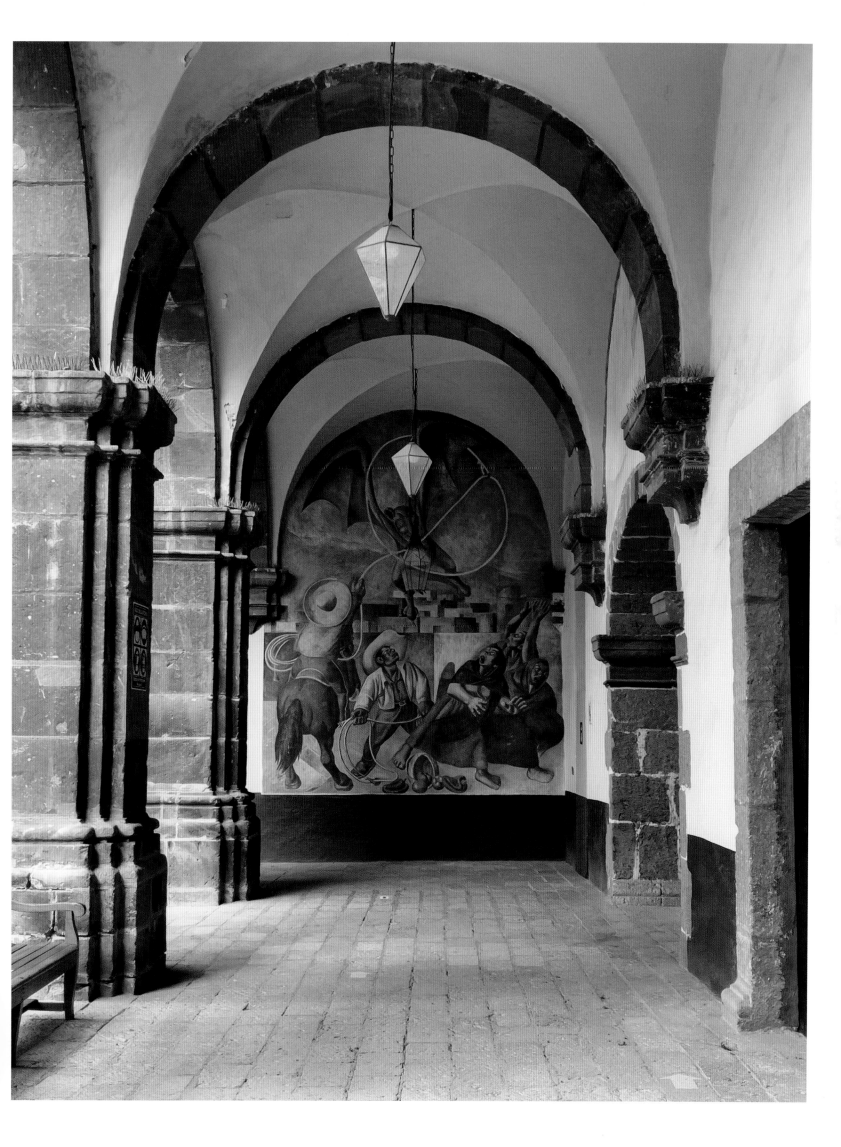

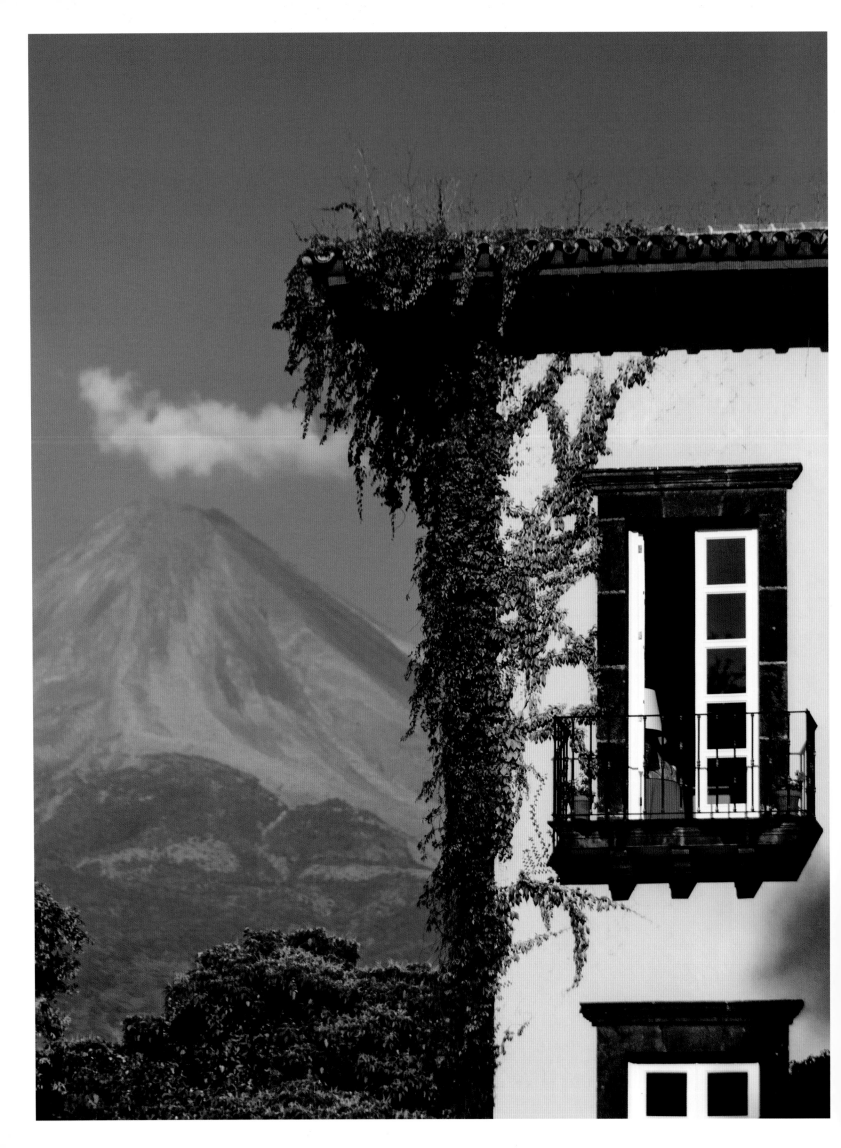

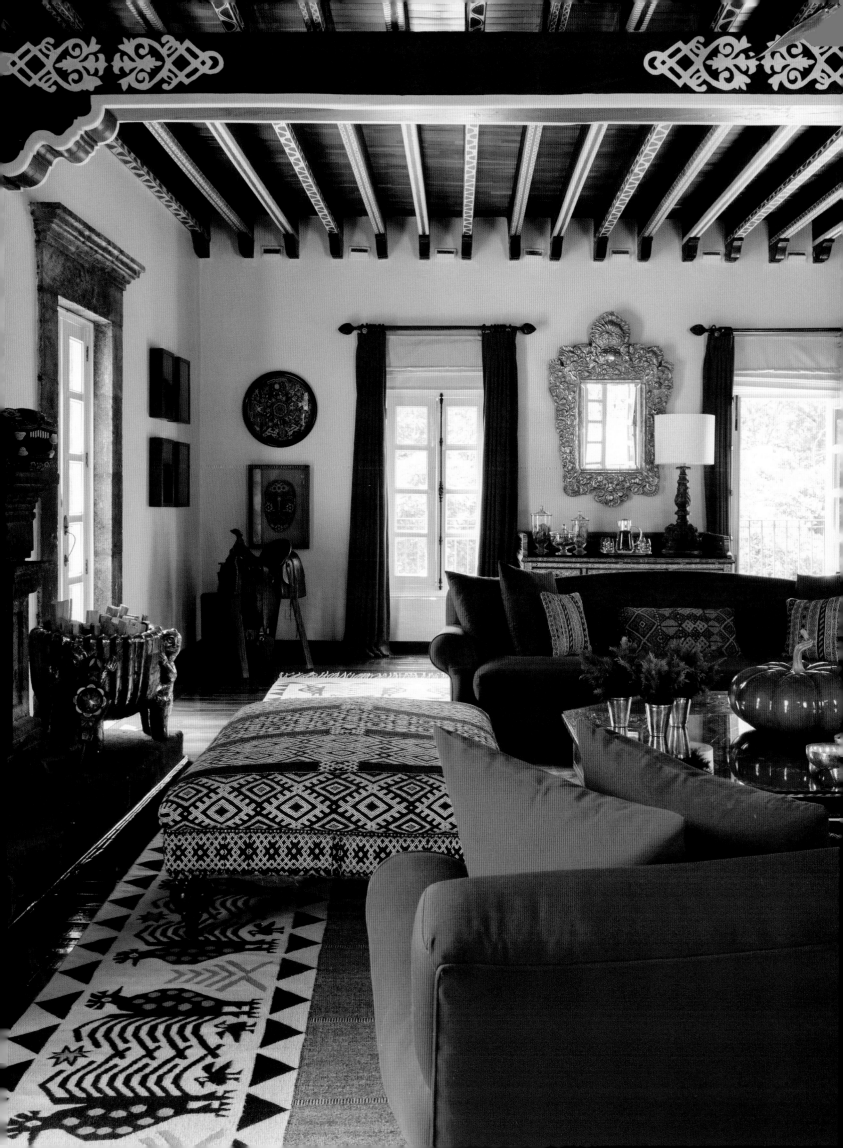

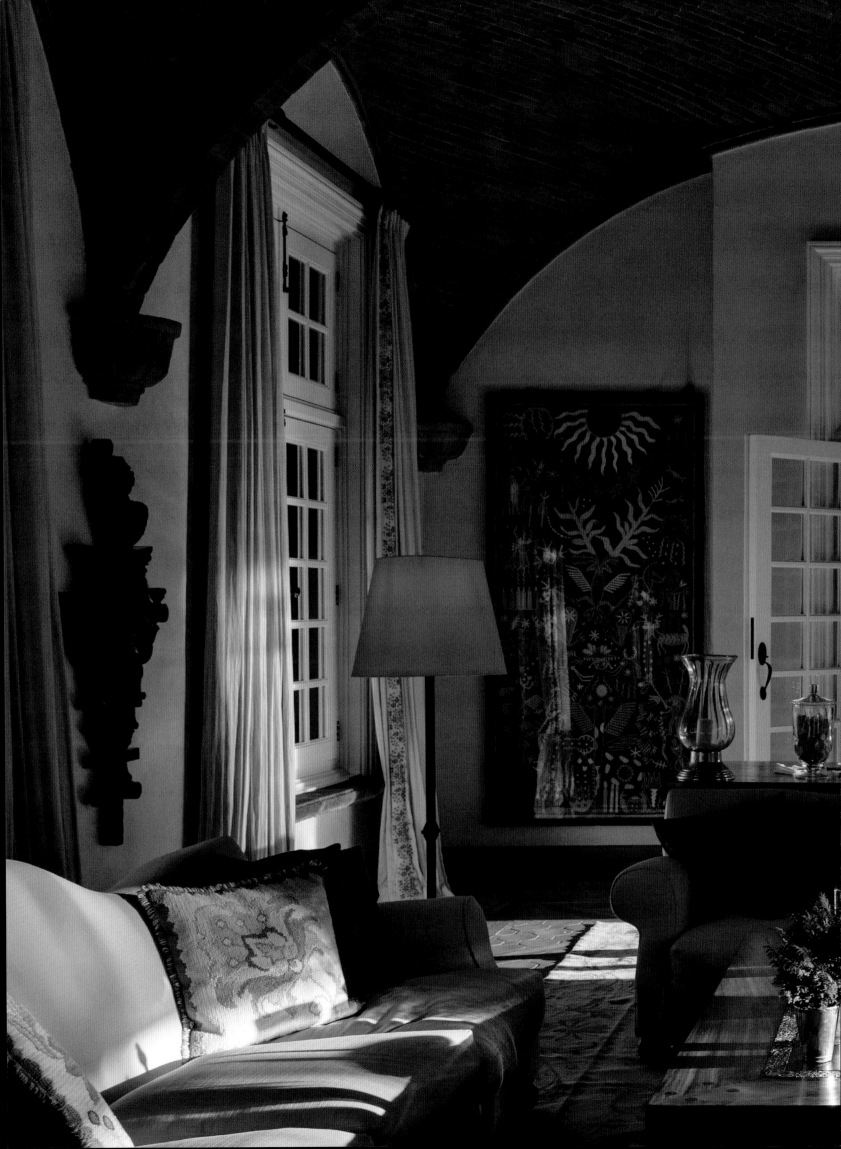

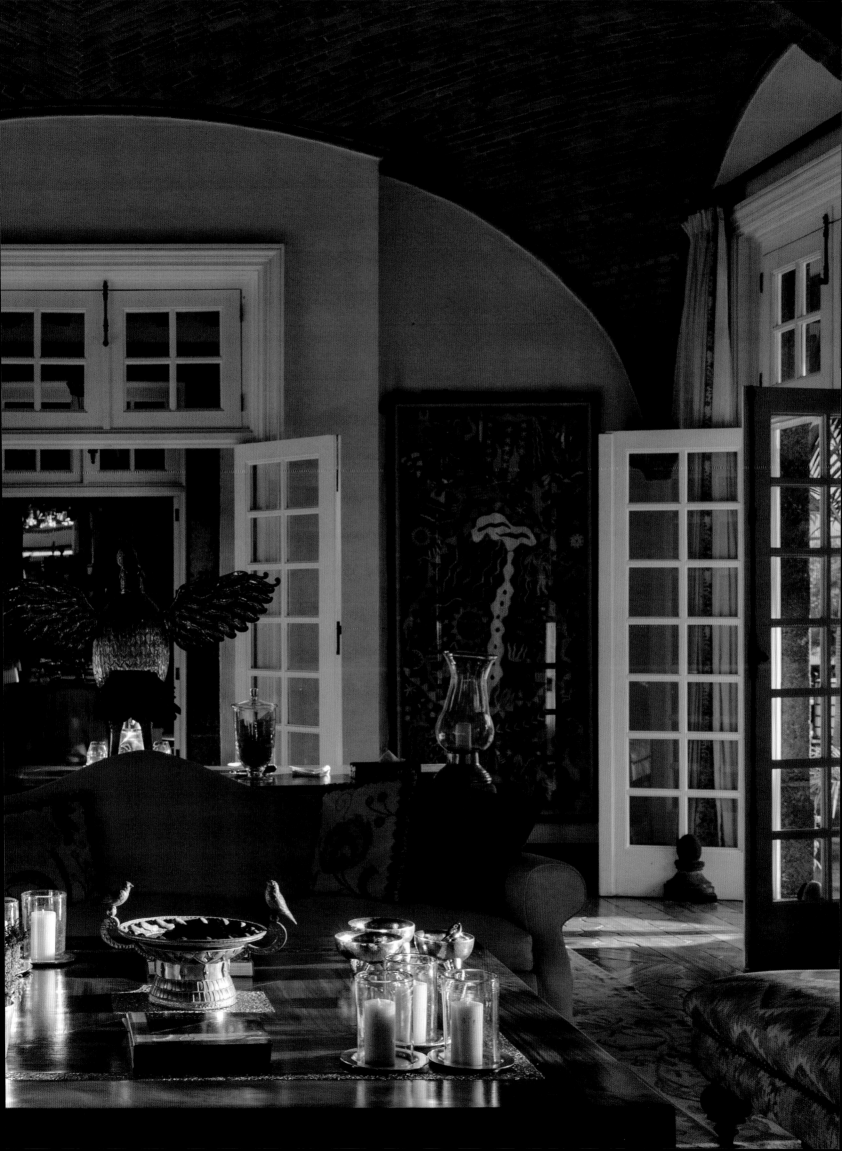

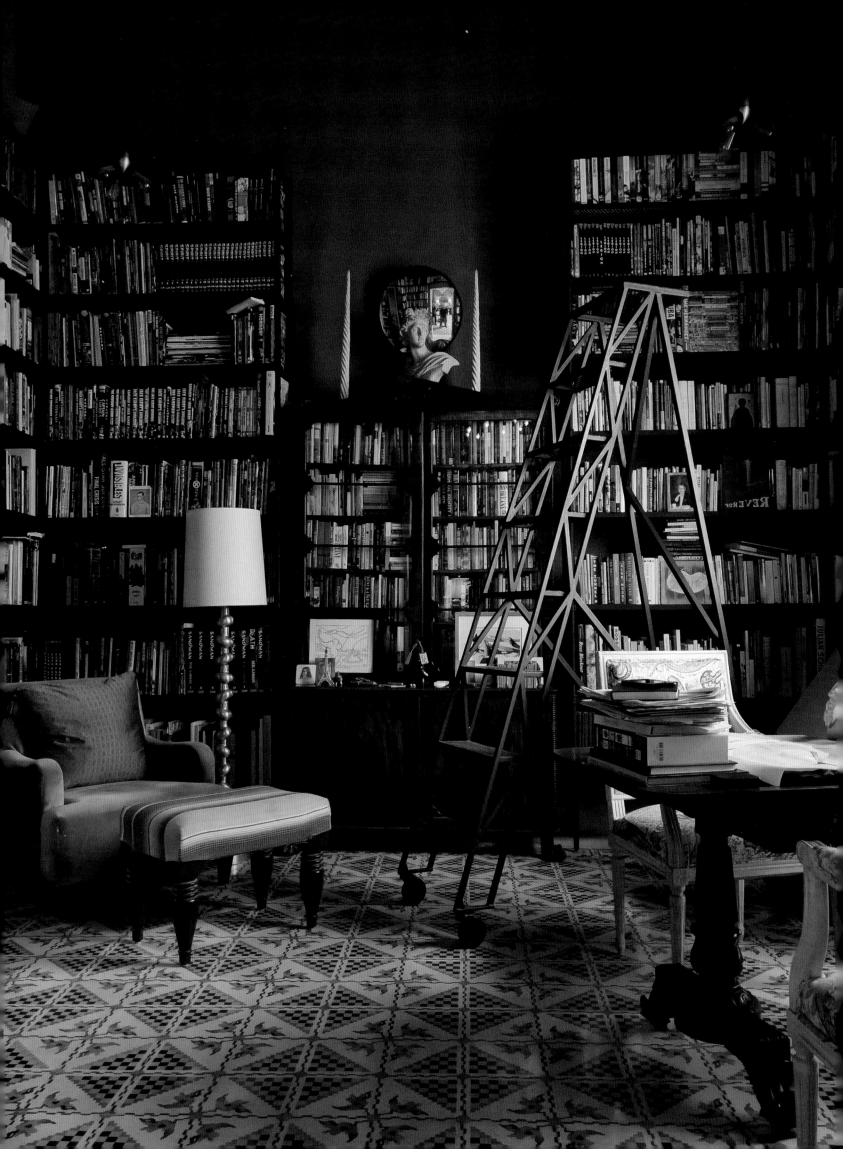

# NEOCLASSICAL

The Second French Empire, from 1852 to 1870, had a brief and ill-fated monarchy in México. But it was México's pursuit of democracy that actually led Mexican culture to be influenced, as it was in the United States, by French design, which was associated with the progressive ideal of *liberté*. French Neoclassicism flourished during the thirty-one years, spanning 1877 to 1911, of President Porfirio Díaz, who—while no champion of actual *liberté*—was a true design Francophile. French style ironically came to represent Mexican independence, from the architecture of public government to more primitive expressions in the architecture of small businesses. No less important, the style was used like icing on a cake to update the facades of Spanish colonial houses, which with their rainbow of exterior colors are renovators' treasures in many city *centros* today.

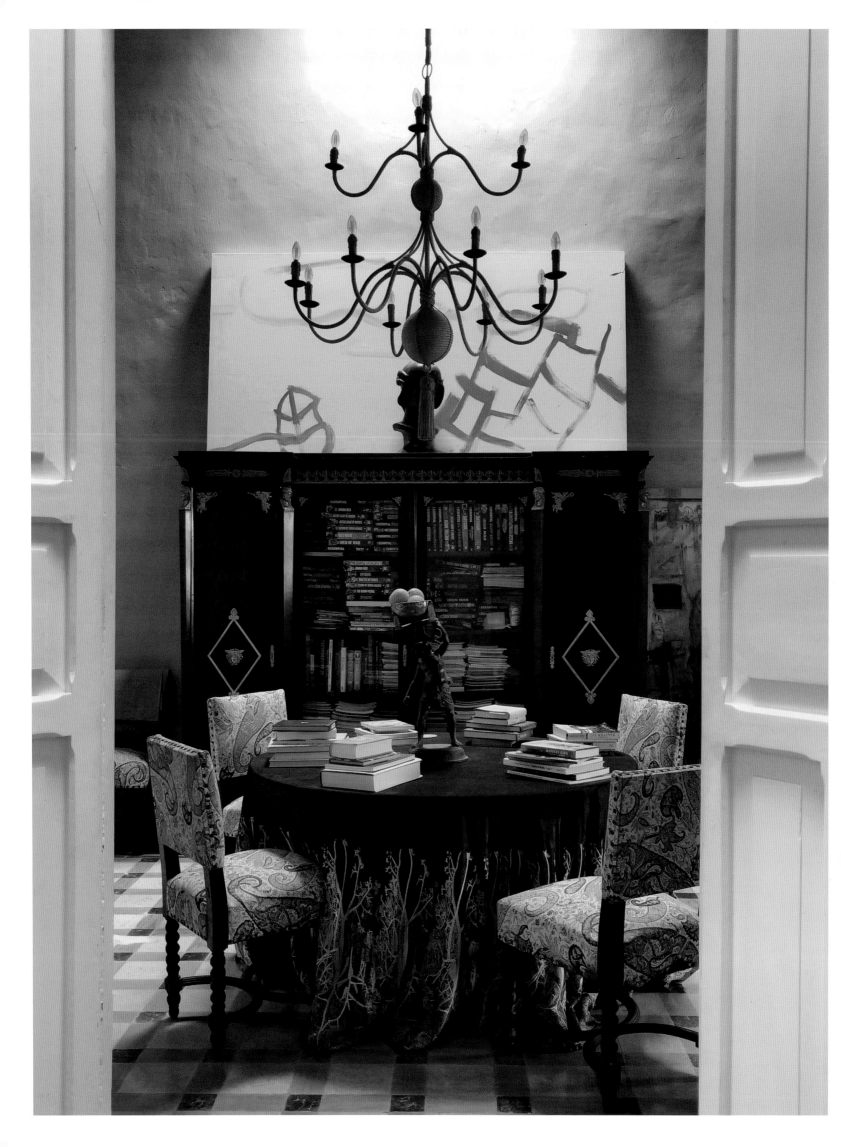

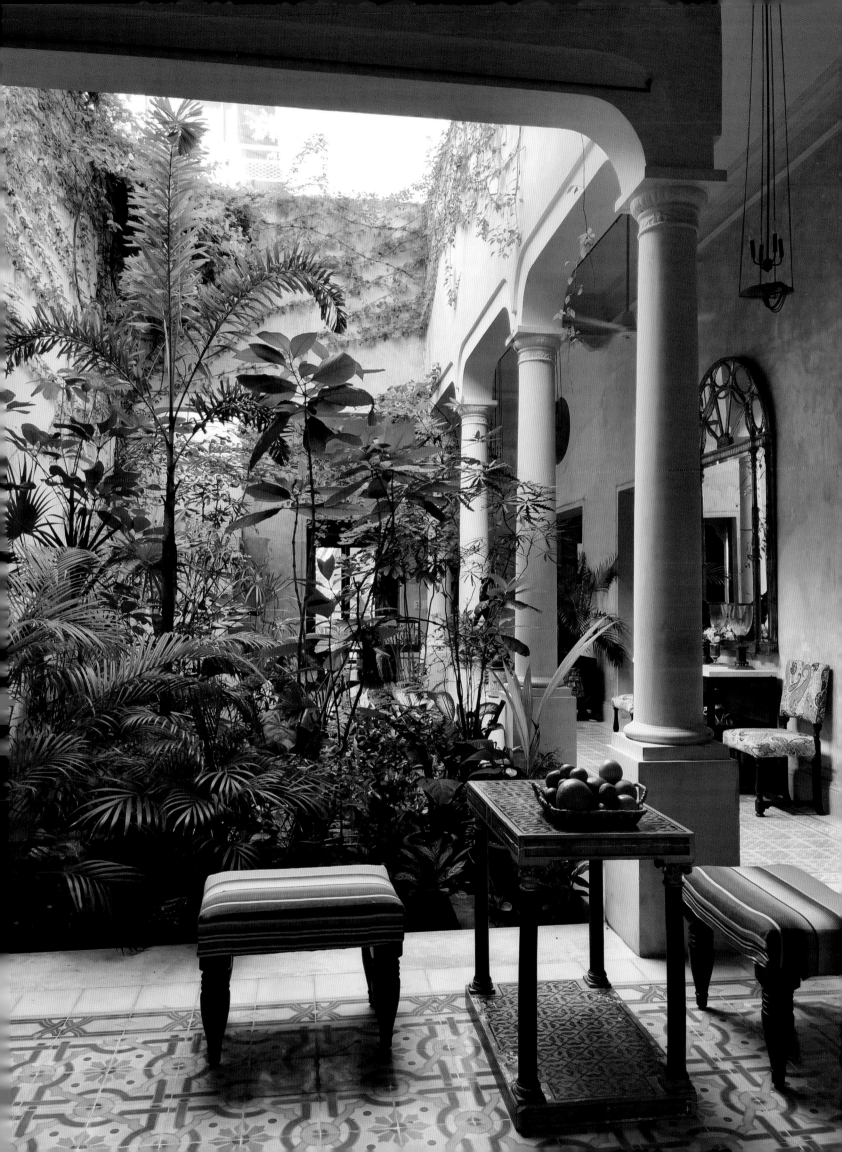

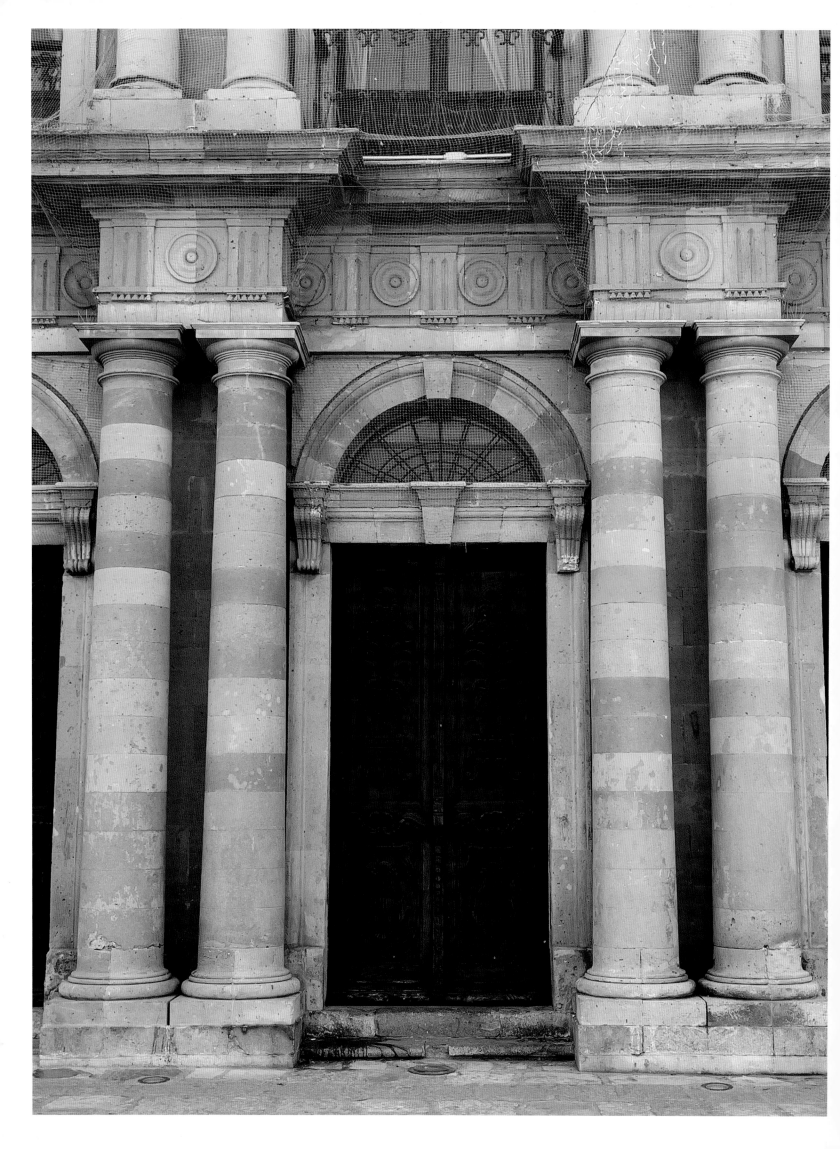

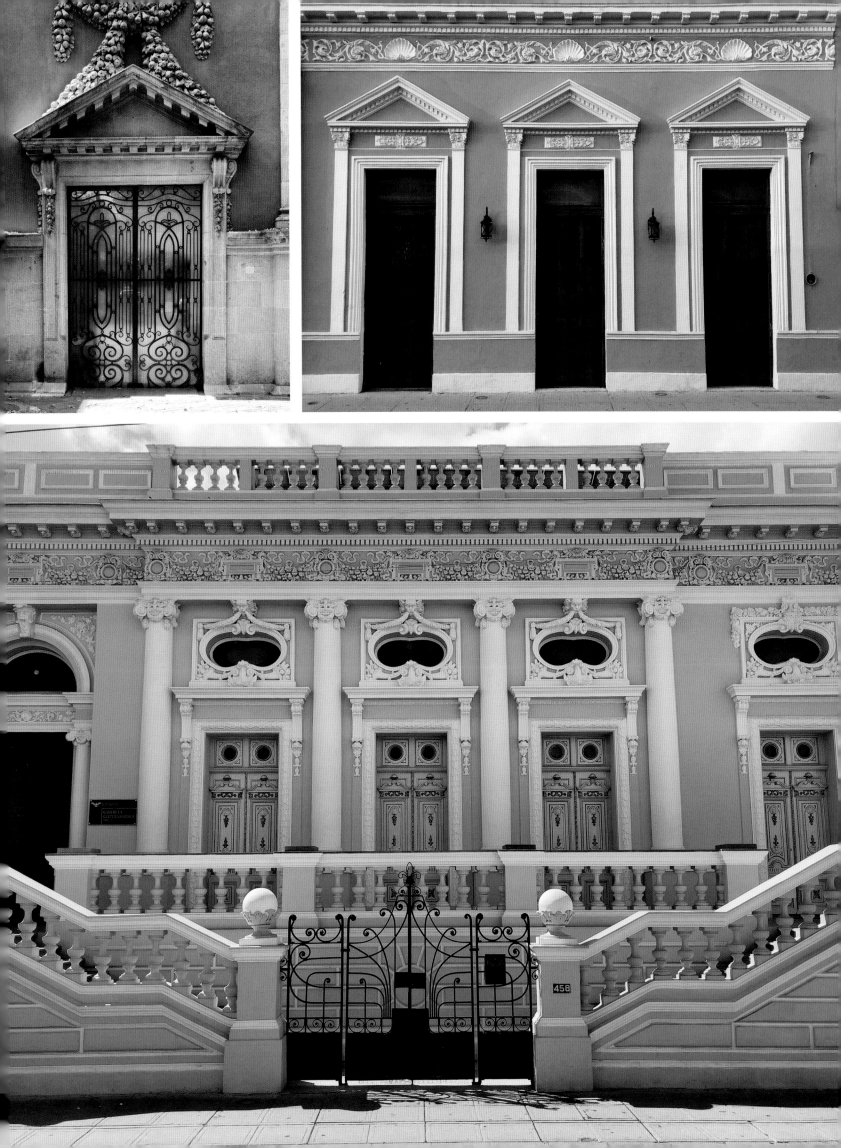

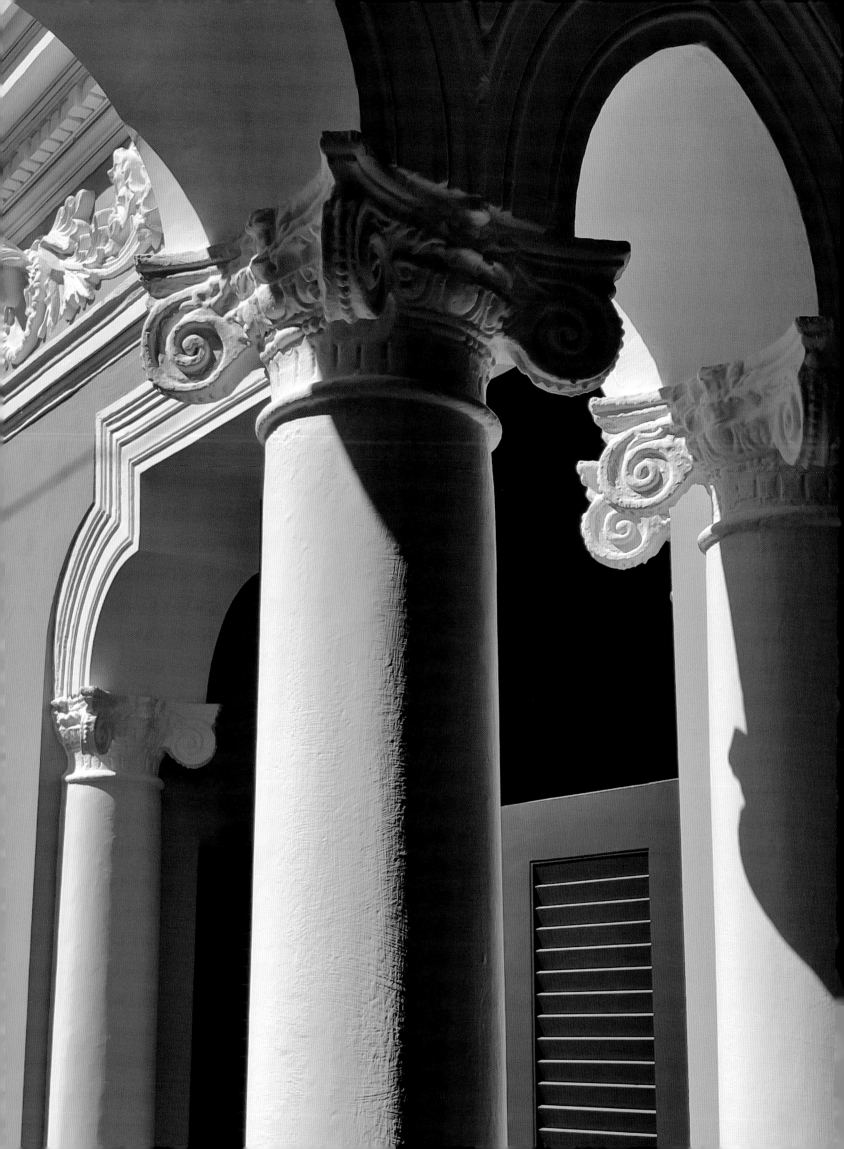

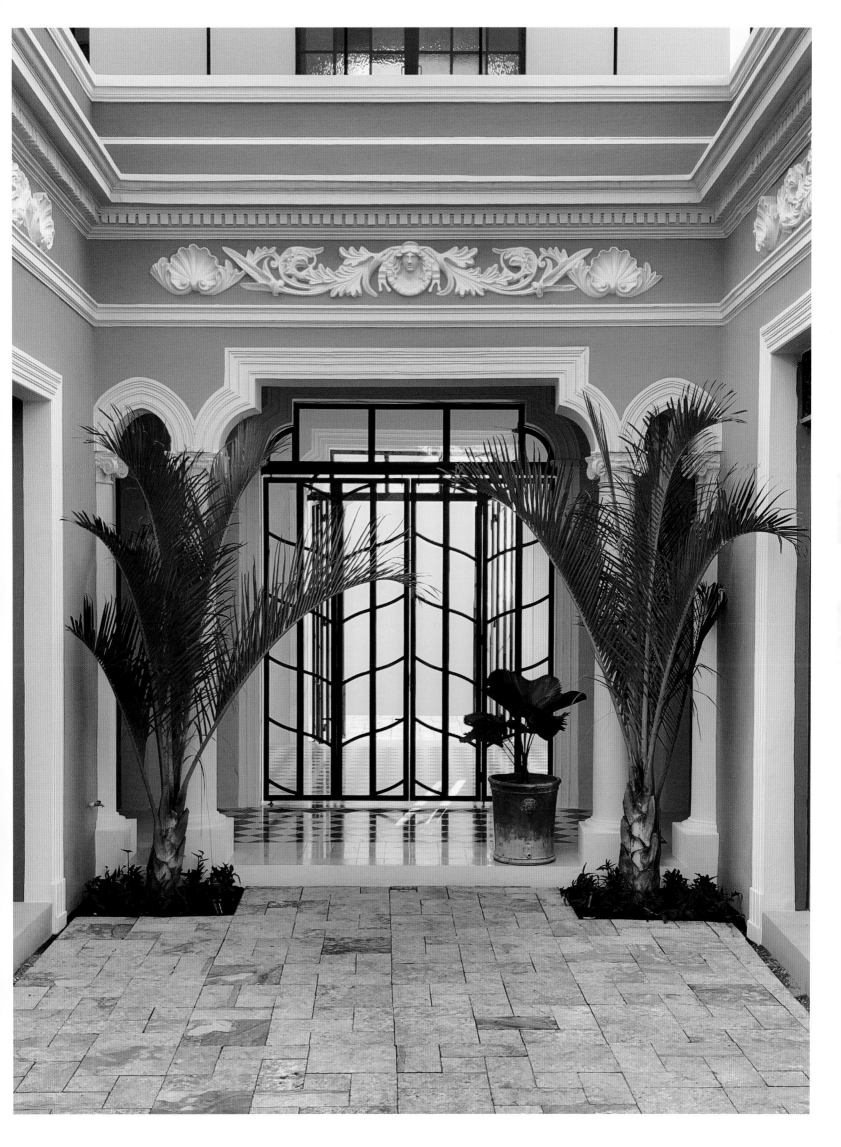

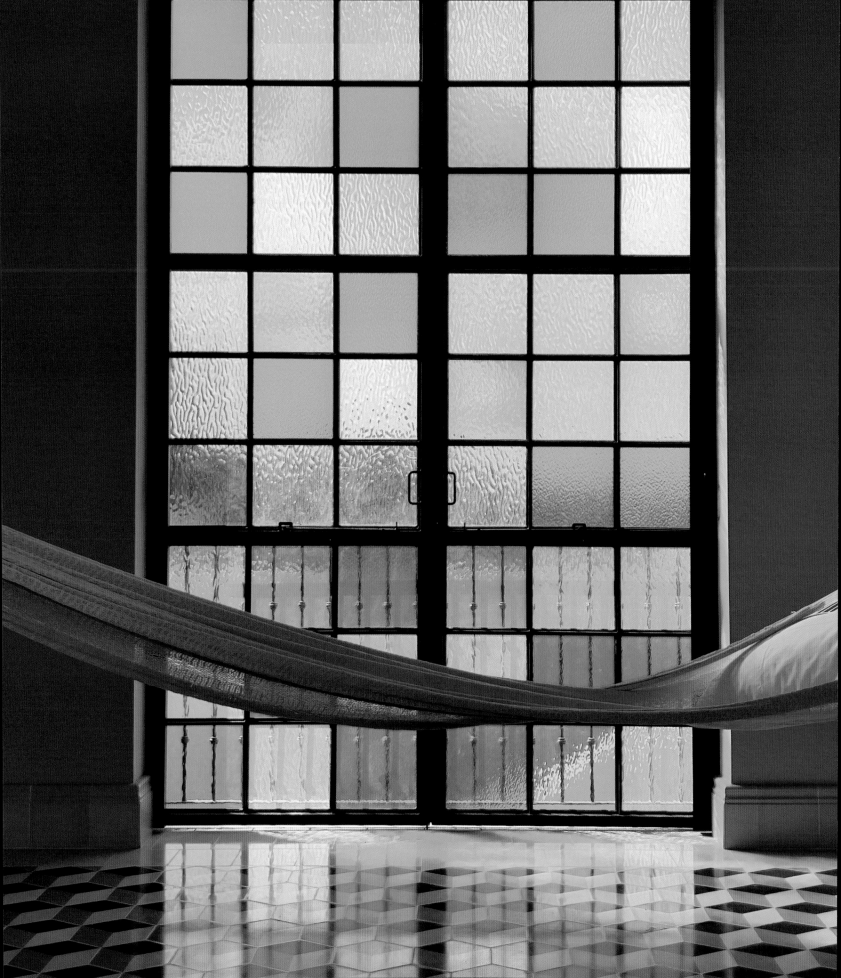

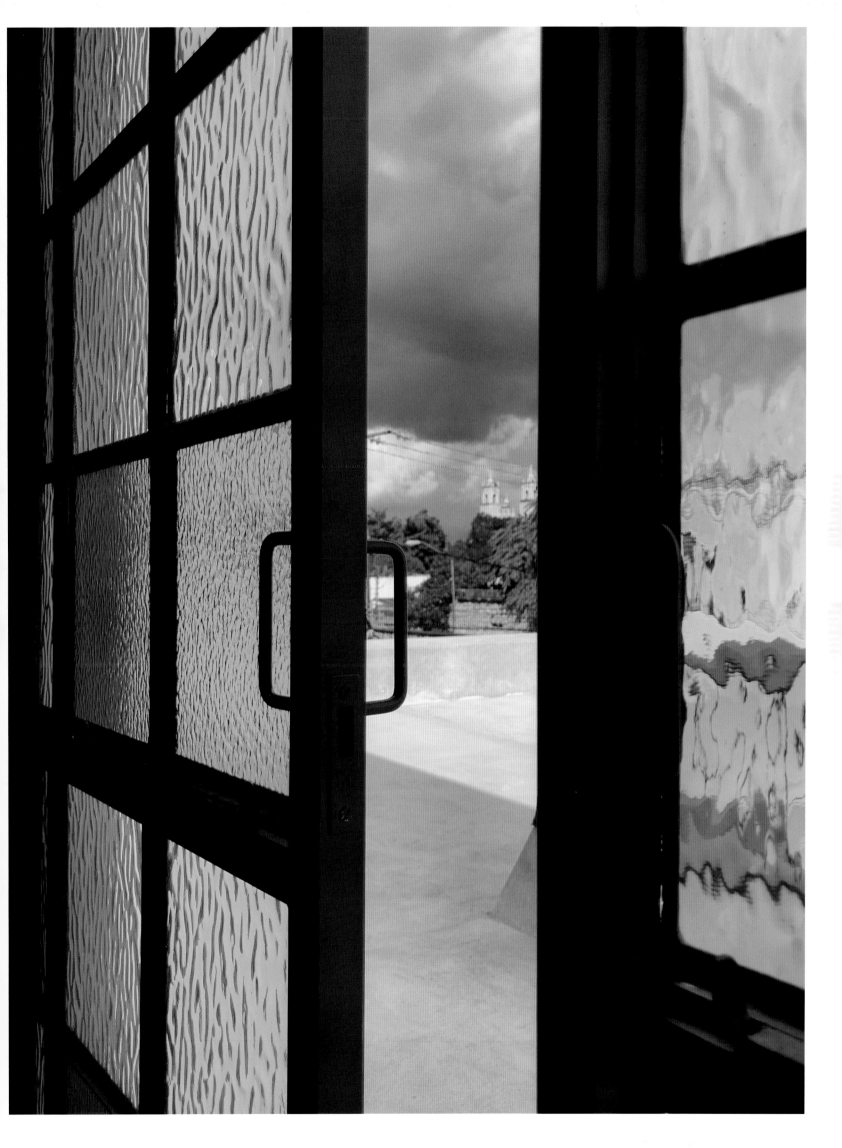

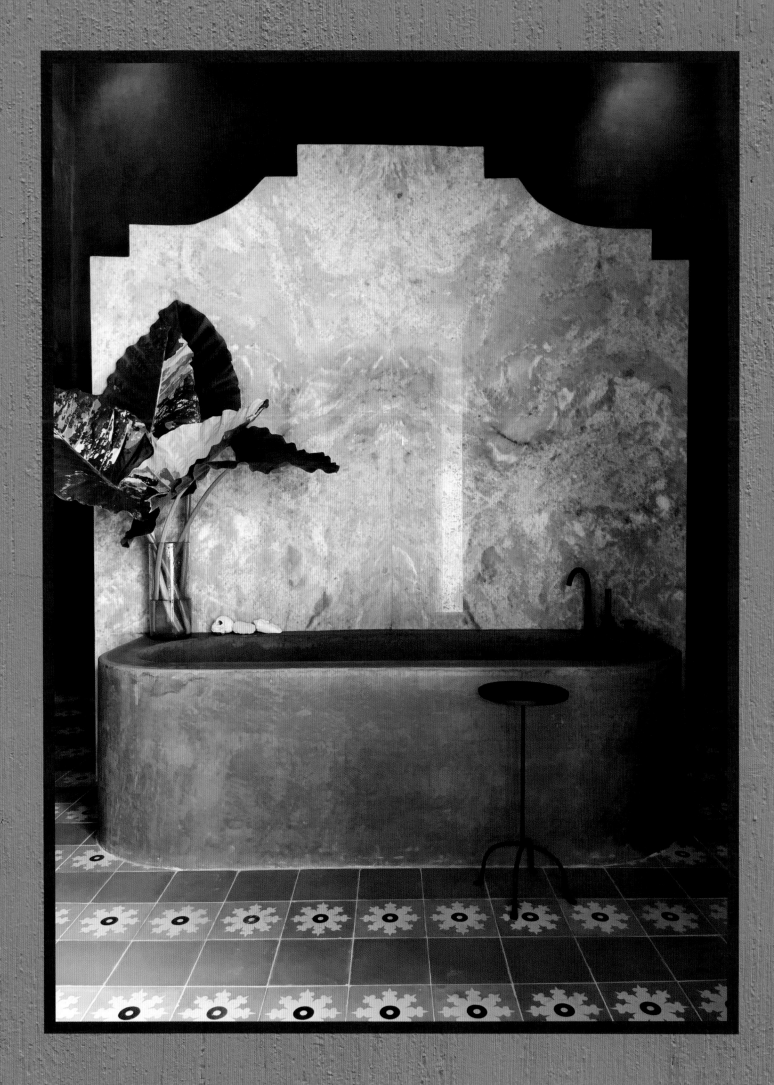

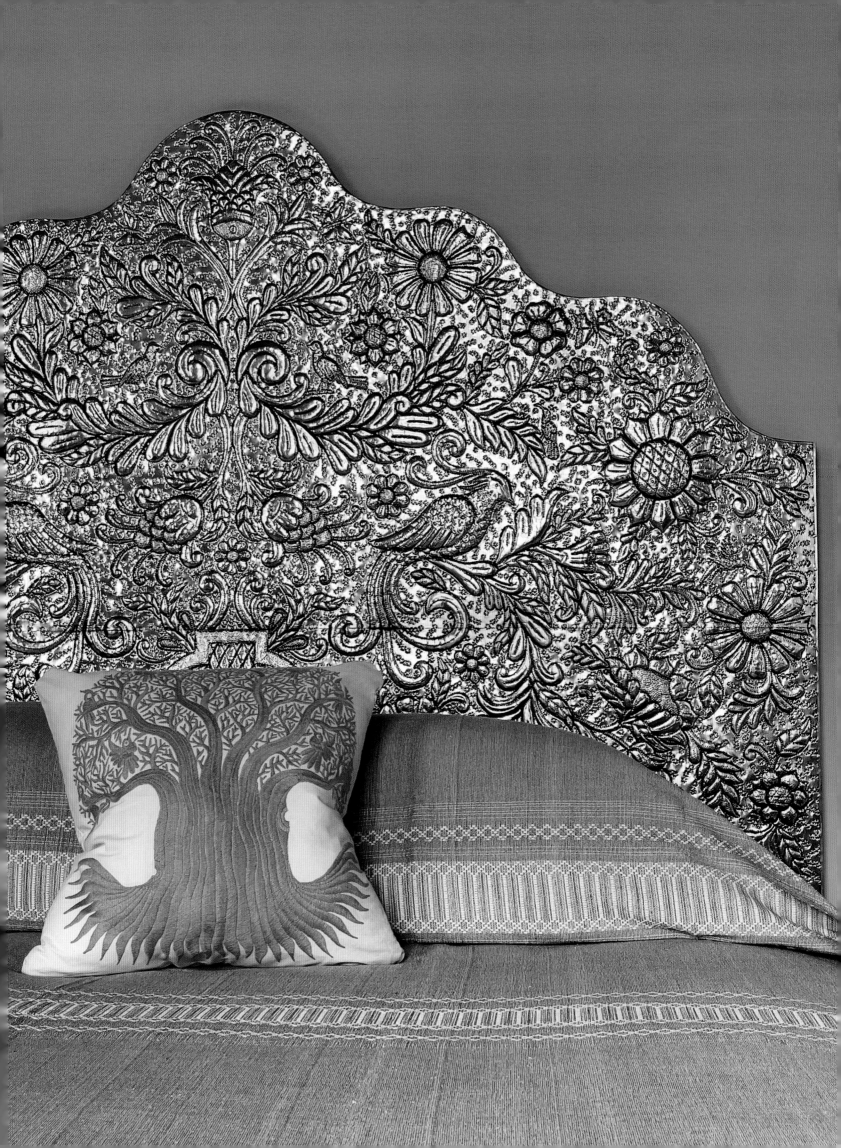

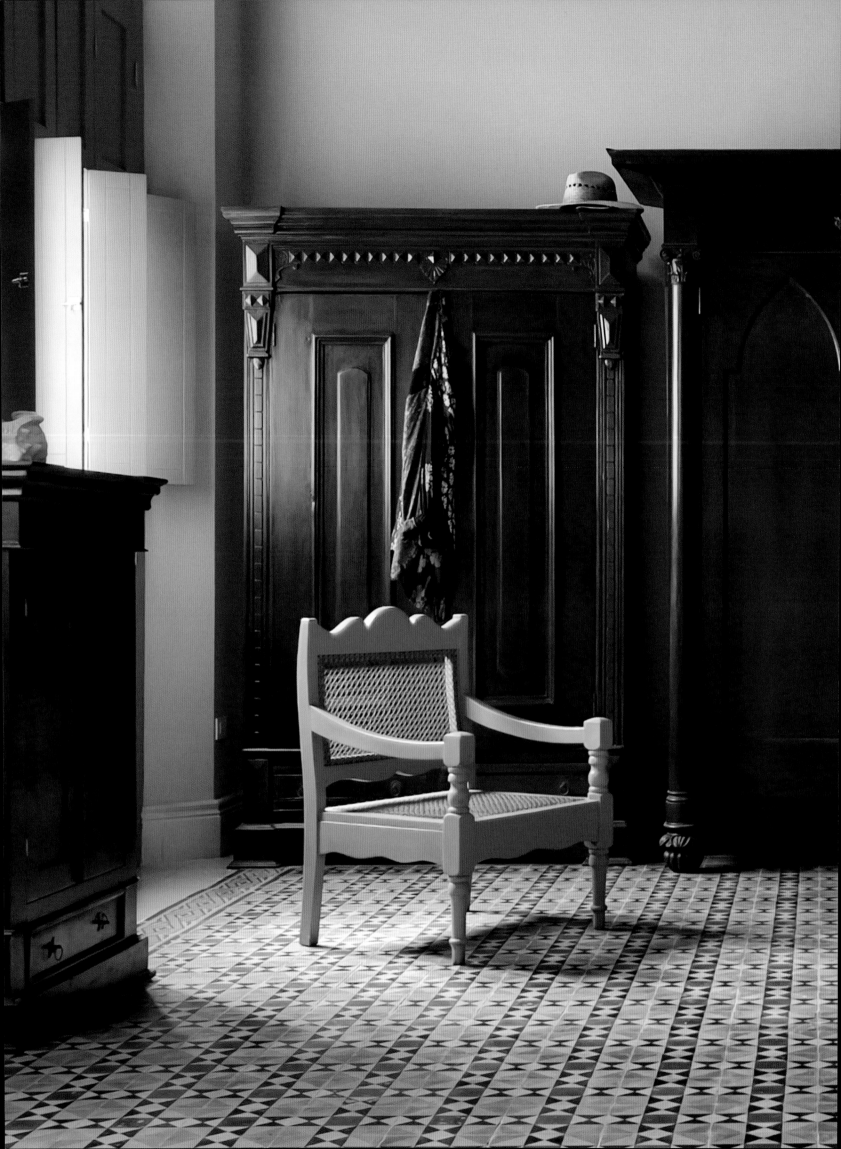

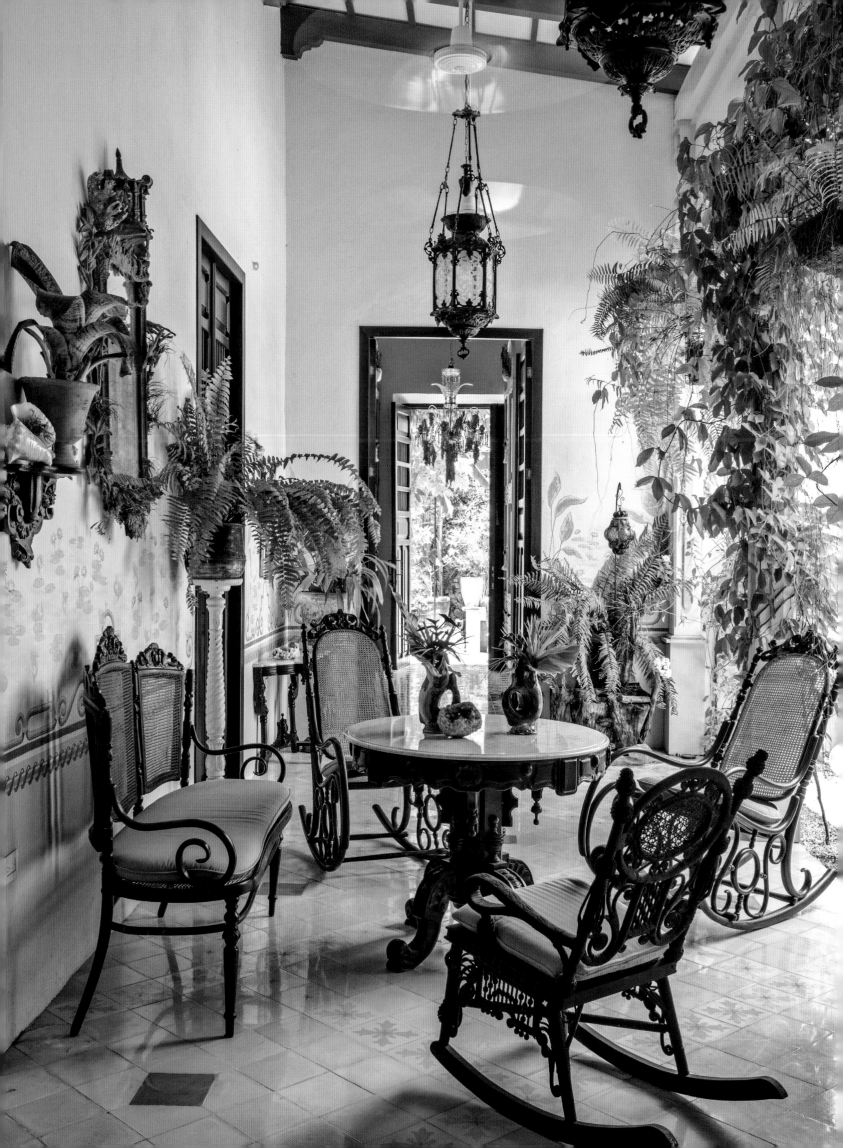

# ART NOUVEAU

More of a transitional style in México, Art Nouveau had
its most significant expression in some important public
buildings of México City, like the *Palacio de Bellas Artes*
that anchors one end of *Parque Alameda*—the oldest
public park in North America. But key elements of Art
Nouveau's architectural style, notably iron and glass
door and window canopies, found both decorative and
functional appeal on the houses of all styles in city centers
and their first suburbs. Hints of the style can also be found
in the decorative painting of interior walls, the patterns
of ubiquitous pasta tiles, and colored glass in doors and
windows. The style's French roots and associations literally
closed out the decorative influence of the Porfiriato
Era in the first decade of the twentieth century.

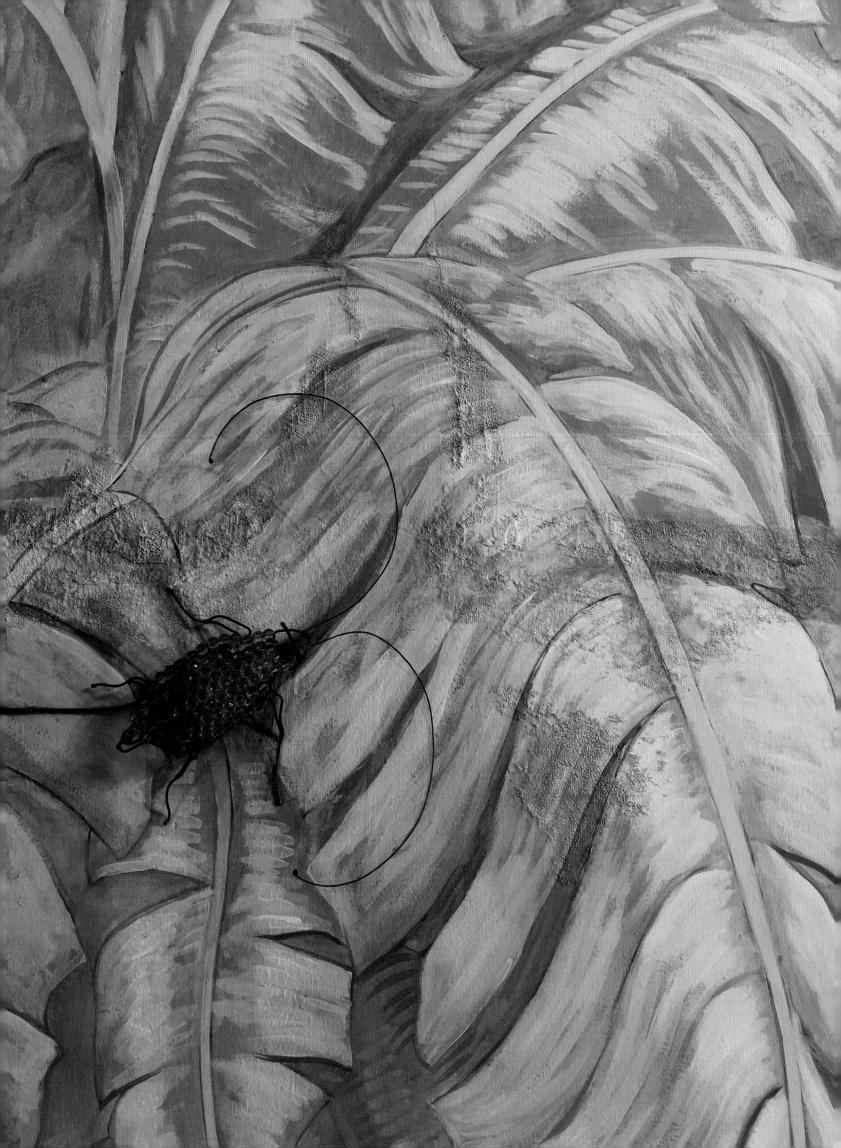

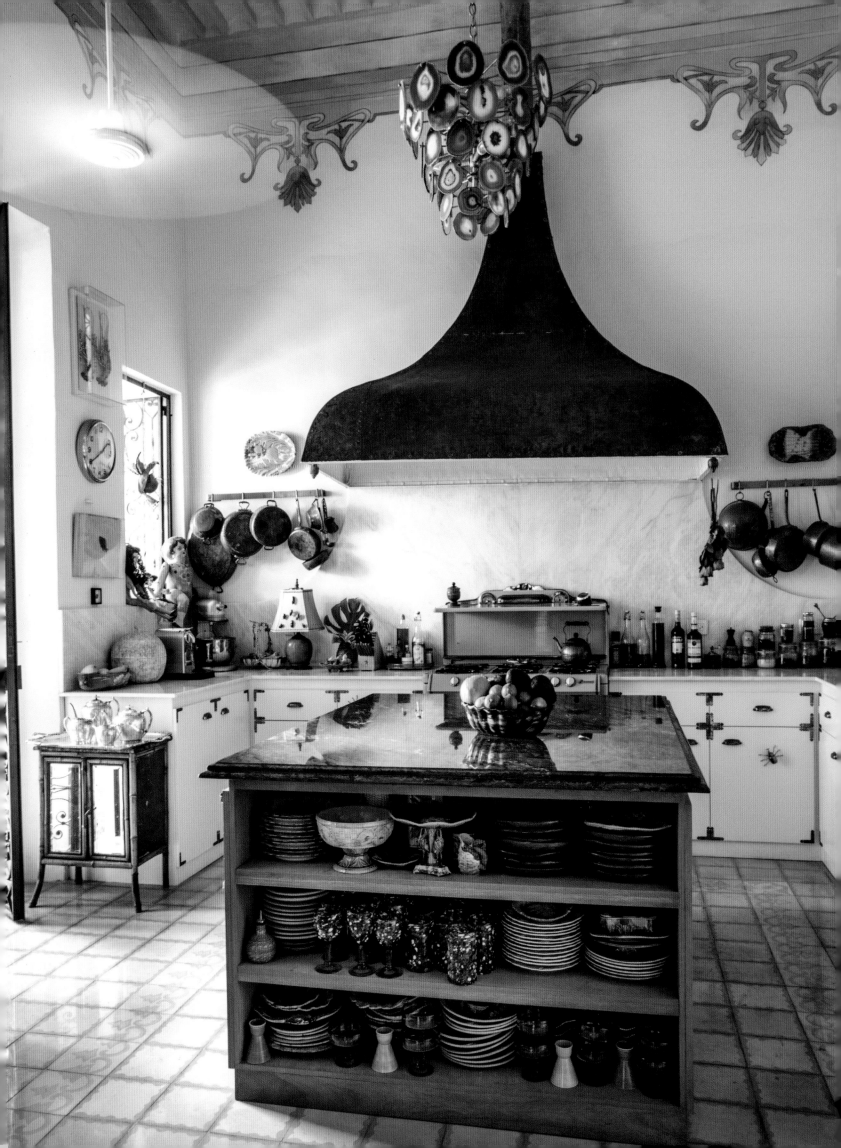

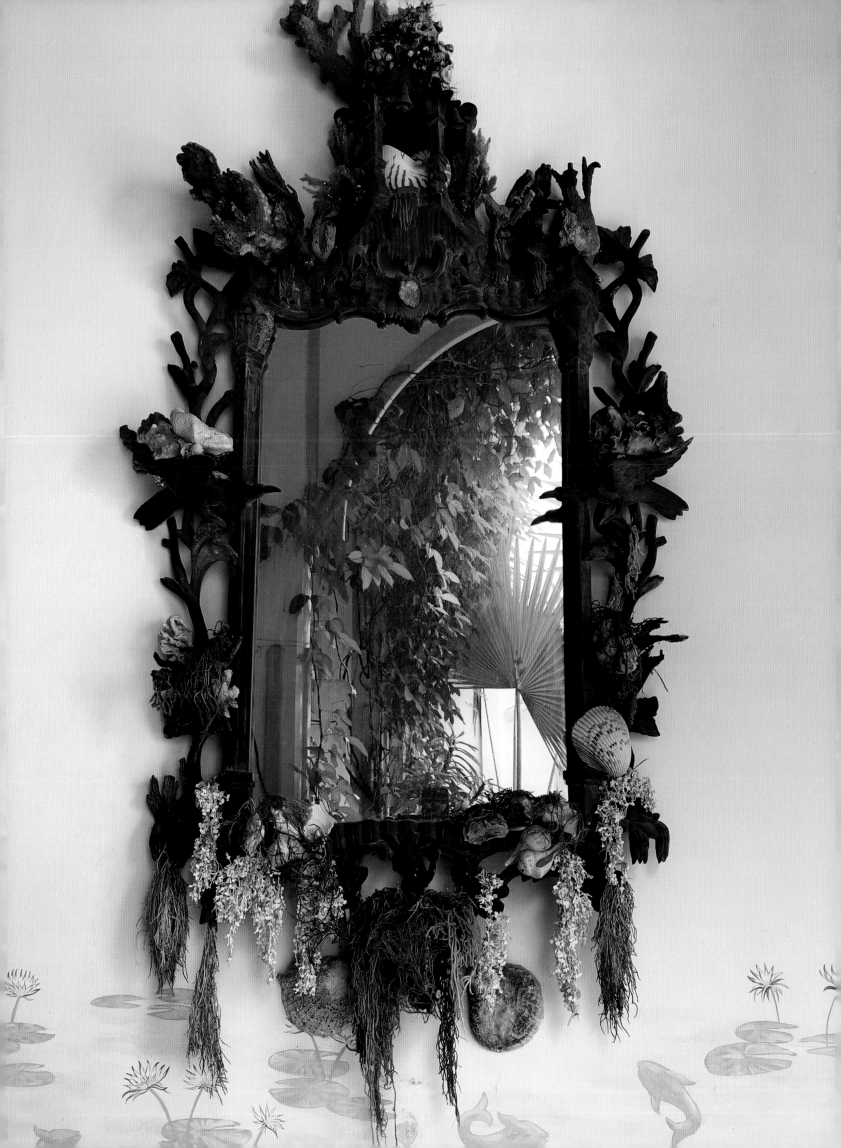

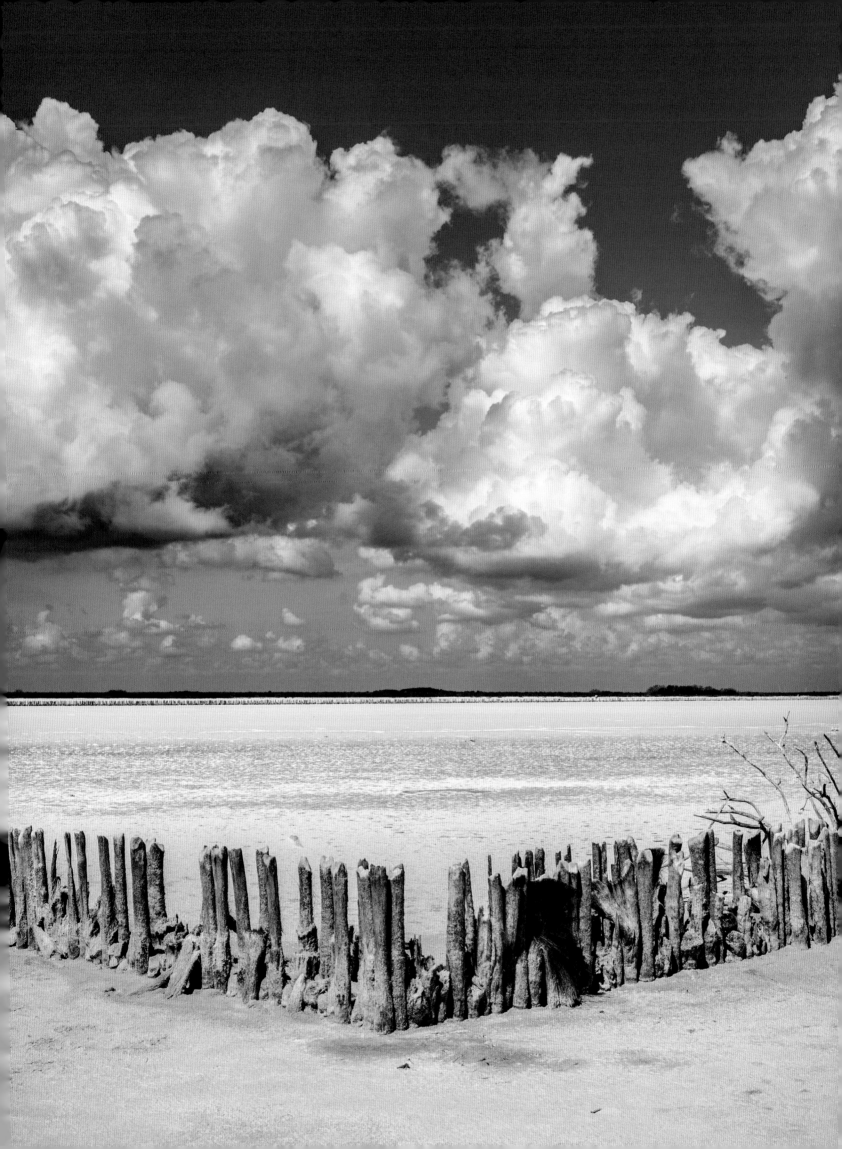

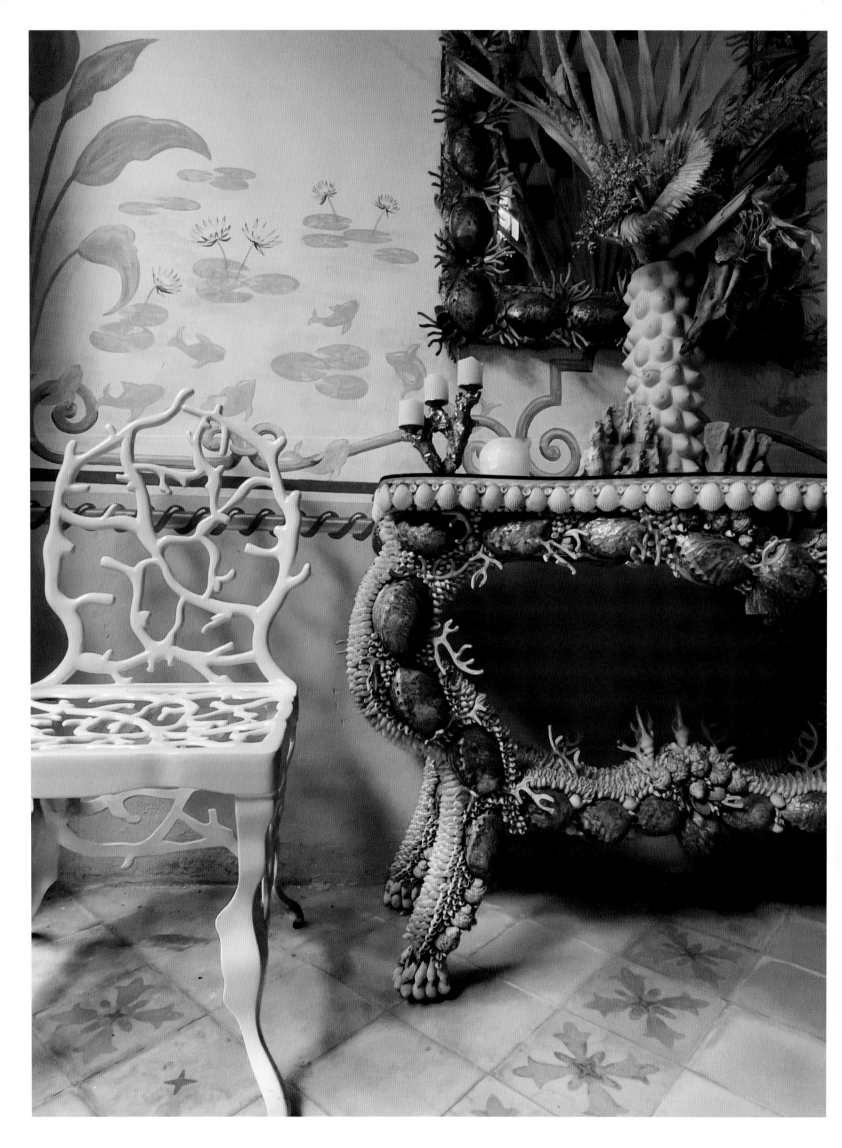

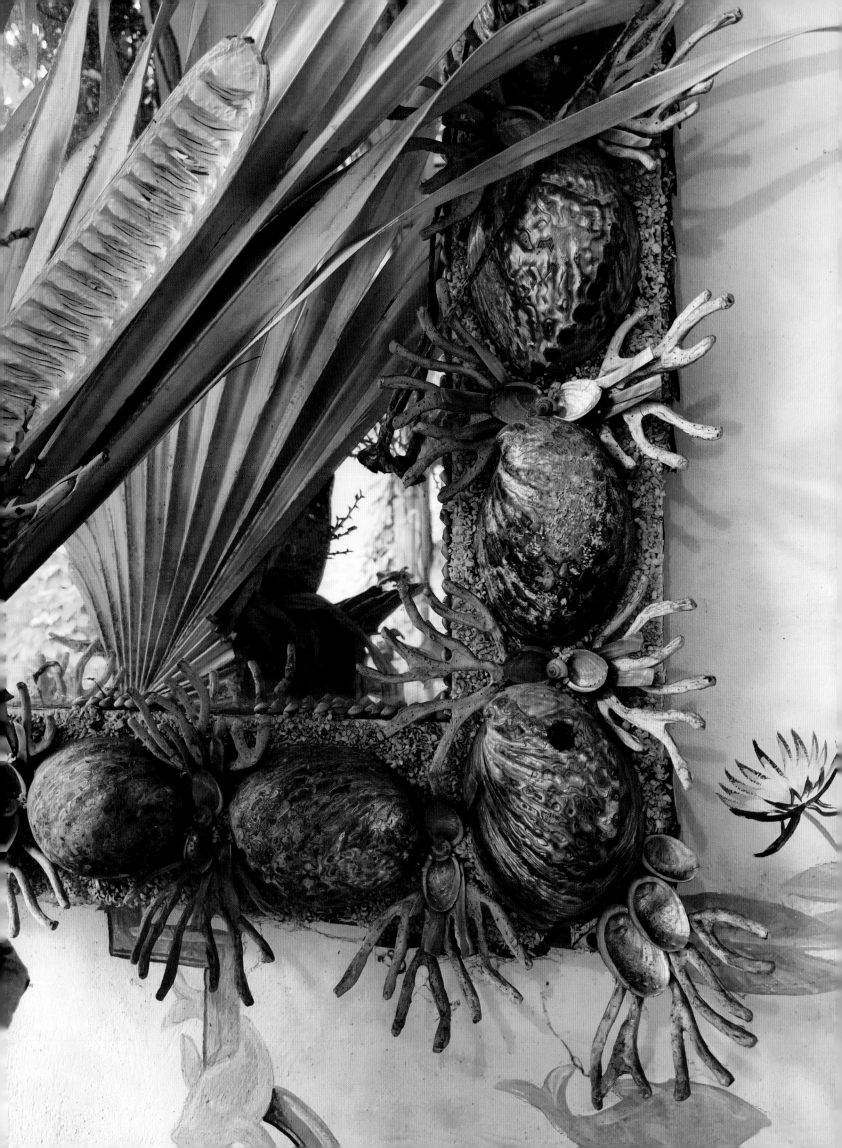

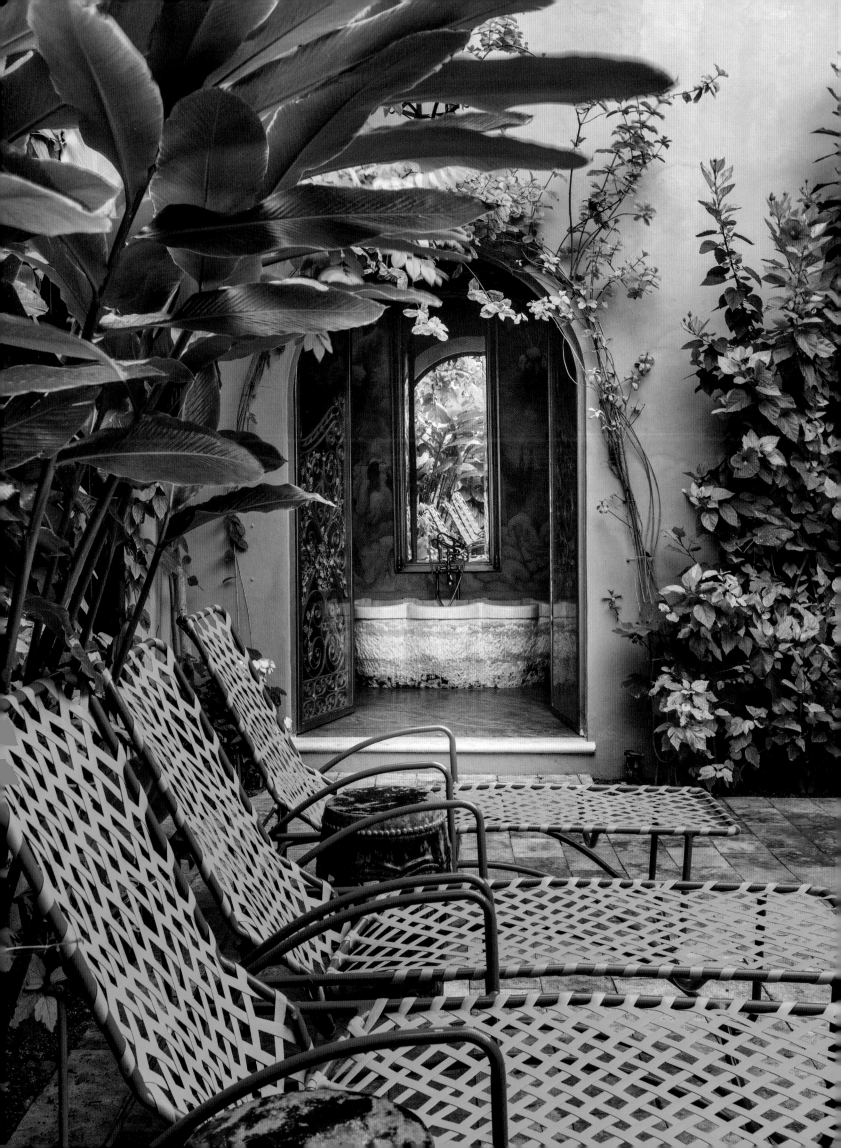

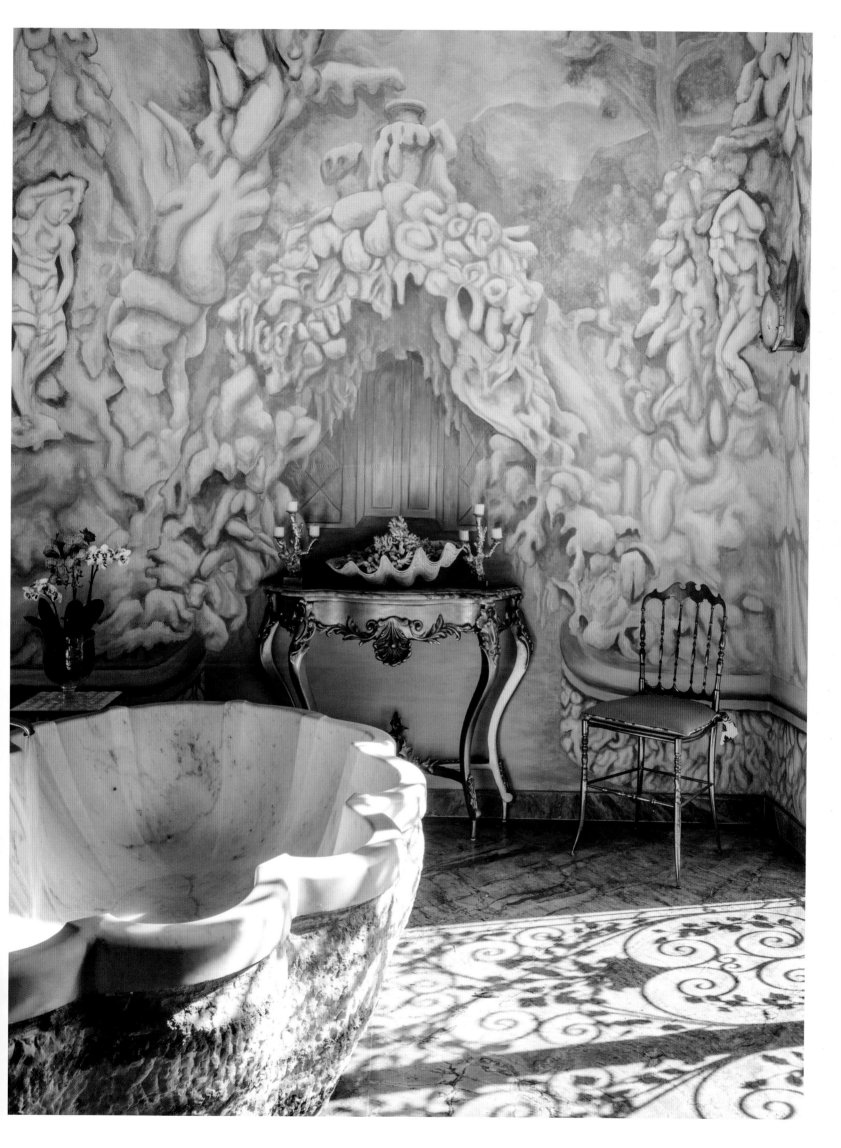

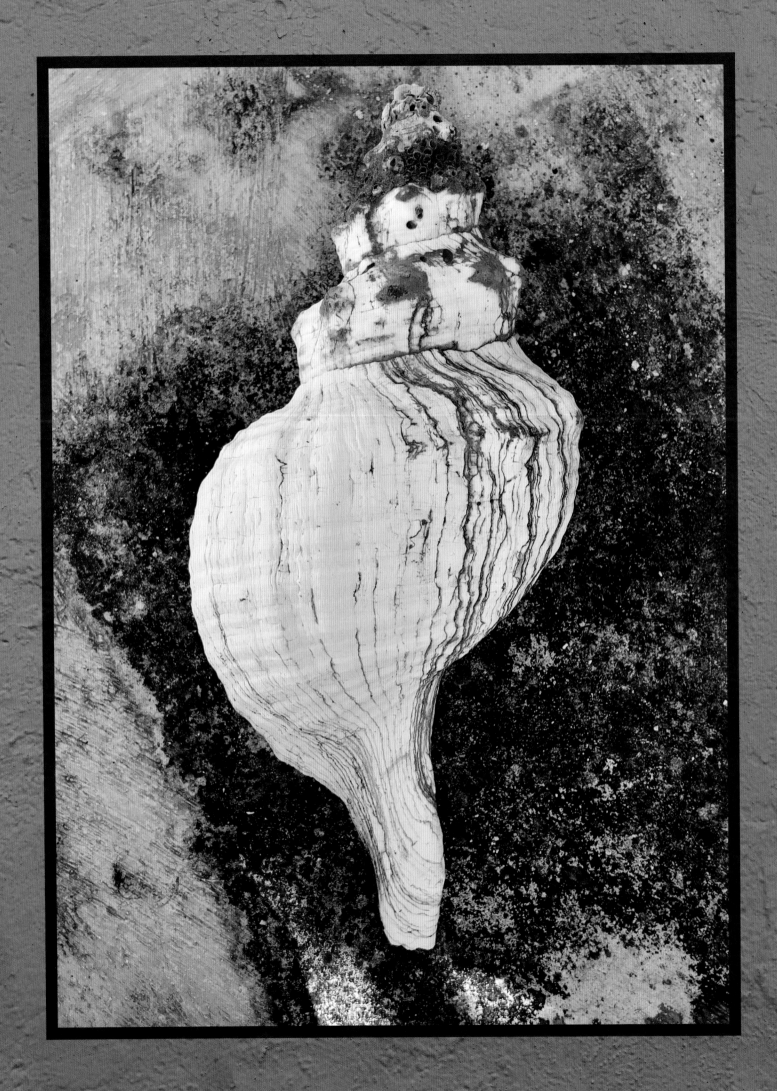

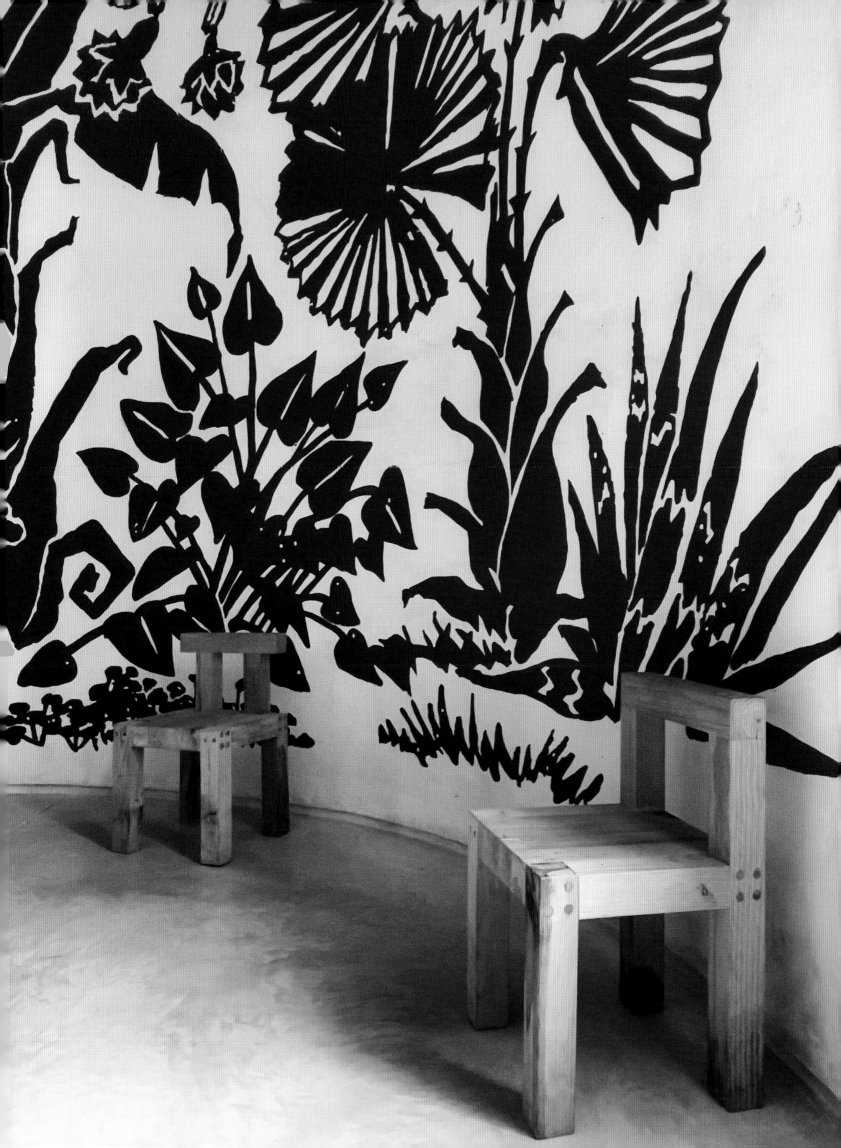

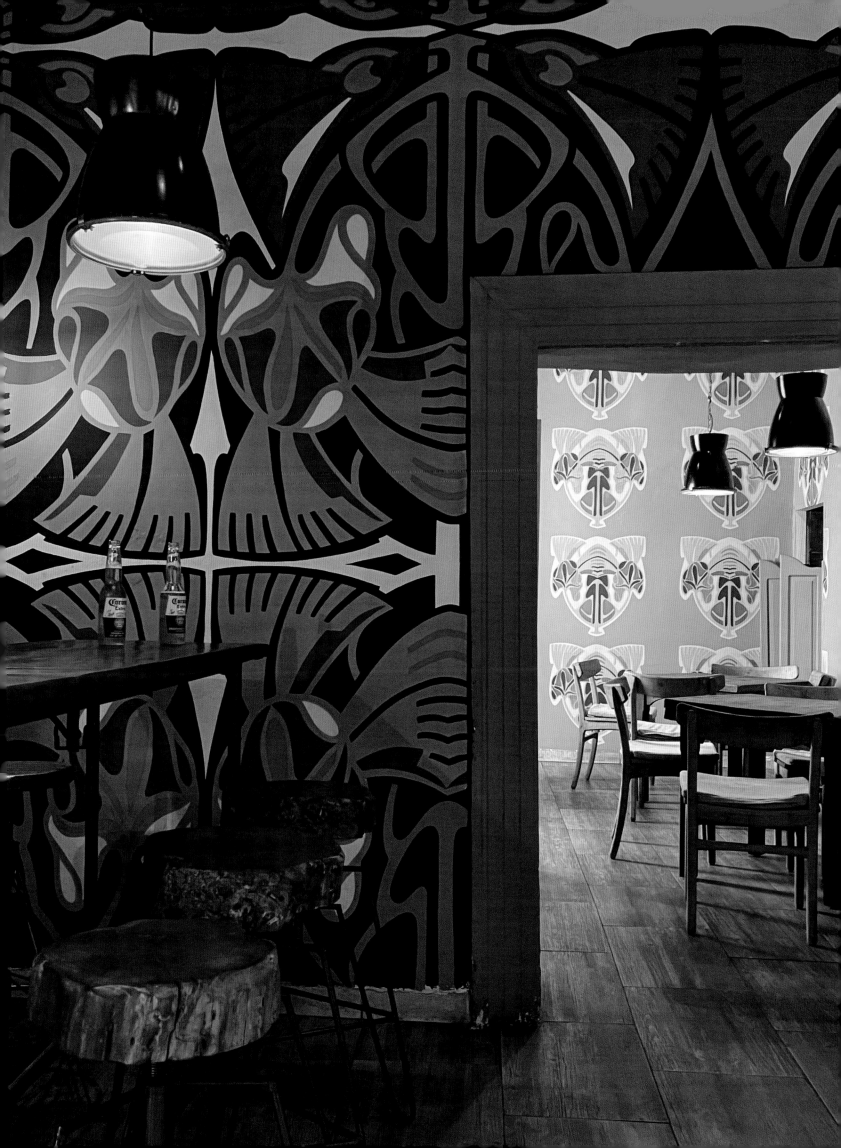

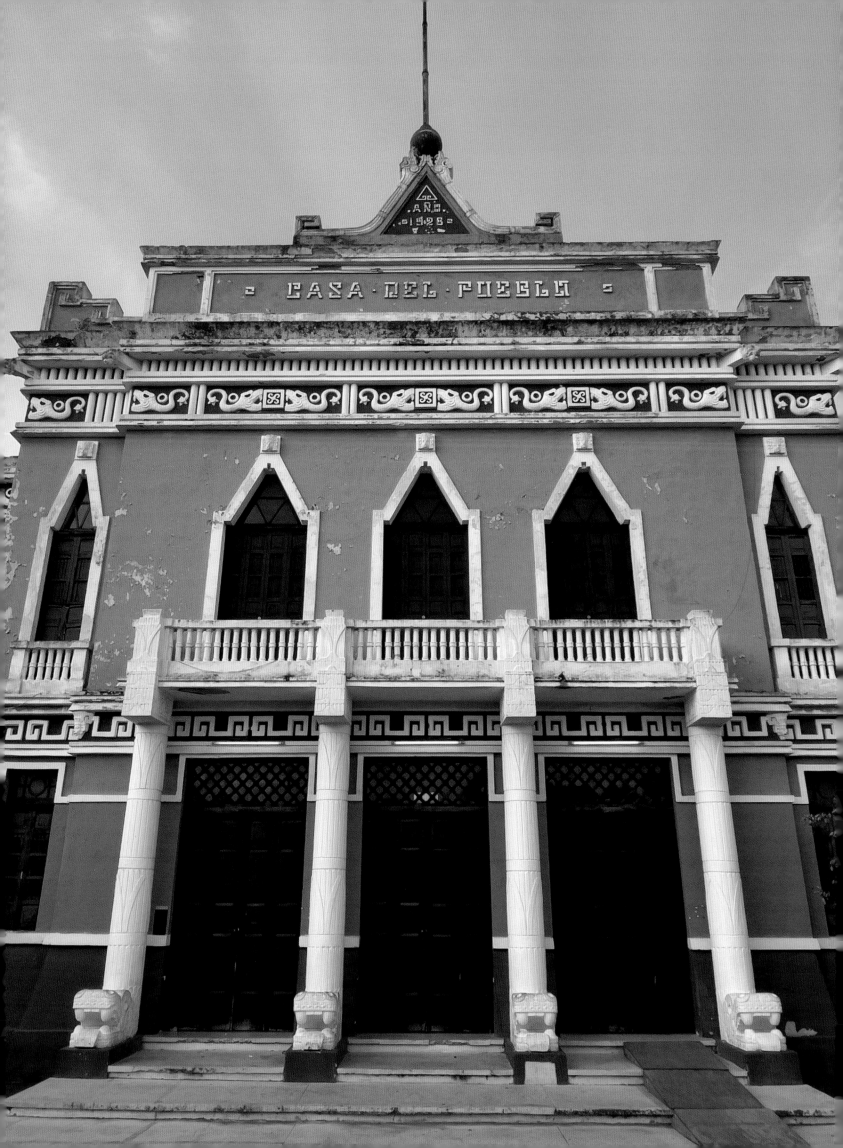

# ART DECO

The movement called Art Deco evolved in the first half of
the twentieth century through several stylistic influences,
with México embracing all of its progressive, international
message. Perhaps the country's most fascinating contribution
was a variation called Mayan Deco. Traditional ancient Maya
architecture and decorative embellishments, with bold lines
and geometric imagery already extensively used in buildings
grand and small for hundreds of years, had a natural affinity
with Art Deco architecture. The style left a treasure trove of
small houses in urban centers, possibly more than anywhere
else in the world, due to Mexican architecture's extensive
use of concrete construction and decorative applications. It
also had endless expressions in México's distinctive pasta
tiles and emerging fine jewelry production.

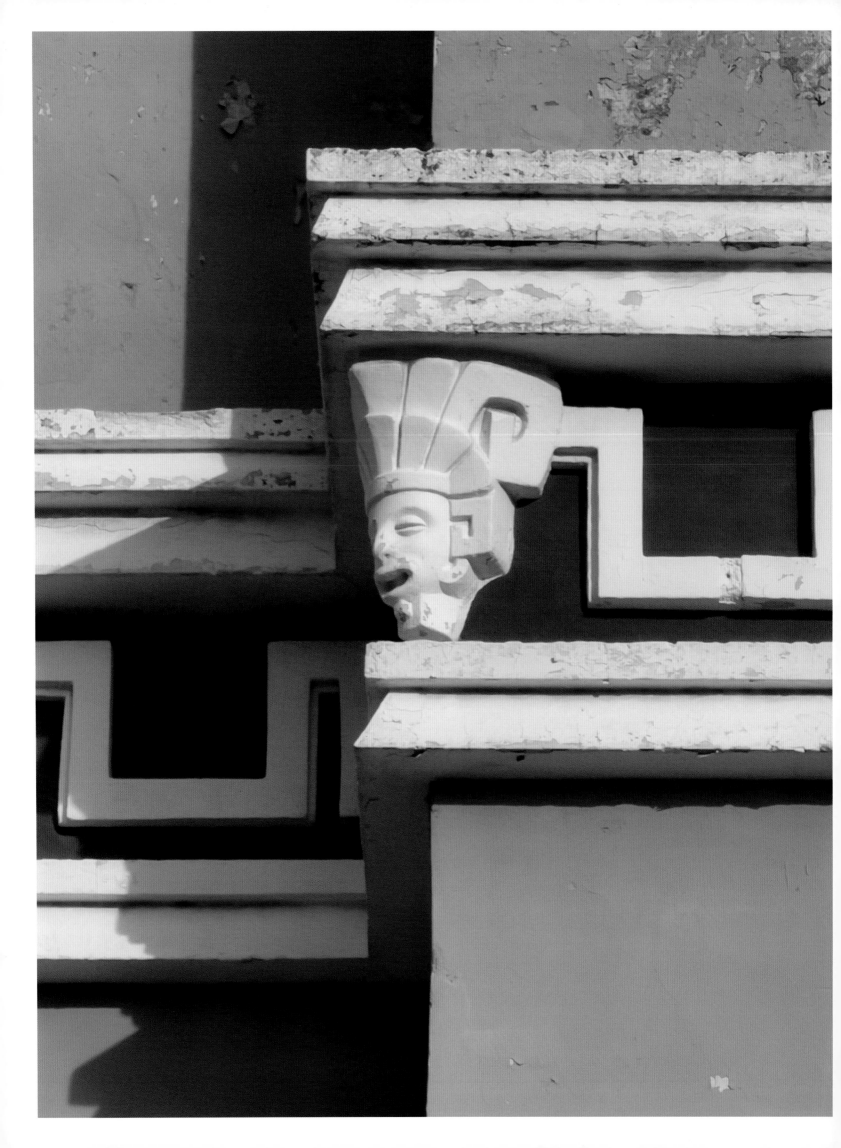

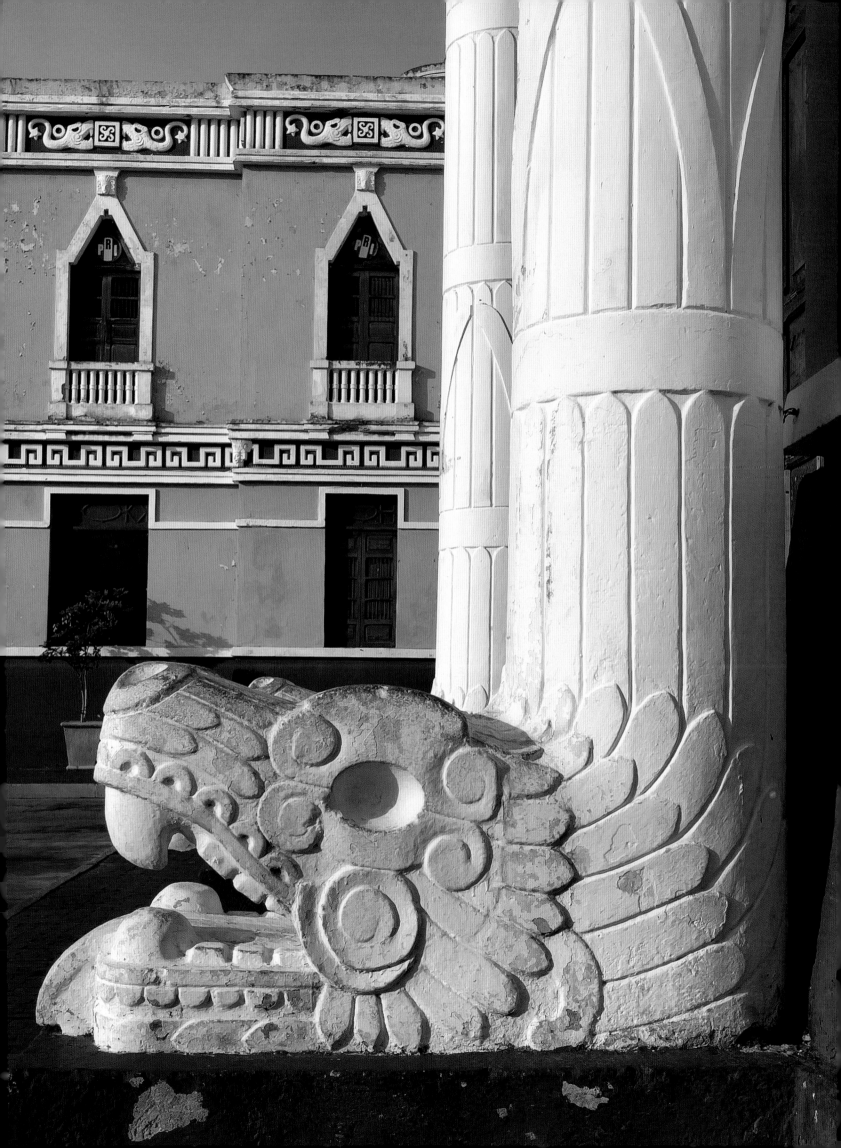

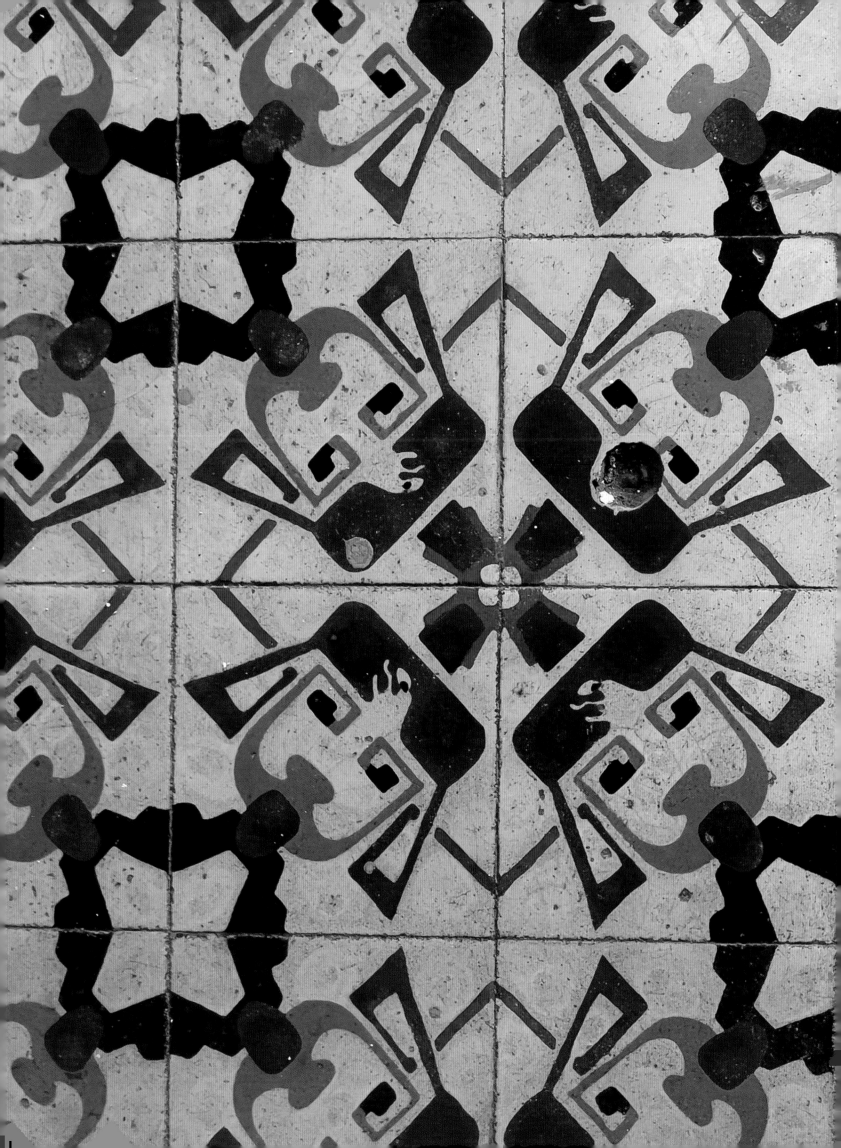

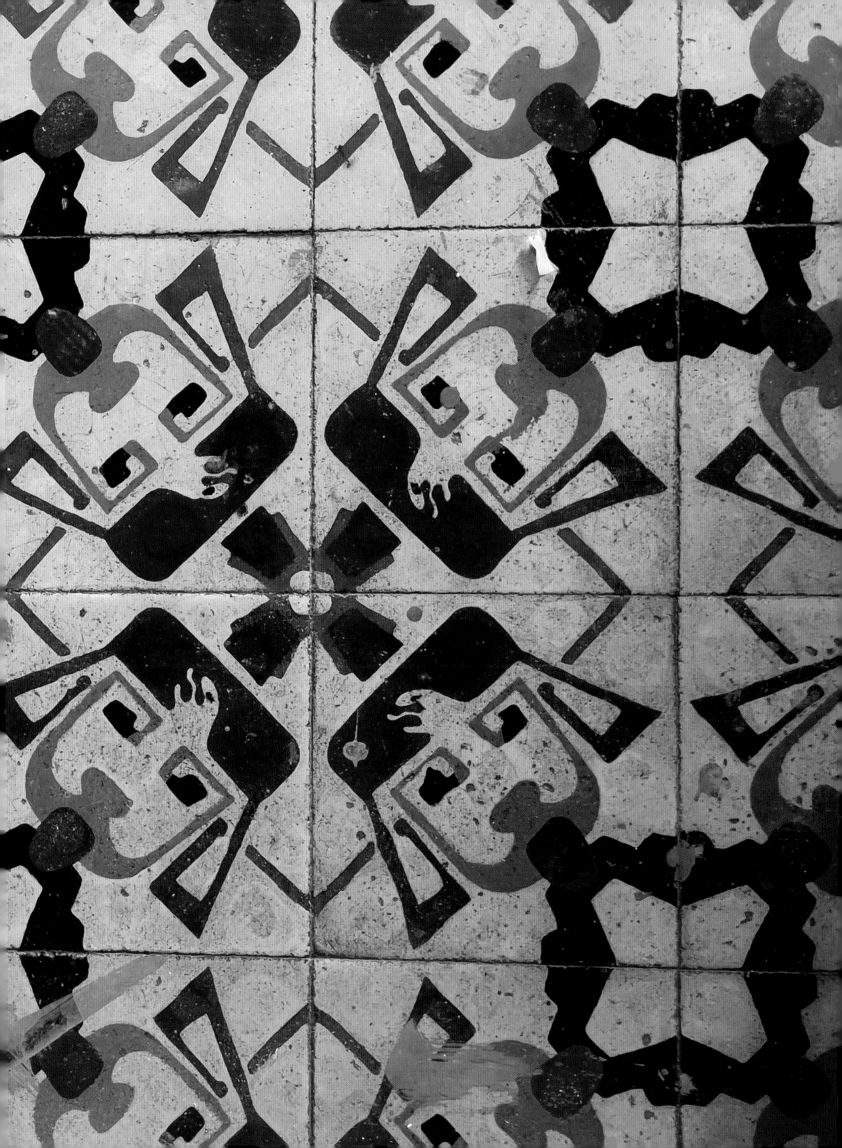

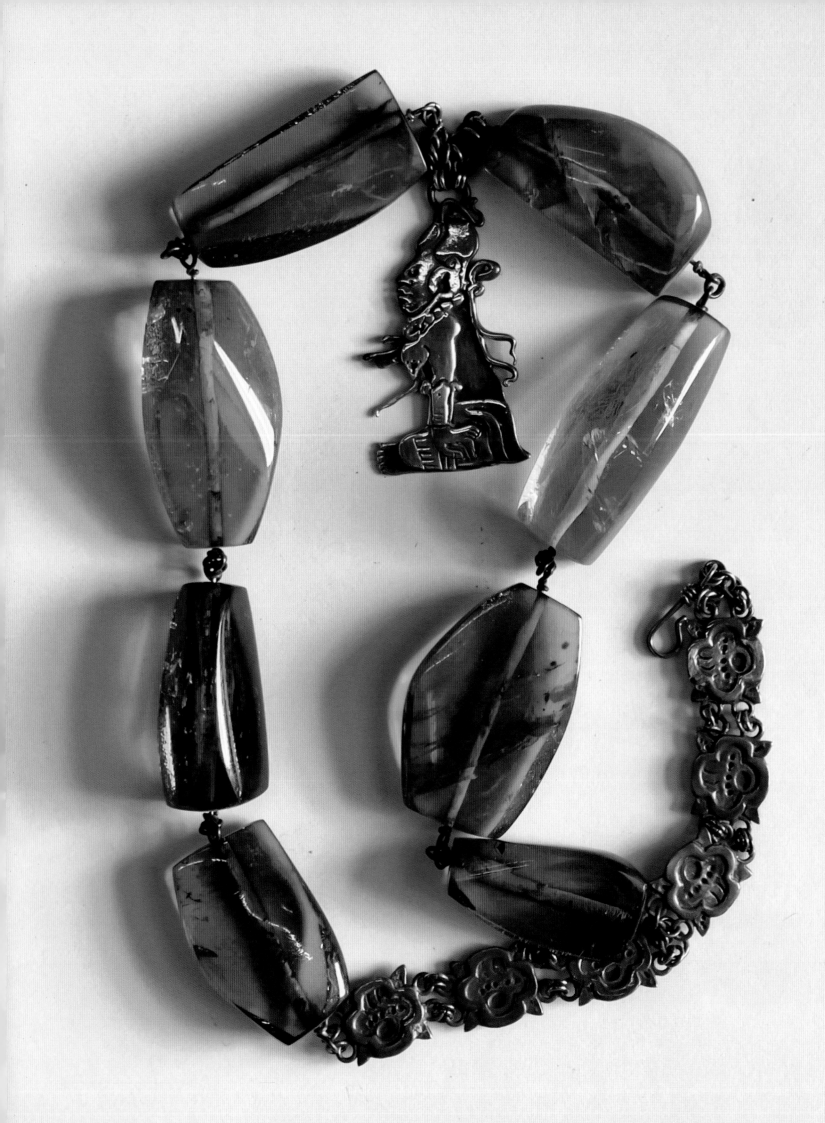

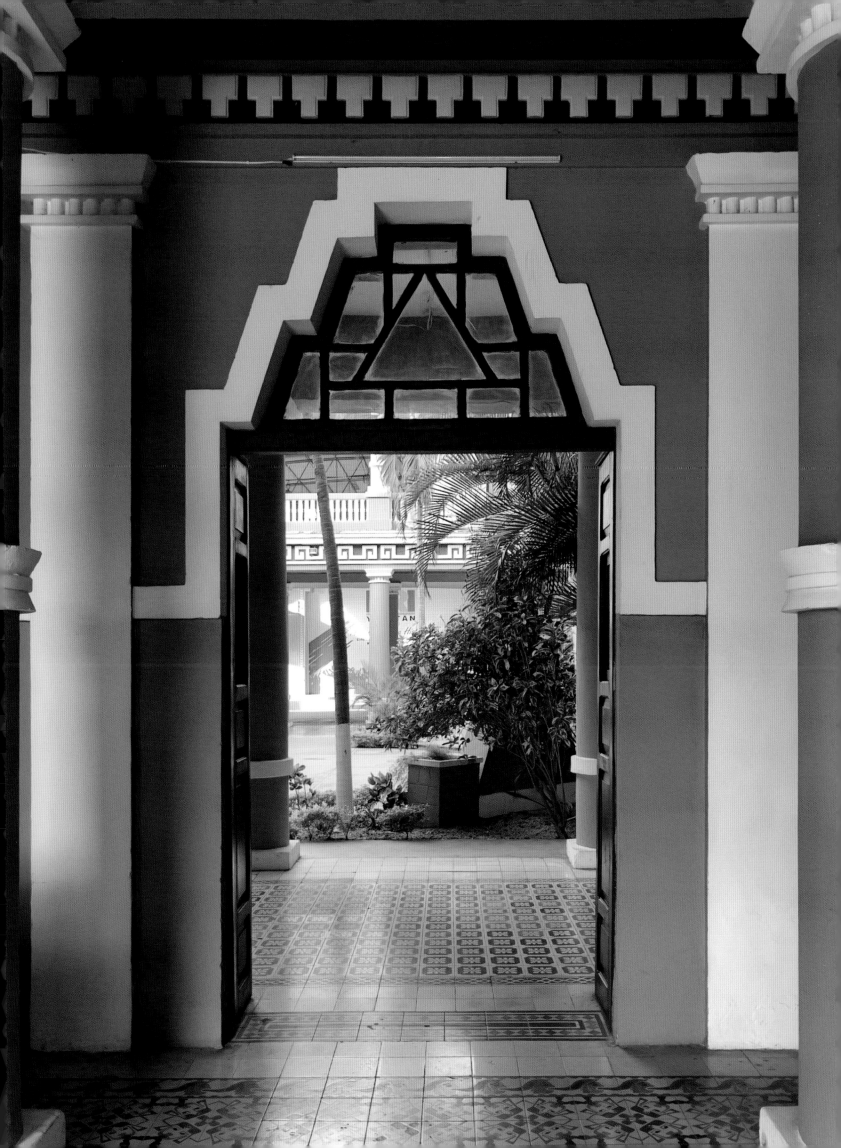

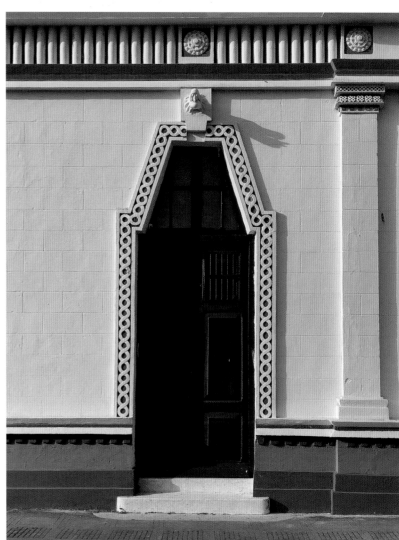
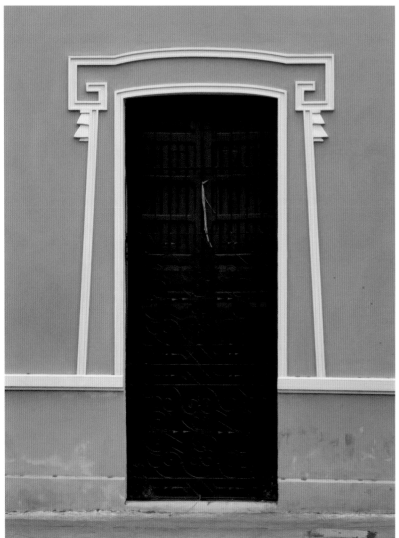

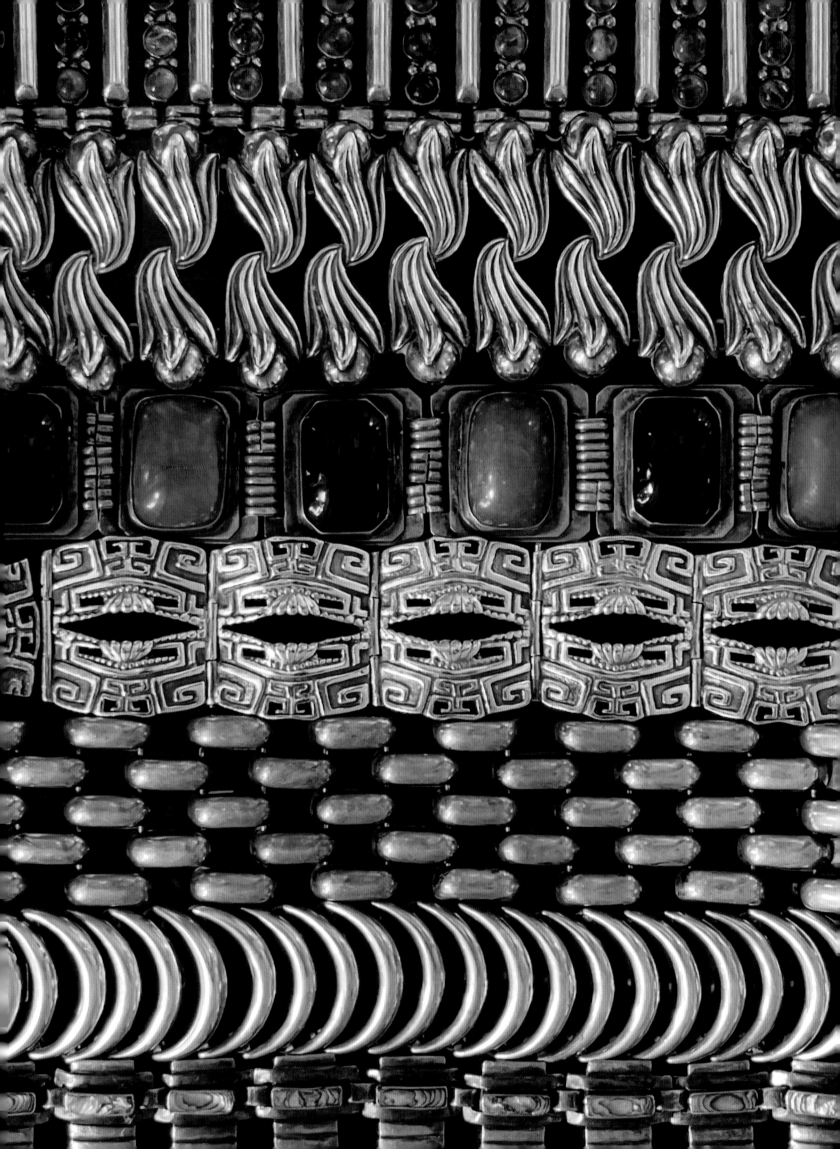

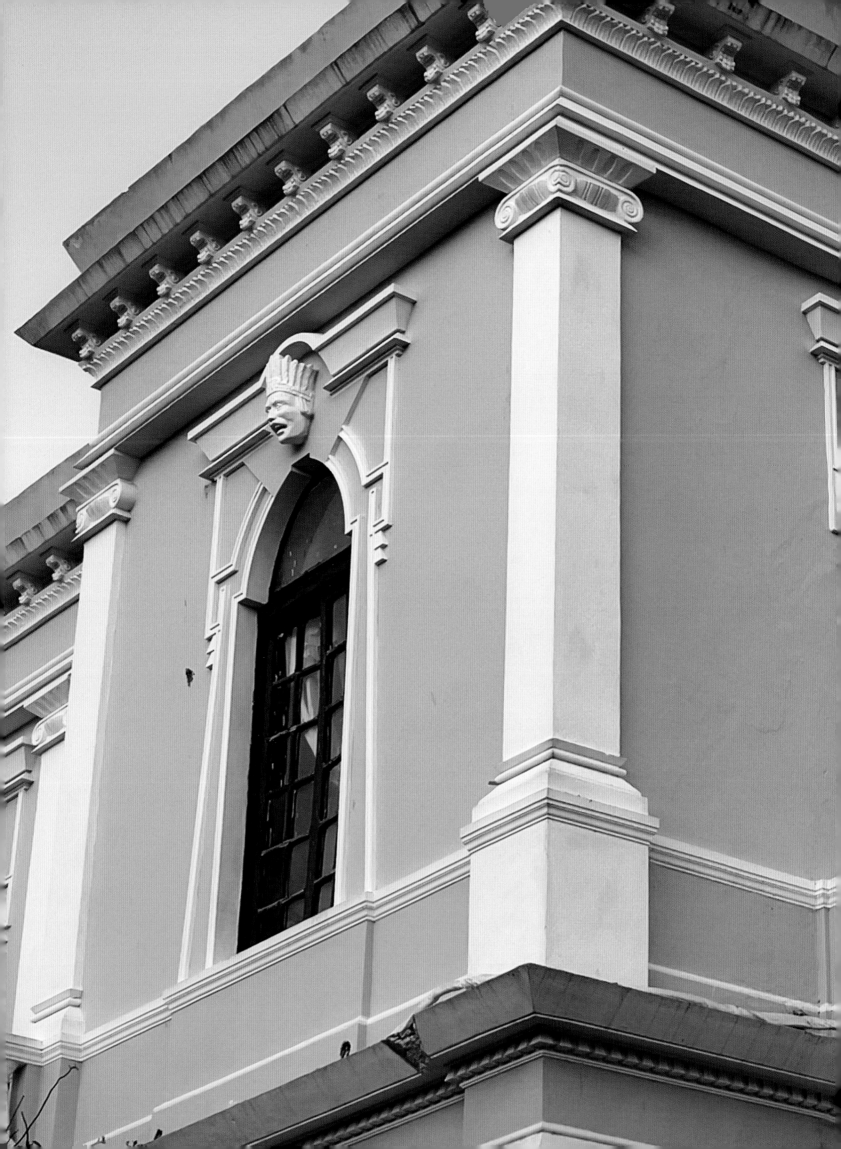

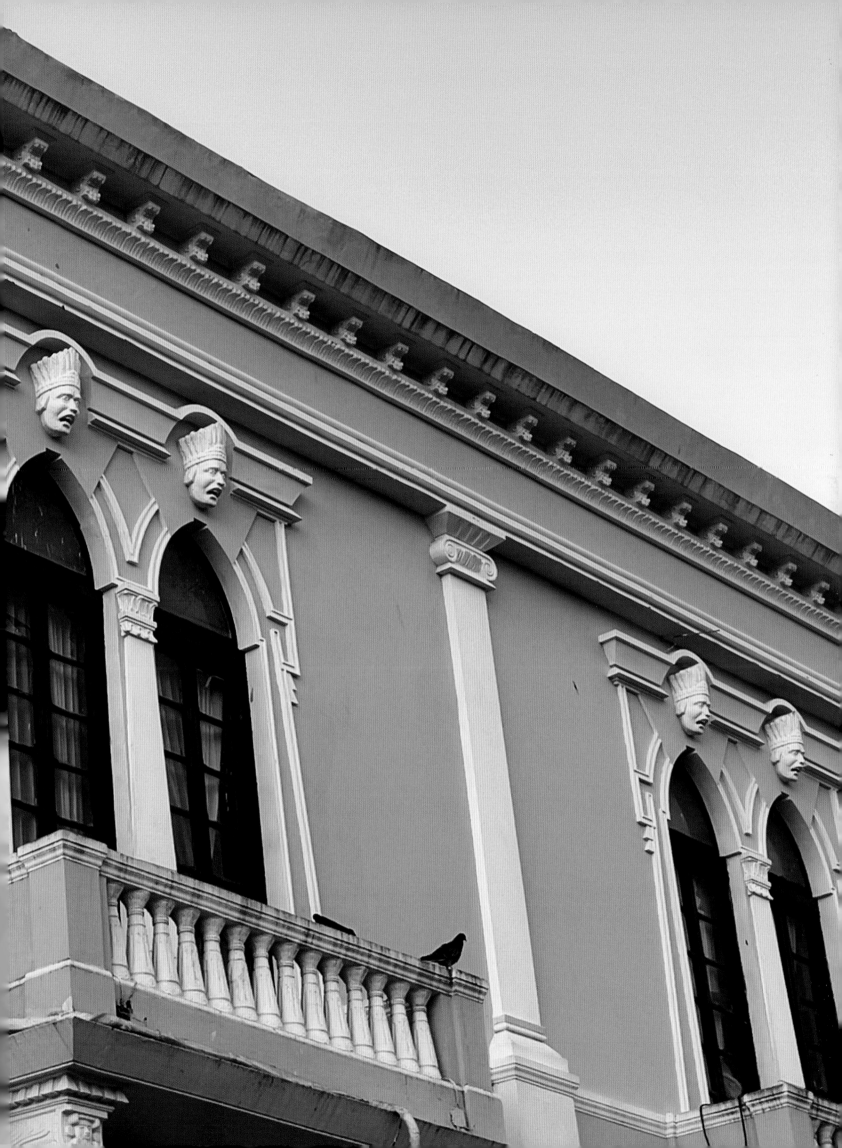

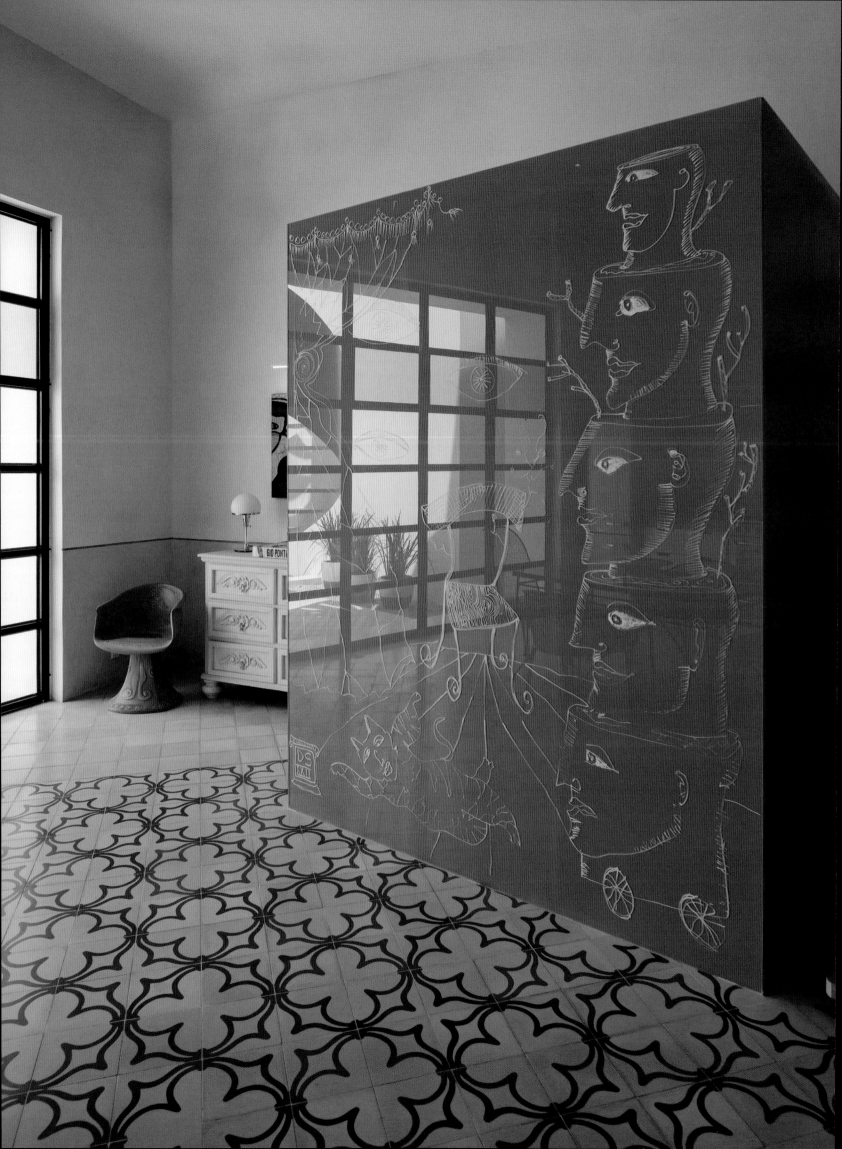

# SURREALISM

While Surrealism originated as an early twentieth-century art movement in Europe, its freedom from traditional constraints and its celebration of the subconscious blossomed wildly—and continues to thrive—in Mexican fine art, decorative arts, and architecture. Roman Catholicism in its highest artistic and ritual expressions was also fertile ground for Surrealism to take root. The indigenous and mixed cultures of México had long reveled in a broad range of historical Latin American magical realism across all aspects of life. The somewhat fringe Surrealist movement elsewhere in the world found a hothouse welcome in México.

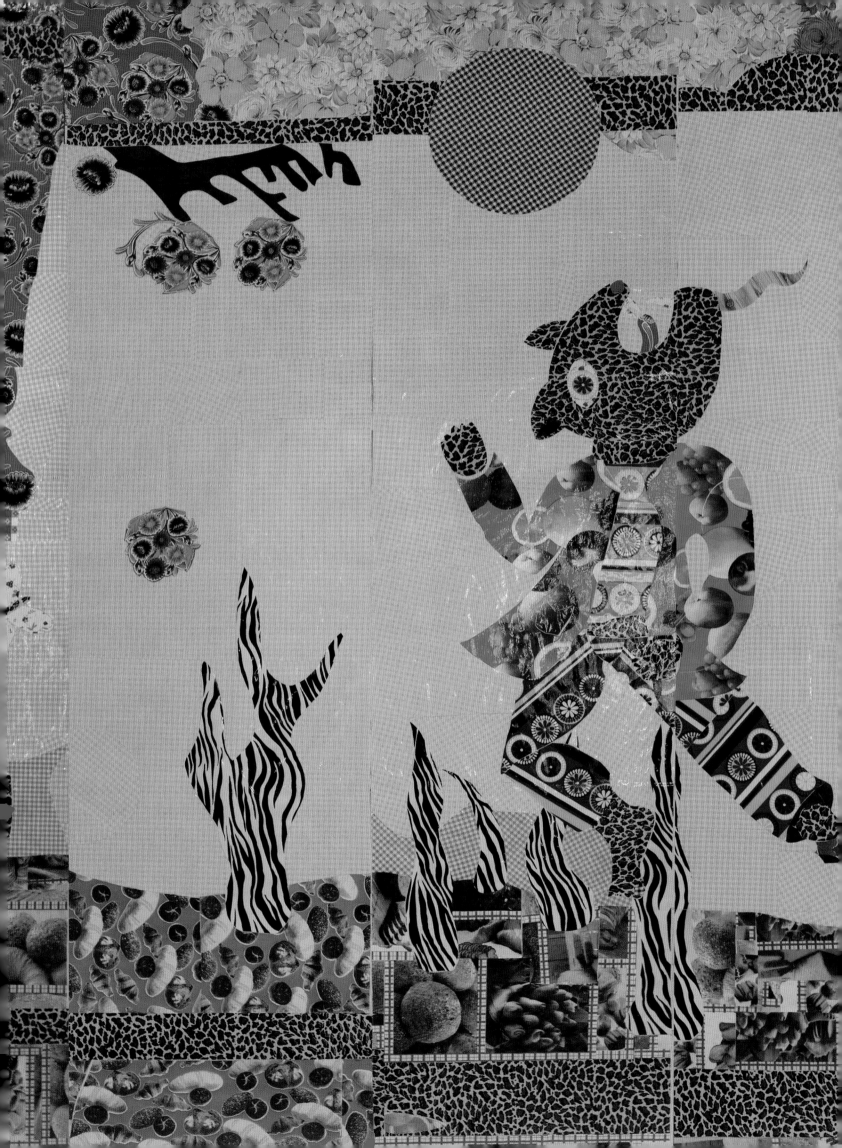

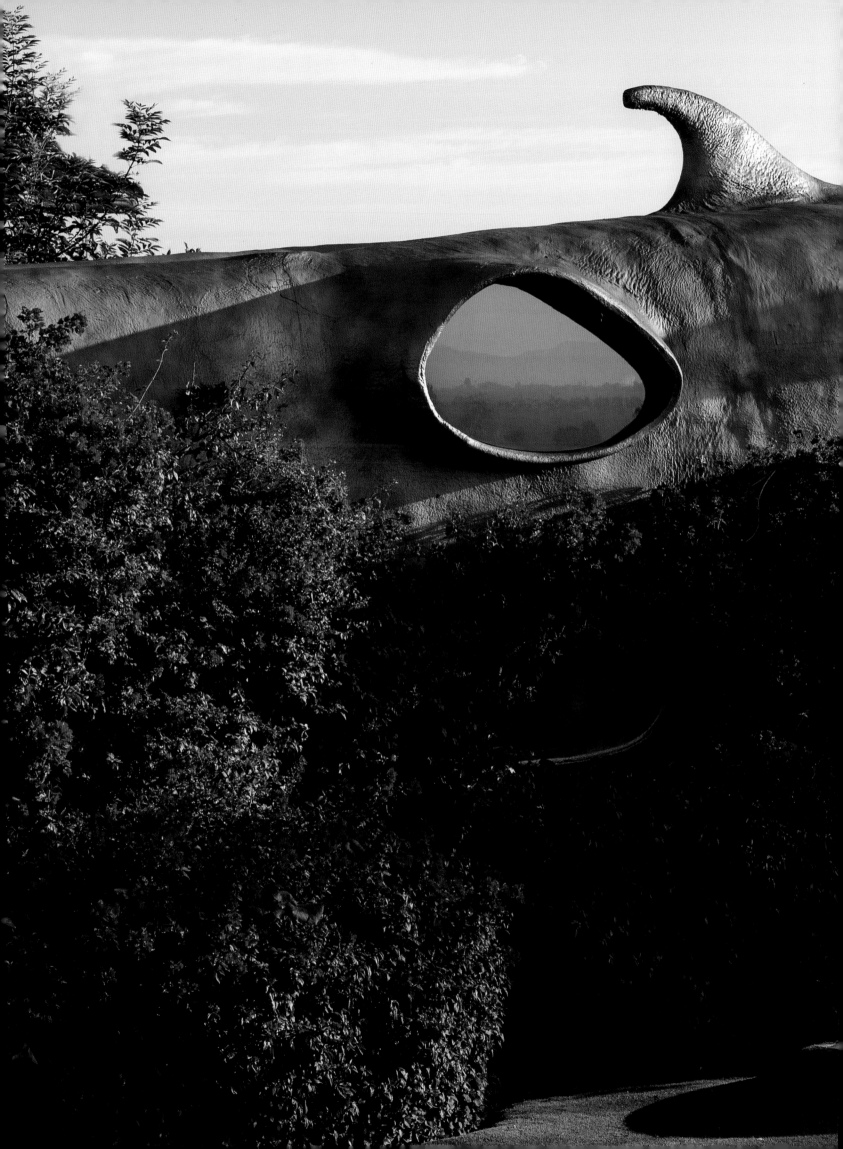

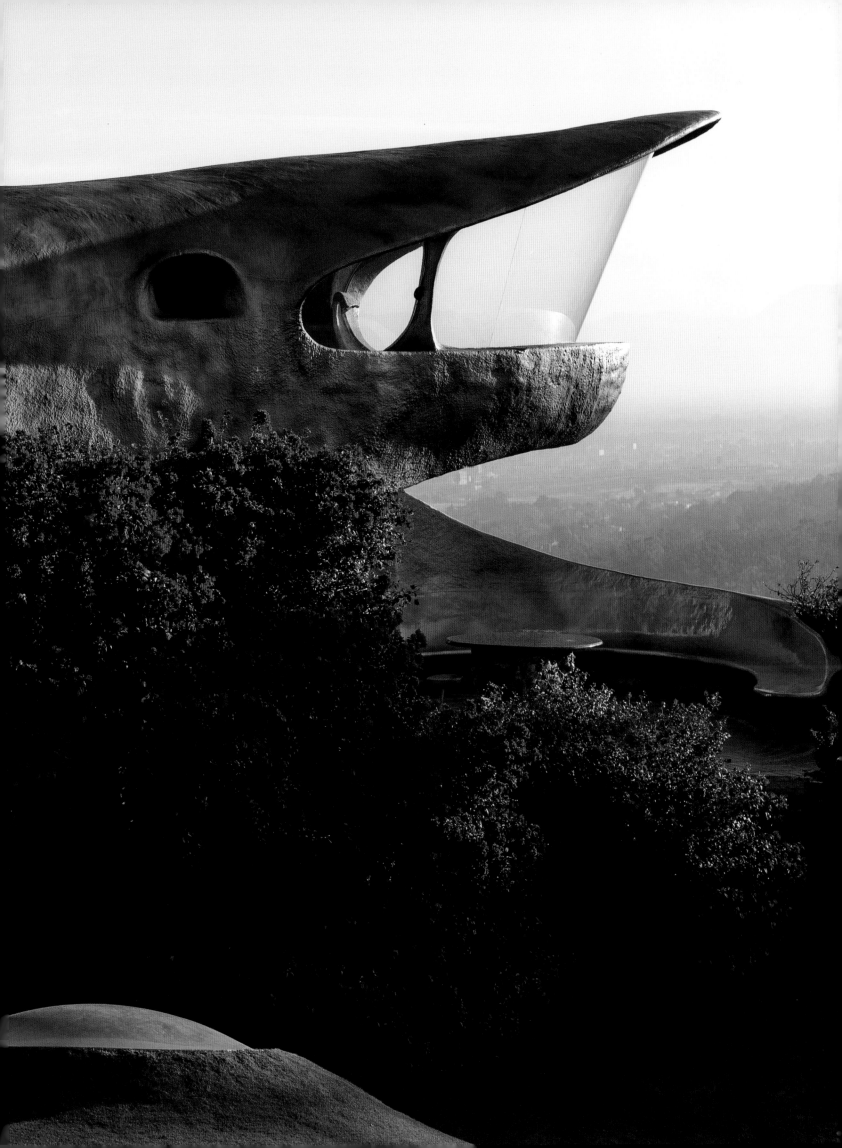

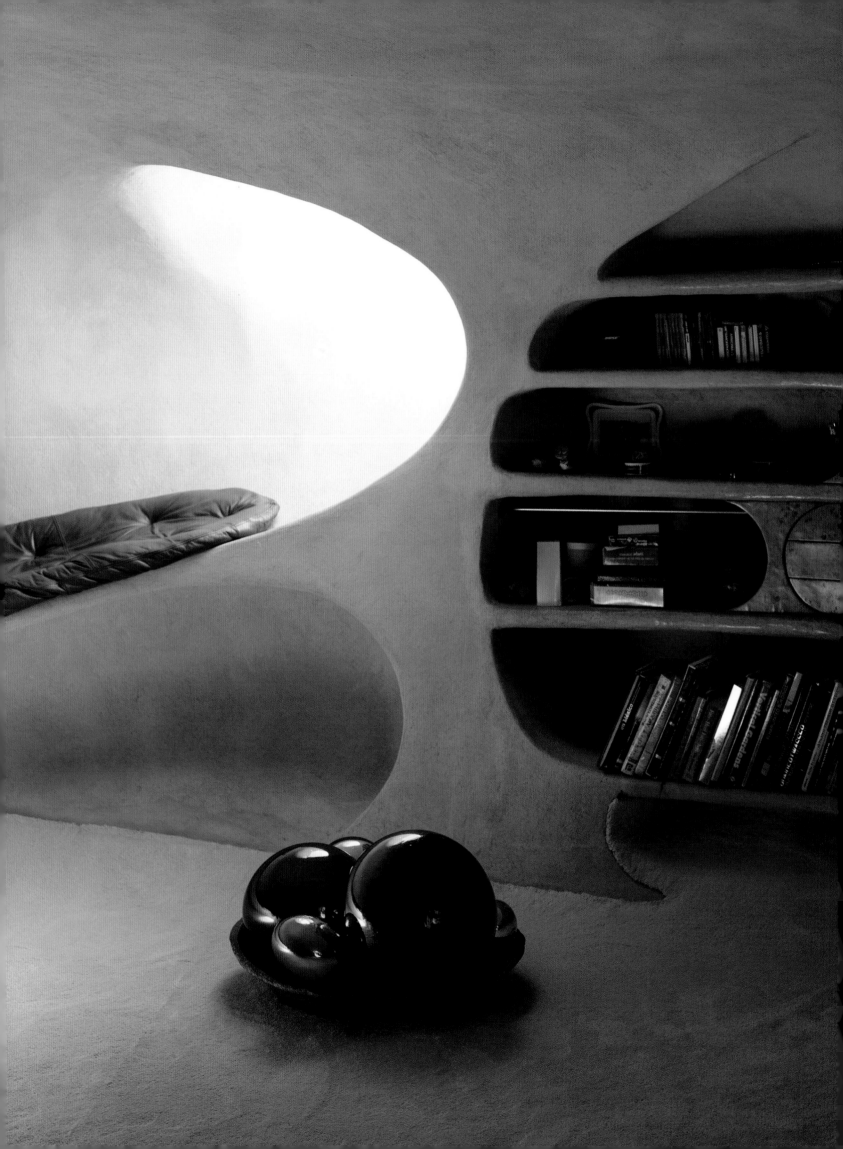

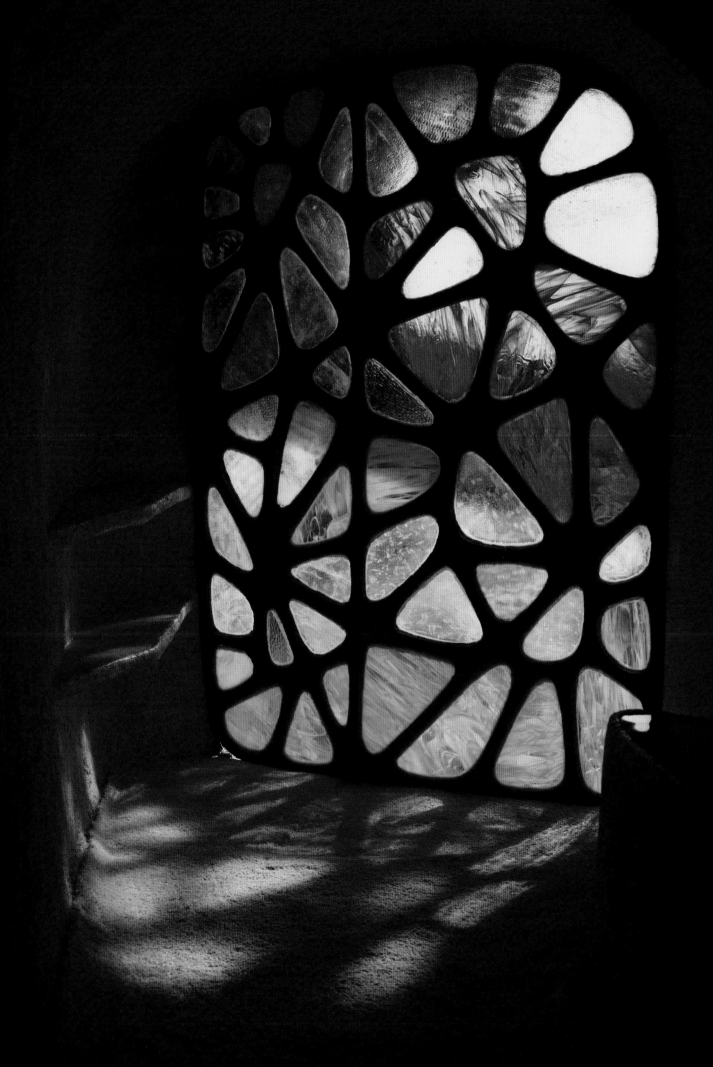

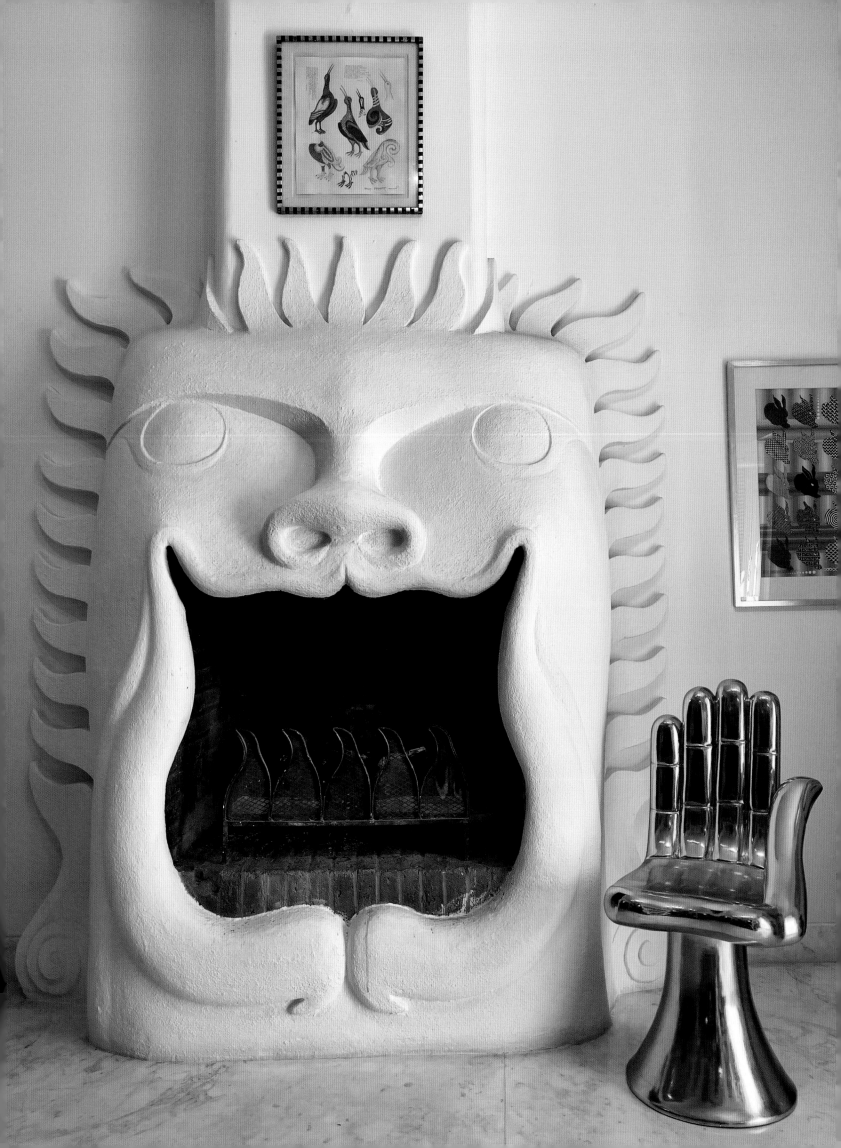

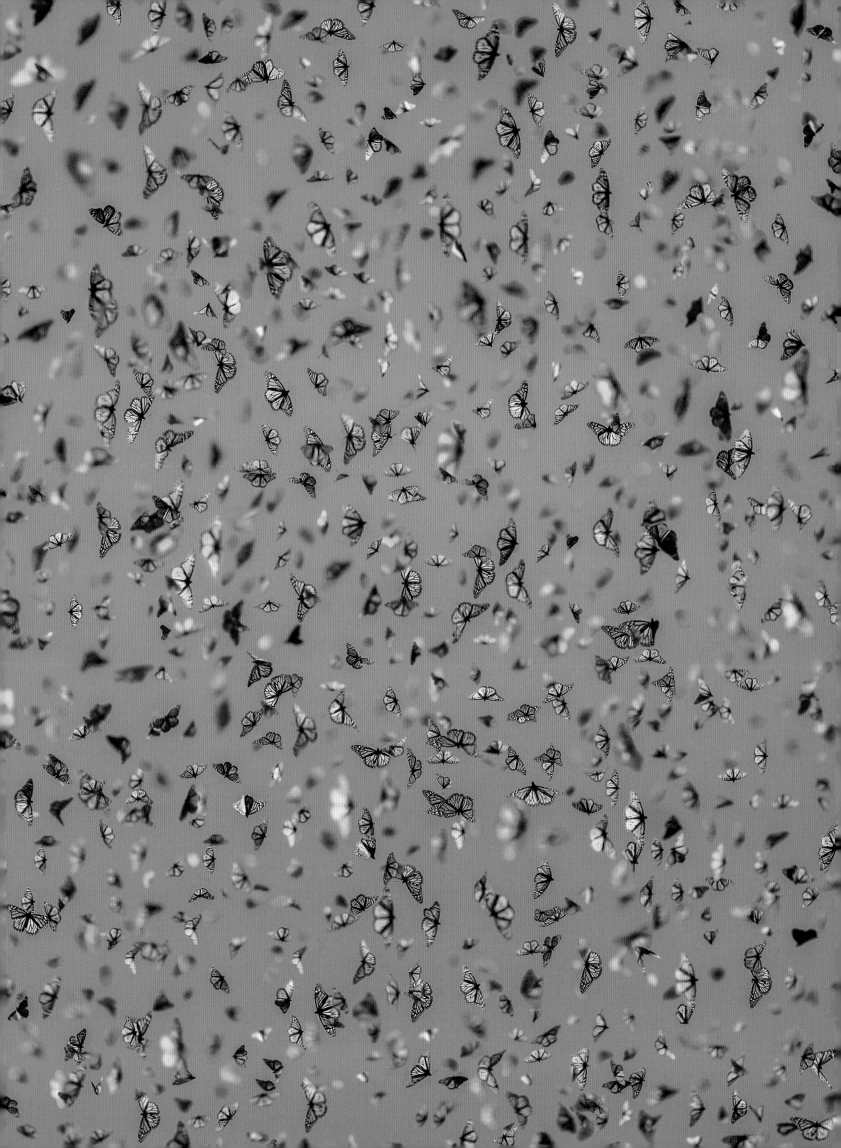

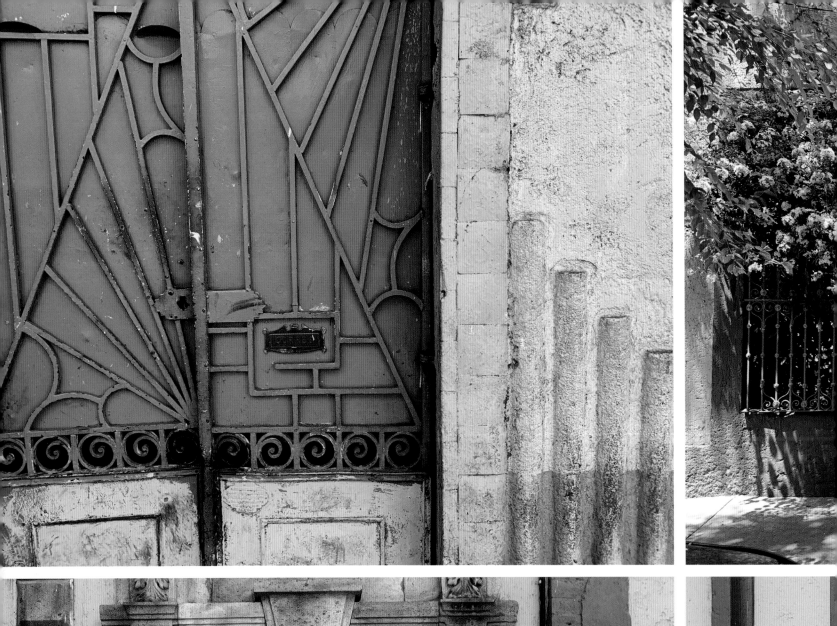

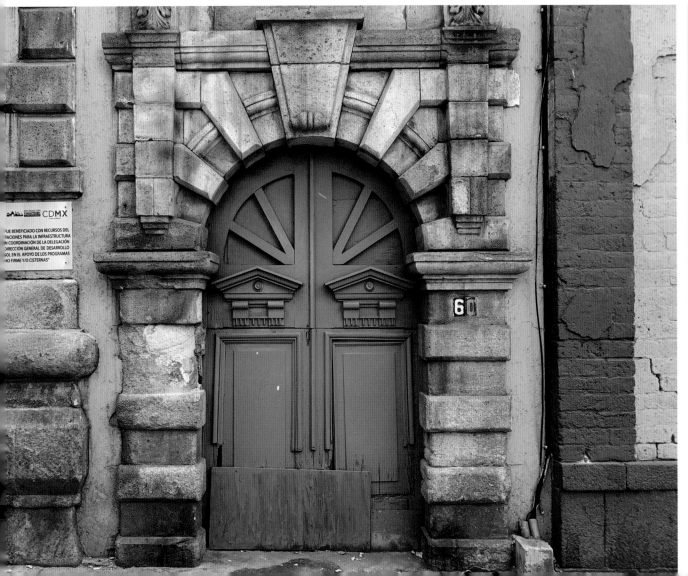

60

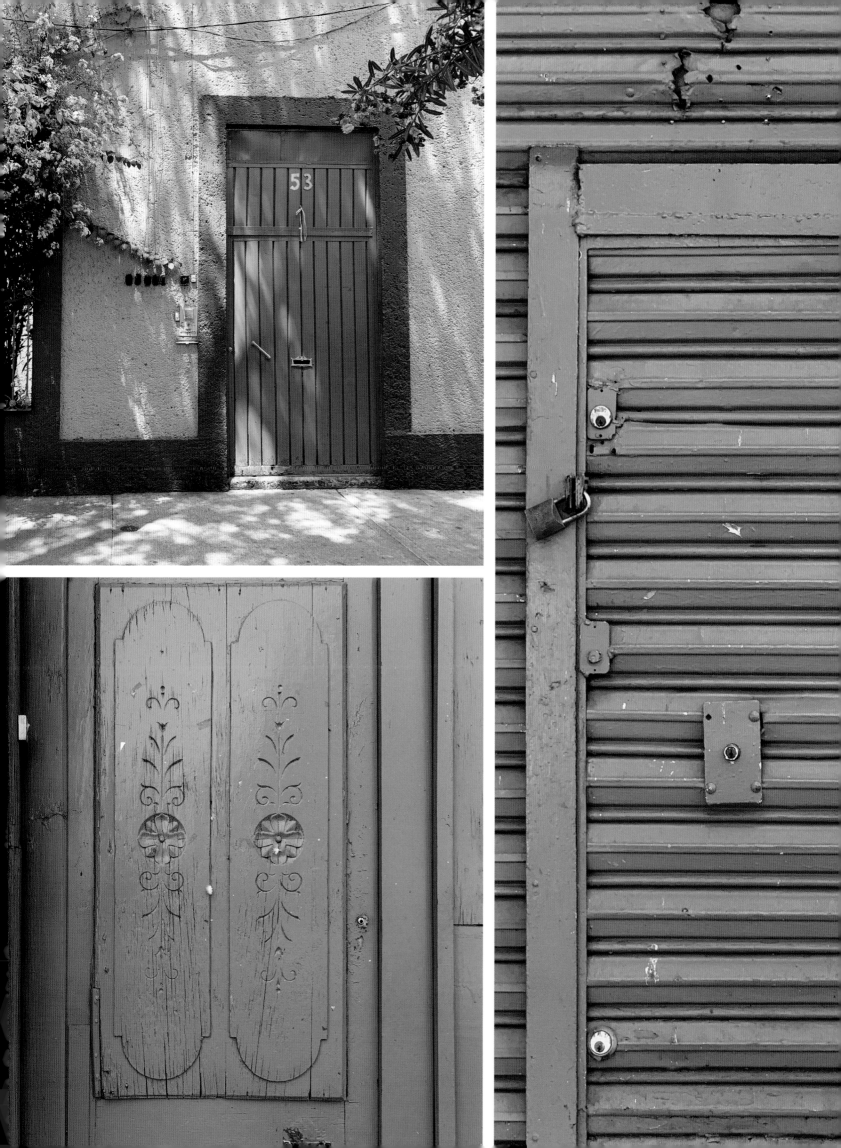

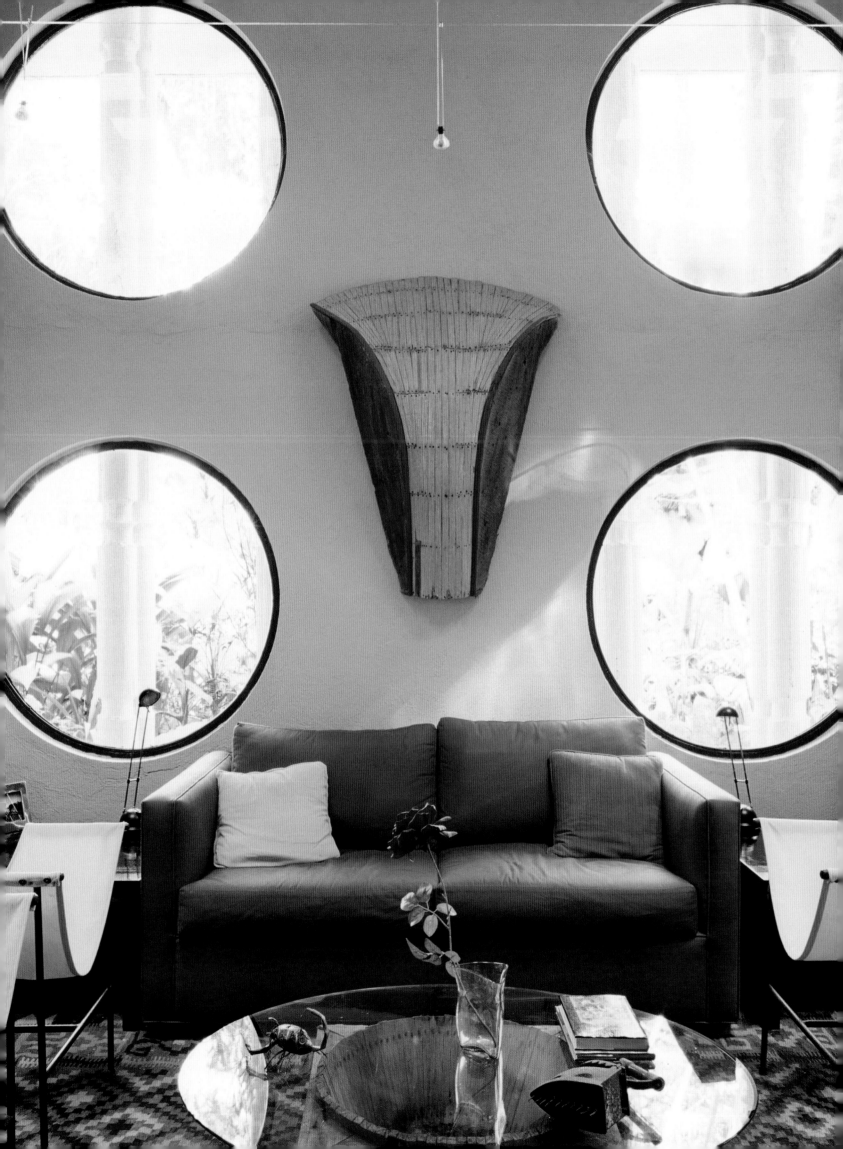

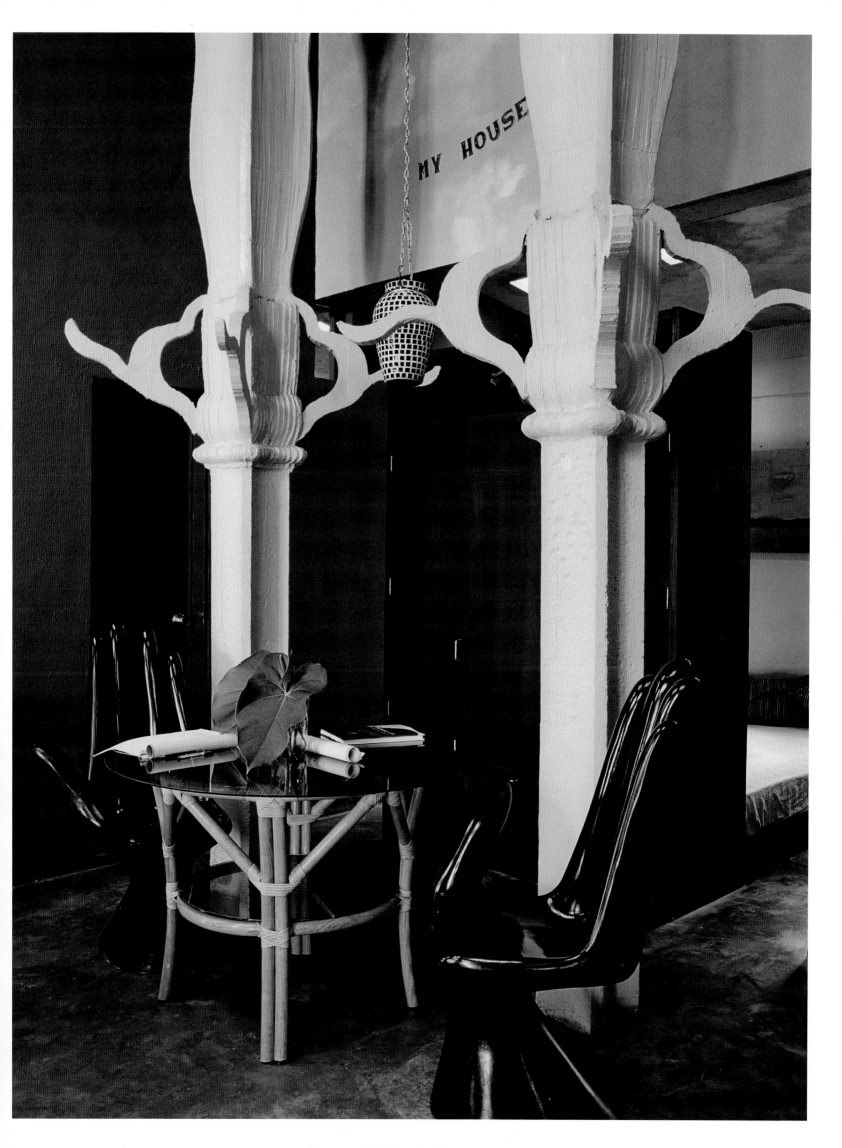

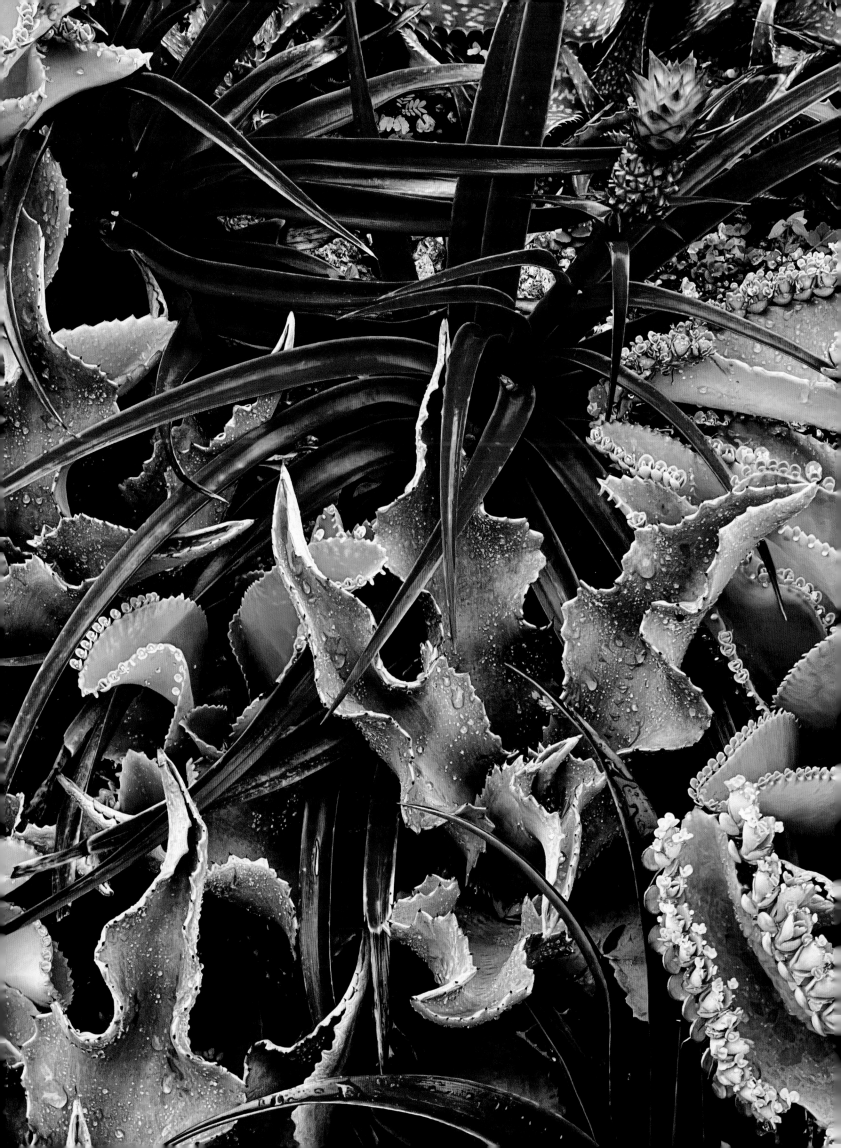

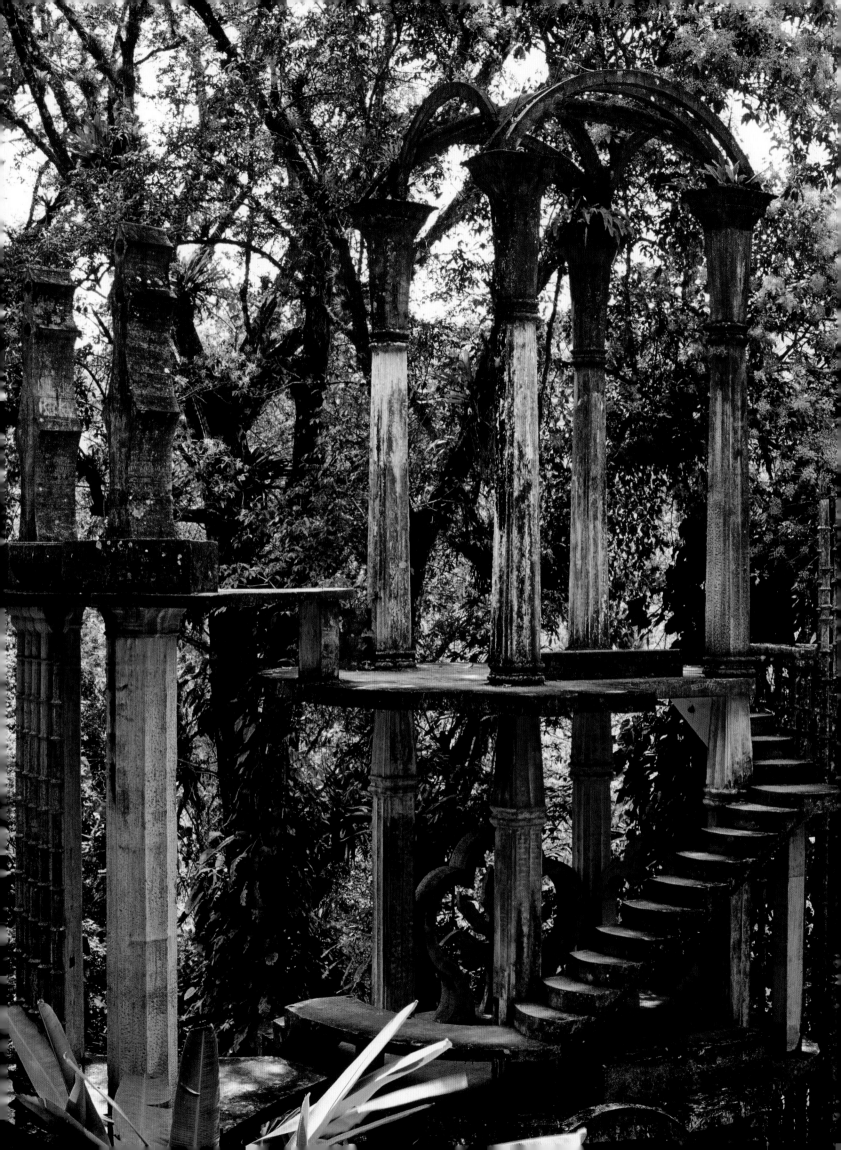

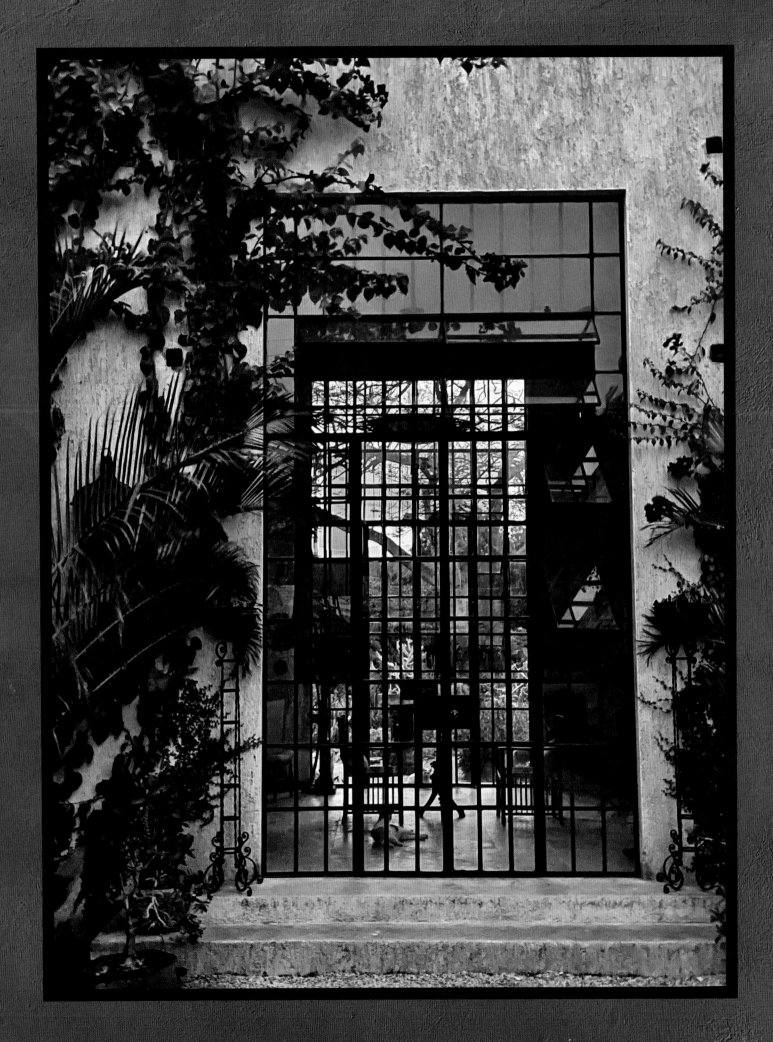

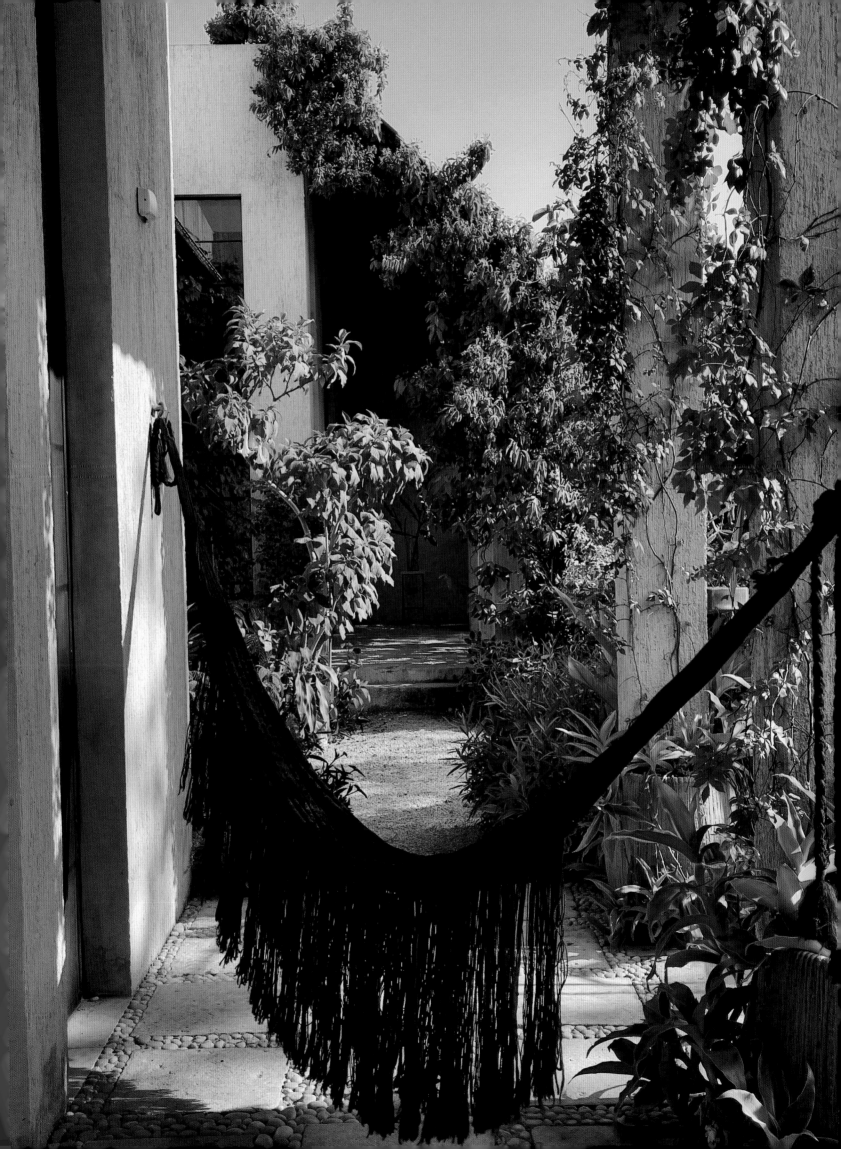

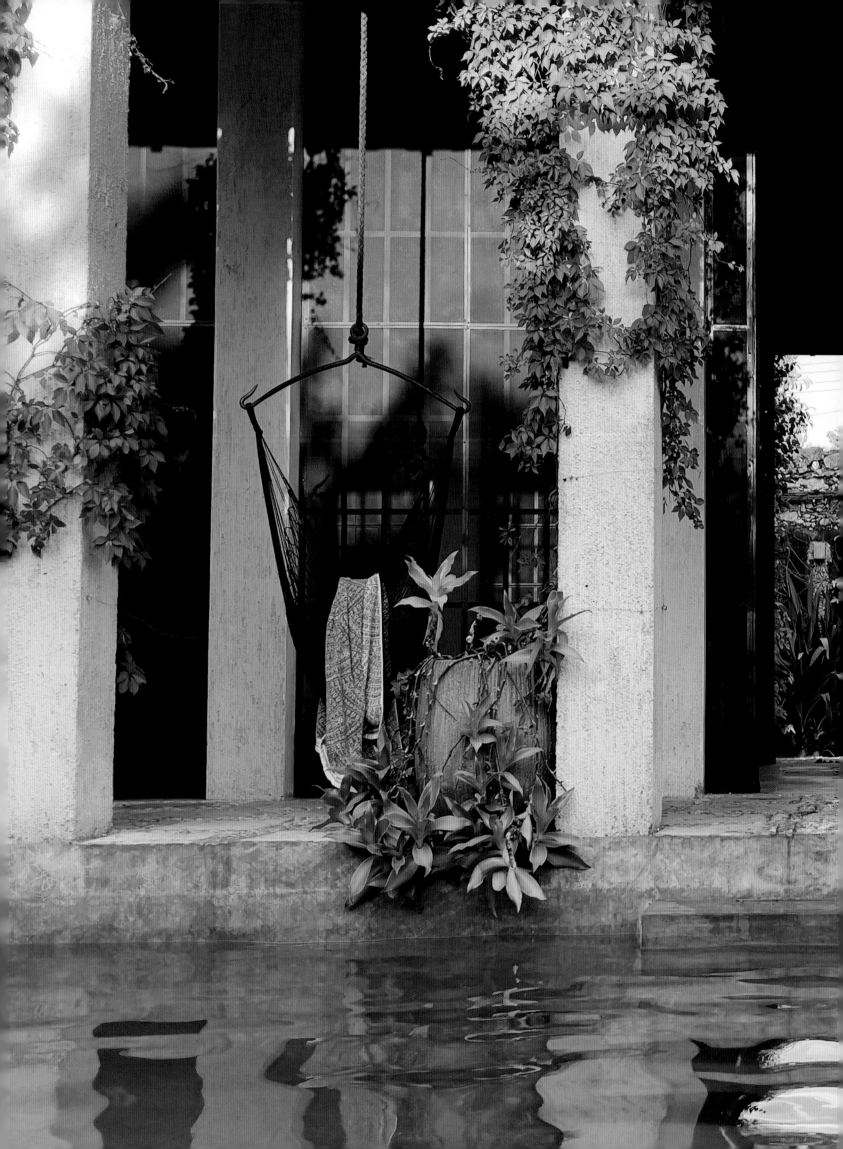

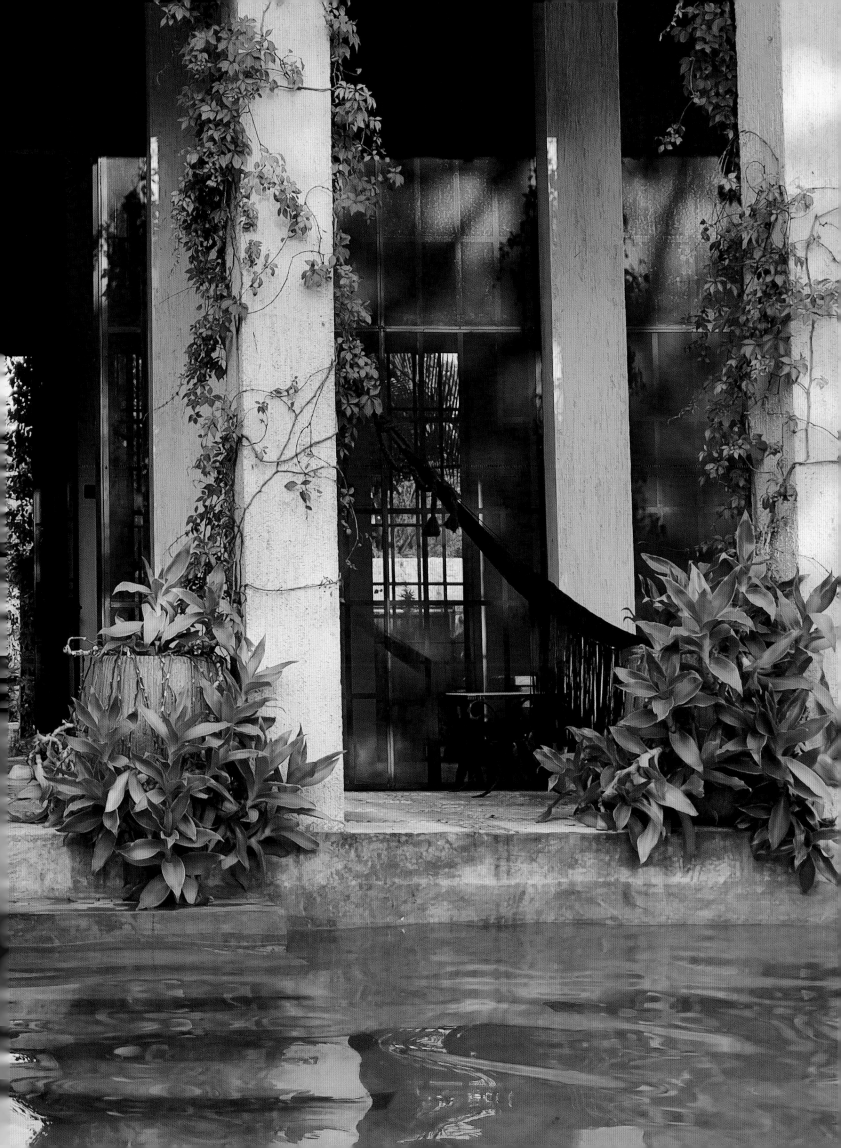

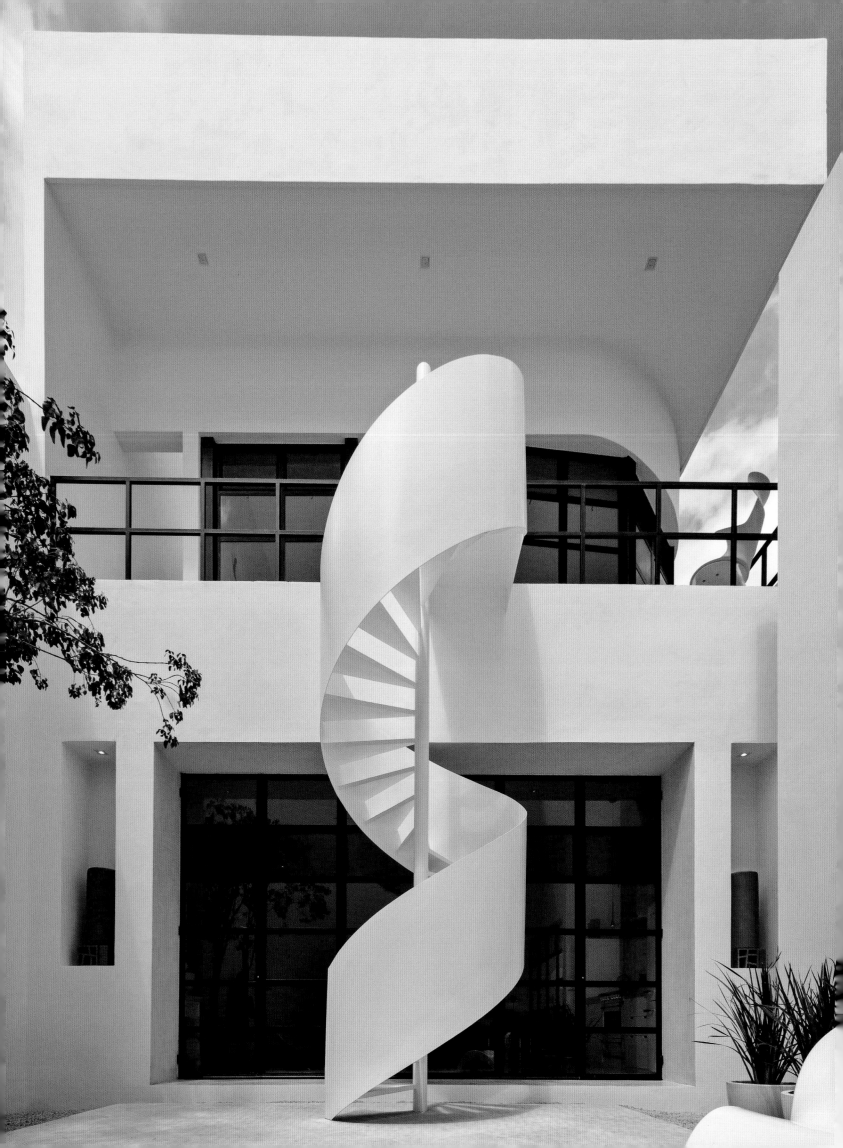

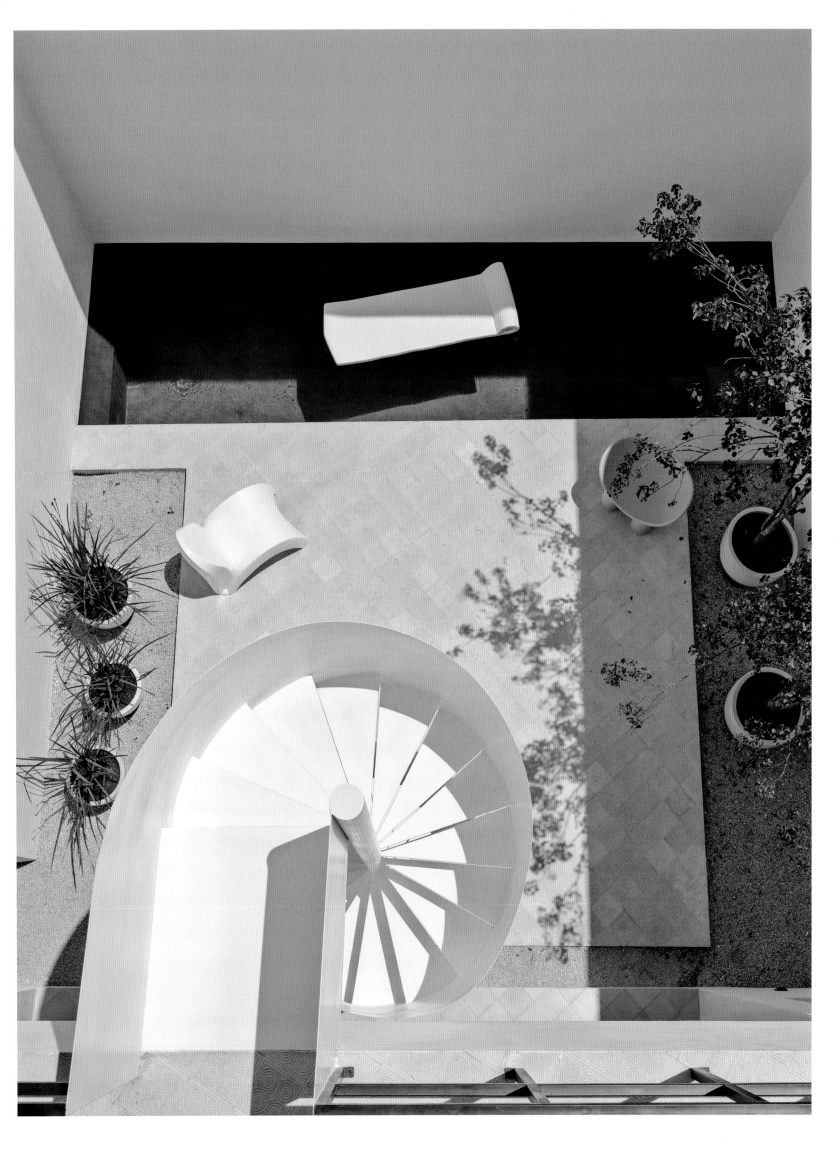

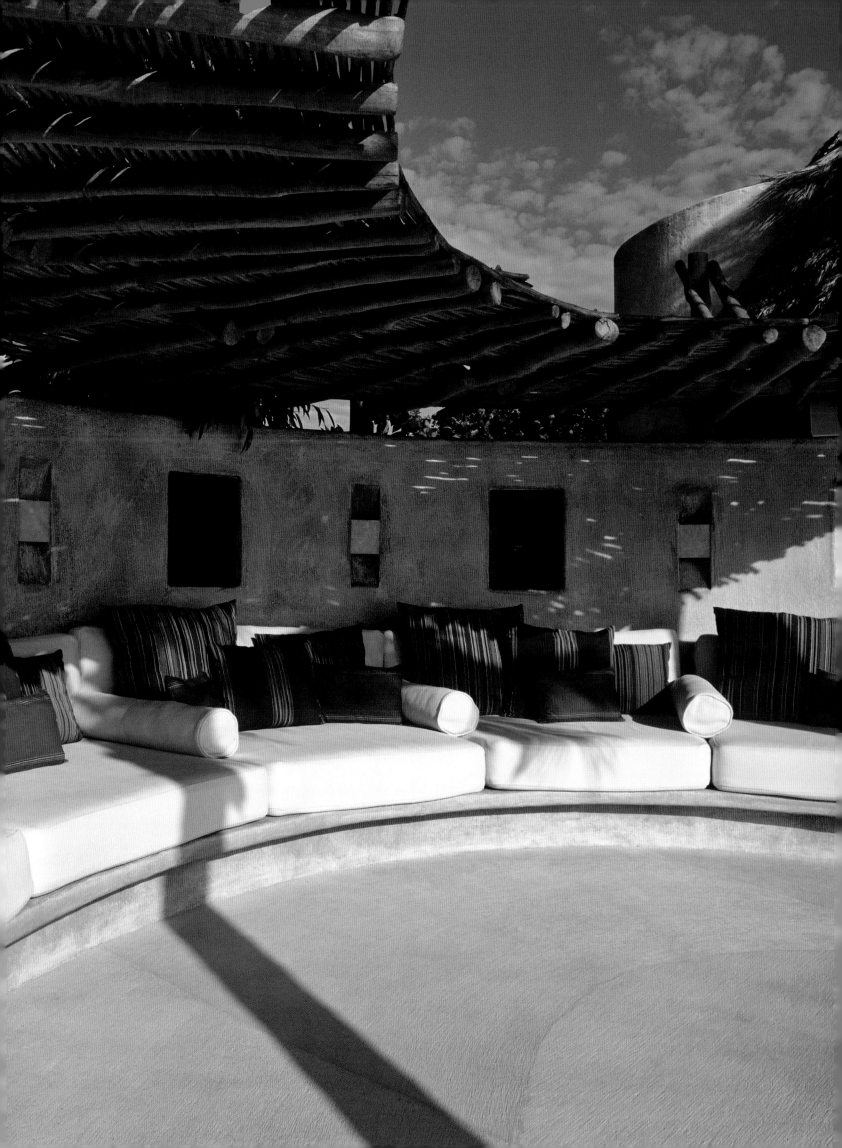

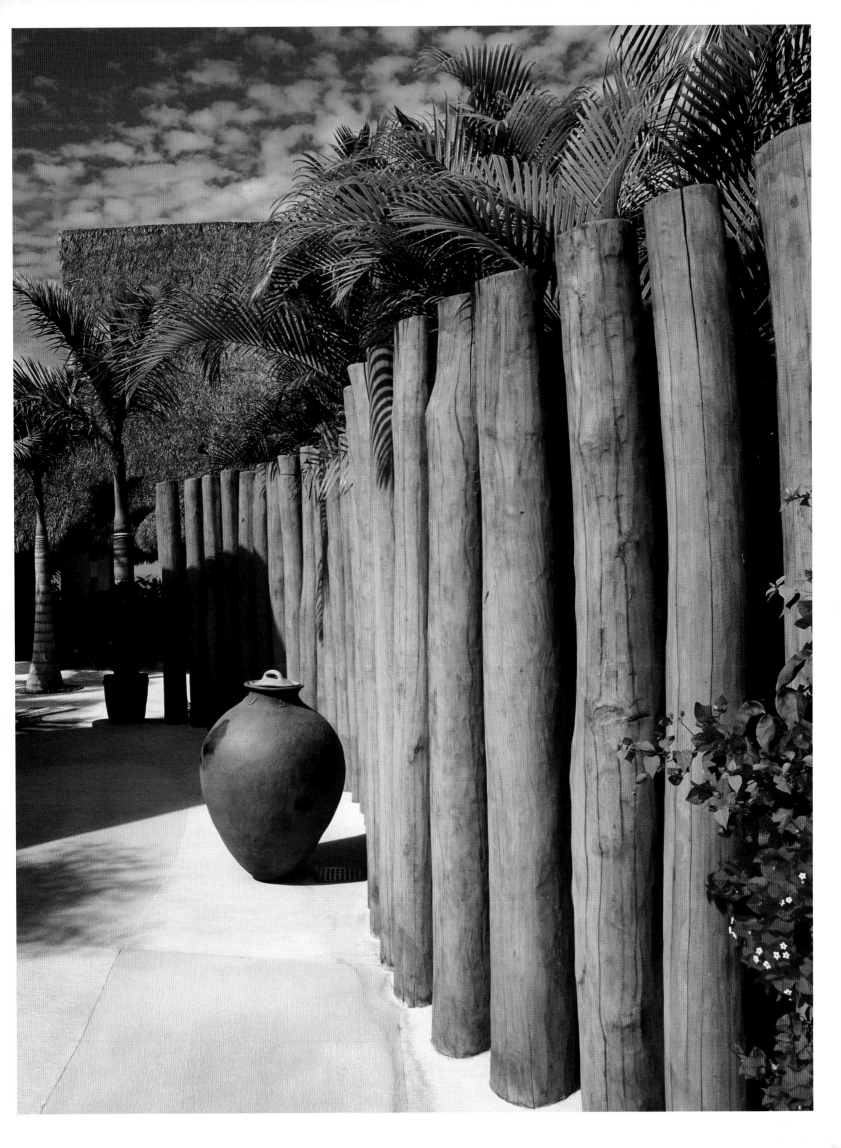

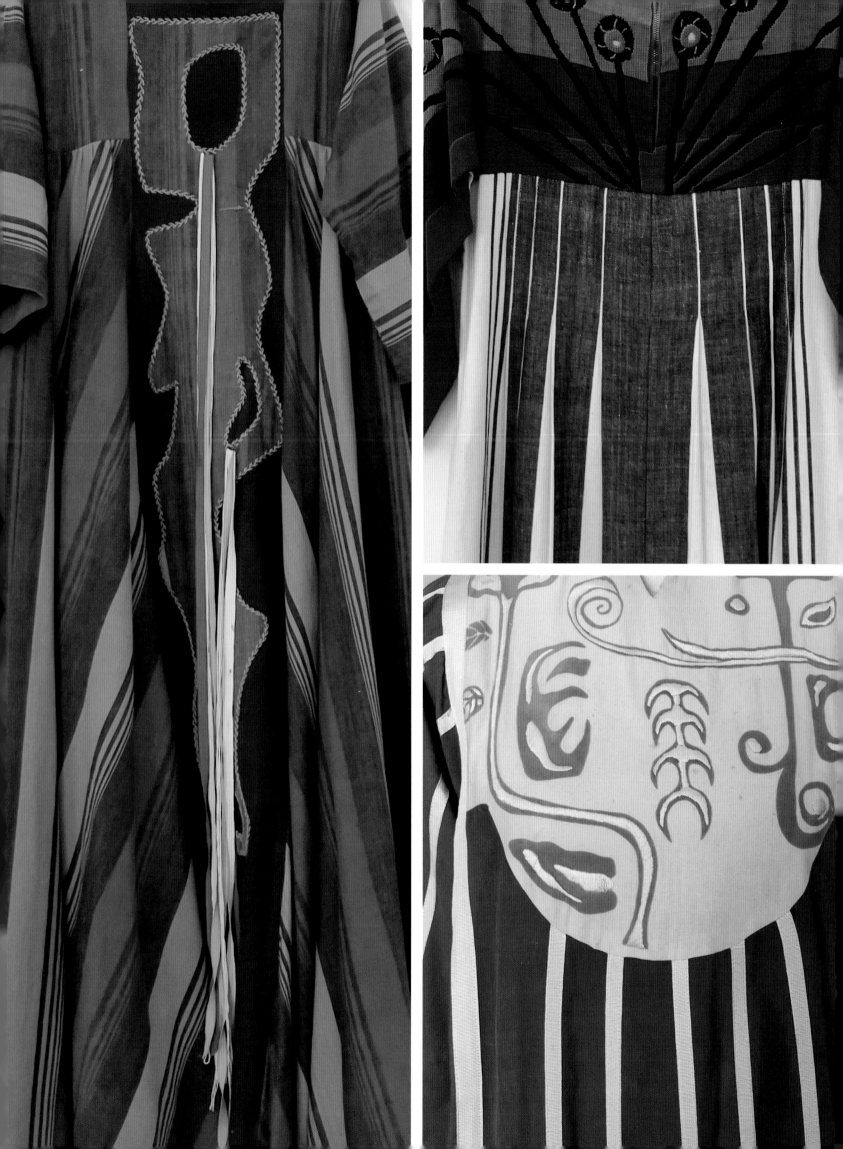

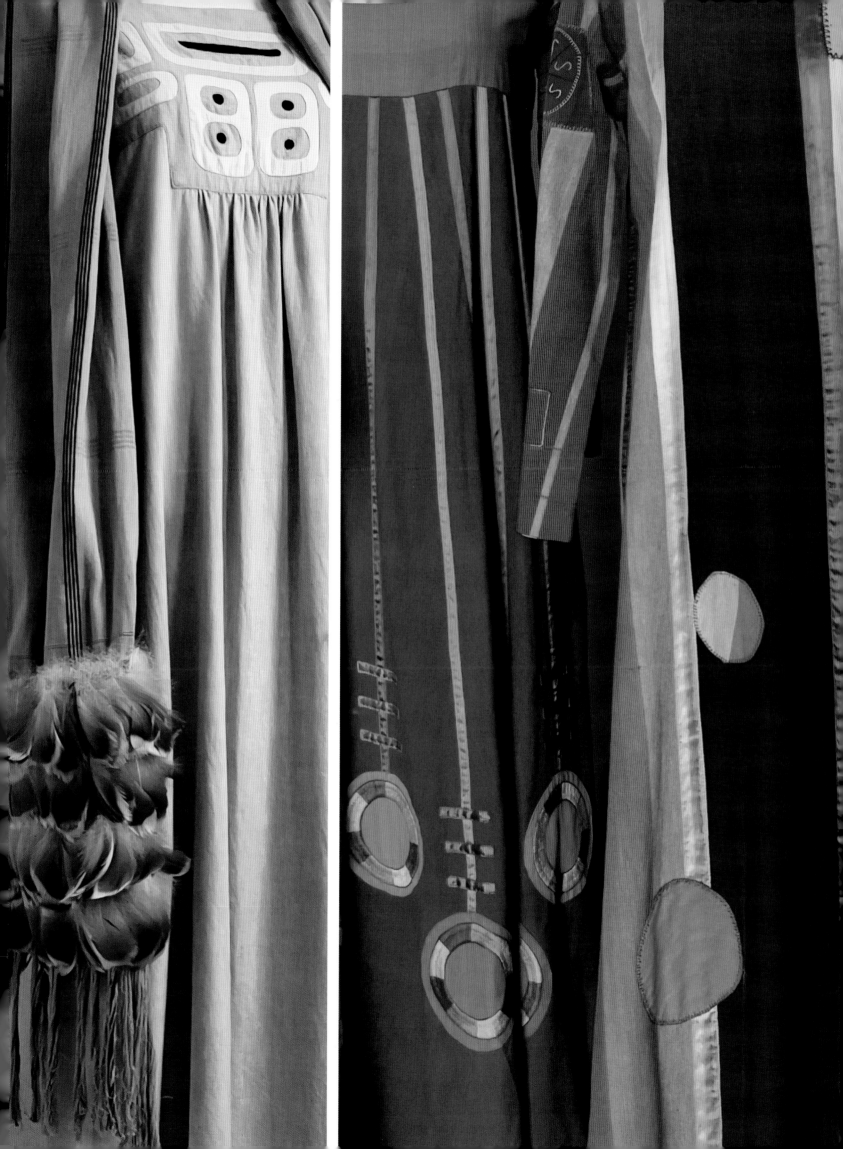

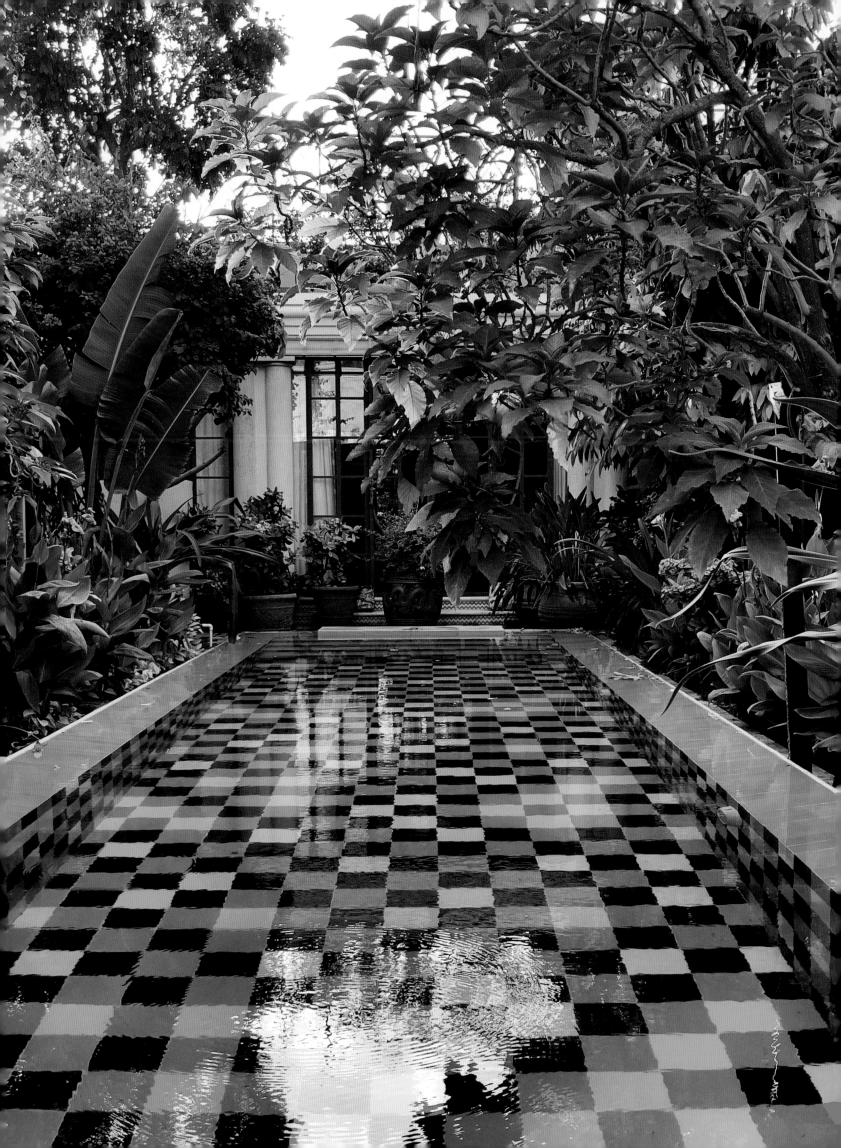

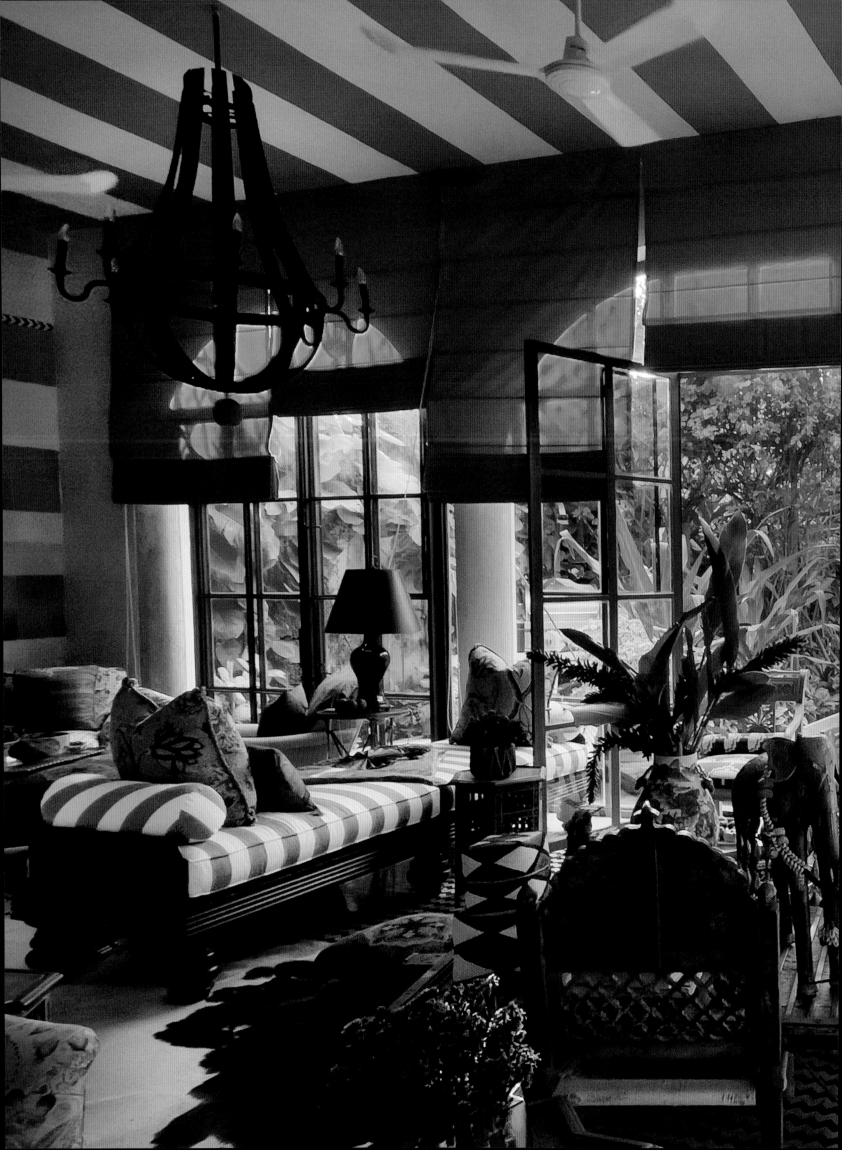

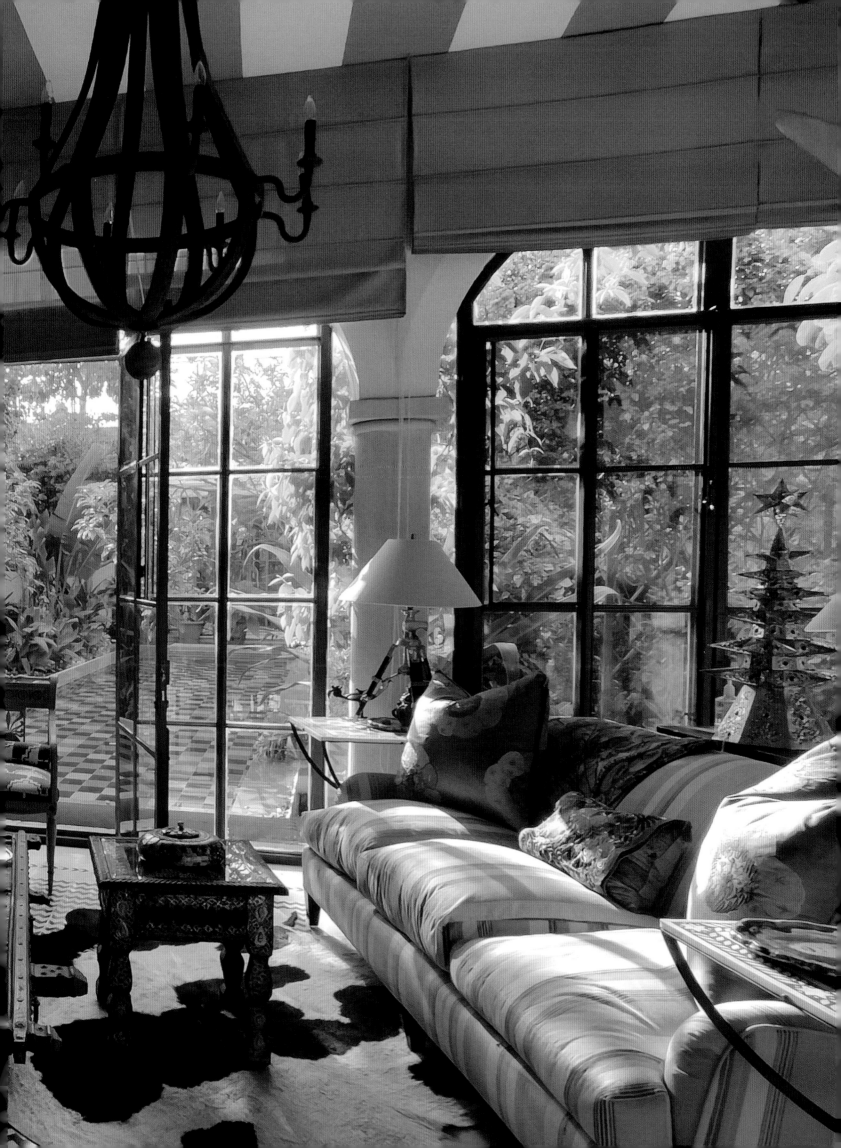

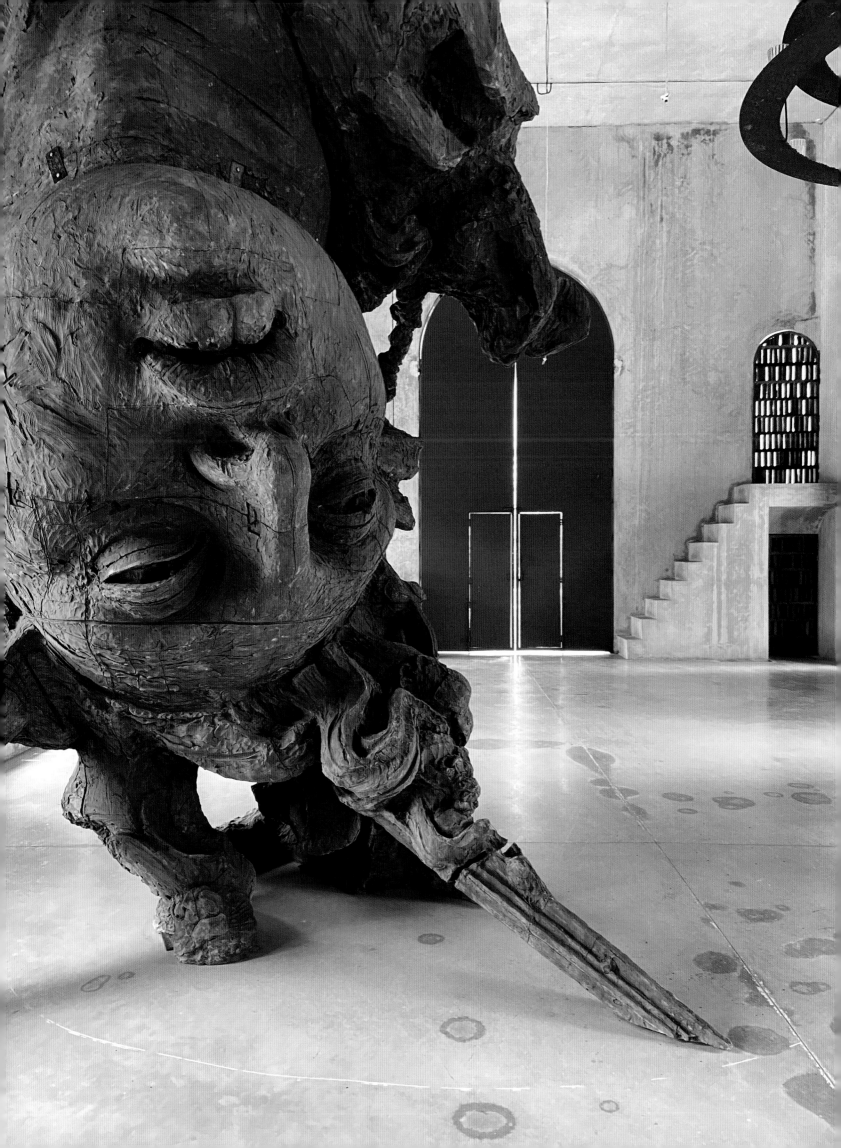

México's ancient traditions of hand-built architecture and its indigenous penchant for monumentalism, even at the domestic level, were both distinct contributions to the Modernist movement of the mid-twentieth century, which struggled from its beginning with the fundamental human need for warmth. Color and texture in Mexican Modernism gave the architecture an enduring, real-life appeal. It is epitomized by the work of the legendary Louis Barragán and the other early Mexican Modernist architects who founded the Tapatía Architecture School in Guadalajara. They and others imbued the Modernist movement here with a vernacular language that endures and continues to evolve even today.

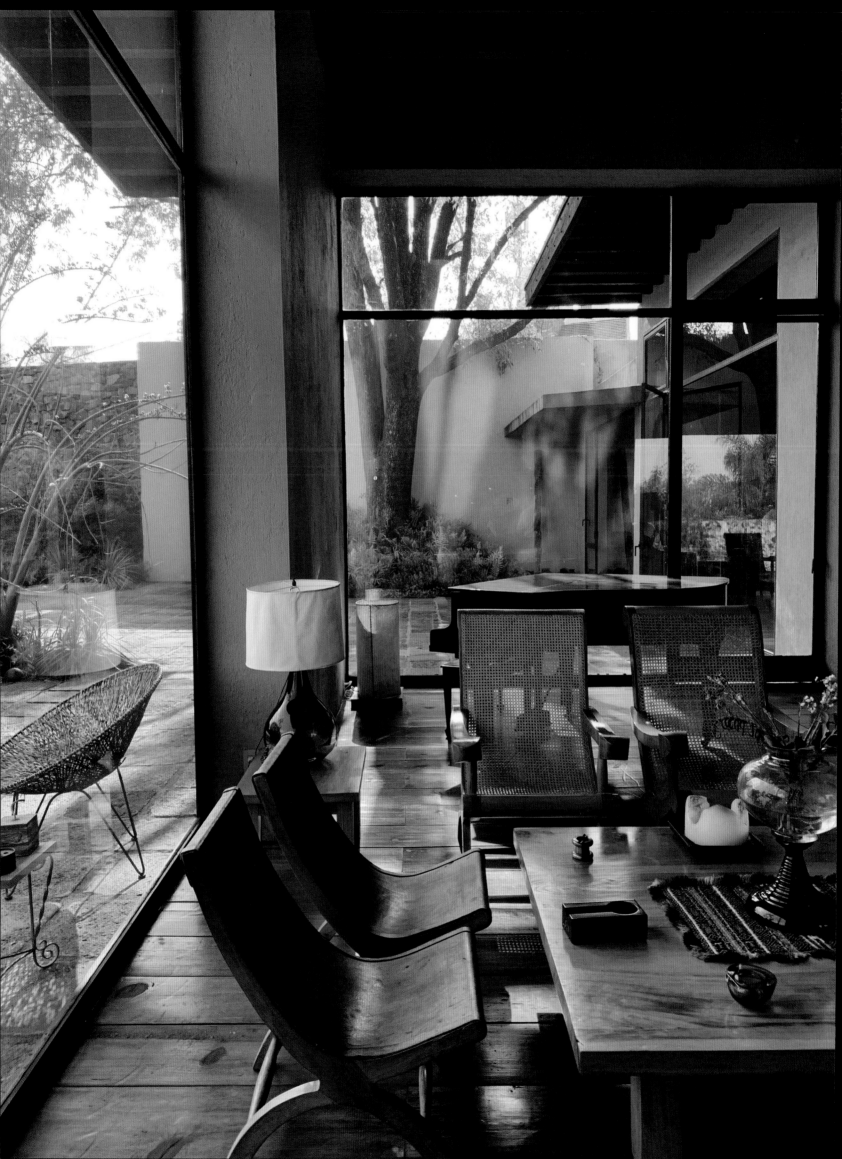

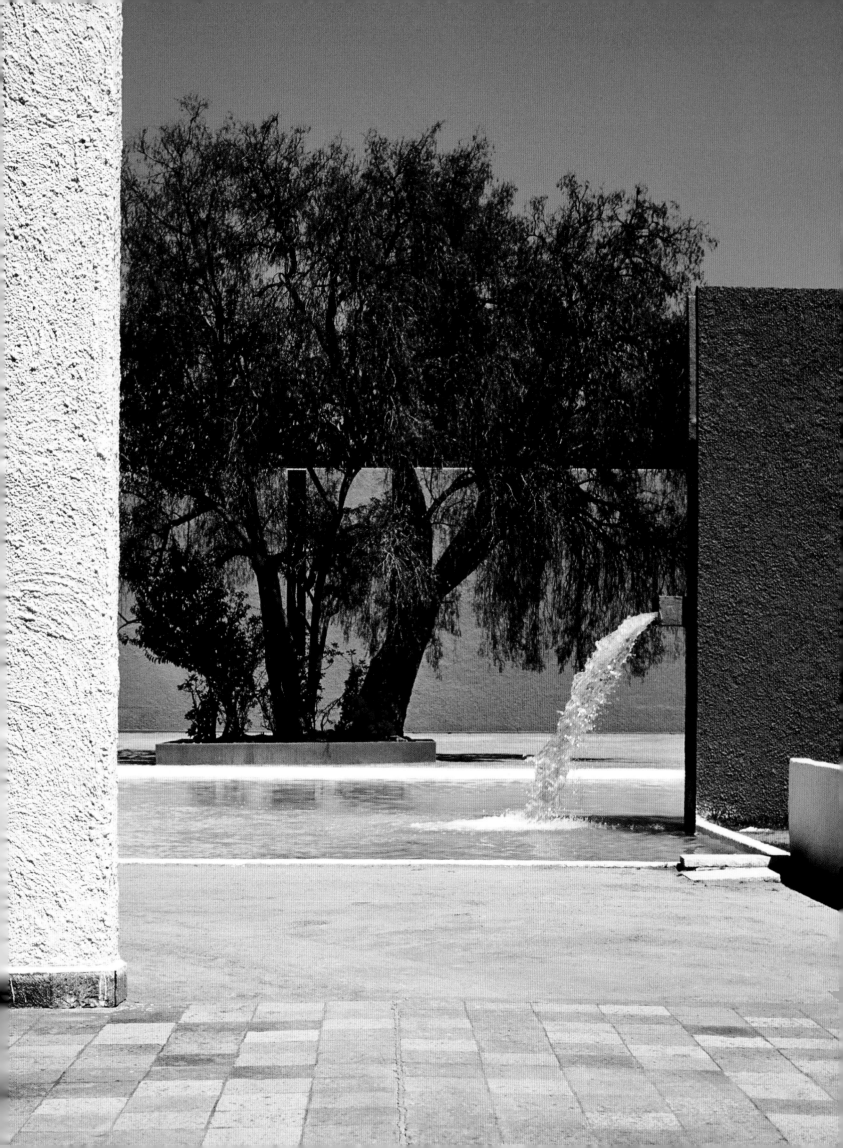

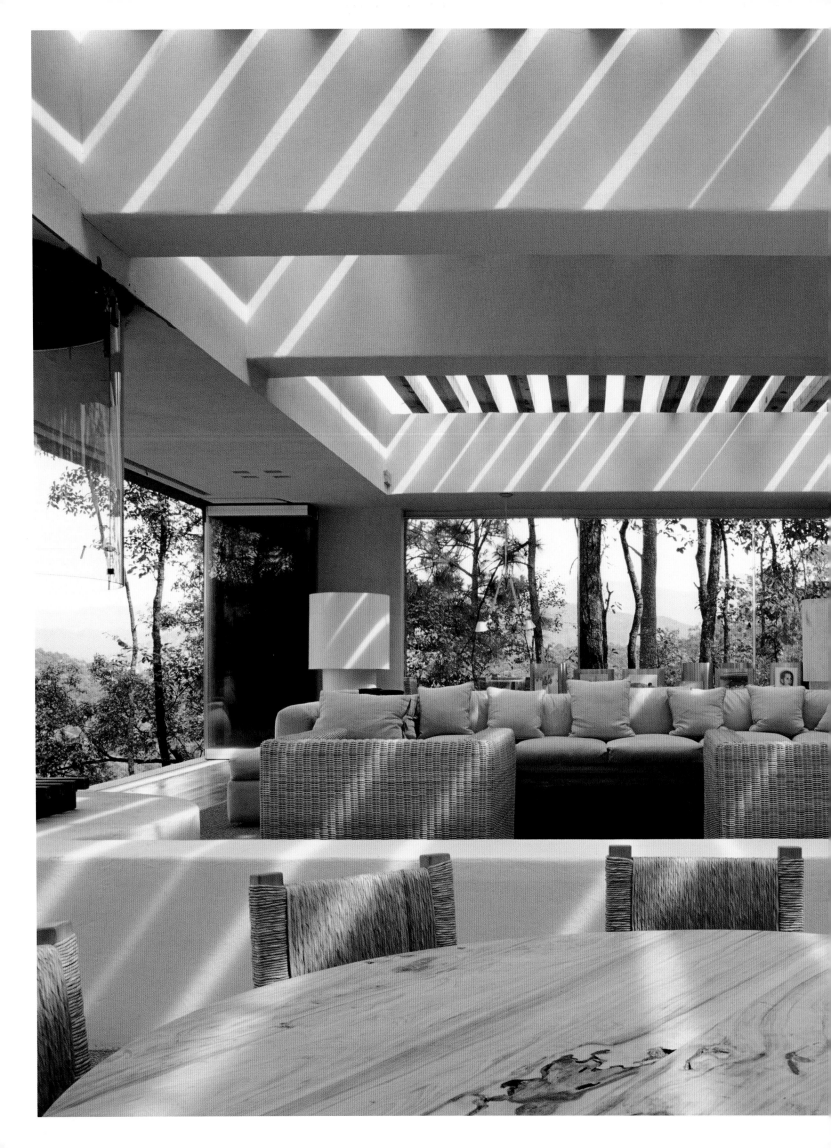

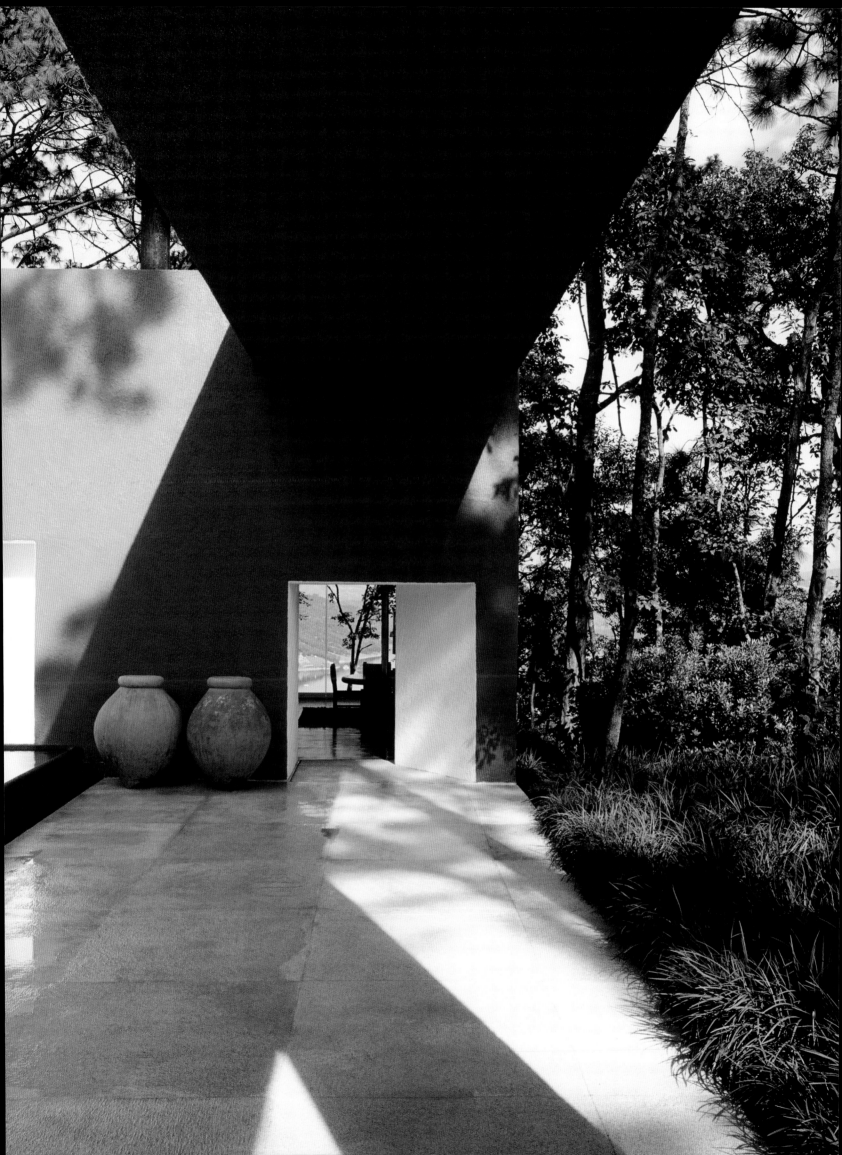

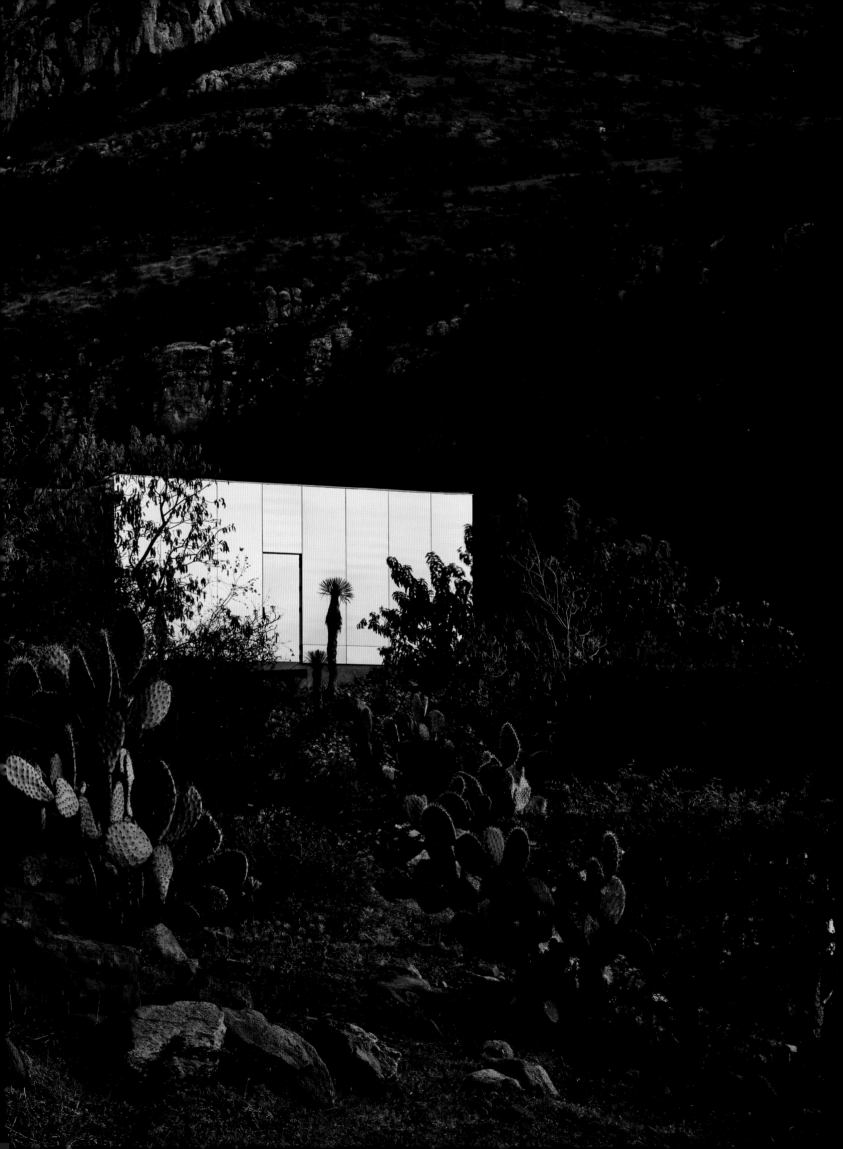

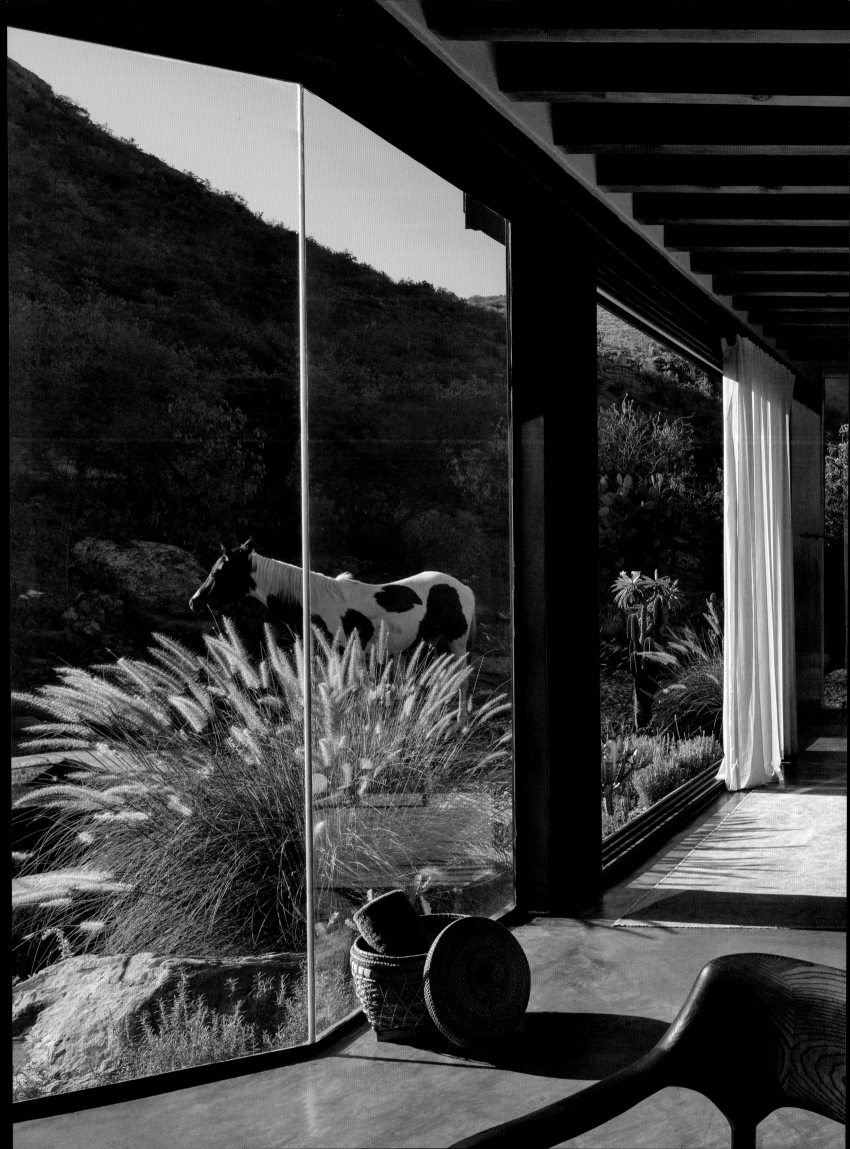

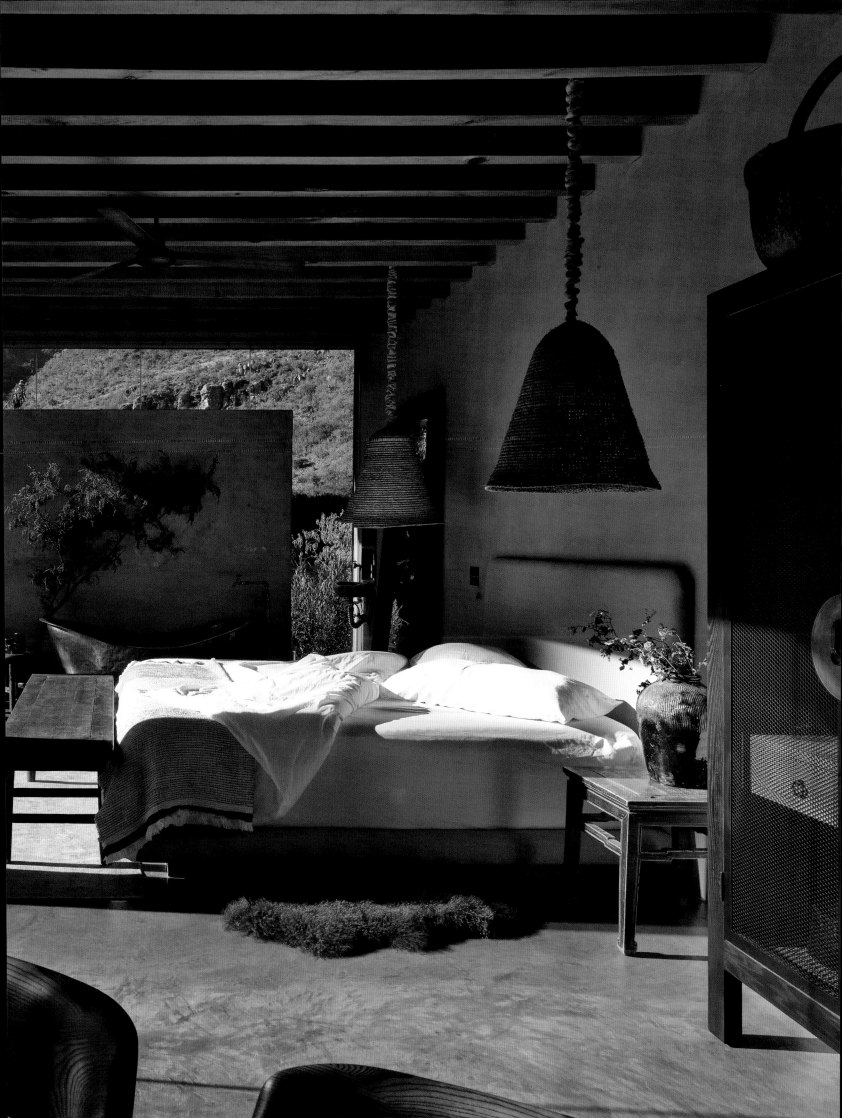

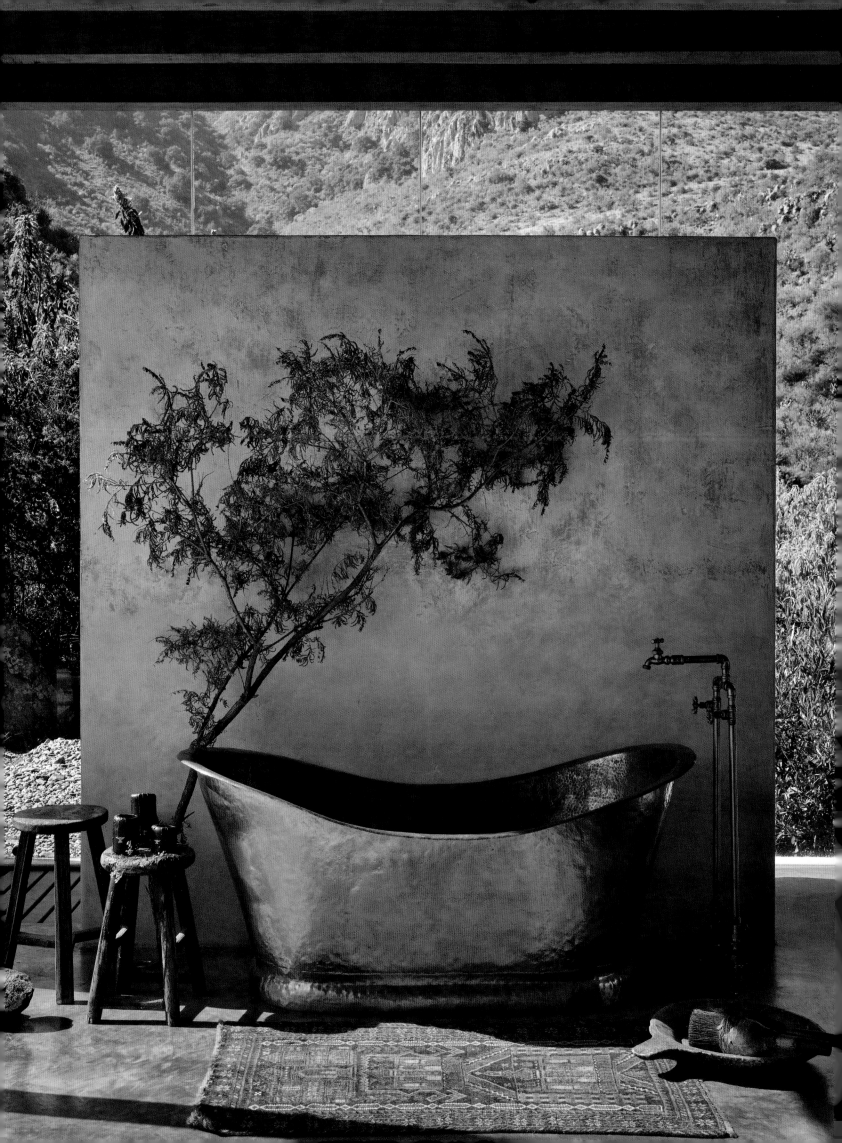

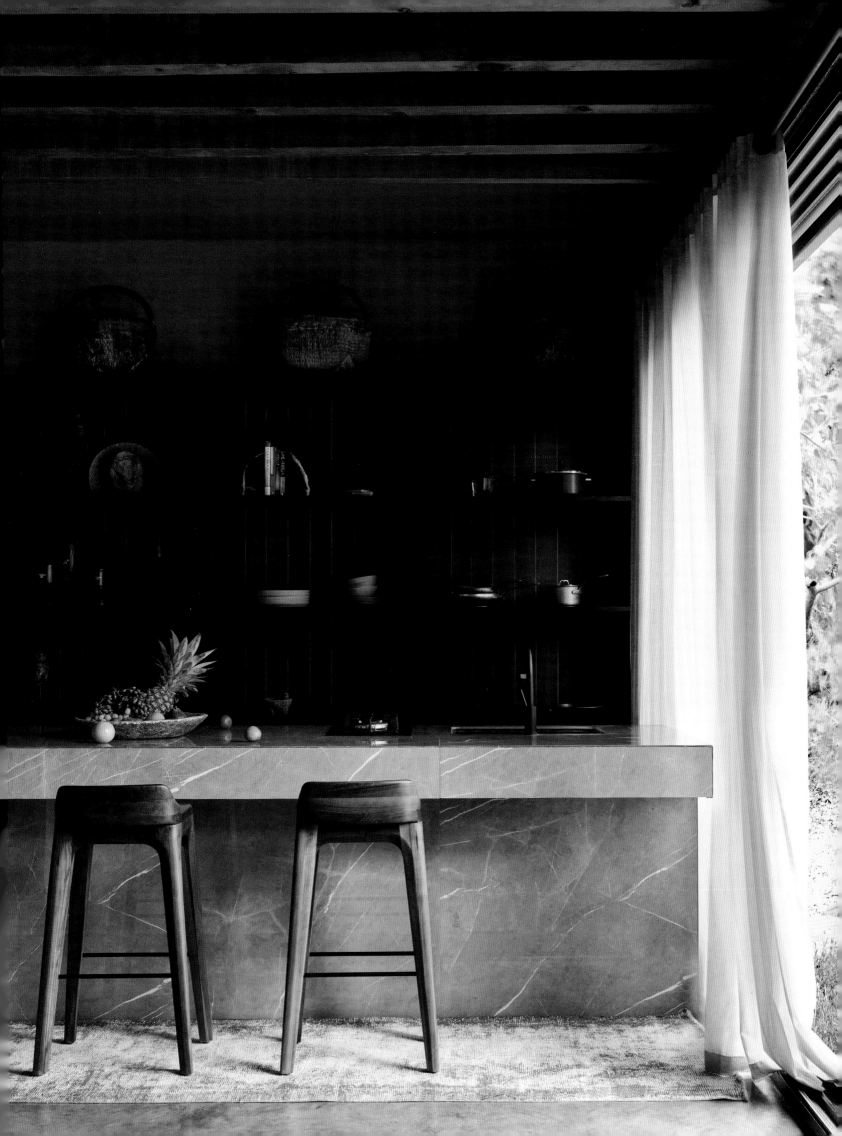

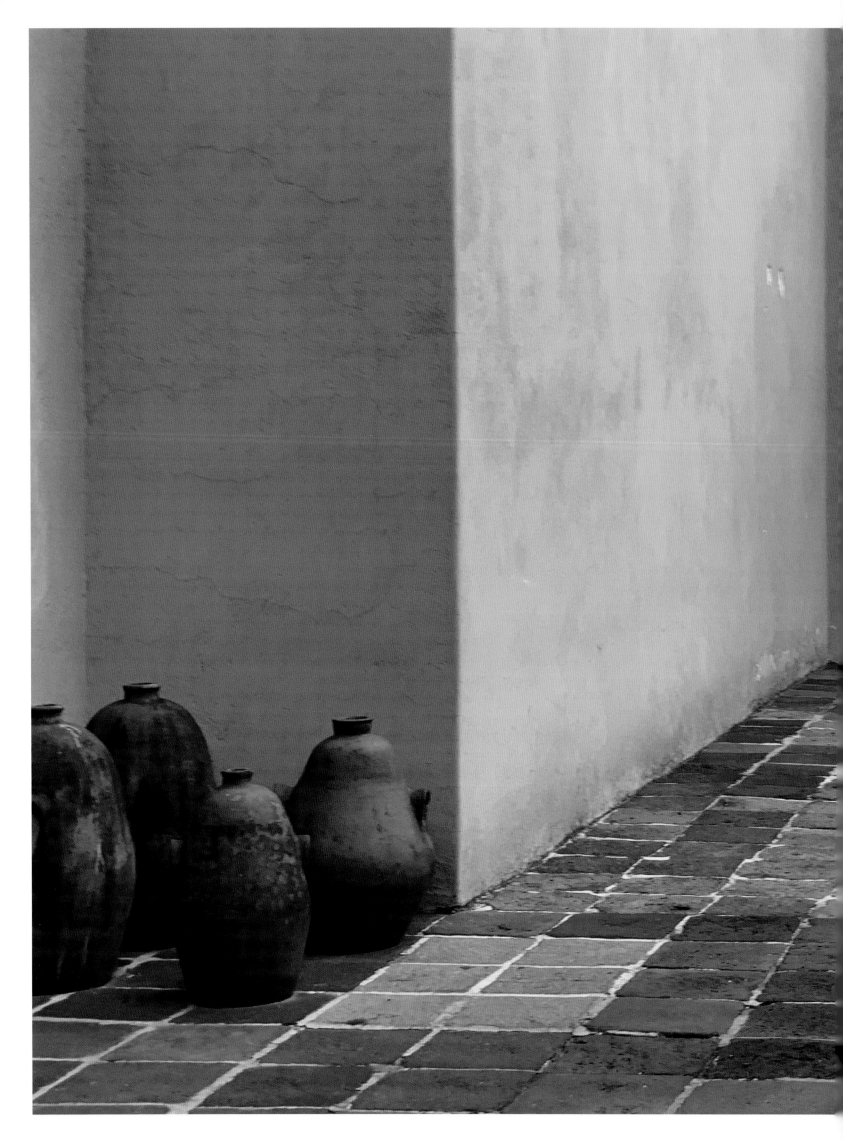

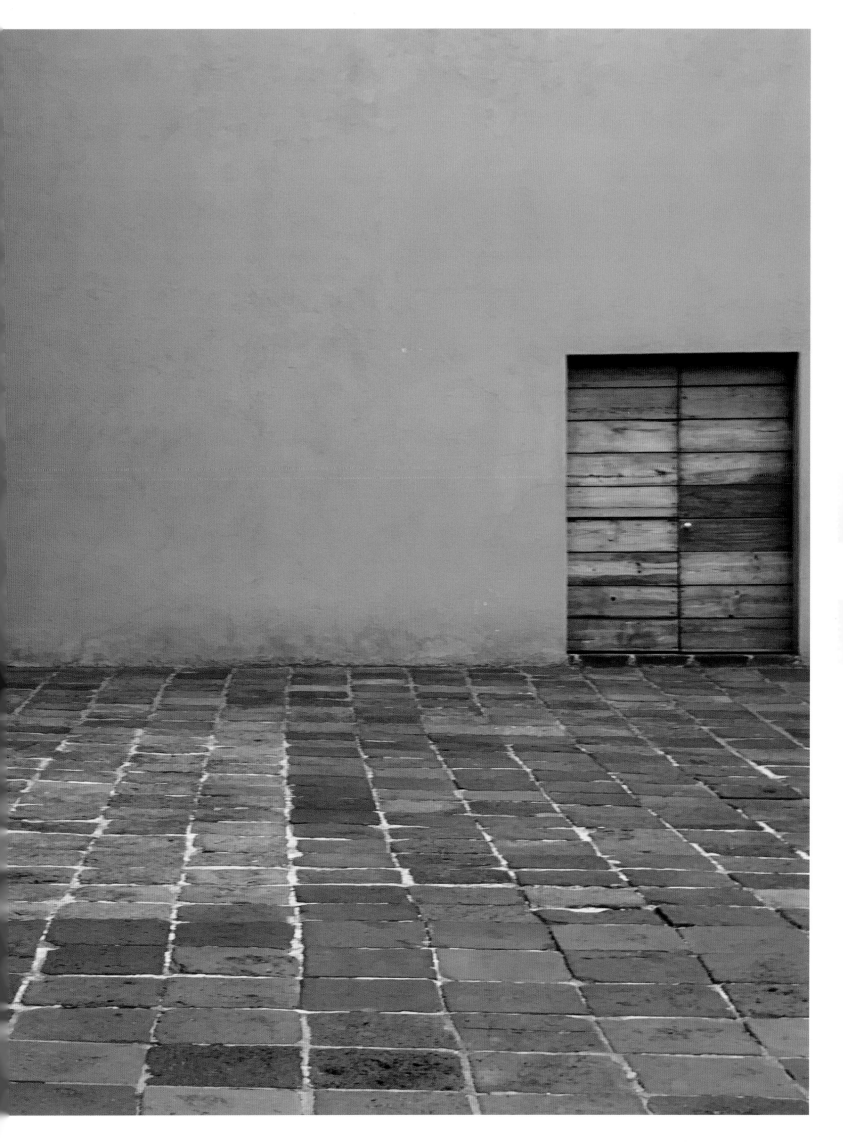

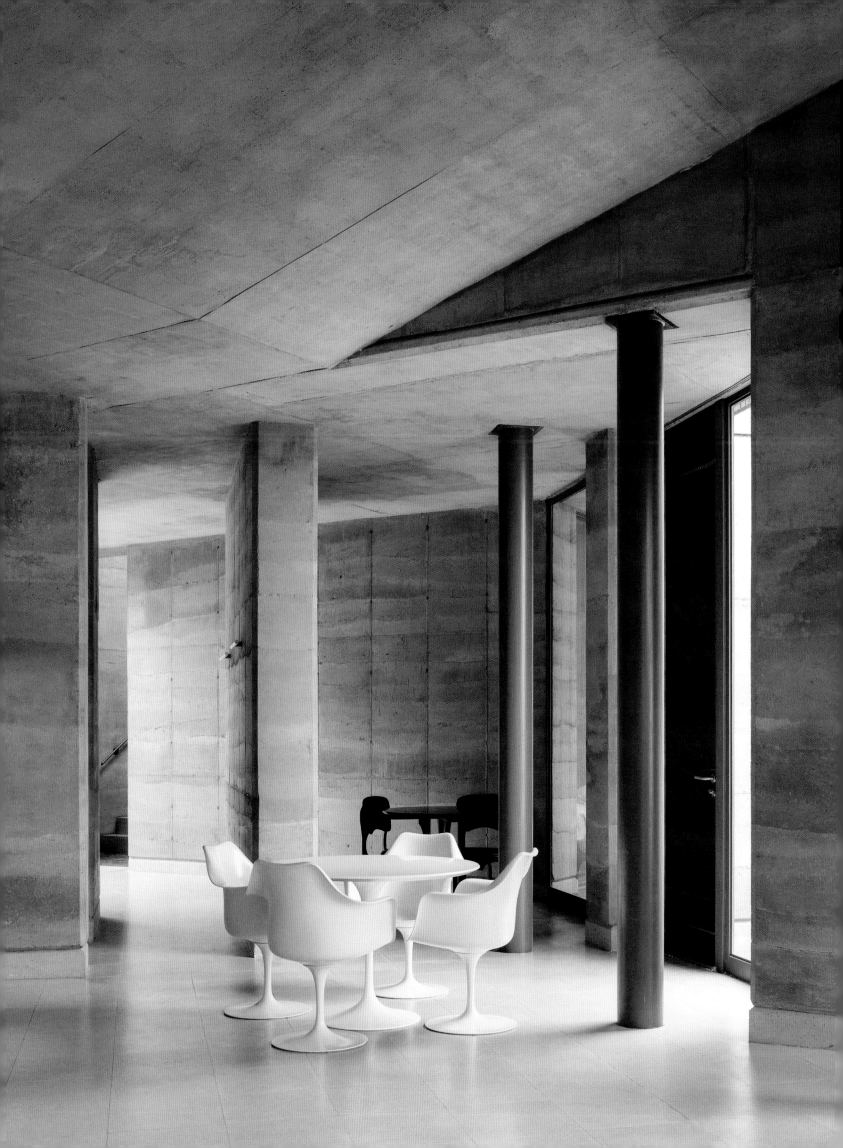

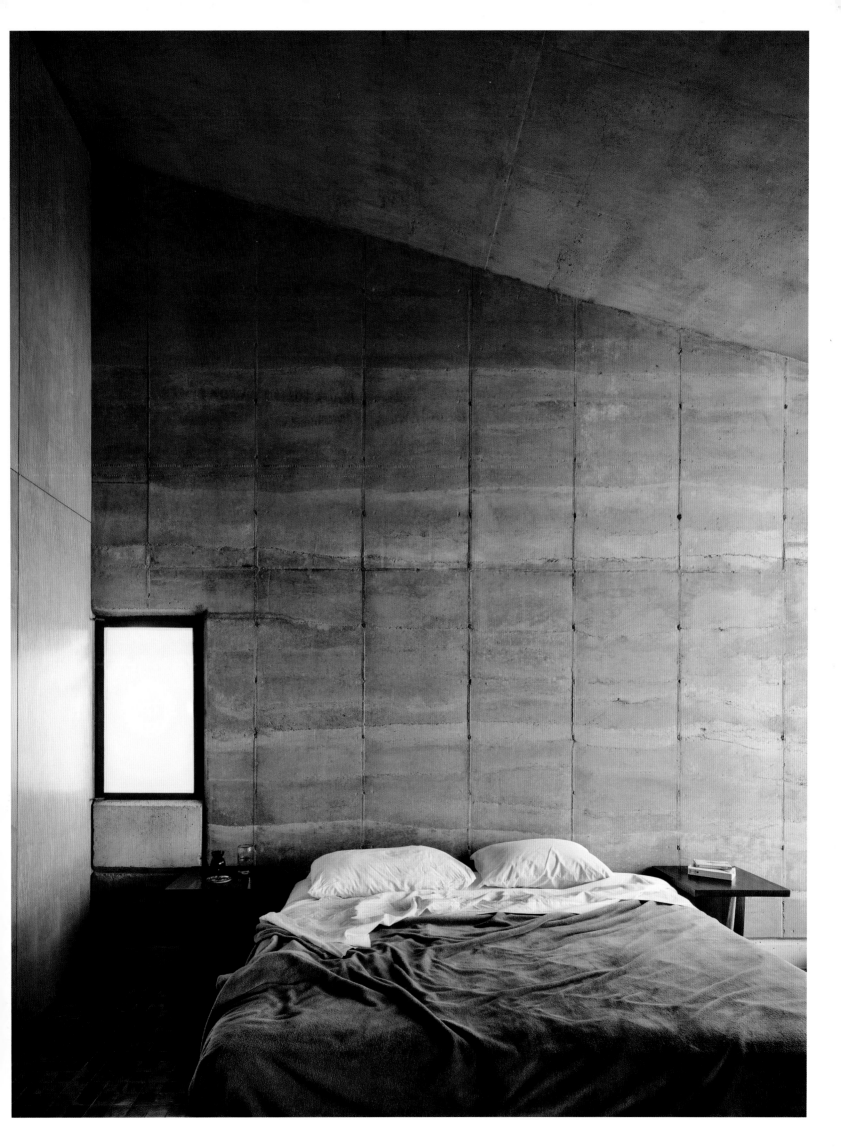

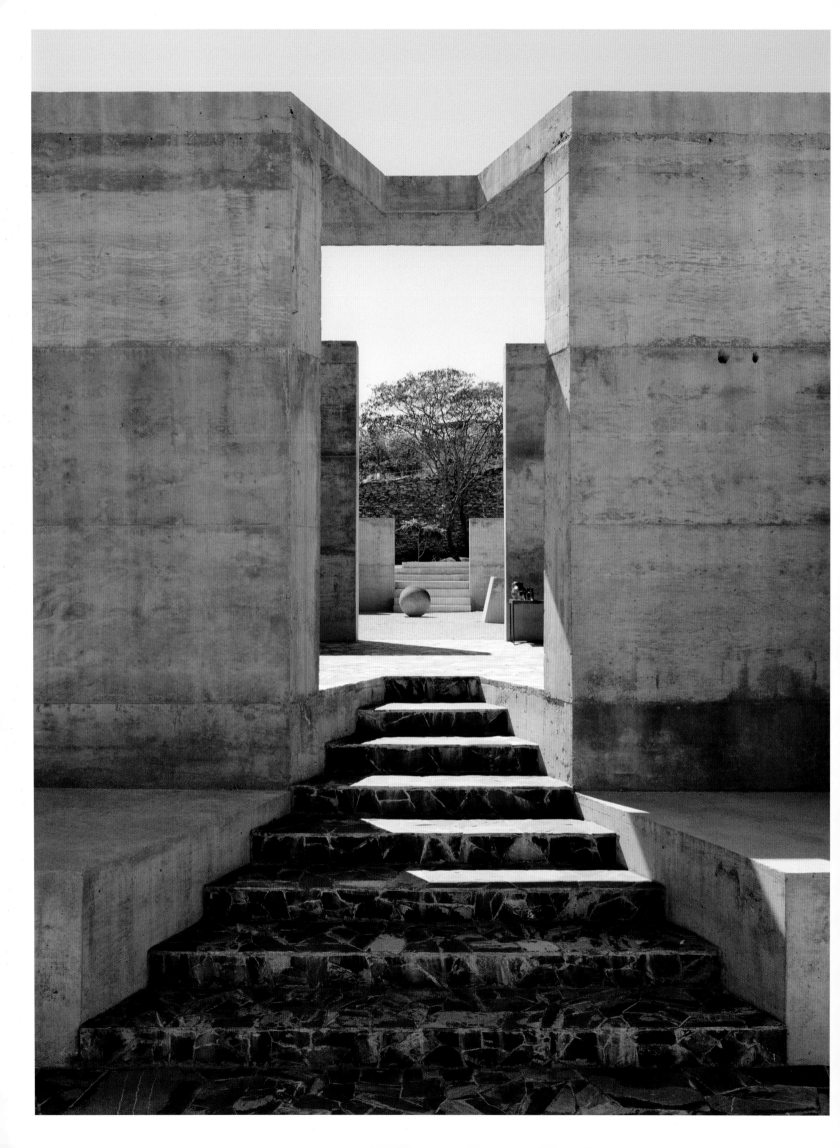

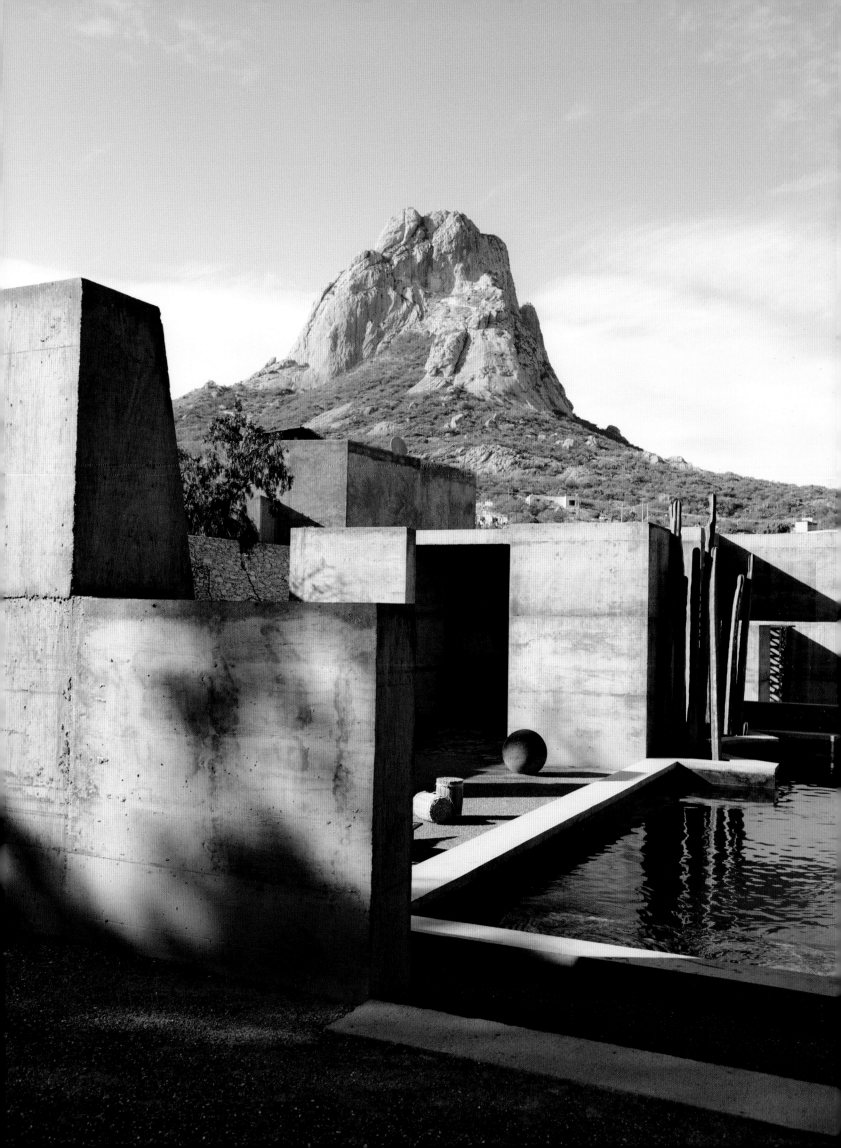

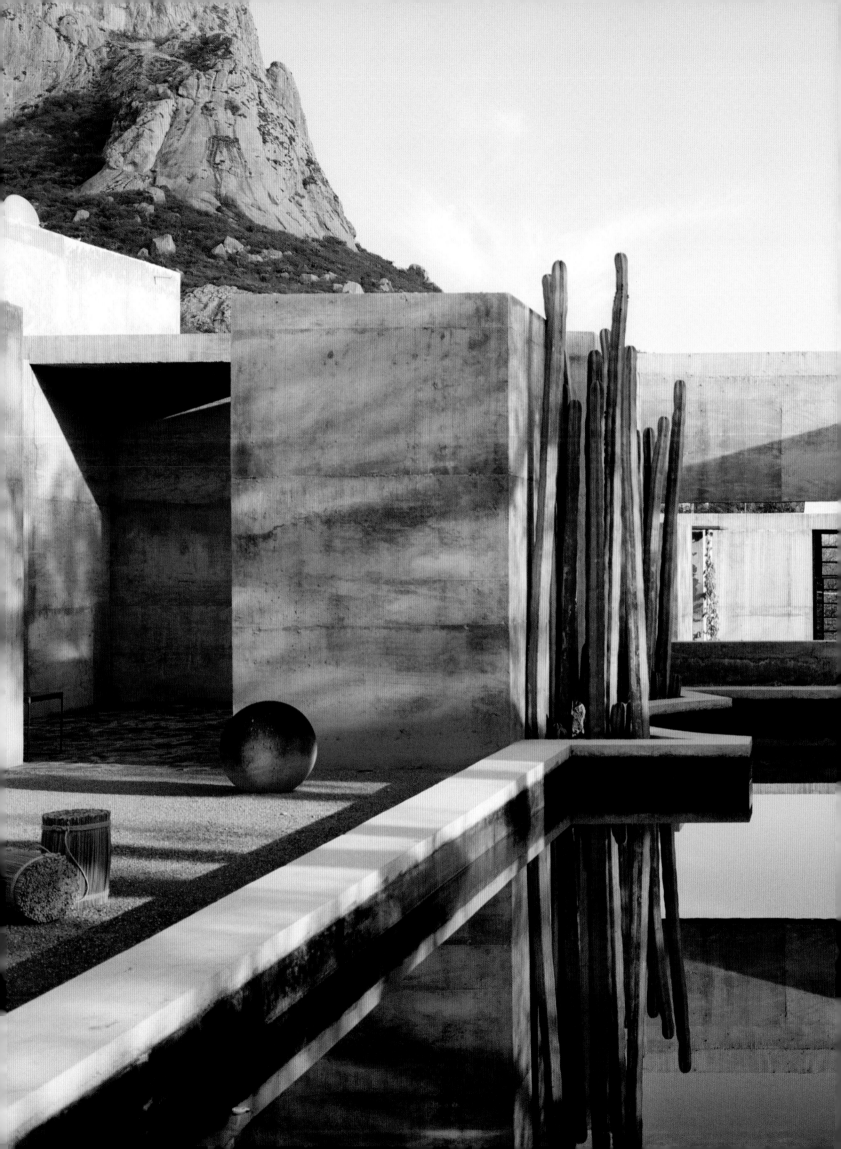

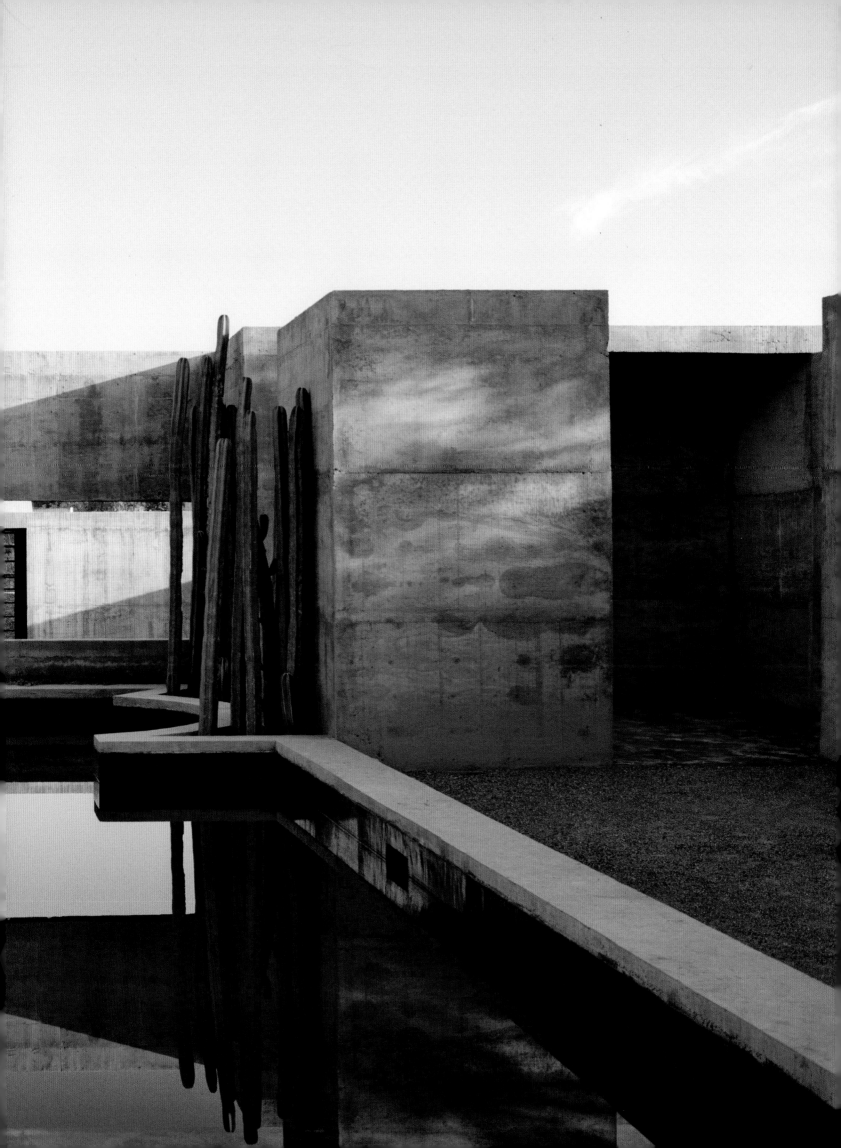

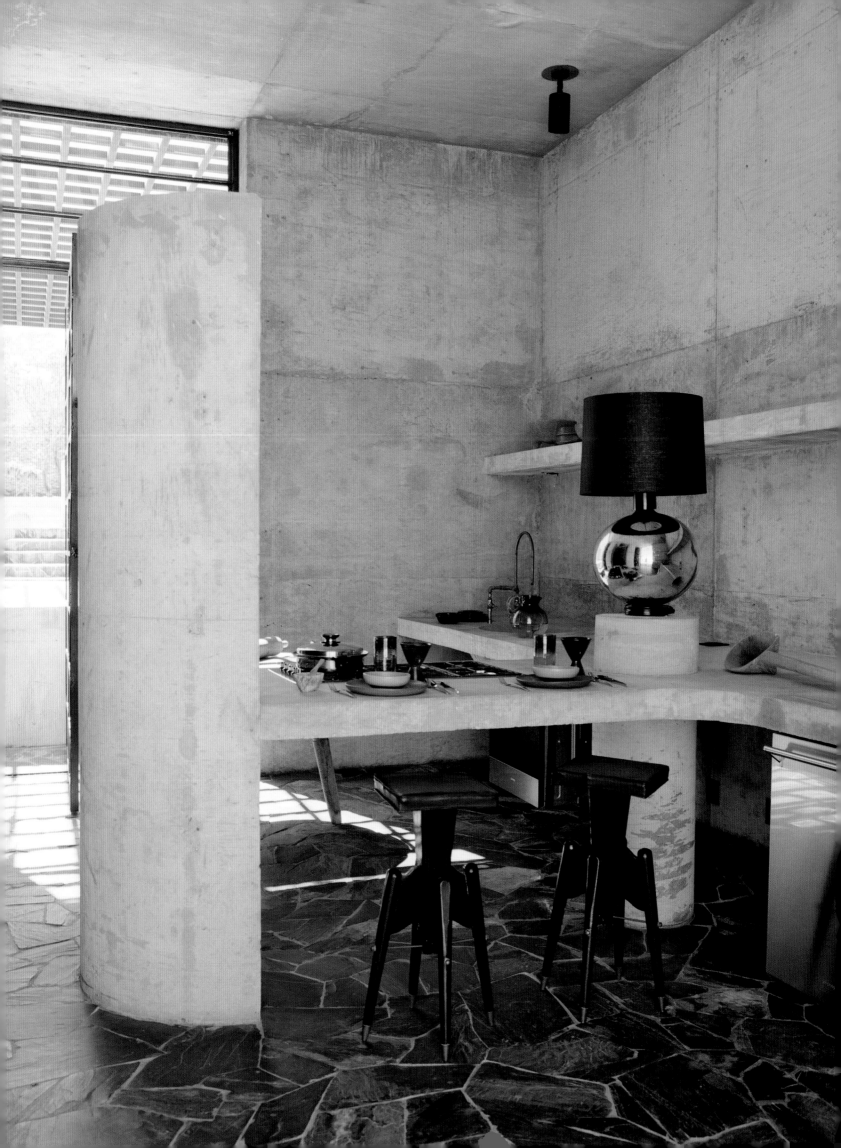

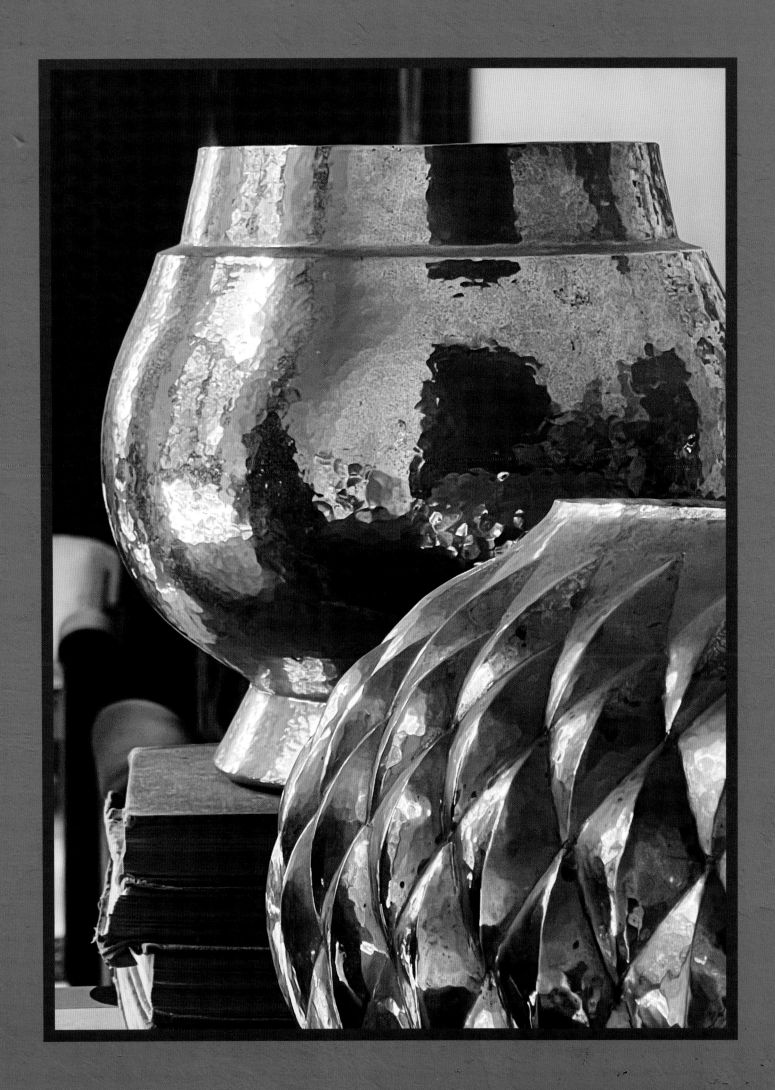

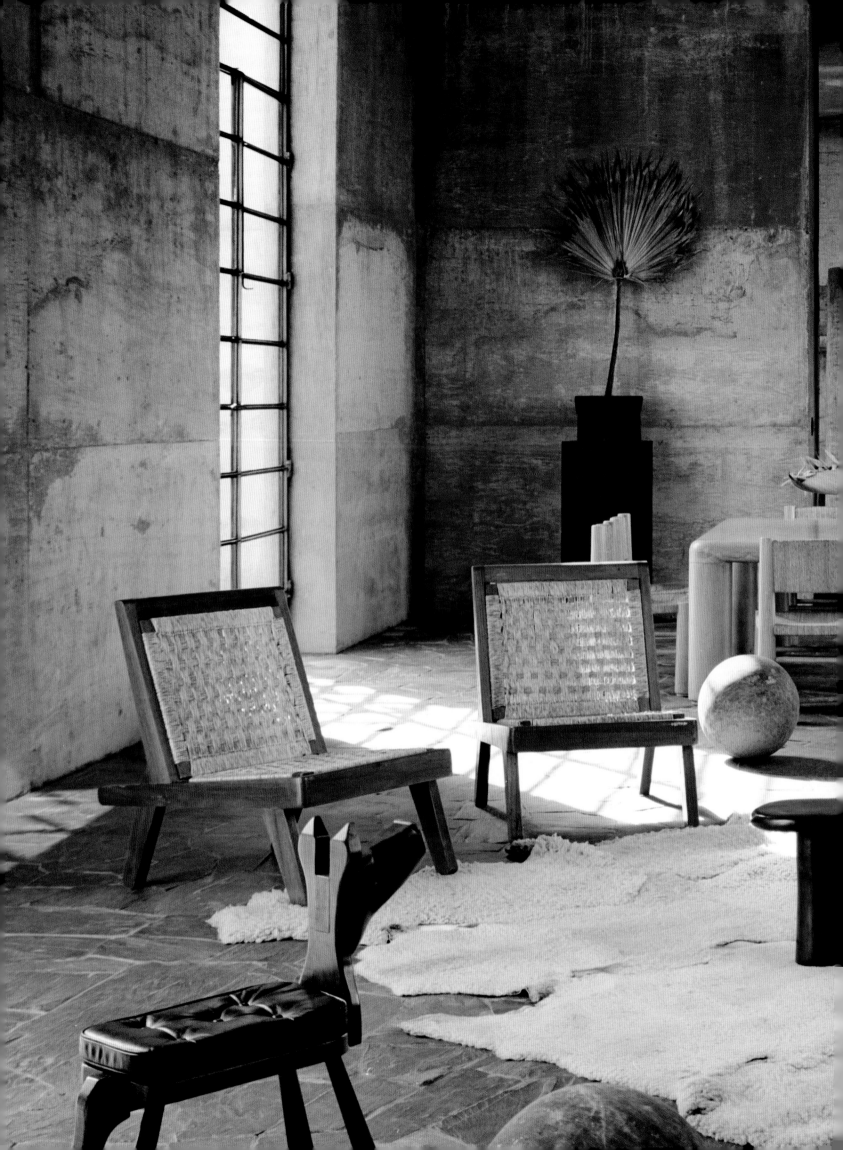

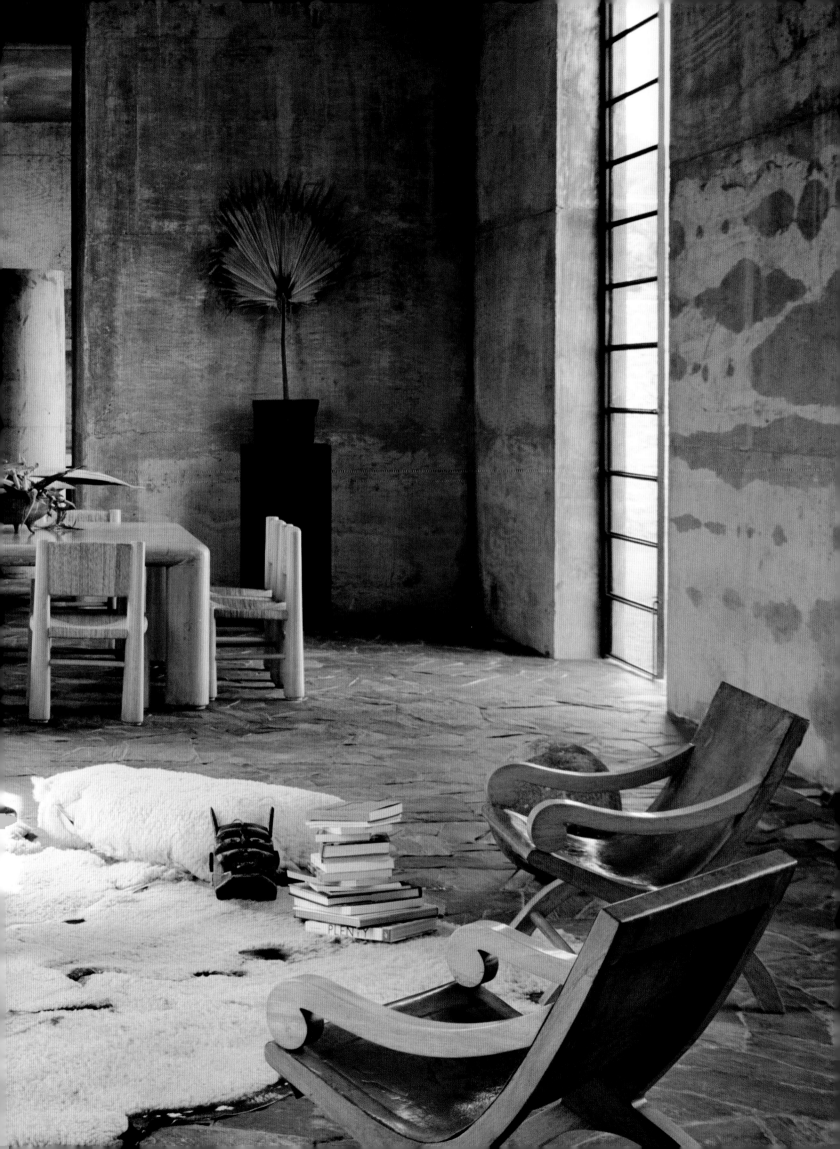

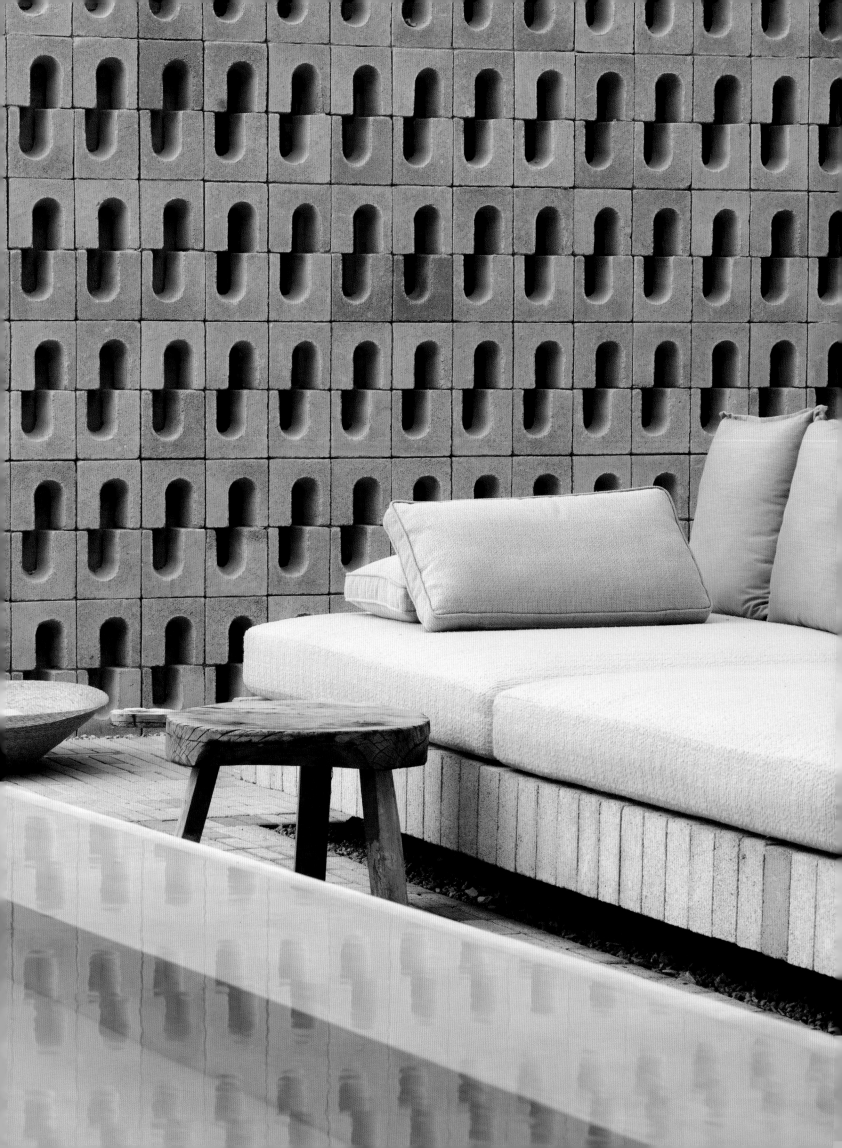

# CONTEMPORARY

While contemporary technically means the present, it has come to define a freeform style, and at least for the foreseeable future shows no signs of being supplanted by a new decorative "period." It's almost impossibly broad to define, encompassing endless historical references combined with unrestrained freedom—a time when a heightened sense of individual style is expressed through the decorative arts and architecture, both old and new. Technology, always playing a fascinating role behind the scenes, has, like nothing before, completely enabled design in all its possible expressions. This is also a time for new dialogues in design, especially on a north-south axis across the Americas. A distinctly Mexican design is emerging on the international stage, one that echoes the *Mexicanidad* movement but without political baggage. Mexican Contemporary is a particularly cognizant and exciting blend of the past and the future.

215

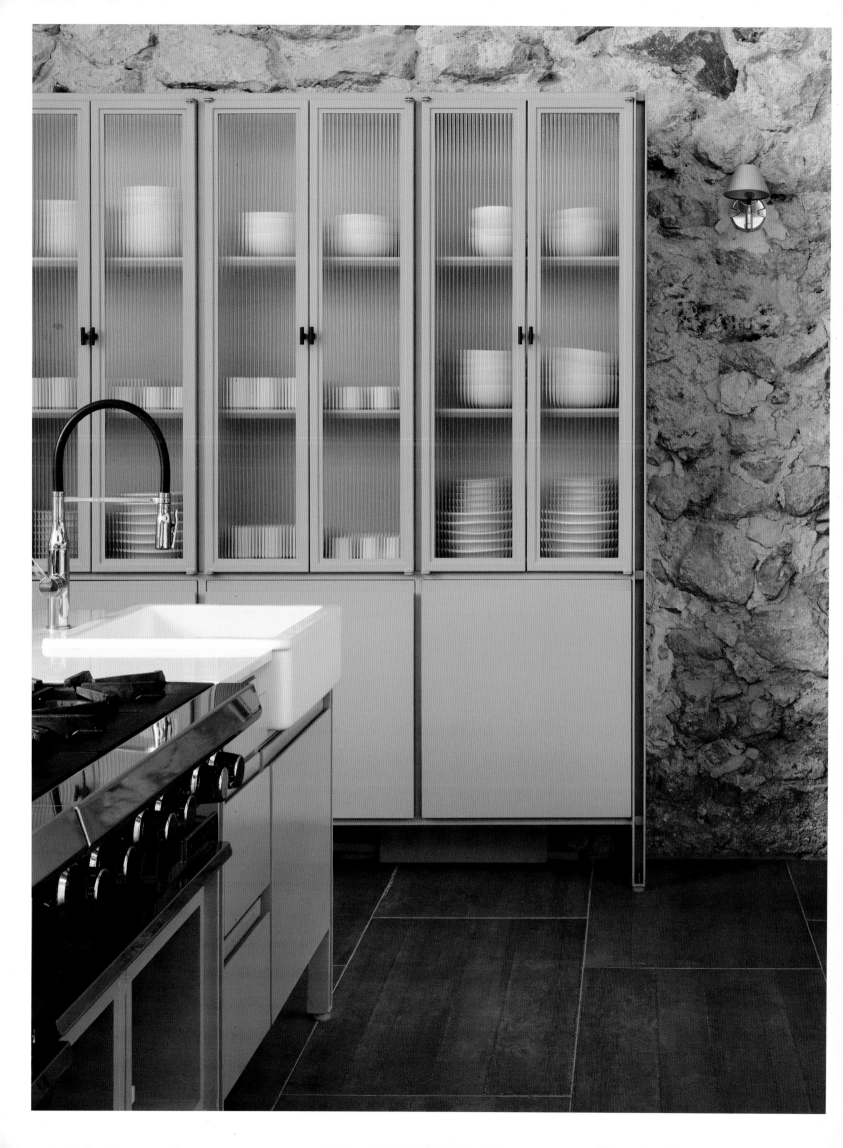

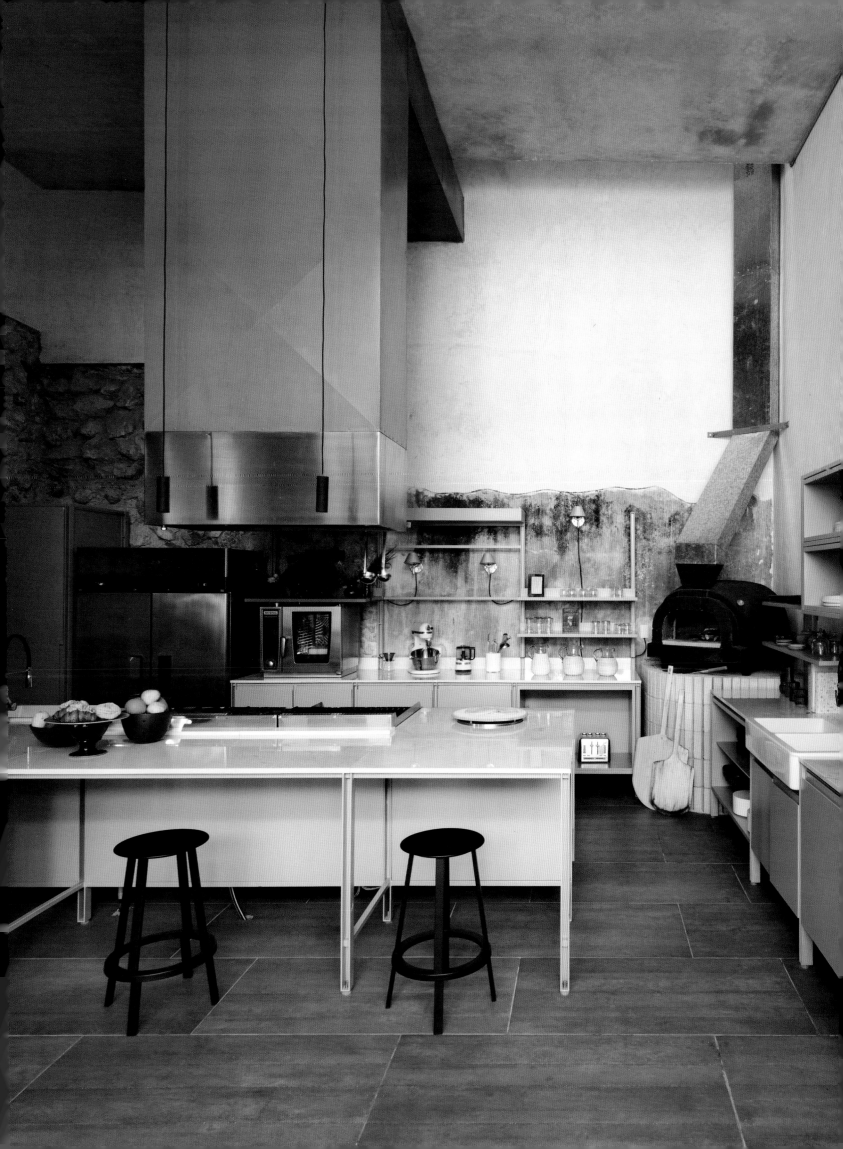

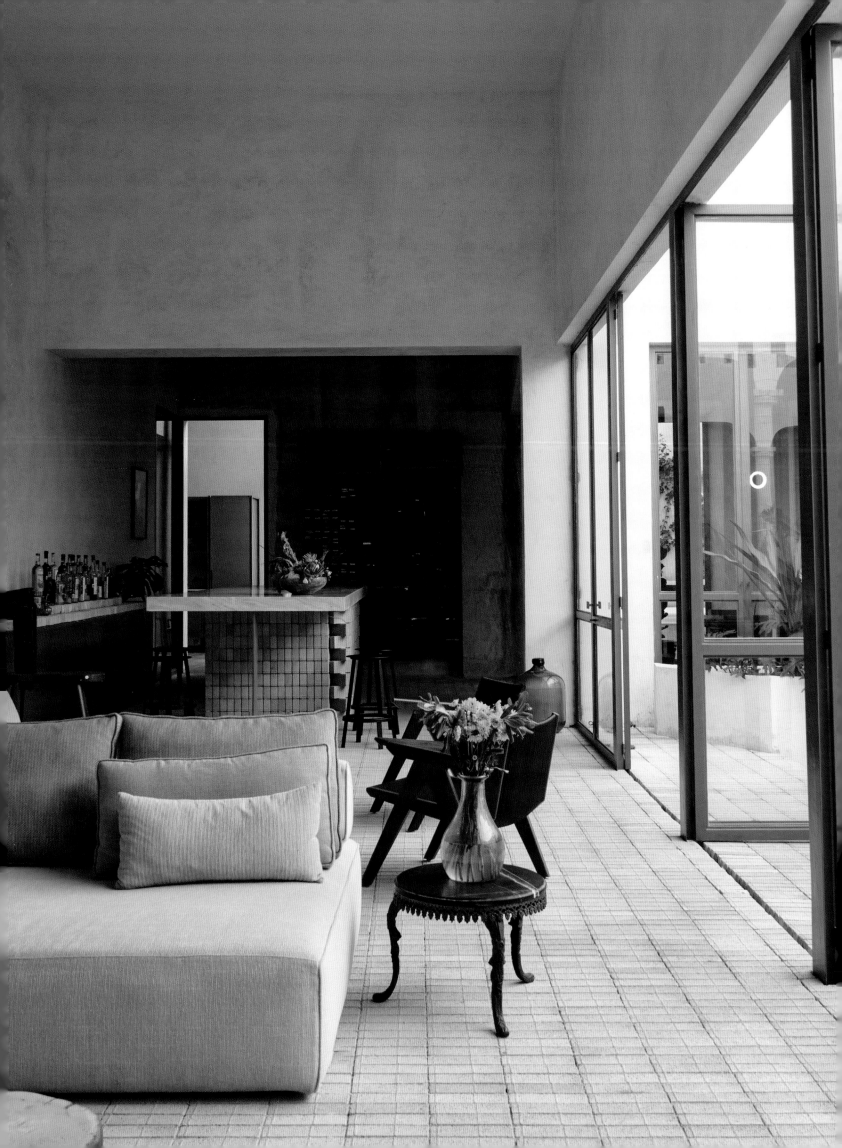

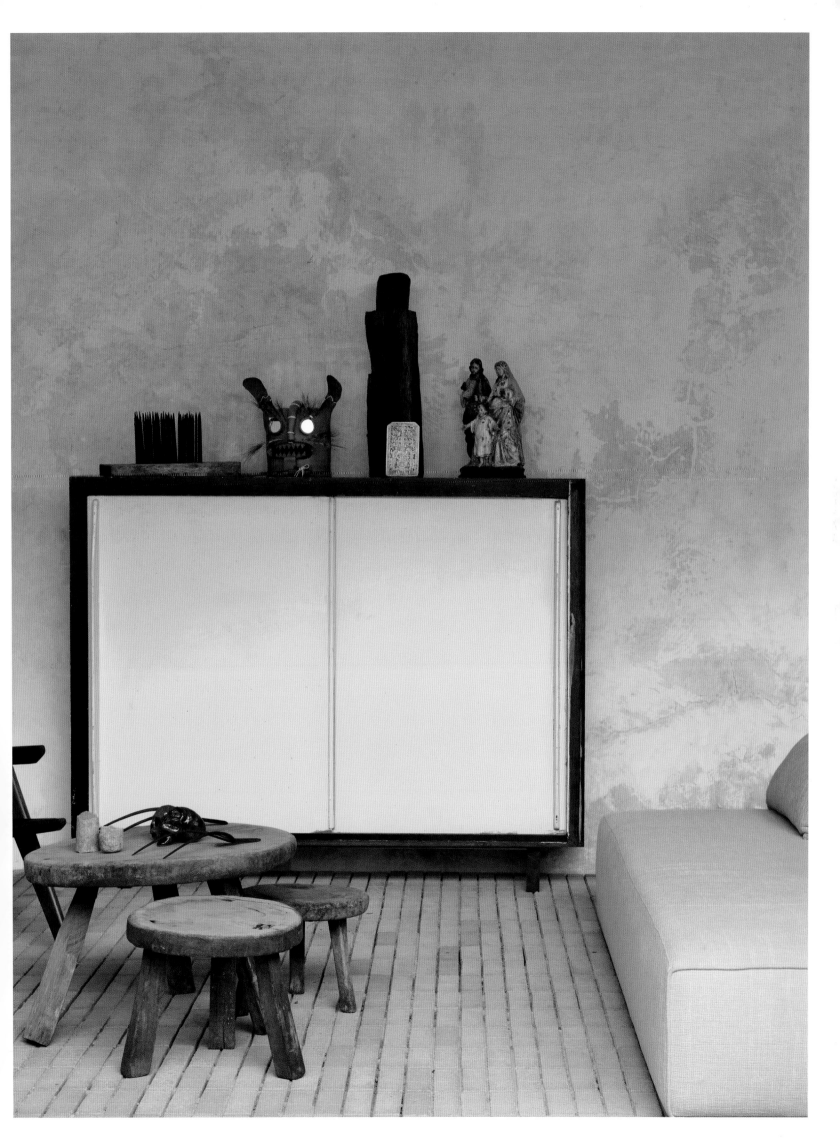

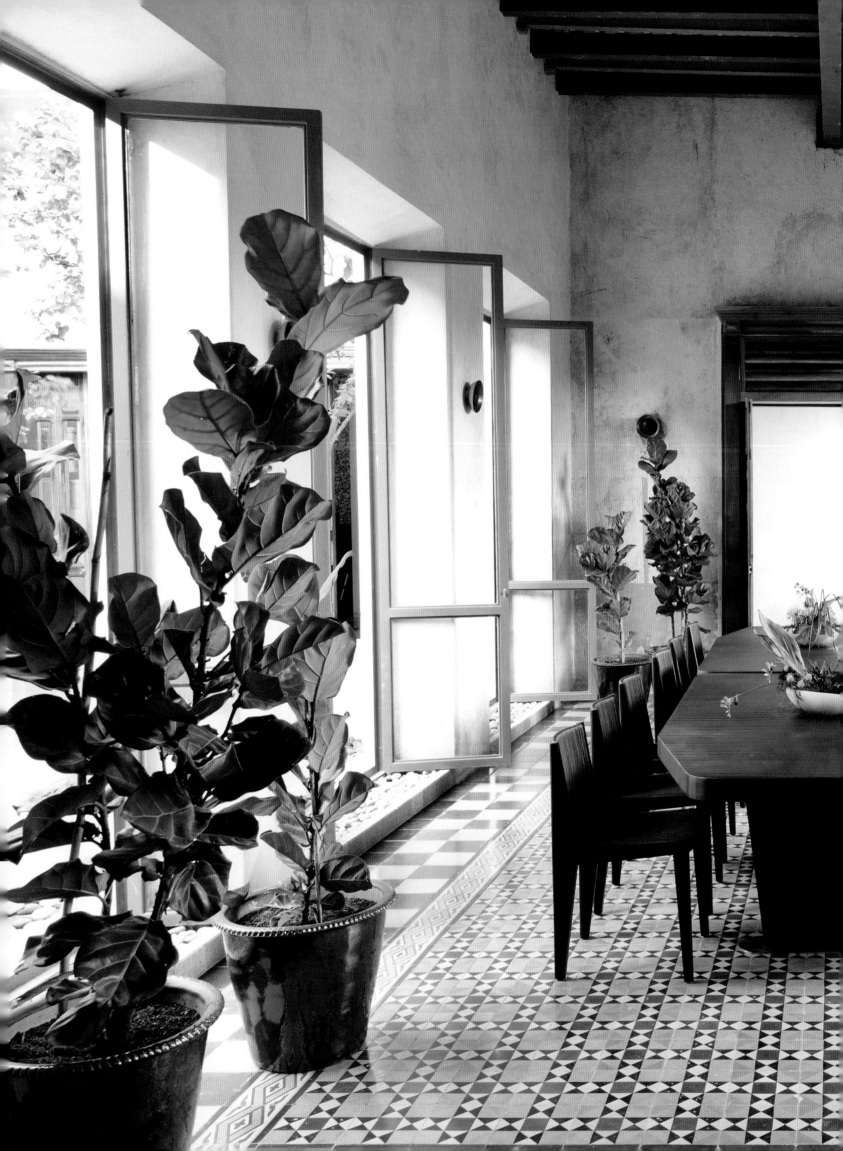

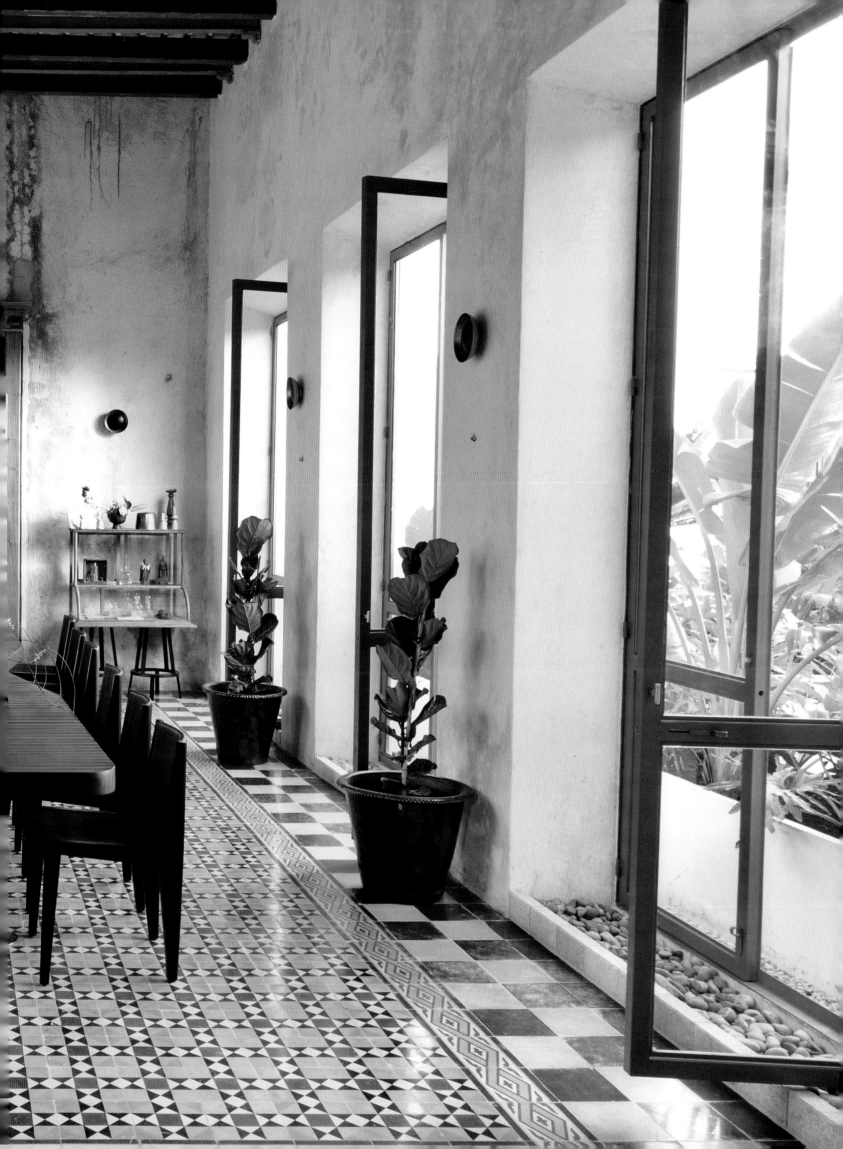

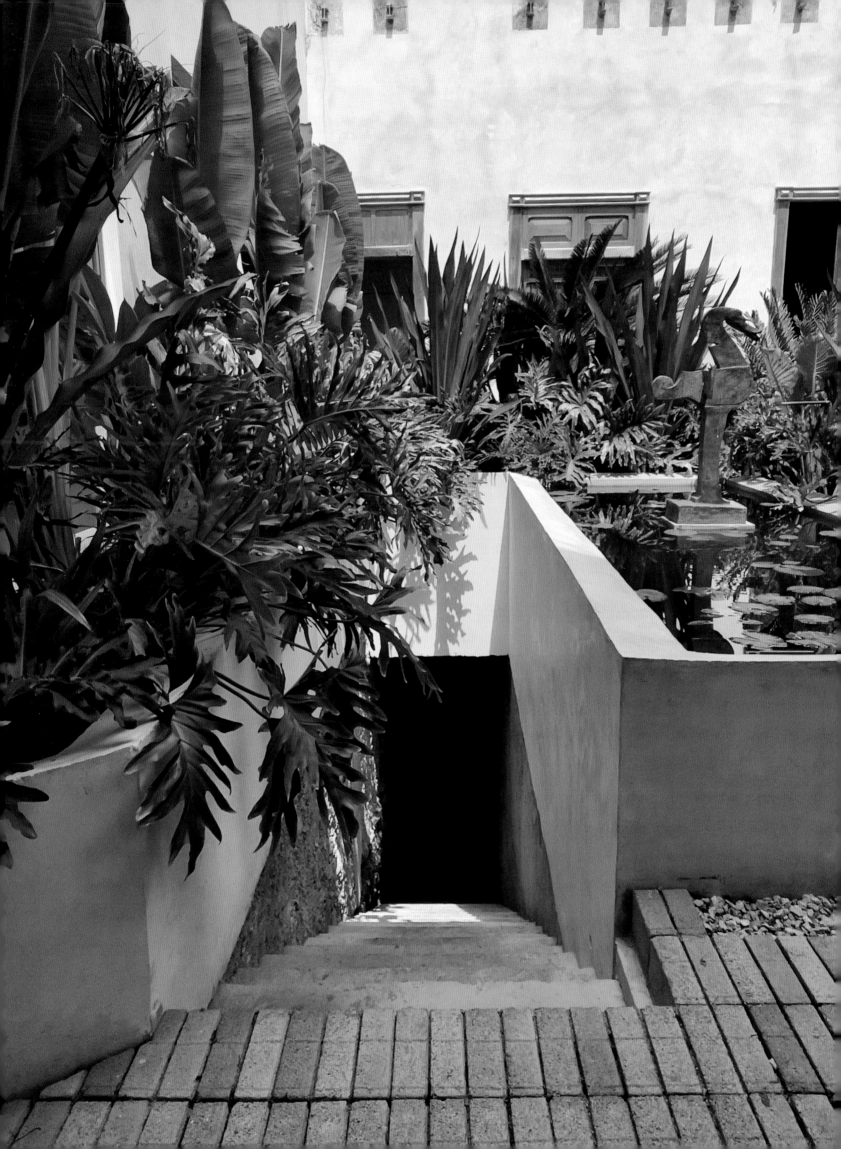

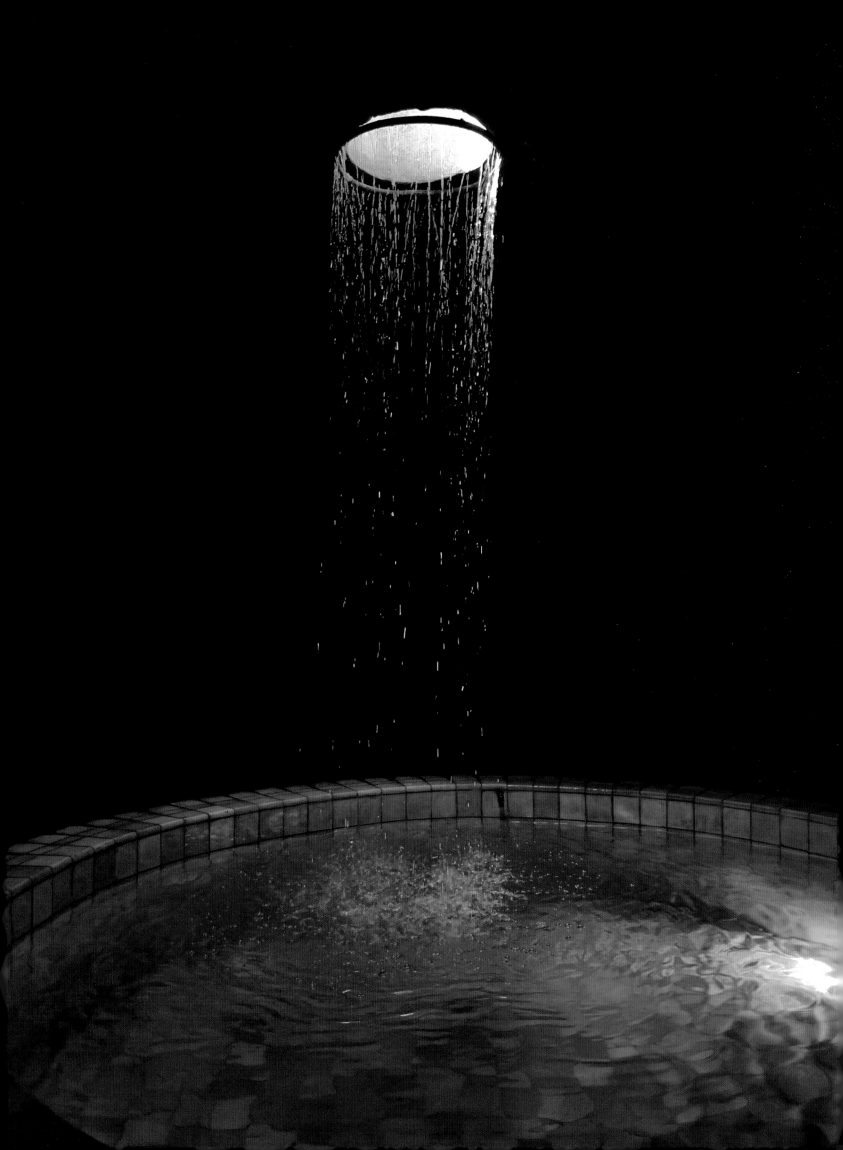

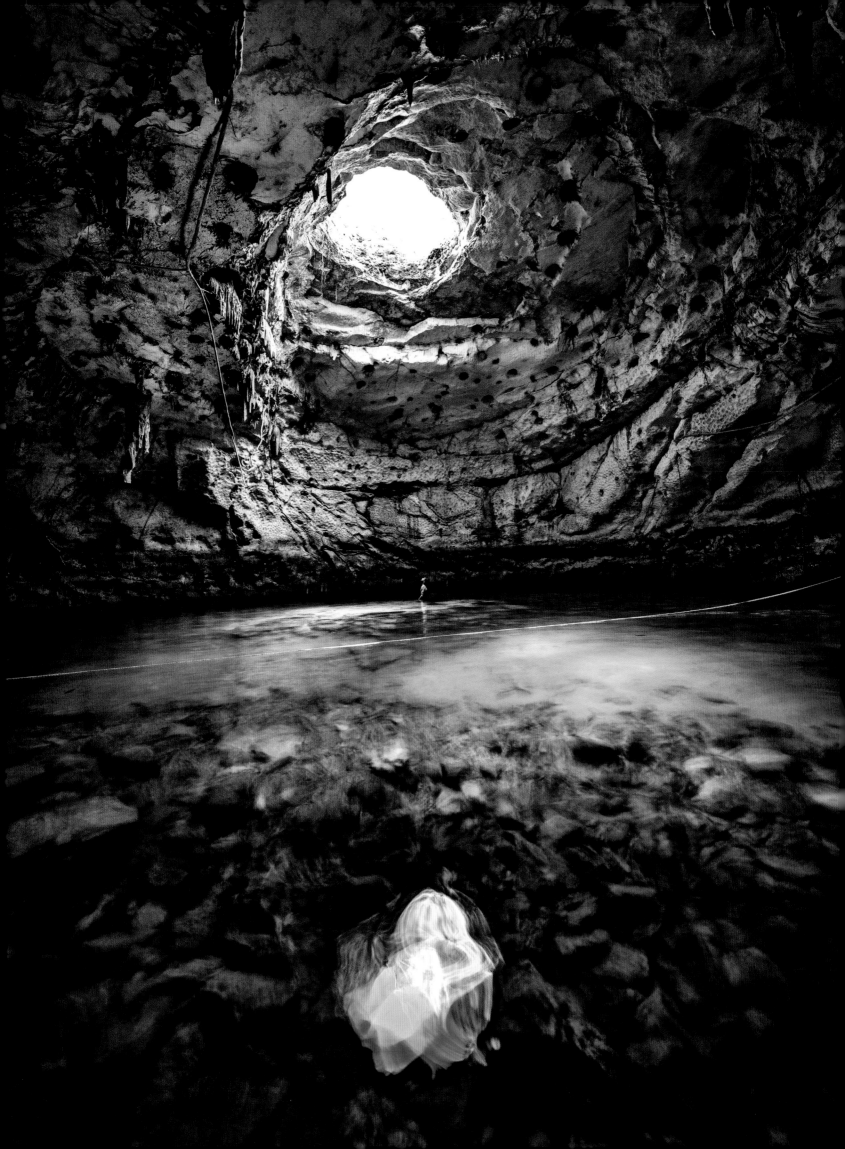

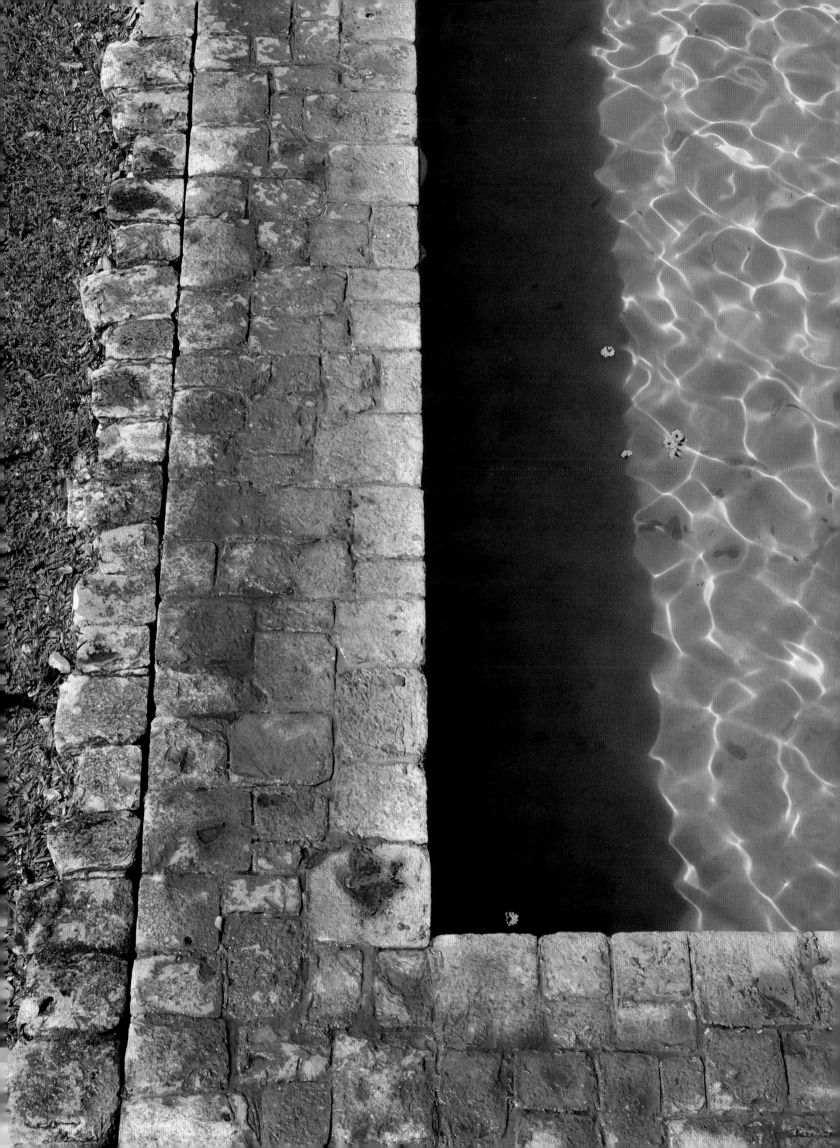

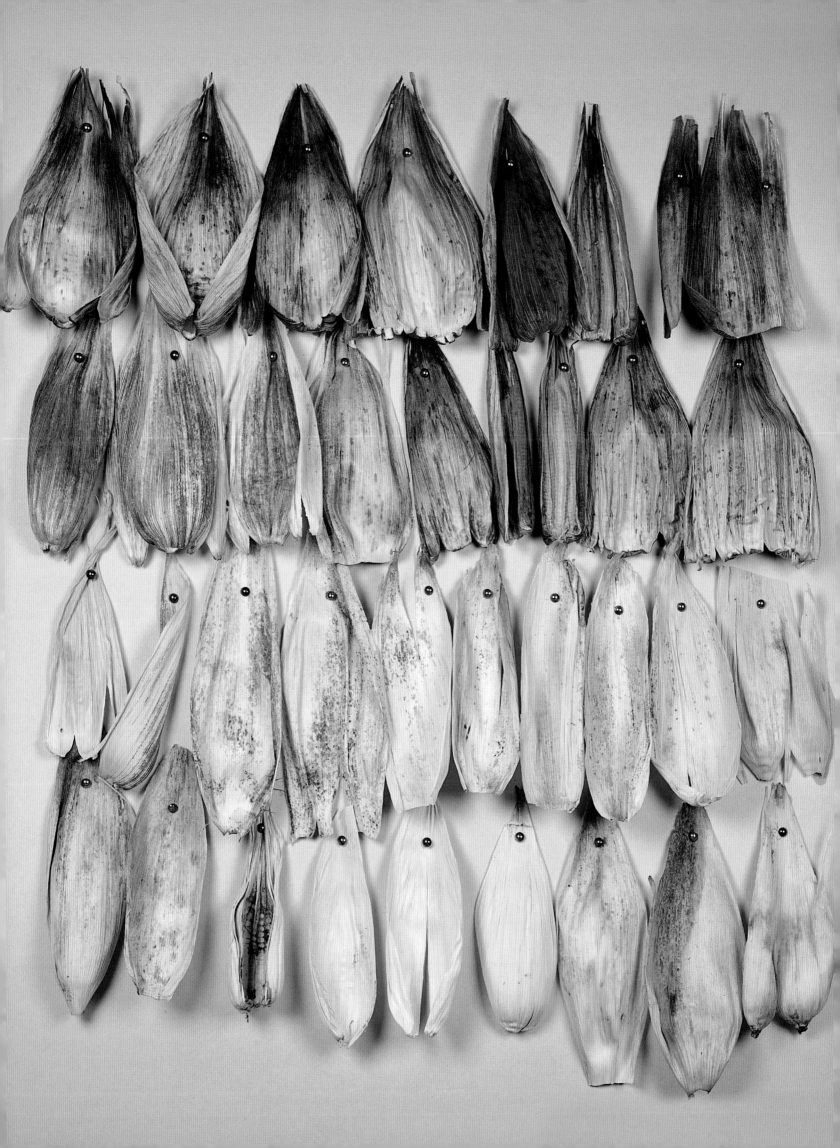

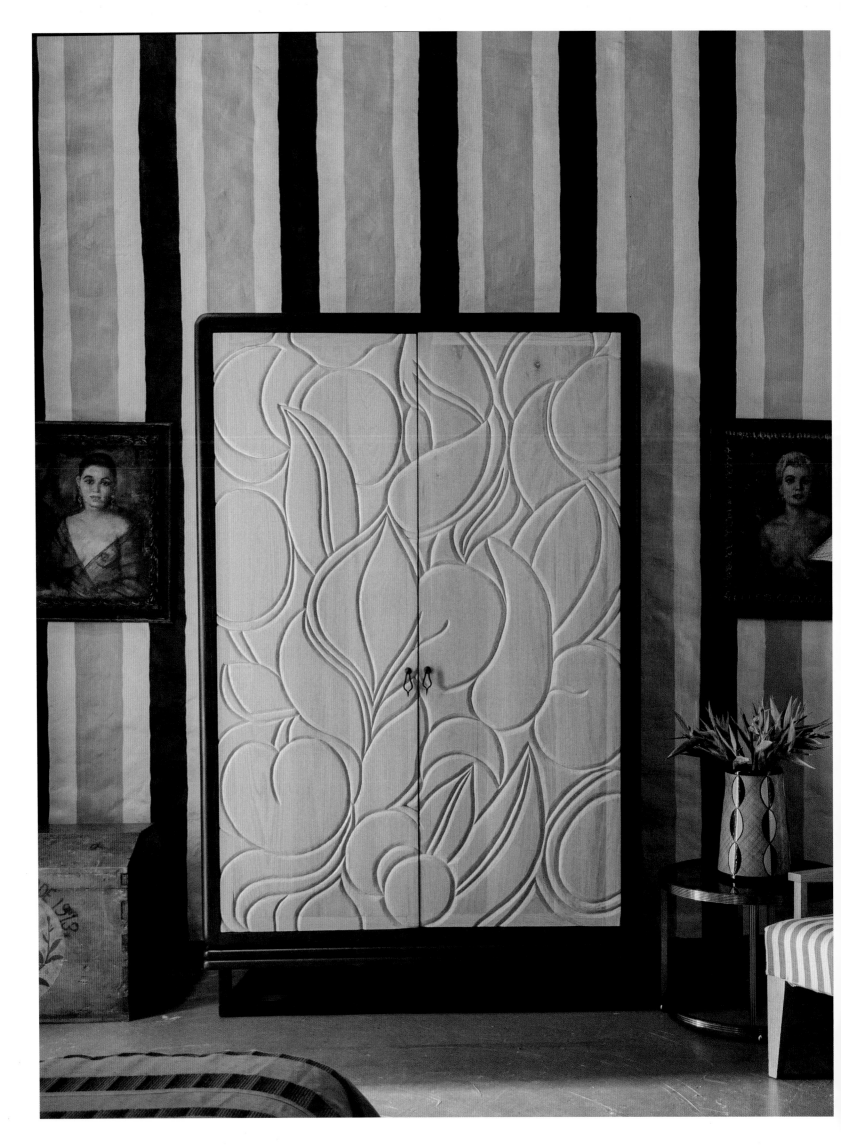

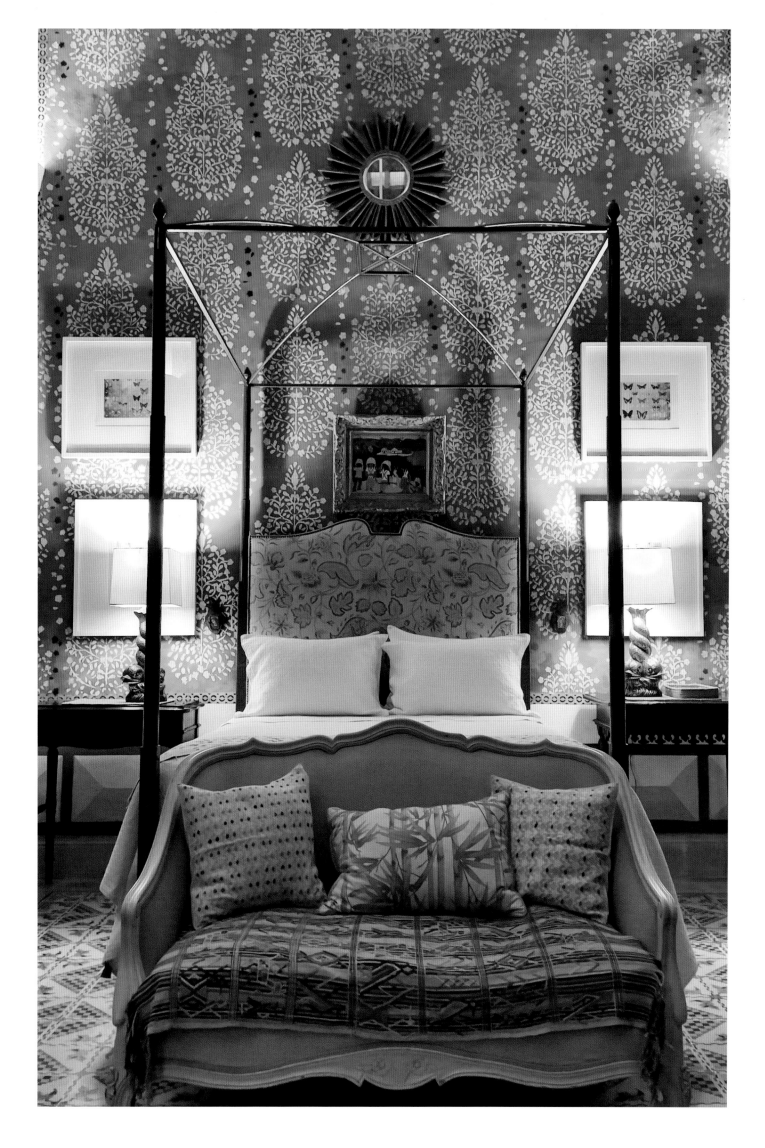

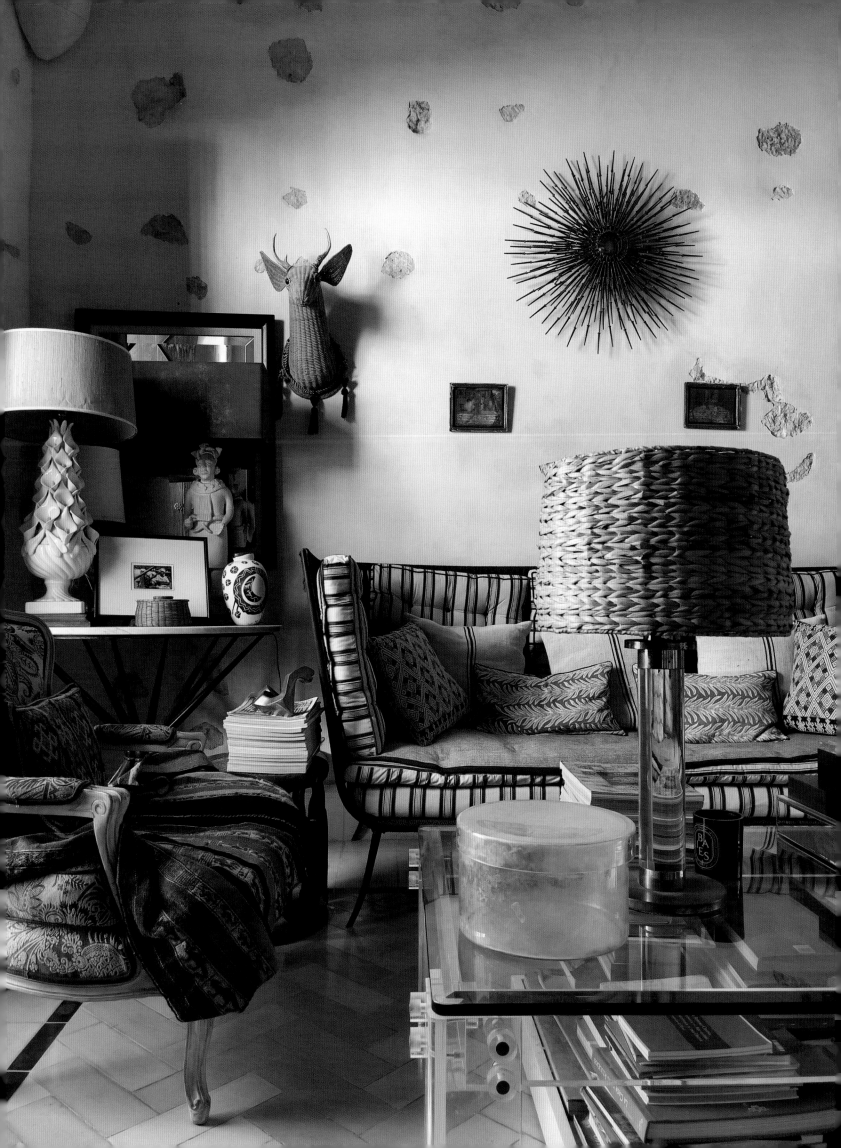

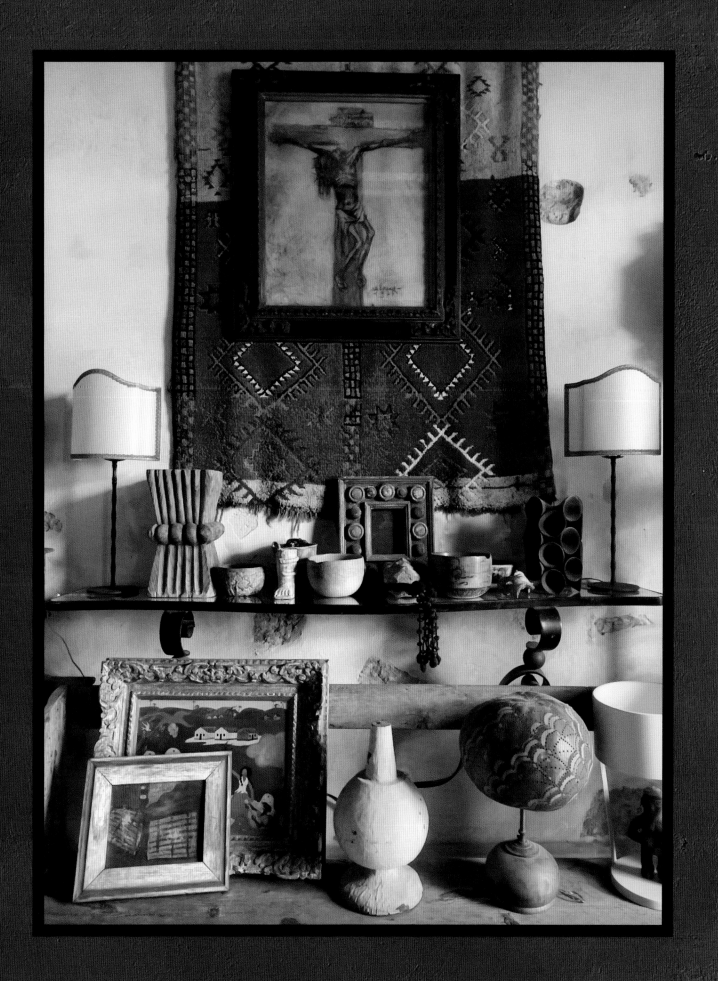

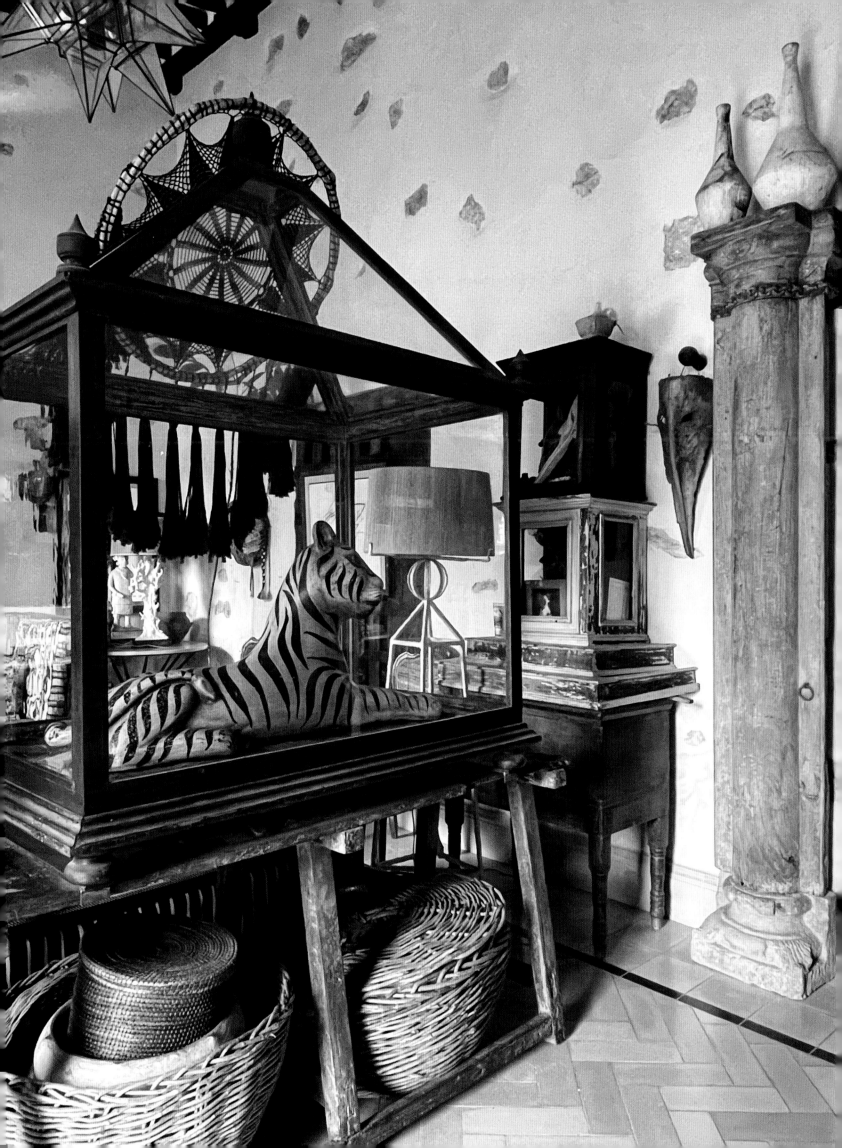

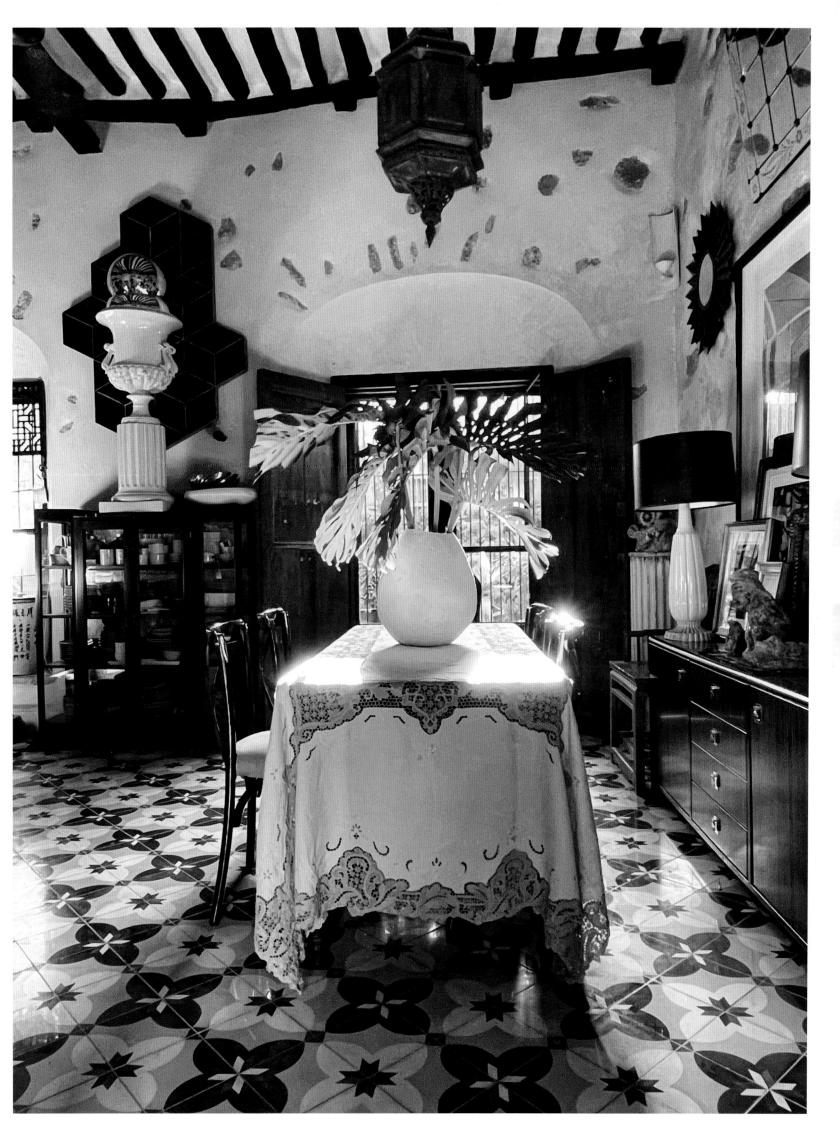

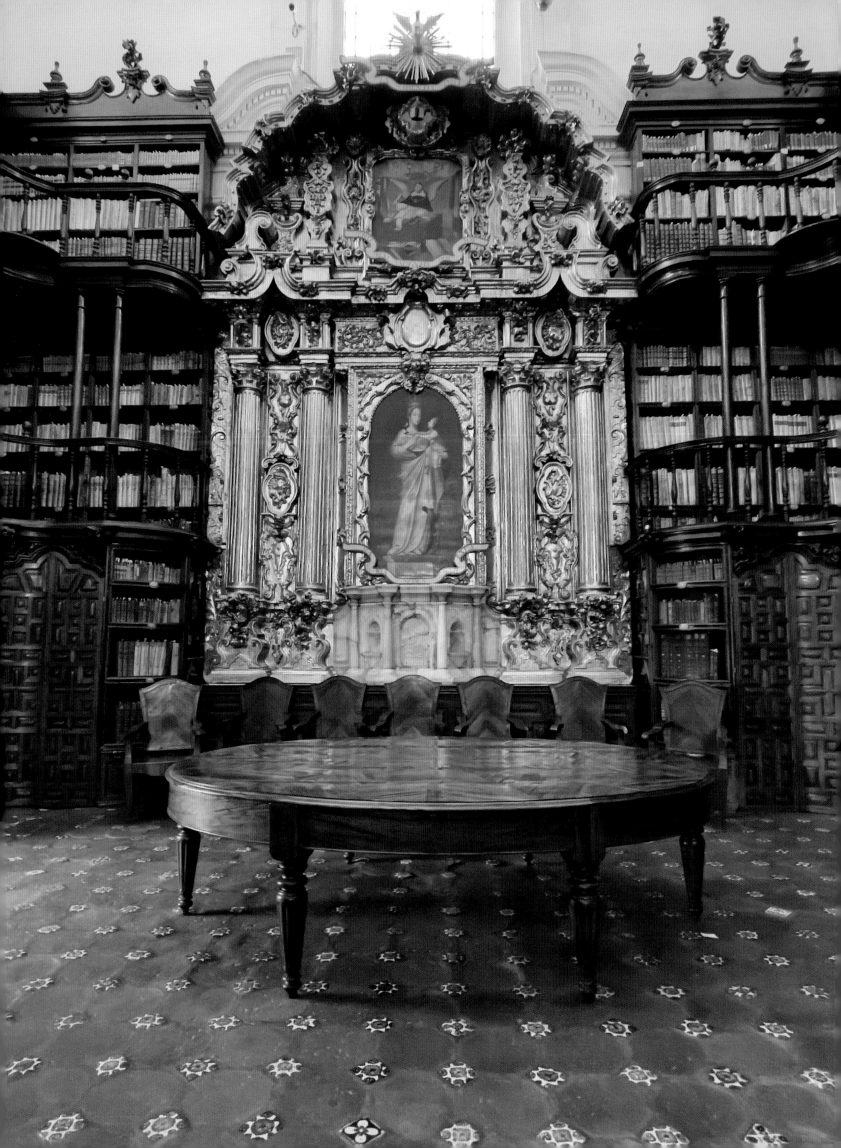

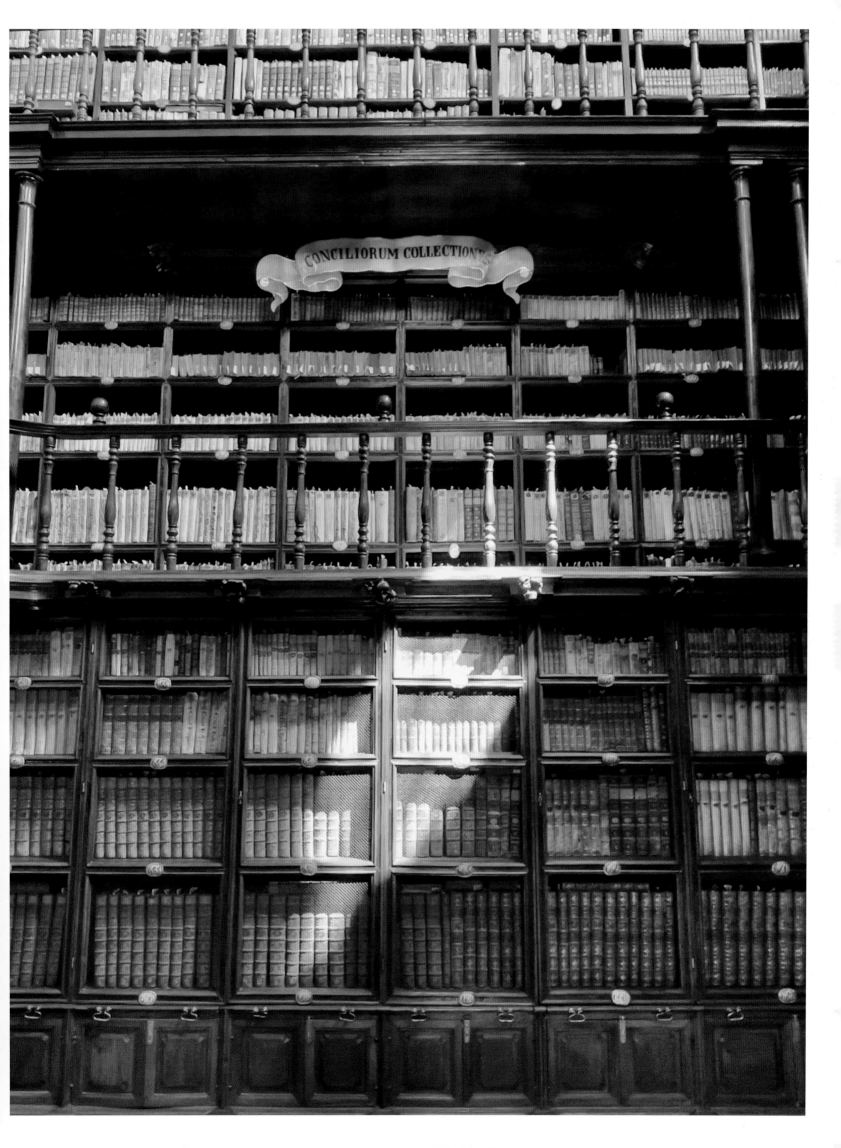

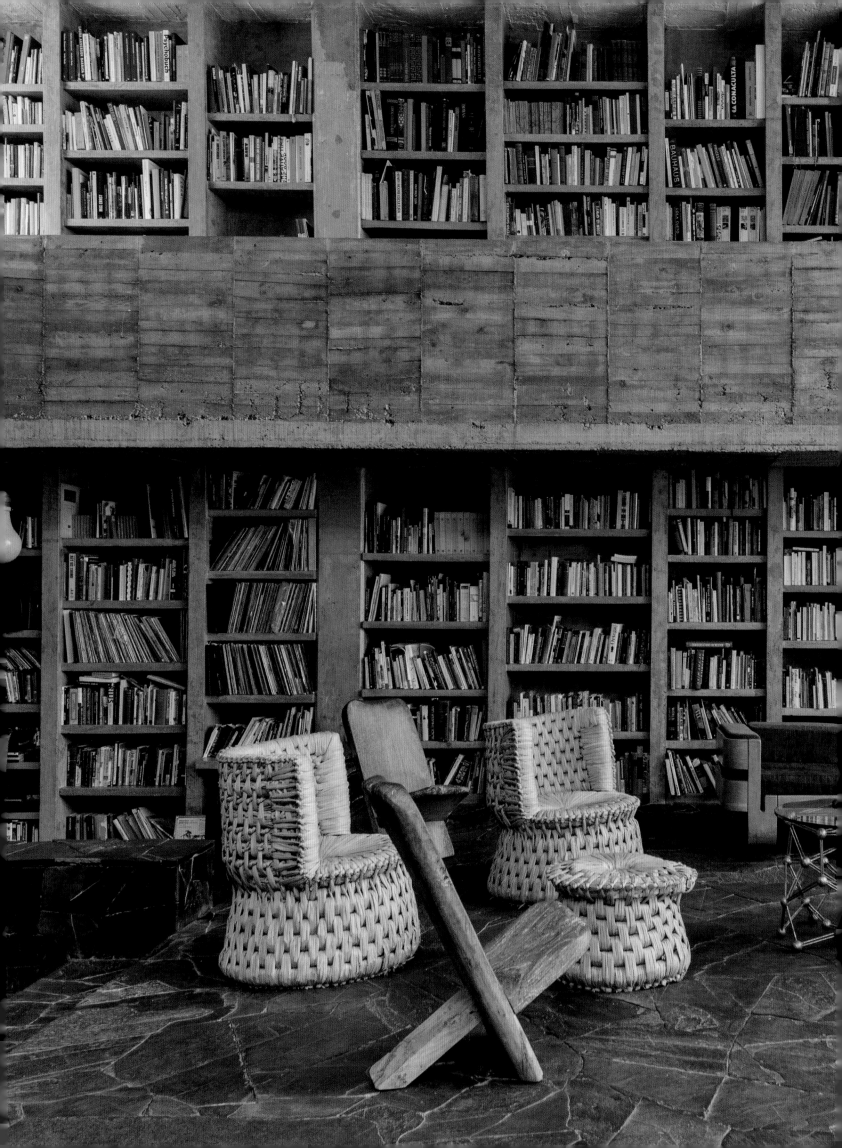

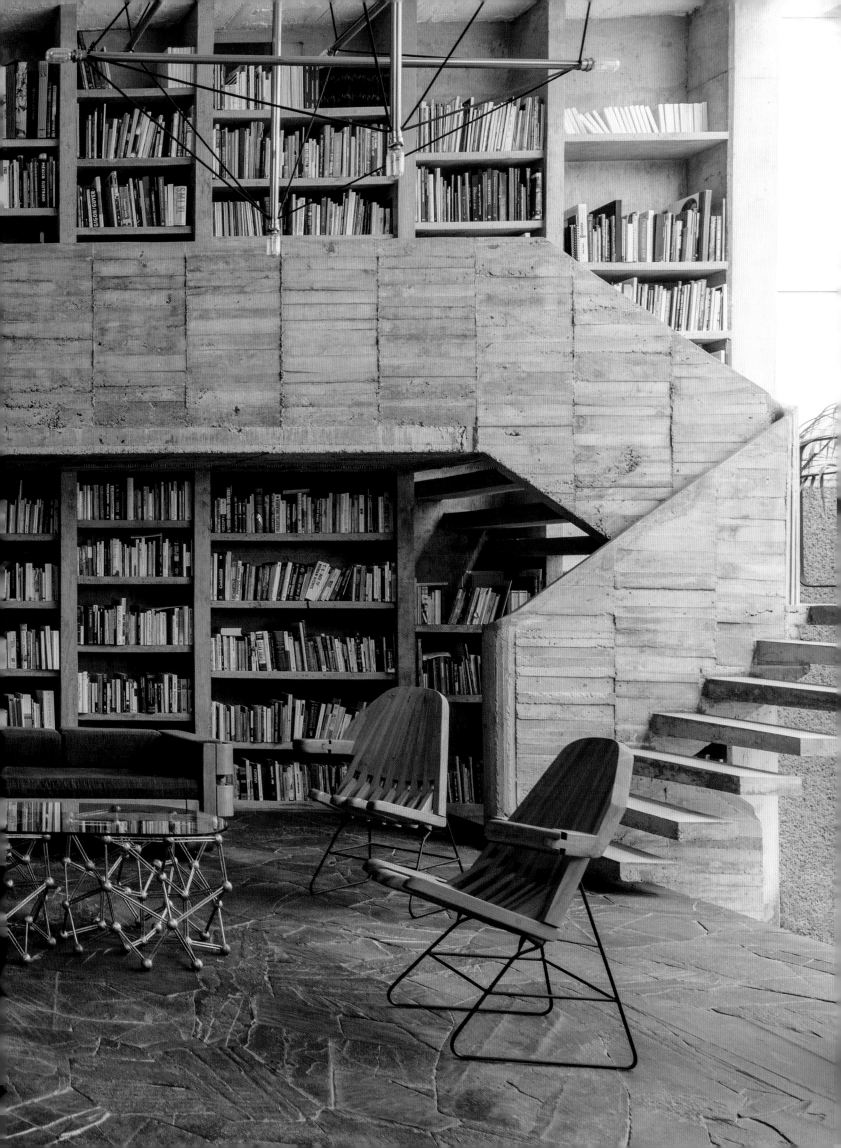

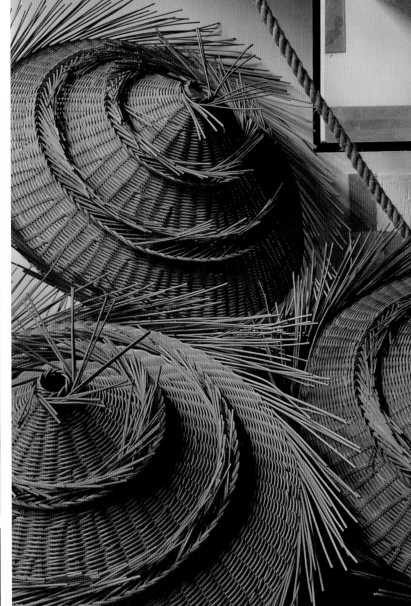

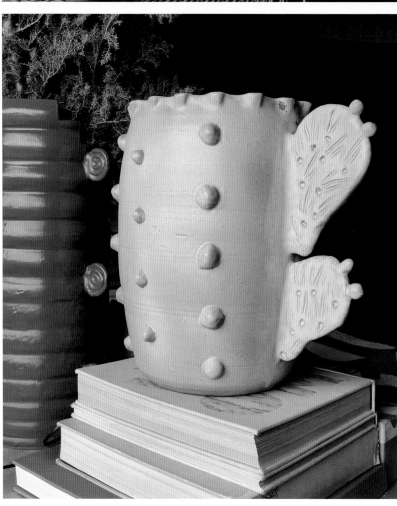

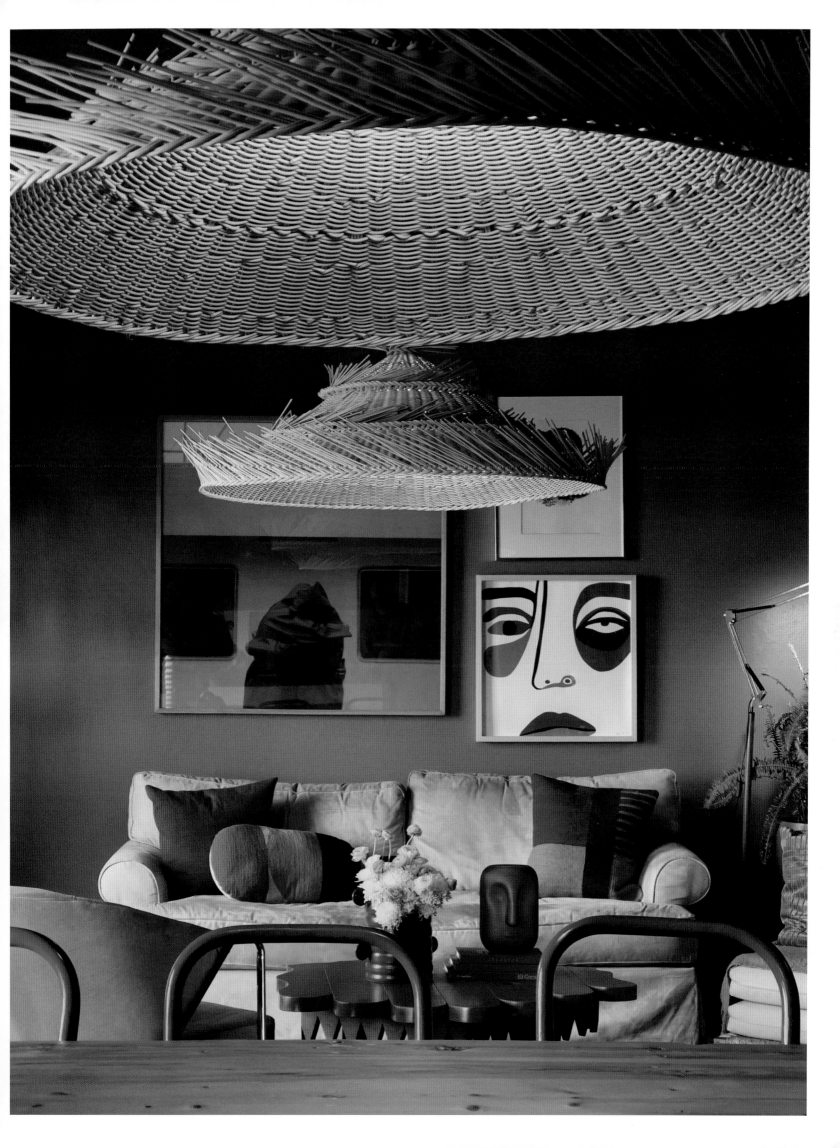

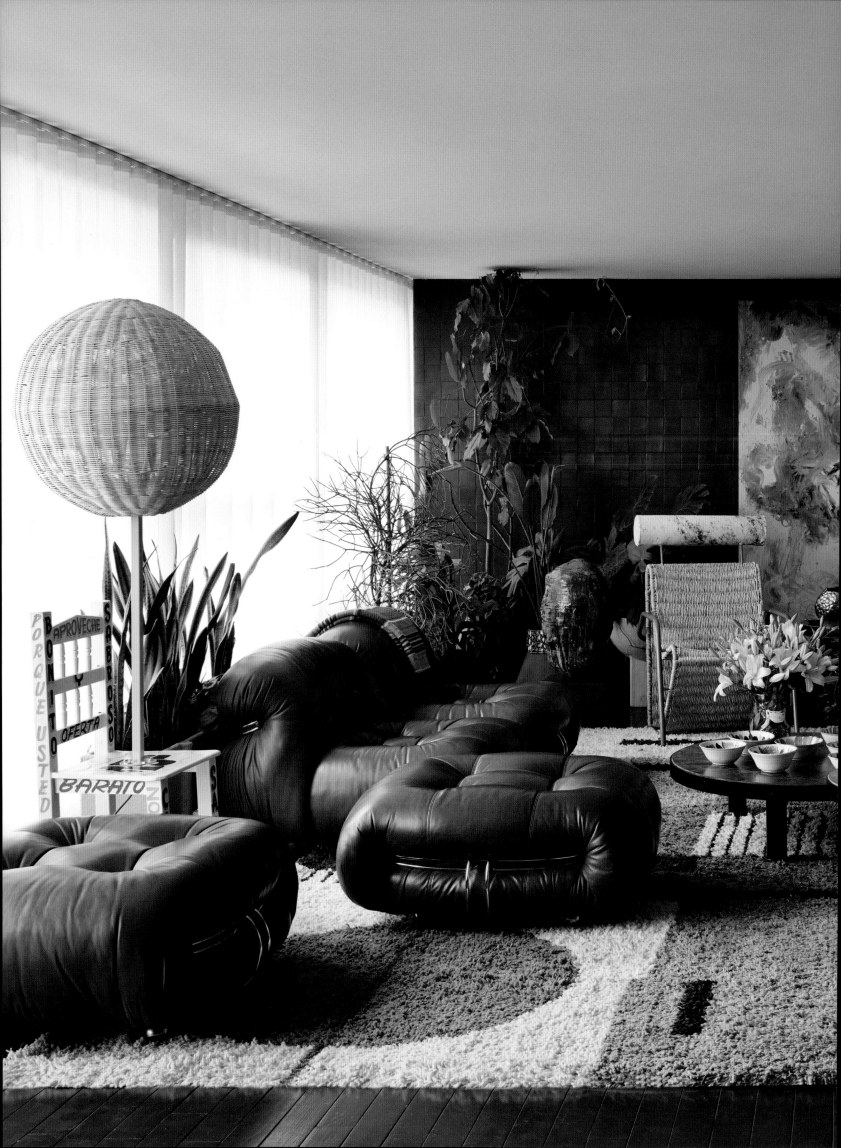

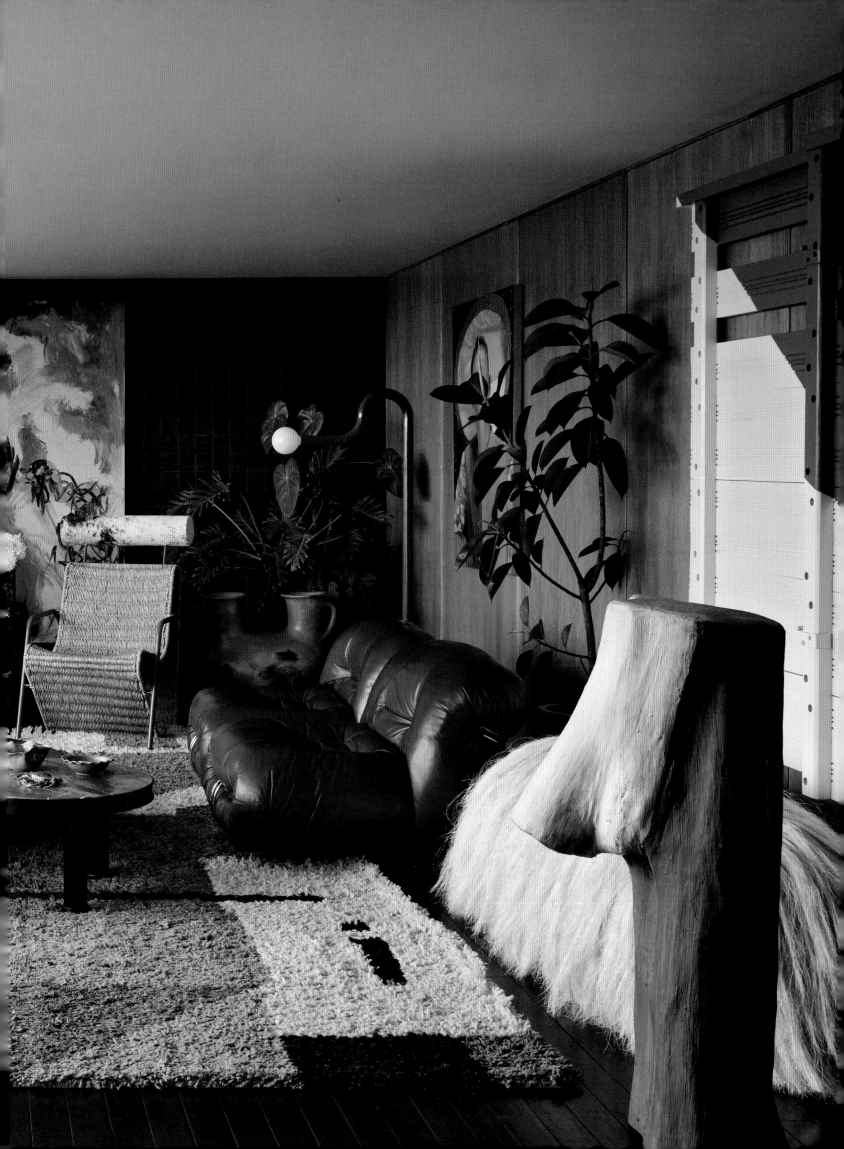

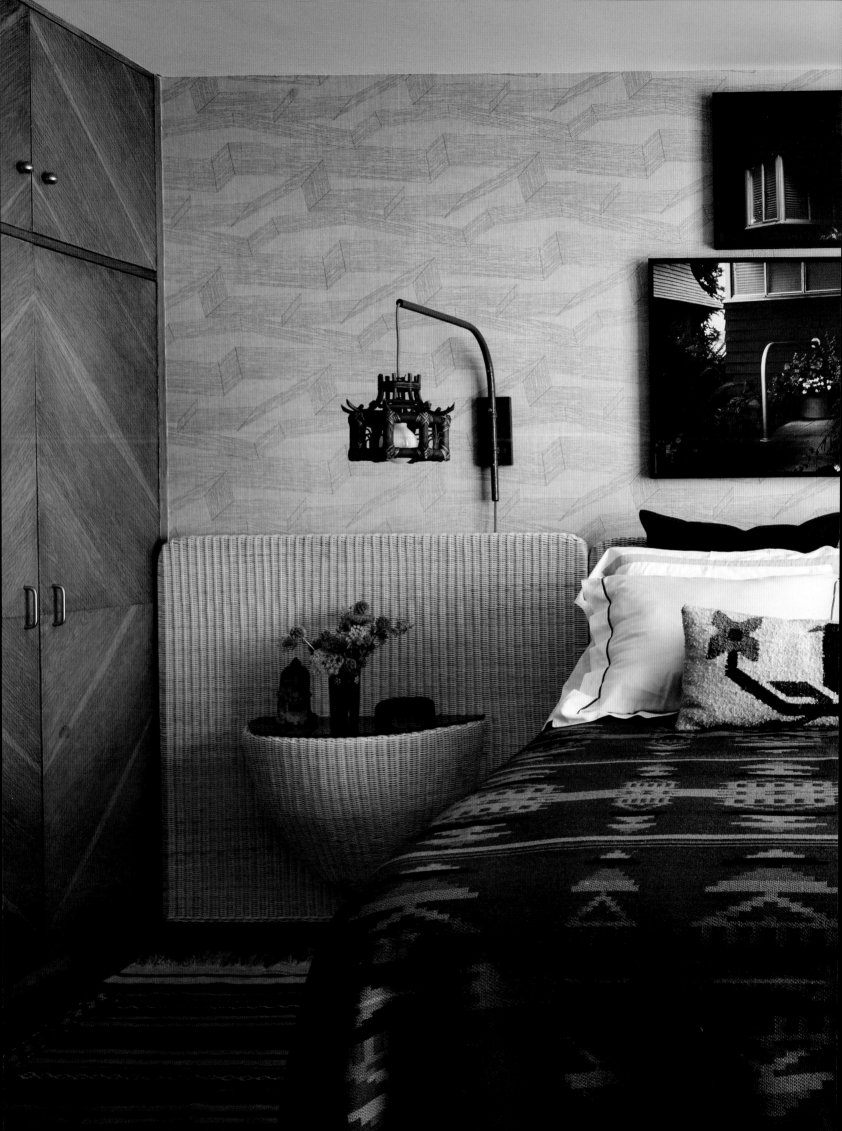

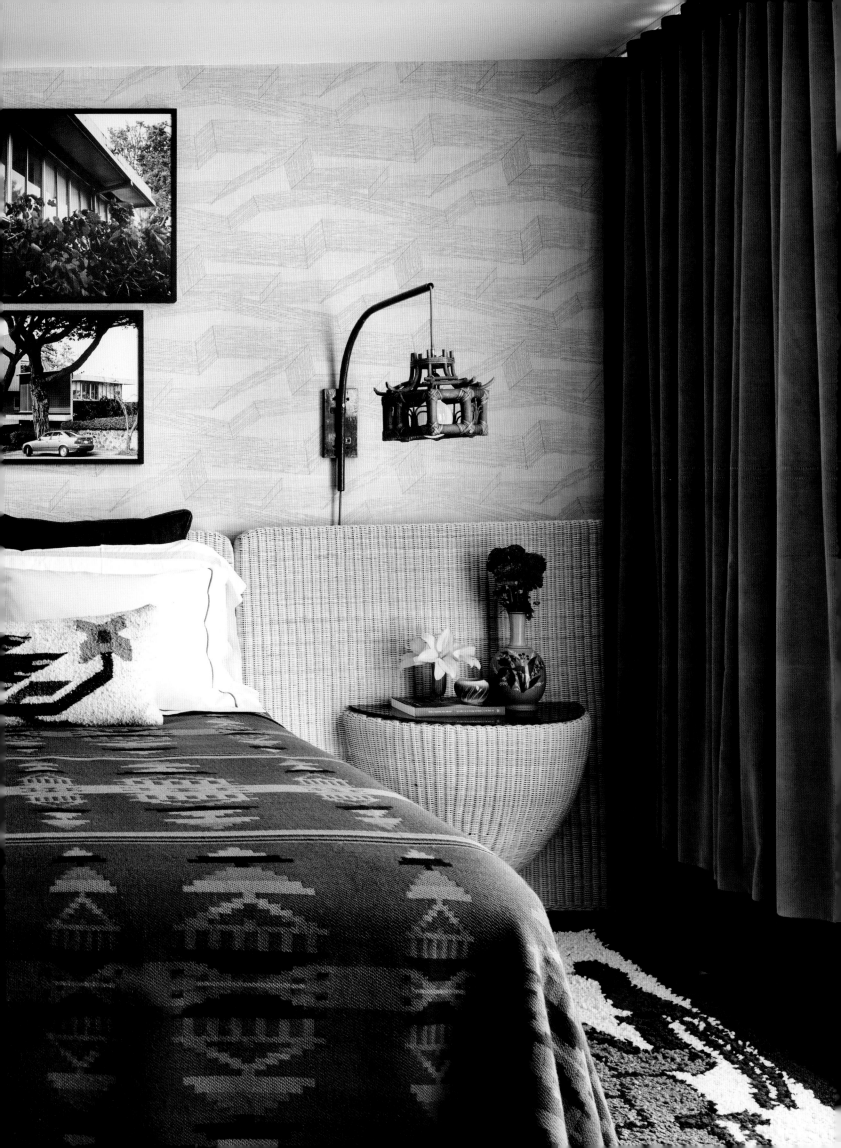

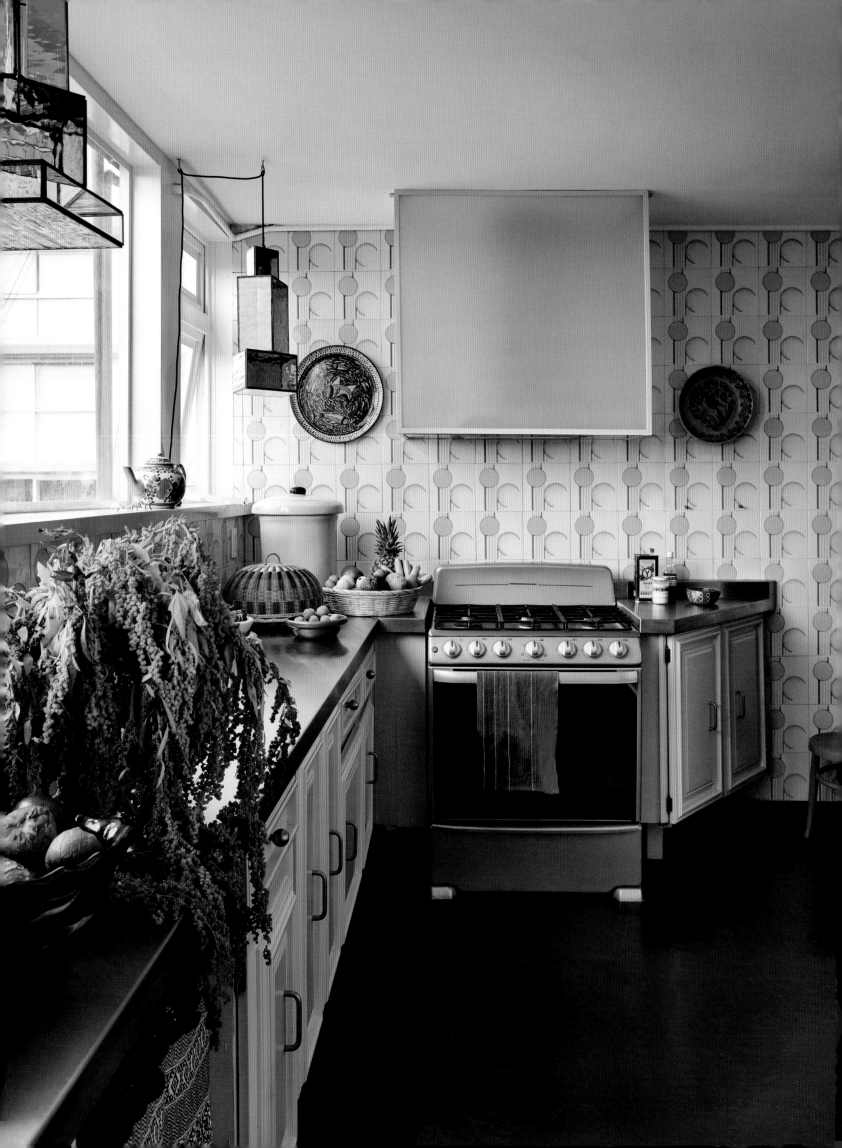

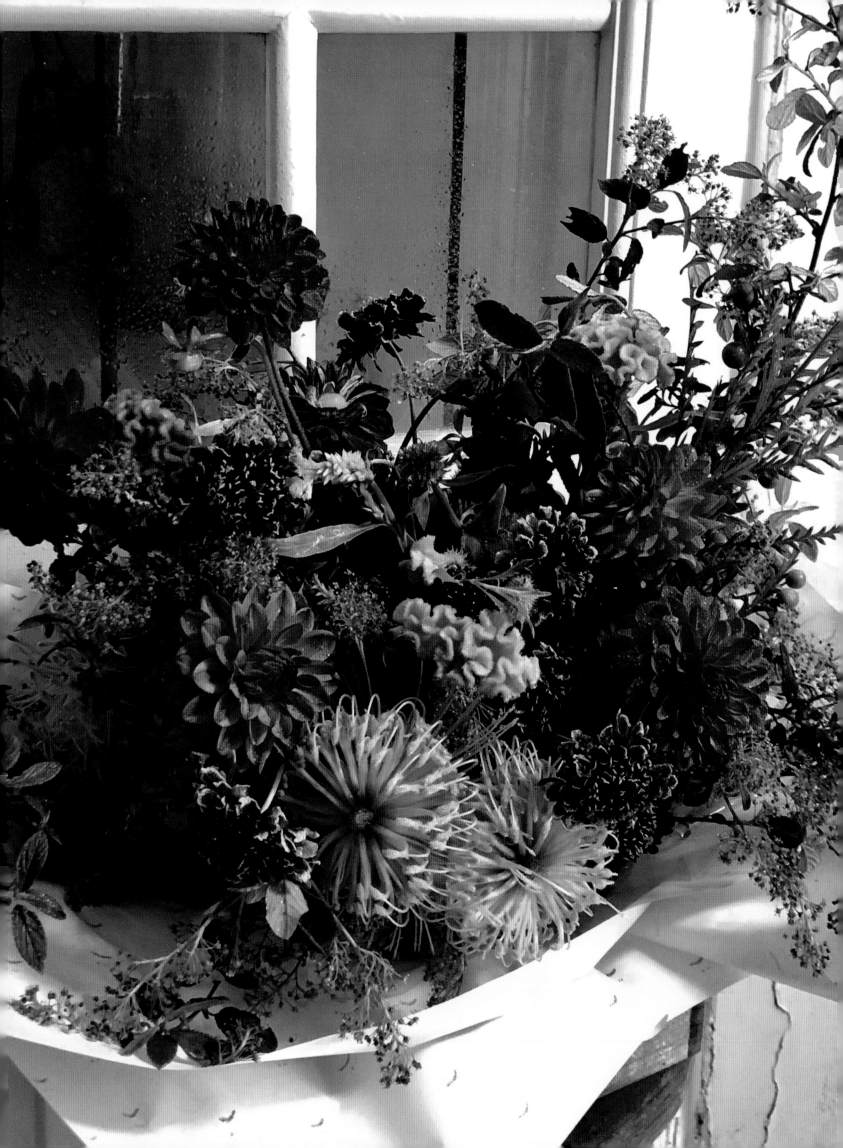

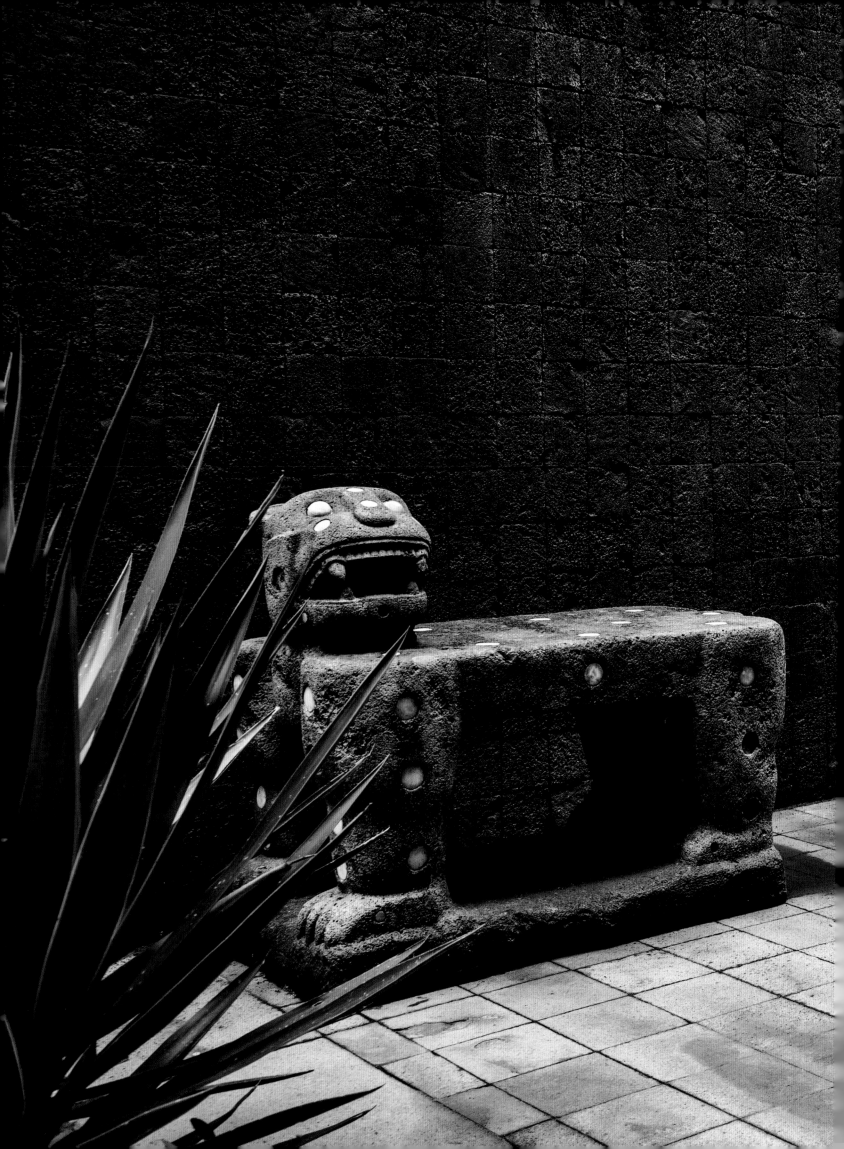

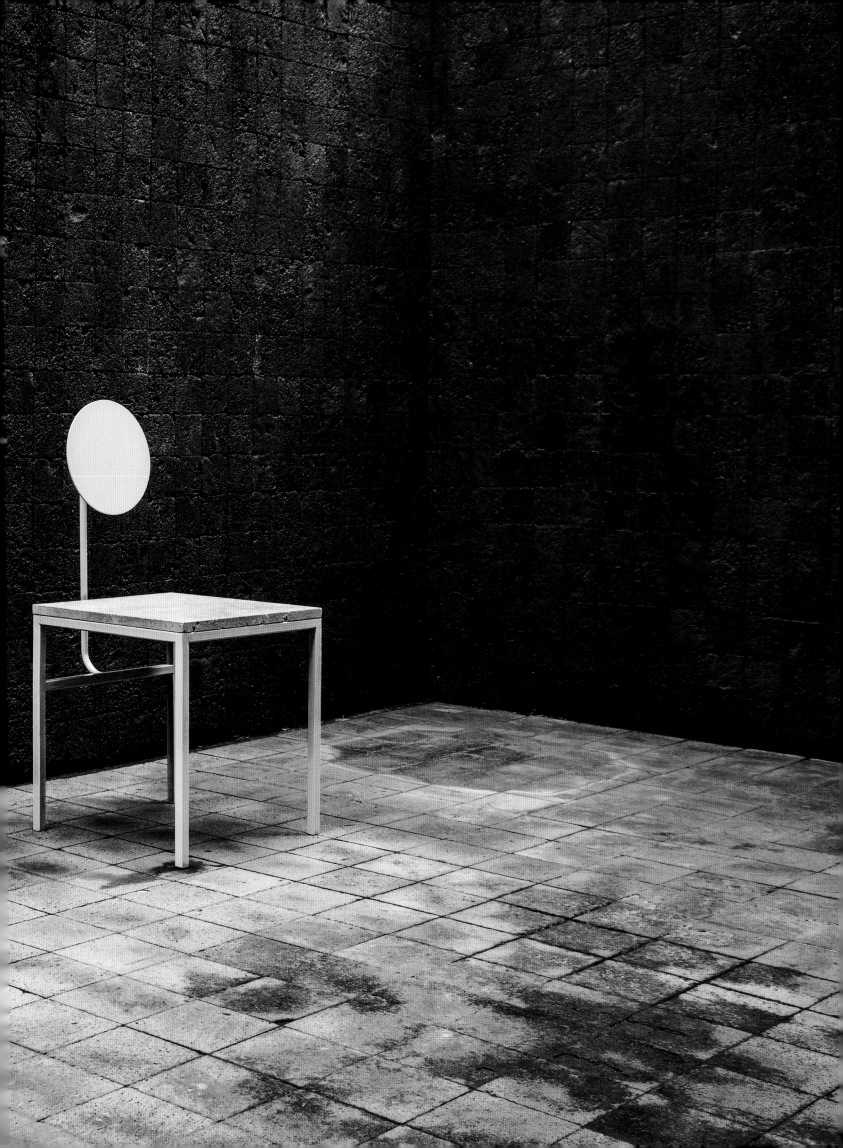

# PHOTO INDEX

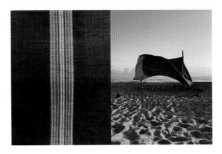

**0–1**

Henequin and sansevieria textile woven by Maestra Paola Petronila Maas Cab. Courtesy of Angela Damman, founder of the Mayan Youth Artisan Initiative. | The beach on the Gulf of México, Yucatán.

Photography by Newell Turner | Patricia Robert.

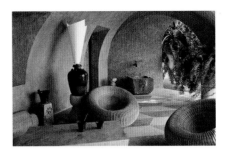

**2–3**

Casa Cayman, residence of antiques dealer and designer Michael Possenbacher on the Pacific Ocean coast. Architecture by Alex Possenbacher.

Photography by Mark Luscombe-Whyte/ The Interior Archive.

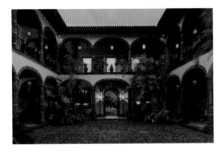

**4–5**

Courtyard of the nineteenth-century Hacienda de San Antonio, now a boutique hotel developed by the late Sir James Goldsmith, in the mountains of Colima.

Photography by Davis Gerber, Hacienda de San Antonio.

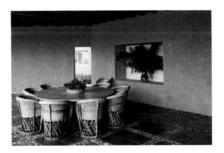

**6–7**

Dining room of Casa del Sabino, Valle de Bravo, State of México. Architecture by José de Yturbe.

Photography by Mark Luscombe-Whyte/ The Interior Archive.

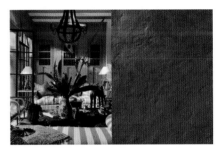

**8–9**

Residence of interior designer Lemeau Arrott-Watt. Mérida, Yucatán.

Photography by Newell Turner.

**10–11**

Terraced garden of designers Andrew Fisher and Jeffry Weisman, San Miguel de Allende, Guanajuato.

Photography by Jeffry Weisman.

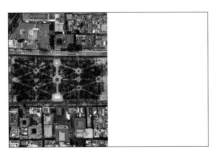

**12–13**

"Panteon Español," Parque Alameda Central with jacaranda trees in bloom, México City. Established in 1592 on the site of an Aztec market. The oldest public park in North America.

Photography by Santiago Arau.

**14–15**

Pyramid of Kukulcán, in the Pre-Columbian Maya city of Chichen Itza, Yucatán.

Photography by Santiago Arau.

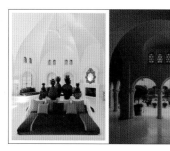

**16–17**

Cuixmala, former residence of the late Sir James Goldsmith. Now a luxury eco-resort overlooking the Pacific Ocean. Costa Alegre, Jalisco.

Photography by Davis Gerber, Cuixmala.

**18–19**

A tableau of natural and handmade objects in the residence of Robert Willson and David Serrano, Mérida, Yucatán.

Photography by Newell Turner.

**20–21**

"The Rio Grande—My Berlin Wall," an art performance in San Ygnacio, Texas organized by and featuring the work of Michael Tracy.

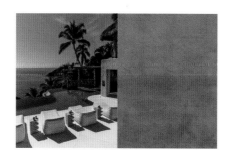

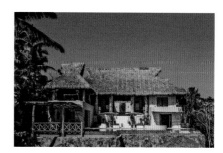

**22–23**

"Montezuma Observing the Comet," a miniature from *The History of the Indies* by Diego Duran (1537–1588).

1579 manuscript, Biblioteca Nacional, Madrid, Spain.

**24–25 | PRE-COLUMBIAN**

Casa Parasol, interior design by Antoine Ratigan, in Careyes, Jalisco overlooking the Pacific Ocean.

Photography by Rafael Lührs.

**26–27**

Casa Parasol, interior design by Antoine Ratigan, in Careyes, Jalisco overlooking the Pacific Ocean.

Photography by Rafael Lührs.

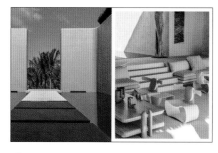

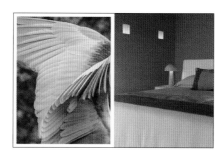

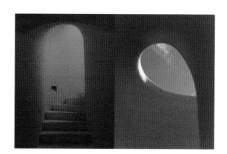

**28–29**

Casa Parasol, interior design by Antoine Ratigan, in Careyes, Jalisco overlooking the Pacific Ocean.

Photography by Rafael Lührs.

**30–31**

Feathers of a *roseate* spoonbill. | Casa Parasol, interior design by Antoine Ratigan, Careyes, Jalisco.

Photography from Agefotostock/Alamy | Rafael Lührs.

**32–33**

Casa Parasol, interior design by Antoine Ratigan, Careyes, Jalisco.

Photography by Rafael Lührs.

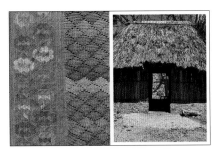

**34–35**
Detail of a Maya textile, at La Calaca, San Miguel de Allende, Guanajuato. | Traditional Maya-style house, Hacienda Subin, Yucatán.

*Photography by Newell Turner.*

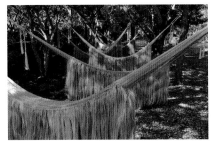

**36–37**
Pink-dyed henequin hammocks, a collaboration of Yucatán designer Angela Damman and México City designer Fernando Laposse.

*Photography by Pepe Molina.*

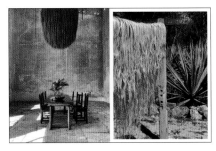

**38–39**
Studio space at the residence of artist Angela Damman, with a chandelier in naturally dyed henequin. | Henequin fibers after processing, drying in the sun. Hacienda of Angela and Scott Damman, where he is propagating old varieties of henequin and expanding their fields.

*Photography by Newell Turner.*

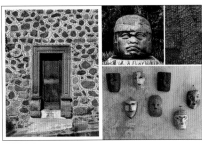

**40–41**
Façade of indigenous stonework, San Miguel de Allende, Guanajuato. | Olmec head, State of Veracruz. | Naturally dyed indigenous sash belt, at La Calaca, San Miguel de Allende, Guanajuato. | An assortment of indigenous fiesta masks, Casa Adela, Atotonilco, Guanajuato.

*Photograph by Newell Turner | Santiago Aru (Olmec head).*

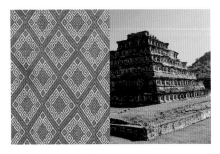

**42–43**
Woven Maya pattern, Chiapas. | The Pyramid of the Niches, El Tajín, Veracruz. There is debate about which indigenous people built the pyramid: Totonacs, Xapaneca, or Huastec.

*Photography by Newell Turner | World Pictures/ Alamy Stock Photo.*

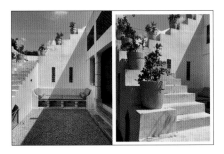

**44–45**
Residence of John Prentiss Powell, Mérida, Yucatán.

*Photography by Newell Turner.*

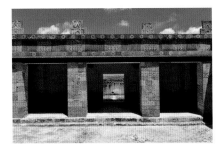

**46–47**
Courtyard of Quetzalpapálotl Palace, Teotihuacán, near México City.

*Photography by Prakich Treetasayuth/Alamy Stock Photo.*

**48–49**
Mexican Baroque mural by Antonio Martinez de Pocasangre in the eighteenth-century Sanctuary of Jesús Nazareno de Atotonilco, State of Guanajuato. | Exterior concrete stucco detail, San Miguel de Allende, Guanajuato.

*Photography by Newell Turner.*

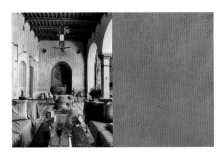

**50–51 | BAROQUE**
Loggia living room of architect Bruce Bananto, Mérida, Yucatán.

*Photography by Newell Turner.*

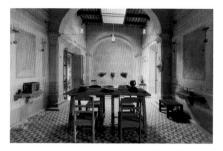

**52–53**
Dining room and design studio in the residence of architect Bruce Bananto, Mérida, Yucatán.

*Photography by Newell Turner.*

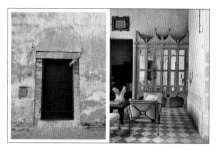

**54–55**
Exterior, residence of architect Bruce Bananto, Mérida, Yucatán. | Cabinet designed by Bruce Bananto.

*Photography by Newell Turner.*

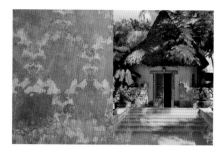

**56–57**
Mural designed and painted by Bruce Bananto. | Pool house in the style of a traditional Maya house, at the residence of architect Bruce Bananto, Mérida, Yucatán.

*Photography by Newell Turner.*

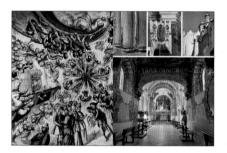

**58–59**
Ceiling detail from the narthex of the eighteenth-century Sanctuary of Jesús Nazareno de Atolonilco, State of Guanajuato. Antonio Martinez de Pocasangre's extensive murals on the ceilings and walls have led the complex to be called "the Sistine Chapel of America and México." | Details from the compound and Chapel of the Holy Burial, 1759–1763.

*Photography by Newell Turner.*

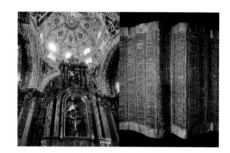

**60–61**
Altar of the seventeenth-century Chapel of the Rosario, Church of Santo Domingo, Puebla. Considered the peak of Baroque in New Spain. | Wall-mounted sculpture from a series of gold tablets by artist Andrew Fisher, San Miguel de Allende, Guanajuato.

*Photography by Newell Turner.*

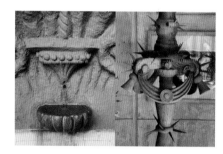

**62–63**
A public wall fountain, San Miguel de Allende, Guanajuato. | Detail of candlestick designed by Mike Diaz, México City.

*Photography by Newell Turner.*

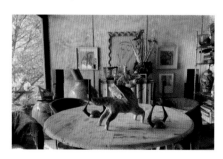

**64–65**
Table, chest, and frame designed by Mike Diaz, in his apartment, México City.

*Photography by Newell Turner.*

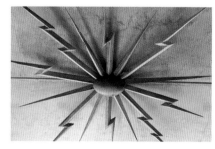

**66–67**
Ceiling mounted starburst designed by Mike Diaz, in his apartment, México City.

*Photography by Newell Turner.*

**68–69**
Decorative ball with stars designed by Mike Diaz. | Tall candlestick designed by Mike Diaz and twentieth-century rare, small *butaque* chair (left) designed by William Spratling, both in the Diaz apartment, México City.

*Photography by Newell Turner.*

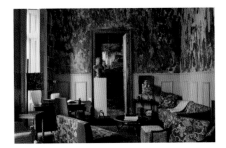

**70–71**
Former apartment of interior designer
Dirk-Jan Kinet, México City *Centro*.

Photography by Lorena Darquea.

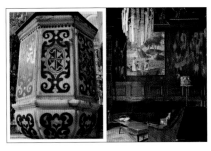

**72–73**
Marble lectern in Church of Santo
Domingo, Puebla. | Former apartment of
interior designer Dirk-Jan Kinet. México
City *Centro*.

Photography by Newell Turner | Lorena Darquea.

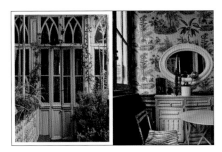

**74–75**
Former apartment of interior designer
Dirk-Jan Kinet, México City *Centro*.

Photography by Lorena Darquea.

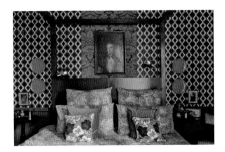

**76–77**
Former apartment of interior designer
Dirk-Jan Kinet, México City *Centro*.

Photography by Lorena Darquea.

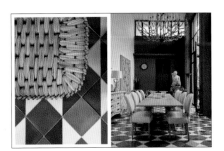

**78–79**
Detail of contemporary pasta tiles and
woven *tule* (seagrass) stool. | Dining room
of Robert Willson and David Serrano,
Mérida, Yucatán.

Photography by Newell Turner.

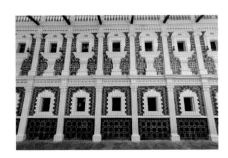

**80–81**
Seventeenth-century *Patio de los Azulejos* in
Talavera tile, Puebla.

Photography by Newell Turner.

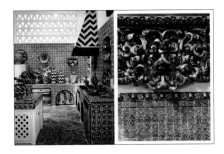

**82–83**
Kitchen in the residence of interior designer
Michelle Nussbaumer, San Miguel de
Allende, Guanajuato. | Wall detail in the
seventeenth-century Chapel of the Rosario,
Church of Santo Domingo, Puebla.

Photography by Douglas Friedman/Trunk Archive
| Newell Turner.

**84–85 | COLONIAL**
View toward the pool house at the
residence of architect and designer Laura
Kirar and Richard Frazier, Hacienda Subin,
Yucatán.

Photography by Newell Turner.

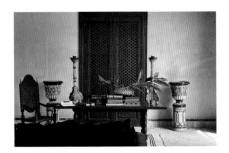

**86–87**
Residence of architect and designer Laura
Kirar and Richard Frazier, Hacienda Subin,
Yucatán.

Photography by Newell Turner.

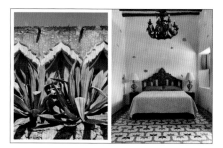

**88–89**

Residence of architect and designer Laura Kirar and Richard Frazier, Hacienda Subin, Yucatán.

*Photography by Newell Turner.*

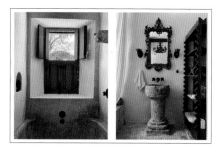

**90–91**

Residence of architect and designer Laura Kirar and Richard Frazier, Hacienda Subin, Yucatán.

*Photography by Newell Turner.*

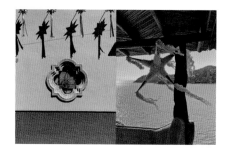

**92–93**

Lanterns above a quatrefoil window, San Miguel de Allende, Guanajauto. | Star piñata hanging on a terrace above Lake Chapala, Jalisco.

*Photography by Newell Turner | Jeffry Weisman.*

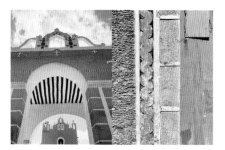

**94–95**

Franciscan monastery and church completed in 1561, Izamal, Yucatán. Built atop a pyramid and the acropolis of an ancient Maya city, the complex includes a massive atrium surrounded by an arcade. | A segment of wall featuring a variety of decorative treatments, two of which are painted in Izamal's famous yellow.

*Photography by John Ellis.*

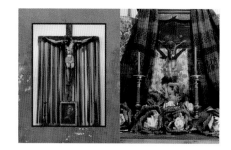

**96–97**

Altar crucifix in the former Discalced Carmelite chapel in the legendary Art Instituto Allende, San Miguel de Allende, Guanajuato. | A home-style altar at La Calaca, owned by Evita Avery, San Miguel de Allende, Guanajuato. An indigenous black Christ surrounded by a purple rebozo and paper flowers.

*Photography by Newell Turner.*

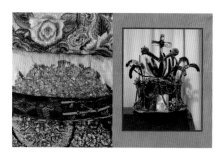

**98–99**

Details of Maya embroidery on blankets, Hacienda Sisal (Maya Cooperative), Mérida, Yucatán. | Vintage fiesta hat from the collection of Evita Avery, San Miguel de Allende, Guanajuato.

*Photography by Newell Turner.*

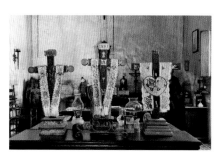

**100–101**

Maya embroidered stoles draped over indigenous folk-style crosses. Office of Juan Escalante Pérez, Motul, Yucatán.

*Photography by Newell Turner.*

**102–103**

Antique horse bridle hanging on a restored wall. | Family shrine, office of Juan Escalante Pérez, Motul, Yucatán.

*Photography by Newell Turner.*

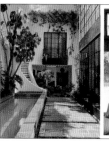

**104–105**

Residence of interior designer Rela Gleason, San Miguel de Allende, Guanajuato. | Straw hats and basketry by an entry to the residence of Rela Gleason, San Miguel de Allende, Guanajuato.

*Photography by Newell Turner.*

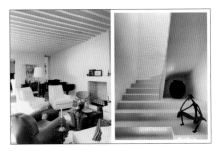

**106–107**
Residence of interior designer Rela
Gleason, San Miguel de Allende,
Guanajuato.

Photography by Newell Turner.

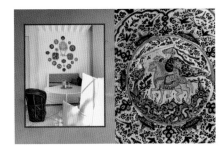

**108–109**
Breakfast room with a collection of
Talavera plates and platters, in the
residence of interior designer Rela Gleason,
San Miguel de Allende, Guanajuato. | Detail
of an early Talavera basin, or *lebrillo*, in the
small museum at the seventeenth-century
*Patio de los Azulejos*, Puebla.

Photography by Newell Turner.

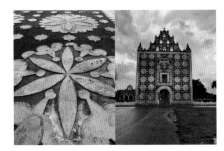

**110–111**
Restored exterior detail. | Church and
former convent of Santo Domingo de
Guzmán, Uayma, Yucatán. Built in 1646.

Photography by Newell Turner.

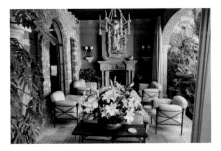

**112–113**
Living room loggia at the residence of
interior designers Jeffry Weisman and
Andrew Fisher, San Miguel de Allende,
Guanajuato.

Photography by Newell Turner.

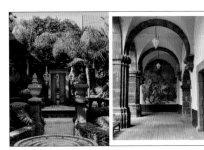

**114–115**
Lower pool terrace at the residence of interior
designers Jeffry Weisman and Andrew
Fisher, San Miguel de Allende, Guanajuato.
| "El Fanatismo del Pueblo" fresco by Pedro
Martínez (1939) in the Ignacio Ramírez "The
Necromancer" Cultural Center of the National
Institute of Fine Arts. Originally the Convent
Real de la Concepción, built in 1754, San
Miguel de Allende, Guanajuato.

Photography by Newell Turner.

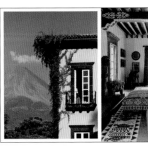

**116–117**
Hacienda de San Antonio with the active
Colima Volcano in the distance, State
of Colima. | Hacienda de San Antonio.
Decorated by Alix Marcaccini, daughter of
the late Sir James Goldsmith, and interior
designer Armand Aubery with French
designer Robert Couturier consulting.

Photography by Davis Gerber, Hacienda de
San Antonio.

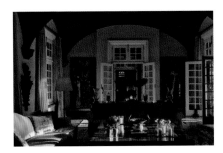

**118–119**
Hacienda de San Antonio, State of Colima.

Photography by Davis Gerber, Hacienda de
San Antonio.

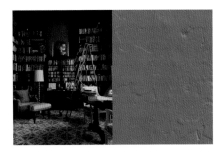

**120–121 | NEOCLASSICAL**
Residence of interior designer
Louis Navarette and artist Ric Best,
Mérida, Yucatán.

Photography by Newell Turner.

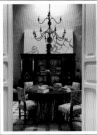

**122–123**
Residence of interior designer
Louis Navarette and artist Ric Best,
Mérida, Yucatán.

Photography by Newell Turner.

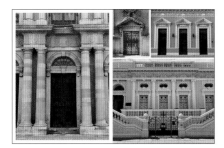

**124–125**
Ángela Peralta Theater, San Miguel de Allende, Guanajuato. | Facades in Mexico City and Mérida, Yucatán.

Photography by Newell Turner.

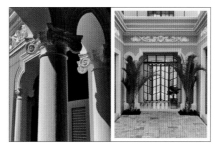

**126–127**
Residence of Newell Turner and Douglas Clarke. Architecture and restoration by Workshop Architects, Mérida, Yucatán.

Photography by Newell Turner.

**128–129**
Residence of Newell Turner and Douglas Clarke. Architecture and restoration by Workshop Architects, Mérida, Yucatán.

Photography by Newell Turner.

**130–131**
Residence of Newell Turner and Douglas Clarke. Architecture and restoration by Workshop Architects, Mérida, Yucatán.

Photography by Newell Turner.

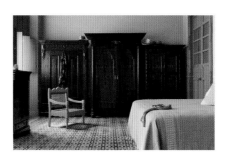

**132–133**
Residence of Newell Turner and Douglas Clarke. Architecture and restoration by Workshop Architects, Mérida, Yucatán.

Photography by Newell Turner.

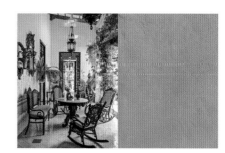

**134–135 | ART NOUVEAU**
Casa Pistache, by designer Marjorie Skouras. Mérida, Yucatán.

Photography by John Ellis.

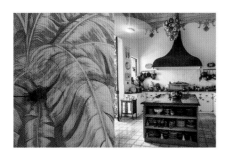

**136–137**
Grisaille mural with insect lamp. | Kitchen with Art Nouveau decorative wall treatment. Both in Casa Pistache, by designer Marjorie Skouras, Mérida, Yucatán.

Photography by Newell Turner | John Ellis.

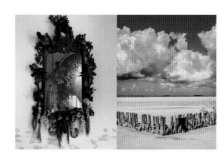

**138–139**
Casa Pistache, by designer Marjorie Skouras, Mérida, Yucatán. | Gulf of México salt flats, Yucatán.

Photography by Newell Turner | Patricia Robert.

**140–141**
Casa Pistache, by designer Marjorie Skouras. Mérida, Yucatán.

Photography by Newell Turner.

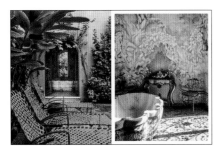

**142–143**
Casa Pistache, by designer Marjorie
Skouras, Mérida, Yucatán.

Photography by John Ellis.

**144–145**
Sand-worn and sun-bleached conch shell.
| Javier Marín mural in the shop Barro de
Sac Chich, established by the Javier Marín
Foundation, Sac Chich, Yucatán.

Photography by Newell Turner.

**146–147**
Pasta tile detail in Casa Pistache, by
designer Marjorie Skouras, Mérida,
Yucatán. | Murals by Lucas Rise at Don
Taco Tequila, San Miguel de Allende,
Guanajuato.

Photography by Newell Turner.

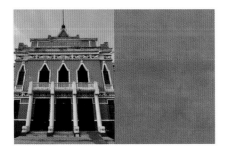

**148–149 | ART DECO**
Casa del Pueblo, completed in 1928,
Mérida, Yucatán.

Photography by Newell Turner.

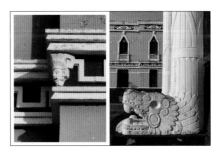

**150–151**
Casa del Pueblo, completed in 1928,
Mérida, Yucatán.

Photography by Newell Turner.

**152–153**
Casa del Pueblo, completed in 1928,
Mérida, Yucatán.

Photography by Newell Turner.

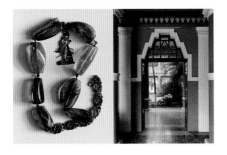

**154–155**
Amber *amarillo* beads with silver pendant
of Ixchel, the Maya goddess of moon,
embroidery, and forest, at Hacienda Sisal
(Maya cooperative), Mérida, Yucatán.
| Casa del Pueblo, completed in 1928,
Mérida, Yucatán

Photography by Newell Turner.

**156–157**
Doorways in Mérida, Yucatán. | Vintage
sterling silver bracelets, including designs
by Margot Van Voorhies de Taxco,
Frederick W. Davis, and the Los Castillo
workshop. All from the collection of Jenne
Maag, Mérida, Yucatán.

Photography by Newell Turner.

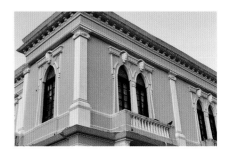

**158–159**
A former residence on Paseo de Montejo,
Mérida, Yucatán.

Photography by Newell Turner.

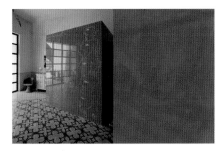

**160–161 | SURREALISM**
Estudiolo, guesthouse of Robert Willson and David Serrano. Architecture by Workshop Architects, Mérida, Yucatán.

Photography by Tamara Uribe.

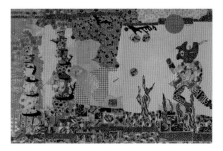

**162–163**
Section of a large wall mural—a collage of common vinyl tablecloths—by David Serrano.

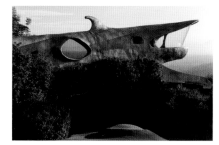

**164–165**
Casa Orgánica, architecture and interiors by Javier Senosiain Aguilar, México City.

Photography by Fabian Martinez.

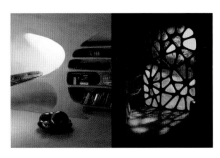

**166–167**
Casa Orgánica, architecture and interiors by architect Javier Senosiain Aguilar, México City.

Photography by Fabian Martinez.

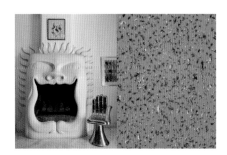

**168–169**
Fireplace and Hand Chair by Pedro Friedeberg, at Gallery Casa Diana, also the residence of director Carmen Gutiérrez, San Miguel de Allende, Guanajuato. | Monarch butterflies.

Photography by Newell Turner | Santiago Arau.

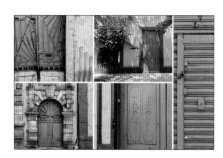

**170–171**
Doorways on Calle Violeta, México City.

Photography by John Ellis.

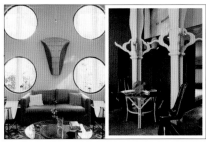

**172–173**
Interiors of Las Pozas, residence of the late Edward James, Xilitla, San Luis Potosí.

Photography by Mark Luscombe-Whyte/ The Interior Archive.

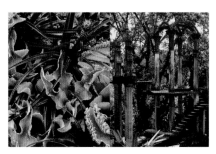

**174–175**
Detail from a garden designed by Lisa Gaffney, Mérida, Yucatán. | Garden folly at Las Pozas, residence of the late Edward James, Xilitla, San Luis Potosí.

Photography by Lisa Gaffney | Mark Luscombe-Whyte/The Interior Archive.

**176–177**
Private residence and gardens designed by Lisa Gaffney, Mérida, Yucatán.

Photography by Newell Turner.

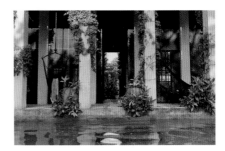

**178–179**
Private residence and gardens designed by
Lisa Gaffney, Mérida, Yucatán.

Photography by Newell Turner.

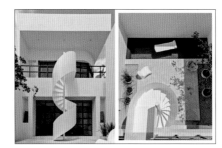

**180–181**
Estudiolo, guesthouse of Robert Willson
and David Serrano. Architecture by
Workshop Architects, Mérida, Yucatán.

Photography by Tamara Uribe.

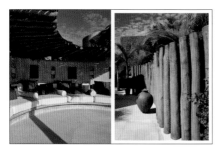

**182–183**
Casa Luna, by architect Manolo Mestre,
Careyes Bay, Puerto Vallarta, Jalisco.

Photography by Mark Luscombe-Whyte/The
Interior Archive

**184–185**
Vintage caftans from the collection of
interior designer Marjorie Skouras.

Photography by Newell Turner.

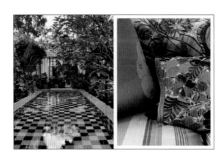

**186–187**
Residence of interior designer Lemeau
Arrott-Watt, Mérida, Yucatán. Architecture
by Workshop Architects, Mérida, Yucatán.

Photography by Newell Turner.

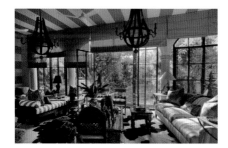

**188–189**
Residence of interior designer Lemeau
Arrott-Watt. Mérida, Yucatán.

Photography by Newell Turner.

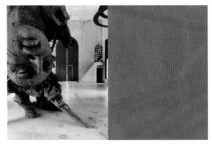

**190–191 | MODERNISM**
Plantel Matilde arts center, Sac Chich,
Yucatán. Architecture by artist Javier Marín
and architect Arcadio Marín, who are
brothers. Sculpture by Javier Marín.

Photography by Veronica Gloria, Plantel Matilde,
Fundación Javier Marín.

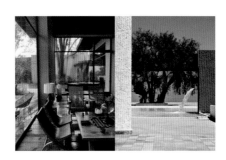

**192–193**
An interior view of Casa Prieto-Lopez and
the horse fountain of Cuadra San Cristóbal,
both by legendary architect Luis Barragán.

Photography by John Ellis. © 2022 Barragan
Foundation, Switzerland / Artists Rights Society
(ARS), New York. | Mark Luscombe-Whyte/The
Interior Archive.

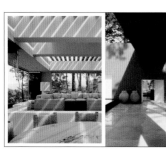

**194–195**
Private residence by architect José de
Yturbe, Valle de Brava, State of México.

Photography by Mark Luscombe-Whyte/The
Interior Archive.

**196–197**
Casa Etérea, State of Guanajuato.
Architecture and design by Prashant Ashoka.

Photography by Kevin Scott.

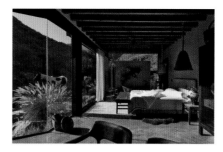

**198–199**
Casa Etérea, State of Guanajuato.
Architecture and design by Prashant Ashoka.

Photography by Kevin Scott.

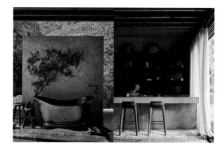

**200–201**
Casa Etérea, State of Guanajuato.
Architecture and design by Prashant Ashoka.

Photography by Kevin Scott.

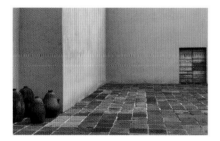

**202–203**
A courtyard by legendary architect Luis
Barragán, México City.

Photography by John Ellis. © 2022 Barragan
Foundation, Switzerland / Artists Rights Society
(ARS), New York.

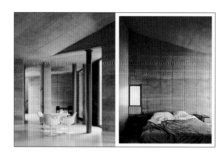

**204–205**
Private residence in Ajijic on Lake
Chapala, Jalisco. Rammed earth design and
construction by architect Tatiana Bilboa.

Photography by Rory Gardiner/OTTO.

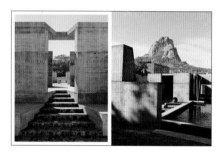

**206–207**
Private residence, Bernal, Querétaro.
Architectural and interior design by
Emmanuel Picault, owner of Chic by
Accident gallery, México City.

Photography by Tom de Peyret.

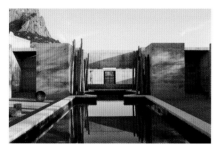

**208–209**
Private residence, Bernal, Querétaro.
Architectural and interior design by
Emmanuel Picault, owner of Chic by
Accident gallery, México City.

Photography by Tom de Peyret.

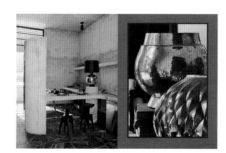

**210–211**
Private residence, Bernal, Querétaro.
Architectural and interior design by
Emmanuel Picault, owner of Chic by
Accident gallery. México City. | Silver vases
by architect and designer Laura Kirar,
Hacienda Subin, Yucatán.

Photography by Tom de Peyret | Newell Turner.

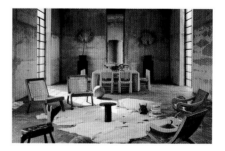

**212–213**
Private residence. Bernal, Querétaro.
Architectural and interior design by
Emmanuel Picault, owner of Chic by
Accident gallery, México City.

Photography by Tom de Peyret.

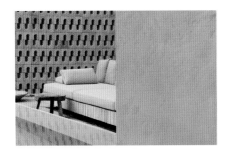

**214–215 | CONTEMPORARY**
Casa Escuela, by architect Ezequiel Farca and designer Mónica Calderón. Their residence as well as a multidisciplinary art residency/cultural hub. Mérida, Yucatán.

Photography by Fernando Marroquin.

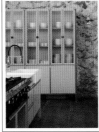

**216–217**
Casa Escuela, by architect Ezequiel Farca and designer Mónica Calderón. Their residence as well as a multidisciplinary art residency/cultural hub. Mérida, Yucatán.

Photography by Fernando Marroquin.

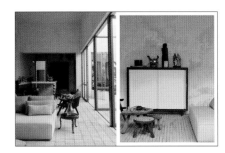

**218–219**
Casa Escuela, by architect Ezequiel Farca and designer Mónica Calderón. Their residence as well as a multidisciplinary art residency/cultural hub. Mérida, Yucatán.

Photography by Fernando Marroquin.

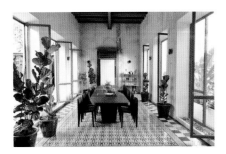

**220–221**
Casa Escuela, by architect Ezequiel Farca and designer Mónica Calderón. Their residence as well as a multidisciplinary art residency/cultural hub. Mérida, Yucatán.

Photography by Fernando Marroquin.

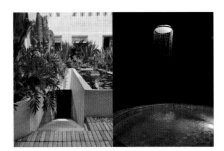

**222–223**
Casa Escuela, by architect Ezequiel Farca and designer Mónica Calderón. Their residence as well as a multidisciplinary art residency/cultural hub. A particularly large *cisterna* was accessed, and an underground spa created in the space. Mérida, Yucatán.

Photography by Newell Turner.

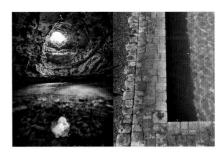

**224–225**
Cenote Hoolkosom, Homun, Yucatán. | Pool with stone surround that allows the water surface to gently breach the stone pavers. Designed by Laura Kirar for Hacienda Subin, Yucatán.

Photography by Santiago Arau | Newell Turner.

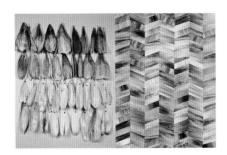

**226–227**
The dried husks of a heritage corn variety. | Totomoxtle, or native corn husk marquetry, by product designer Fernando Laposse, México City.

Photography by Jake Curtis.

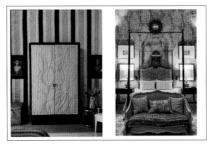

**228–229**
Guestroom in Maison Hidalgo designed by Laura Kirar, San Miguel de Allende, Guanajuato. | Bedroom designed by Josue Ramos Espinoza, Mérida, Yucatán.

Photography by Pepe Molina | Veronica Gloria.

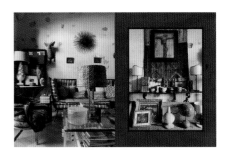

**230–231**
Residence of designer Josue Ramos Espinoza, Mérida, Yucatán.

Photography by Newell Turner.

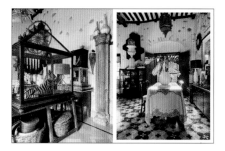

**232–233**
Residence of designer Josue Ramos
Espinoza, Mérida, Yucatán.

Photography by Newell Turner.

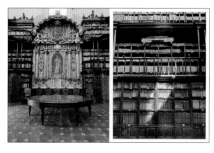

**234–235**
Biblioteca Palafoxiana, Puebla. The oldest
public library in the Americas, established
in 1646.

Photography by Newell Turner.

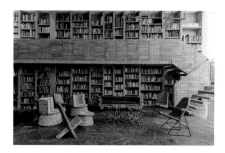

**236–237**
Private library of architect Pedro Reyes
and fashion designer Carla Fernández,
México City.

Photography by Giorgio Possenti.

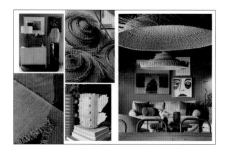

**238–239**
Residence of product designer Daniel
Valero and interior designer Mayela
Ruiz Delgado, San Miguel de Allende,
Guanjuato. Wicker lighting, woven rug,
and ceramics by Daniel Valero. Interiors
by Mayela Ruiz Delgado.

Photography by Newell Turner.

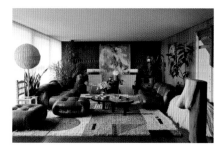

**240–241**
Apartment of Rodman Primack and Rudy
Weissenberg, owners of AGO Projects,
México City.

Photography by Stephen Kent Johnson/OTTO.

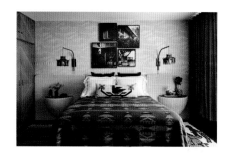

**242–243**
Apartment of Rodman Primack and Rudy
Weissenberg, owners of AGO Projects,
México City.

Photography by Stephen Kent Johnson/OTTO.

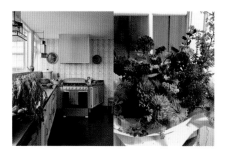

**244–245**
Apartment of Rodman Primack and
Rudy Weissenberg, owners of AGO
Projects, México City. | Floral arrangement
featuring dahlias, the flowers of the Aztecs,
by Dafne Tovar Muñiz of La Florería & Co,
México City.

Photography by Stephen Kent Johnson/OTTO.
| Dafne Tovar Muñiz

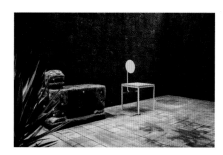

**246–247**
Courtyard tiled in lava rock with
indigenous jaguar chair and the KIIN chair
by Studio Martes, represented by LUTECA,
México City, New York City, Los Angeles,
and Paris.

Photography by Ramiro Chaves for LUTECA.

**262–263**
The coat of arms of México on the façade
of the National Museum of Anthropology,
México City. Architecture by Pedro
Ramírez Vázquez, 1964.

Photography by Newell Turner.

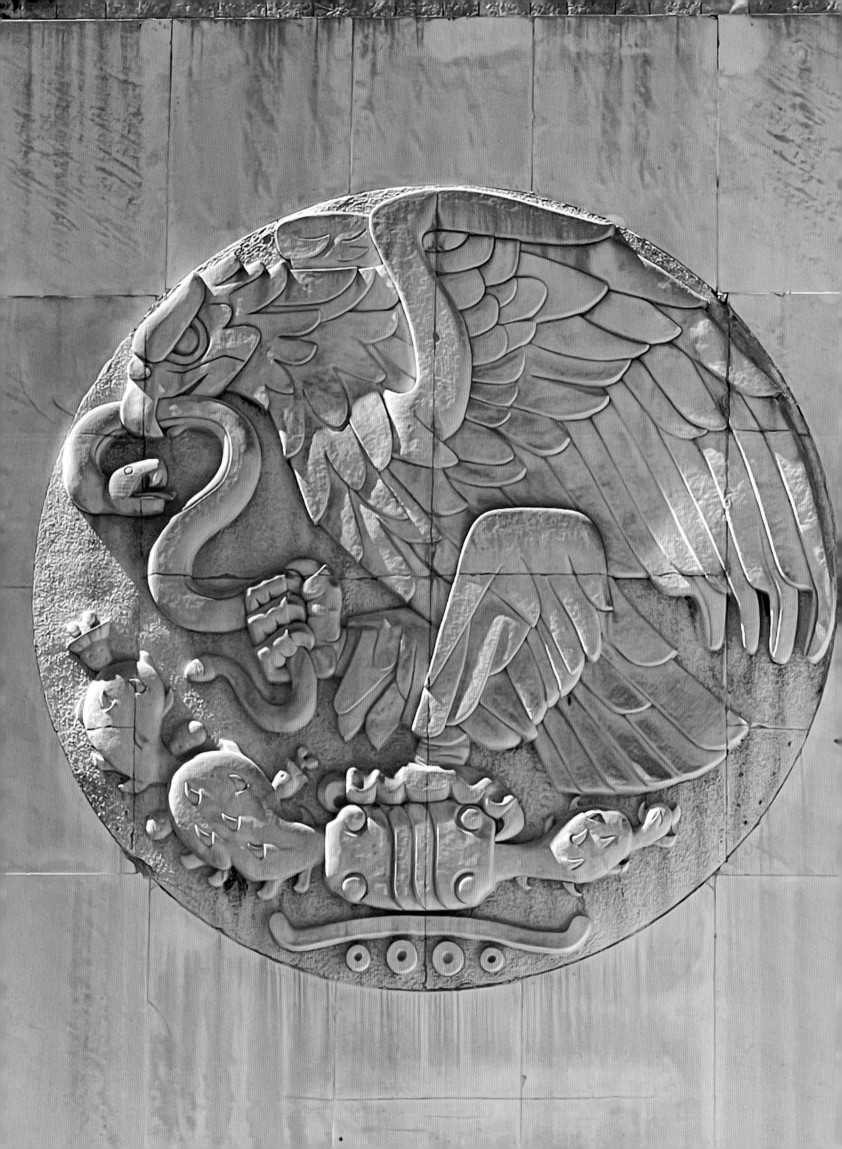

# ACKNOWLEDGMENTS

Decades of working in the magazine world and years of experience as an editor in chief have given me a particular appreciation for the contributions of the many people who helped produce this book.

I am indebted to Stephen Drucker, who has been both a mentor and friend for more years than either of us wants to count. This book started with a text he sent me after seeing posts on my Instagram feed: "Are you working on a book?" Stephen guided me to The Vendome Press and was indispensable as my editor.

At Vendome, I thank the entire team led by Mark Magowan and Beatrice Vincenzini, both of whom trusted my vision and Mexican experience. Special thanks to Celia Fuller for the beautiful book design and her understanding of the power of subtleties in graphic design. Also, a deep thank you to Karen Howes whose role as photography editor was both resourceful and diligent.

Thank you Susana Ordovás, who shares a passion for Mexican design, for the lovely Foreword. Thank you to all the homeowners, collectors, institutions, foundations, and shops who opened their doors to me. And thank you to the professional photographers whose creative eyes for light and interior spaces anchor my visual narrative.

Last but not least, thank you to my partner in life, Douglas Clarke, who continues with me on our journey of discovery in Mérida and México. His patience with my constant impulse to stop and take a picture, as well as his unlimited encouragement in life . . . I can't imagine without.

***Muchas gracias México por la cálida bienvenida!***

Mexican
First published in 2023 by The Vendome Press
Vendome is a registered trademark of The Vendome Press LLC

www.vendomepress.com

**VENDOME US**
PO Box 566
Palm Beach, FL 33480

**VENDOME UK**
132–134 Lots Road
London, SW10 0RJ

PUBLISHERS
Beatrice Vincenzini, Mark Magowan, and Francesco Venturi

Distributed in North America by Abrams Books
Distributed in the UK, and rest of the world, by Thames & Hudson

ISBN: 978-0-86565-423-5

EDITOR Stephen Drucker
MANAGING EDITOR Miranda Harrison
PRODUCTION DIRECTOR Jim Spivey
DESIGNER Celia Fuller

Library of Congress Cataloging-in-Publication Data available upon request

Printed and bound in China by 1010 Printing International Ltd.

SECOND PRINTING

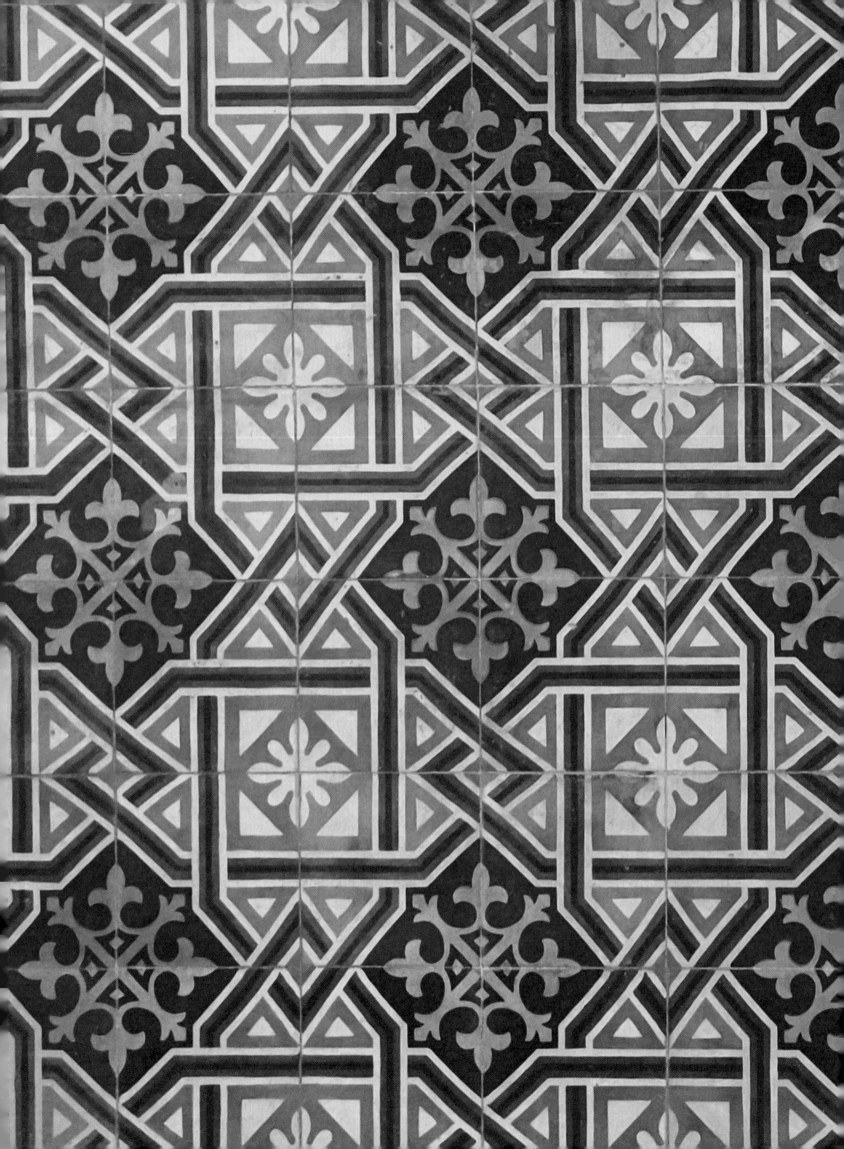